# A TREASURY OF

# ART MASTERPIECES

*From the Renaissance to the Present Day*

EDITED BY

*Thomas Craven*

A FIRESIDE BOOK
PUBLISHED BY SIMON AND SCHUSTER

# CONTENTS

NOTE: A COMPLETE INDEX OF ALL THE ARTISTS AND THE PAINTINGS REPRODUCED IN THIS BOOK
WILL BE FOUND ON PAGE 323.

# CONTENTS

CONTENTS

CONTENTS

CONTENTS

# CONTENTS

# FOREWORD

## BY HARRY B. WEHLE

RESEARCH CURATOR, DEPARTMENT OF PAINTINGS, METROPOLITAN MUSEUM OF ART

Recent years which have seen a new generation of Americans grow up have brought for the generations who knew World War I and the succeeding periods of boom and depression a curiously enhanced attitude of nonmaterialism. There is a new mistrust of laying up for ourselves treasures which "moth and rust may corrupt and thieves break through and steal." If we are to lay up anything nowadays it had better be worth-while experiences— things that can be deeply and immediately enjoyed, things that will enrich our daily mental fare, things to store in our memories.

A few years ago, many of our intellectual acquaintances were enthusiastic over revolutionary ideas, if not in connection with politics, then at least where the arts were concerned. Manifestoes met with widespread sympathy when they called for the condemnation of old works of art which were declared to obstruct the roads that belonged to the new generation. Our concert halls were filled with inchoate and challenging dissonances, our art journals joined in with distracting abstractions, and our established museums found themselves under deep clouds of suspicion.

Today all that seems to be very much altered. With the perspective of time and intellectualization, some of the dissonances have been welcomed into the unbroken tradition. But there is also an unmistakable tendency, especially apparent among the intellectuals who had ventured farthest toward the Left, to re-examine the arts of the past in search of the most profound and permanent truths, the most dependable and penetrating beauty. Today Shakespearean revivals are among the most successful plays, one of the most admired motion pictures is based on a novel by Charles Dickens, and conductors of great orchestras find themselves giving more room in their programs to Bach, Beethoven, and Brahms, Handel, Haydn, and Mozart. Thanks largely to the influence of the phonograph and the radio, the understanding of the great music of the past has become so general that Toscanini's broadcasts are treated as events of national importance.

Meanwhile, growing numbers of intelligent music lovers are collecting phonograph records of music by the great masters, so that they may choose their own programs and their own moments for listening. They have come to know, and to anticipate with delight, each new spin of the disk that brings them the musical ideas. While they go on with their workaday pursuits their heads buzz with imponderable and indestructible treasures. They have acquired real and precious values.

It is a closely parallel set of values that American lovers of paintings are finding today. To many who have opportunities for foreign travel the great picture galleries of Europe have become familiar. Larger numbers who remain in America frequently visit our major museums, enriched as they have been through the years by prodigal bequests such as those of Marquand, Morgan, Johnson, Altman, Havemeyer, Friedsam, Birch-Bartlett, Ryerson, Lillie P. Bliss, and Senator Clark, and more recently, the Frick and Bache collections in New York. Now, the great Mellon collection has formed the basis of the National Gallery of Art in Washington, and to this have been added Italian paintings collected by Samel H. Kress. In addition, there are the special occasions when we may become acquainted with individual pictures lent from one or another of the important private collections.

But, to appreciate pictures we need to know them thoroughly. Detailed memories of them afford some of our profoundest pleasures, but in actuality there are few of the world's great paintings to which we travel often enough to know them through and through. The precious thing itself may be spread out, for all comers to see, on the walls of a church in Arezzo or Orvieto. It may be available in a public gallery in Amsterdam or Siena or Madrid; it may hang in an American museum, or it may appear occasionally as a private contribution to a public exhibition. These originals, however, few art lovers are fortunate enough to see frequently and to know thoroughly at first hand. But the modern reproduction or color print when it is accurate and sharp can bring us the ideas of the great masters—reduced in scale perhaps, tuned down as it were—but complete enough, and now in a wide enough repertoire, to make these masterpieces in a sense our own treasured possessions. One hundred and sixty such color prints are provided in this comprehensive and admirable collection of great paintings, from the dawn of the Renaissance down to the present.

# INTRODUCTION

## By Thomas Craven

Of all the imaginative works of man, the most appealing, it seems to me, is great painting. Nothing in the other arts offers itself so directly to the mind, or opens up, in such small compass, so many avenues of interest. For painting reveals itself as a whole, not as a succession of parts; it stands before us in all its glory, apprehensible and undisguised, a complete statement of the infinite surmises and adventures of the human spirit. It weds the past to the present and conceives the future; it deals with experiences as old as time, and always, when it is living and useful, in the terms of some special civilization; always casting its materials in the predominant pattern of the period, but tracing into that pattern the individual variations of genius which make the behavior of the race endlessly dramatic and fascinating throughout the ages.

We may look upon art as a great tree nourished in the soil of human experience, an organic development fertilized by the fresh energy of young and hardy peoples, and expanding unexpectedly with the enrichments of powerful personalities. This art tree, at the close of the thirteenth century, was a shriveled thing of barren forms and ancient mummeries; and then, suddenly, we behold it spurting into amazing bloom under the care of Giotto, the first great painter of the Western world. Giotto, born into an age of the wildest contradictions, where the extremes of good and evil—the most ignoble passions, furious materialistic squabbles, stern intellectual joys and religious feelings—went hand in hand, brought everyday incidents and Italian people into art, men, women, and suckling babies. He painted on the walls of churches New Testament stories and the life of St. Francis; not as abstractions or scholastic symbols, but with psychological insight penetrating to the heart of dramatic action.

After Giotto, we have a set of agreeable, second-rate storytellers—little Giottos—followed by Masaccio, the master of masters with whom the last flat vestiges of medievalism disappear, and then by a line of mighty painters leading to the fullest efflorescence of Italian art in the high Renaissance. We can name only a few of them: Uccello, founder of the science of perspective; Andrea del Castagno; Antonio Pollaiuolo, the pagan anatomist; Piero della Francesca, beloved by modernists for his "cool, intellectual detachment," and the diagrammatic perfection of his designs; the domestic Lippi and his son; and Fra Angelico, the holy monk. In the high Renaissance, with its somewhat affected preoccupation with classical antiquity, we have the sensitive, incredibly gifted, and effeminate Raphael; and Leonardo da Vinci with perhaps the finest intelligence the world has produced—certainly the finest that ever found its way into painting. And we have Michelangelo, creator of the superman and the frescoes in the Sistine Chapel, the greatest singlehanded achievement in the history of art. In contrast to the men of Florence, we have the gentlemen of the Adriatic, the merchants of Venice, founders of the cult of splendor, decorators of sensuality, glorifiers of nakedness and the physical world—Giorgione, Titian, Veronese, and Tintoretto.

While the Italians were cultivating art on a grand scale, another people of utterly different race and breeding were working diligently and independently in their own garden, a bleak garden swept by damp winds and bordering on a cold sea. They were a thrifty, Gothic folk, Flemish and Dutch and German,

with gross appetites, a strait-laced morality, a talent for inventions, and a love of home life—but they were as imaginative in their own way and as close to God in their democratic pieties as were the lofty Italians. They had a genius for painting homely realities, and as craftsmen they had no equals. They produced, in their early days, the Van Eycks and Memling, masters of the art of putting little things together beautifully; they painted marvelous altarpieces and portraits that have never been excelled; and then, in their decline, they became commonplace and kitchen-minded. But they gave us Rubens, the most magnificent, versatile, and influential of painters, a man in whom there is nothing stingy, or mean, or stunted, but everything that is large and opulent and glowing with vitality. They gave us Rembrandt, whose art is a record of the fundamental experiences of the groping human race; the peasant Brueghel, one of the first to paint landscape in relation to the occupational activities of man; Hals, with his speaking likenesses of tavern heroes and fishwives; the magical tones of Vermeer; Dürer, whose *Four Apostles* are not unworthy to stand beside the Prophets of the Sistine Chapel; and Holbein, the most precise and detached of portrait painters.

The branches of art are of incalculable variety. Change the soil and you get a new species. El Greco, a Cretan, went to Spain, became infected with theatrical religiosity, and brought forth distorted figures embodying all the agonies of the Spanish soul. Goya, a native and a ruffian of intellect and prodigious ability, portrayed the high and the low, duchesses and gangsters, the sacred and the profane, with incomparable audacity. In England, Sir Joshua Reynolds and his followers flattered the aristocrats, while Hogarth, drinking beer with honest shopkeepers, made himself the most robust and original of Anglo-Saxon painters. France, after Poussin and his Acadamy had sterilized painting with their internationalism, redeemed herself in a number of men who were artists, not eclectics; and beginning with Chardin, we find that persistent, practical reference to experiences in the French environment which later produced Daumier, master draftsman and humanitarian; Renoir, the exponent of joyous paganism; the trenchant Bohemian studies of Toulouse-Lautrec; and Cézanne, the father of modernism. In the twentieth century, the discoveries of Cézanne

were carried into the field of abstract design by Picasso and the present school of Paris. Today the hope of painting lies in America.

The great movements in art had their origins in specific settings. Italian painting, for example, was composed of a nest of intensely local schools, each with rigidly defined characteristics and each strongly conditioned by local psychologies. Viewed at long range, this great art may be designated nationally as Italian; on closer inspection, it becomes Florentine, Venetian, Sienese, Roman, and Umbrian; in the last analysis, it is the work of outstanding individuals who traced their own original variations into the general pattern of their times. But with the collapse of the city kingdoms of Italy, and the forced, antique flowering of the late Renaissance, the practice of art was abstracted from local settings and converted into an international industry. Art was enthroned; it became the property of aristocrats, the spoil of collectors, the concern of the cultivated, and ultimately the plaything of the precious. A new and mischievous concept came into being—an international esthetic, and with it the pernicious habit among self-conscious intellectuals of regarding art as a universal practice independent of time and independent of locality.

This does not mean that the concept of internationalism in art of which we hear so much today is a fallacy promoted by homeless intellectuals. There is profound truth in it. The division of Europe into nationalities was followed not only by the exchange of economic goods but also by a brisk trading in cultural goods. The cultivated people of France—and the uncultivated too, if we are to credit the reports of the crowds that gathered to behold Napoleon's art robberies—discovered that they could respond to Italian and Flemish art, that its language was not alien. And the same is true of people everywhere when brought into contact with art of enduring value.

But there are two sides to the art business, the appreciative and the creative, and what is good and true for one is not good and true for the other. From the appreciative point of view, art is indeed universal: we may enjoy and understand paintings of such diverse schools as the British and the Florentine. But to the maker of pictures, art is an essentially local occupation—the product of direct experiences with

human beings, of the perception of things in specific settings.

It is plain, I think, that people are quite capable of appreciation when they have access to pictures which are the carriers of human meanings and not merely the solutions of technical problems. Within the last few years, however, the appreciation of painting has been enmeshed in technicalities and structural methods of so occult and forbidding a nature as to drive the average person to despair. It is the habit of certain painters and critics to restrict the significant factors of appreciation to those whose understanding rests upon specialized training, thereby ruling out of court the very audience for which the art of painting was created. Thus technique, essentially a matter for painters and specialists, becomes the whole of art, a field isolated from vulgar understanding; and problems of craft, when dressed up in the faddish raiment of modern psychology, are made to appear enormously impressive. But not even the most frenzied partisans of the abstractionists have the temerity to tell us that the old Italians put those immortal pictures in their churches in order to be comforted by the visible blessings of "plastic form" and "abstract beauty." The layman cannot be fooled to that extent. His common sense tells him that Italian painting expressed collective beliefs and ideals, spiritual joys and sorrows, experiences common to all men. Somerset Maugham discusses these matters with his usual intelligence.

"Technique is not the whole of painting," he says. ". . . it cannot touch the heart nor excite the mind. You might as well say that only a dramatist can appreciate a play. The drama also has its technique, though it is not so abstruse as some of its professors like to pretend, but it is the business only of the dramatist. To understand the technique of an art may be a diversion; it may even give the layman the feeling, agreeable to some people, of being in the know (like addressing the headwaiter of a fashionable restaurant by his first name) but it is not essential to appreciation. It may greatly interfere with it. We know that painters are often very bad judges of pictures, for their interest in technique absorbs them so that they cannot recognize merits, unconnected with it, that may give a picture value."

The main obstacle in the way of appreciation is the lack of familiarity with pictures. Great painting, to be fully understood, must be seen again and again —studied, explored, and contemplated. And here we come upon a serious difficulty. Painting, while enjoying advantages denied the other arts, suffers from inherent disadvantages: the nature of the medium makes the circulation of masterpieces practically impossible. You will have observed that the greatest manifestations of painting in the Western world occurred within small countries; in Italy, Flanders, and Holland, where artists, working within a limited radius, made themselves known to large audiences. But today most Americans—and most Europeans, for that matter—seldom see the canvases of the masters, old or new, and for obvious reasons.

I cannot buy Rembrandts and Holbeins and Daumiers; nor can you nor anyone—save the trustees of heavily endowed museums and a few wealthy collectors. The bulk of the great art of the world is inaccessible to all—save the most fortunate travelers. Some of it—frescoes, for example—remains *in situ*: the rest is deposited in museums which, being metropolitan institutions, are beyond the reach of the average interested person. The choicest specimens of modern art have passed into the clutches of private collectors, and cannot be seen for love or money. On rare occasions, our more enterprising museums, co-operating with local expositions, manage to assemble comprehensive and magnificent displays of paintings borrowed from collectors and the foremost European galleries. Such exhibitions unfailingly attract enormous crowds, and are worth the trouble and expense involved. They bring to most people the initial experience with masterpieces and help to bridge the gulf of unfamiliarity; and they offer at least a fleeting glimpse of greatness, a chance acquaintance with the visual expression of those deep-seated emotions which bind together all human souls and which make painting, of all arts, the universal language.

In default of originals, there is but one consolation—the print, preferably the color print. Artists with a professional interest in structure often find black-and-white prints sufficient for their needs, but to the vast body of appreciators, color is an indispensable element in the enjoyment of pictures. A great painting reproduced in monochrome is a painting robbed of its majesty; it is like a play unperformed, read but unseen, a play stripped of its rich

investiture of visual splendor, movement, and personality. In Europe the color print is an accepted fact, an inexpensive source of satisfaction. But in America, largely because of inexperience with first-rate reproductions, the use of prints is still in its infancy. The artist—the honest man who loves and produces pictures—will confess that the best prints convey, in large measure, the values of the original pictures. He welcomes the dissemination of prints, well knowing that a knowledge and appreciation of the old masters, aided and abetted by collections of reproductions, will stimulate an interest in contemporary art and hasten the day when we shall have, in America, local self-sustaining schools; when paintings will be in popular demand, and prints will circulate as freely as magazines. A utopian dream, perhaps, but one worth fighting for!

It is the tendency of the age to decentralize the consumption of art and to make everyone a participant in works of individual genius. Science and invention have carried great music into the corners of the continent; nobody goes hungry for books; and it is time that every home had a good painting— or a few good reproductions of paintings.

In the selection of pictures from the art of the past, I have conferred with museum directors on questions of authenticity and the many historical difficulties involved in reducing a field of overwhelming richness to a comparatively limited number of masterpieces. But I have adhered throughout to a central purpose: the reproduction of paintings which time has claimed for permanent glory—immortal possessions revealing the characteristics of the period, and the personal variations inscribed by men of genius on the general pattern. No masterpiece has been slighted because it is known to the world through continued reproductions from age to age; but every effort has been made to bring forward, when possible, examples of great art less familiar to the public. No pains have been spared to make the selections truly representative: to illustrate not only general tendencies but diversities in styles and subject matter—the scope of painting and how it has been practiced from the thirteenth to the twentieth century.

Among living artists, I have included the foremost French modernists whose influence, together with that of their immediate predecessors, on certain tendencies of recent painting, no one can ignore; two exponents of Mexican mural decoration; and a number of Americans. What time will do with these vigorous Americans I am not prepared to say, but they fulfill at least one of the preliminaries to great art: they are a part of the society in which they live; their paintings reflect the color and character of that society; and their canvases, exhibited in European galleries, stand out as conspicuously American productions. They are the leaders of the most exciting and important art movement existing in a troubled world; they have achieved a body of painting which has not only afforded enjoyment to large audiences but which has announced the beginning of a distinctly American style. They are forceful individuals whom the history of the period cannot overlook; for the modern reader, after reviewing the masterpieces of the past, seeks naturally the most significant works of his own time.

In the annotations I have not attempted to translate pictures into words, or into geometrical diagrams which mean nothing to the layman. Nor have I resorted to the elaborate and generally useless formula of comparing this picture with that—of cataloguing all the derivations and influences at work in the making of a picture—as if the noble art of painting were an endlessly dull exhibition of comparative anatomy. Most paintings are self-explanatory, and to enumerate their objective contents and to describe what is visually obvious is an obstruction to appreciation. I have endeavored to give such information as may help to establish a work in time and place and, where feasible, to call attention to the significant factors in the production of paintings. This is essentially a book of pictures with annotations designed to facilitate the reader's entrance into the world of art.

# GIOTTO

AFTER the long night of the Middle Ages, daybreak at last appeared in the world of art. It came suddenly in the shining genius of one man, Ambrogiotto di Bondone, remembered universally by the contraction Giotto, a name which stands for most of the great things in painting. As the art of the twentieth century has consciously sought to throw aside the burden of useless erudition—to find a meaning in life and to express the significant emotions in the simplest terms—it has continually retreated, with the result that the oldest and earliest of the masters is now leading the procession.

Giotto took the art of painting from the cobwebbed cellars of medievalism into the daylight where he might observe the actions of men as they went about their business. He was a painter of many experiences, but he retained, in his maturity, that extraordinary freshness of vision which is the special property of children and poets. He was a religious painter, after the custom of his time, but the first to connect dramatic stories with living people; the first to give movement to figures; and to make the sacred matter of art incontrovertibly real and true by portraying it as one who believed in the miracle of life and as one who had observed the effect of the miracle on his fellow men.

Giotto's largest and most important work is at Padua, in a little chapel, the walls of which he decorated in fresco with subjects taken from the lives of the parents of Mary, the Virgin herself, and the Son of God. These stories which have filled the soul with strange and contradictory feelings of joy and terror and sorrow, which young and old from generation to generation have tried to visualize and reconcile with their own imaginings, Giotto painted in a language that is eternally comprehensible to everyone possessed of sight. *The Flight into Egypt* is one of the finest of his frescoes and one of the noblest masterpieces of art. In St. Matthew's Gospel, the source of the story, the flight takes place at night; the Florentine artist painted it in the light of day, with the central characters beautifully joined and emphasized. It is not only a Biblical illustration, but also the old human story of mother and child fleeing from danger—they carry no baggage except drinking vessels—a story told with a stately tenderness and simplicity of means unrivaled in painting.

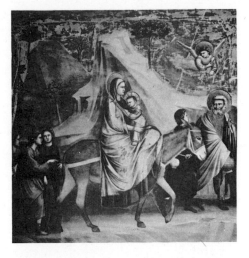

*The Flight into Egypt,* Arena Chapel, Padua. Fresco, 1305-1306. Color plate, page 49.

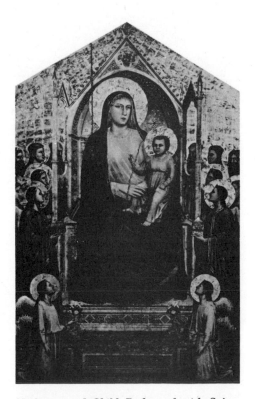

*Madonna and Child Enthroned with Saints and Angels,* which is known as the *Ognissanti Madonna,* Uffizi, Florence. Tempera panel, 10' 8¾" x 6' 7⅞".

*Heads of Saints,* detail from the *Ognissanti Madonna.* Faces portrayed from the first-hand study of men and women, as distinguished from the Byzantine abstractions.

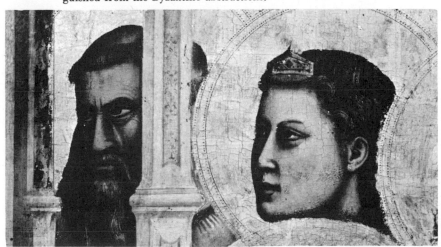

# GIOTTO

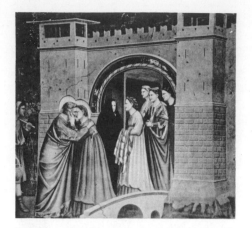

*Meeting of Joachim and Anna*, Arena Chapel, Padua. Fresco, 1305-06. Color plate, page 50.

*The Kiss of Judas*, detail from *The Betrayal of Christ*, in the second cycle of frescoes in the Arena Chapel, 1305-1306. One of the first examples, in paint, of the psychology of human relationships.

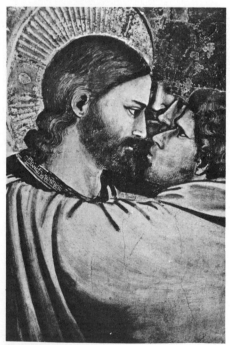

THE Arena Chapel is a long rectangular box pierced by Gothic windows on one side and ceiled with a barrel vault. Giotto converted the room into a picture gallery unfolding the consecutive workings of his mind as he pondered the subject matter, related it to the experiences of man, and embodied it in unalterable forms. Unhampered by architectural difficulties, he divided the walls into squares—decorative panels conceived as friezes and held together by uniform backgrounds of ultramarine.

The first cycle depicts the story of Joachim and Anna, the parents of Mary, as recorded in the apocryphal gospels. Old Joachim, the most pathetic figure in art, whose offering had been rejected by the high priest because "God had judged him unworthy to have children," retired to the sheepfold, where it was announced to him in a vision that his wife was to be the mother of the Virgin. With full consciousness of her destiny, he returned to Jerusalem, the Gospel of St. Mary reading: "Anna stood by the Golden Gate and saw Joachim coming with the shepherds. And she ran, and hanging about his neck, said, 'Now I know the Lord hath greatly blessed me.' " The moment of their meeting was painted by Giotto with solemn gentleness and grace: Joachim, a majestic, purposeful character, his wife reserved in her gladness, and in the background the little human touches new to painting—the attendants peering and smiling at the black-robed maid, now in disgrace, who had taunted her mistress.

According to an old chronicle, when Giotto was engaged in the frescoes—he worked on them for four years—his friend Dante came to Padua and was so dumbfounded that "he took the painted things for real persons, so truly did they represent nature." To the modern eye accustomed to all the expedients and illusions of naturalism, the tale is hard to believe; but it must be borne in mind that to the men of the thirteenth century, Giotto's innovations were nothing short of miraculous. In his concern with the great truths of birth, death, and resurrection, he had no time for the little details; and it is also well to remember that the regeneration of modern painting has been marked by a return to the first principles established by the Florentine. It may indeed be questioned whether painting, considered as a balance between man's formal deductions from nature and the quality of his convictions, has ever exceeded the expressive power of Giotto's best work.

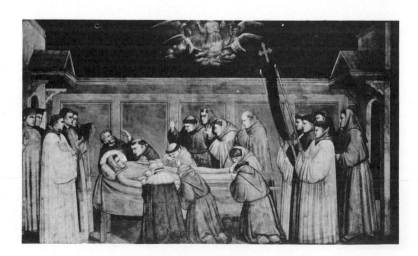

[RIGHT] *The Dormition of St. Francis*, Bardi Chapel, Santa Croce, Florence; about 1317, in Giotto's cycle of St. Francis. Only one of the sculpturesque figures, all awaiting the final moment, is aware that the soul of the saint is ascending to heaven.

# GIOTTO

As concerns the technique of painting, Giotto's problem was to relieve objects from the flatness of the wall, and to enhance their emotional appeal by making them massive and solid. To a degree he succeeded: his figures have the monumental bulk and strength of sculpture; but he had so many difficulties to surmount that he left anatomical details, surface embellishments, the minute study of faces and muscular actions, and the intricacies of perspective and light and shade to the men who came after him. But the absence of a more modern technique does not diminish the forcefulness of his art, or its capacity to express, with the utmost directness and clarity, the various states of the soul. The arms of his figures, for example, removed from their context, are only elongated triangles encased in stiff folds of cloth; the hands are too small, the fingers thin and inflexible. Conjoined with his figures, outstretched in gestures of supplication, or drawn back in terror, they become elements in a larger symbolism conveying both the essential drama of a specific situation, and emotions which have troubled the human race since the dawn of time.

The spirit of the frescoes in the Arena Chapel rises from the quiet nobility of the stories of Joachim and Anna, through the measured flow of sorrow in the second cycle, to the tragic eloquence of *The Deposition*. This picture, as a rendering of the sharpest agonies of the wounded spirit by means of figures stripped of every distracting refinement, is perhaps the greatest of Giotto's frescoes. There is no background, and no landscape; the scene is enacted among the rocks by men and women hewn from rocks. The characters in the tragedy are grouped concentrically, with every line and gesture leading to the body of Christ which rests on the knees of the Virgin. Mary Magdalen holds the feet; St. John leans forward, and the helpless Joseph stands behind the Magdalen—while the general lamentation is enforced from above by a choir of grief-stricken angels. There is not a false or artificial attitude in the composition—not a wasted line or contour. The story is told with the dramatic intensity of the written version in the Gospels: it is told with the compassion and humanity of the earliest of the Florentine masters.

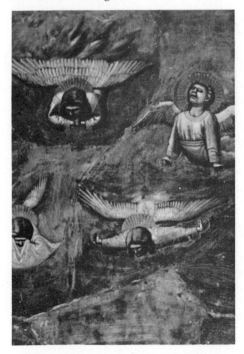

*The Deposition*, Arena Chapel, Padua. Fresco, 1305-1306. Color plate, page 51.

*Mourning Angels*, detail from *The Deposition*. The agony of the earthly drama is reflected in the celestial messengers.

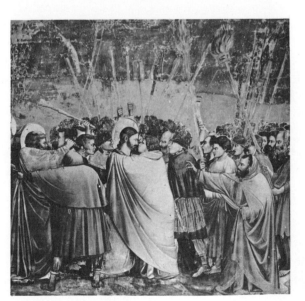

[LEFT] *The Betrayal of Christ*, Arena Chapel, Padua. One of the most dramatic illustrations in art. The disposition of the characters, the upraised weapons, the communicated feelings of condemnation—all these point the eternal moral of the story.

# DUCCIO DI BUONINSEGNA

1260?–1319?                                  SIENESE SCHOOL

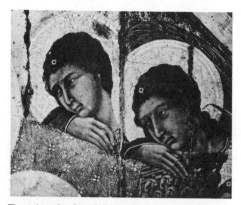

*The Marys at the Tomb*, Opera del Duomo, Siena. Tempera panel, 1308-1311. Color plate, page 52. One of the many panels of the huge altarpiece, the *Majesty*, or *Maestà*, celebrating the glorification of the Virgin.

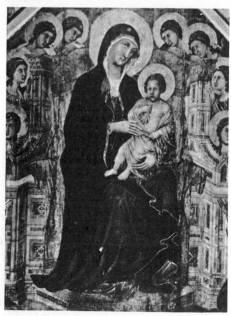

*Two Angels*, detail from the *Majesty*, hieratic figures woven into the grandeur of the conception with the decorative tenderness of the Sienene.

*Virgin and Child Enthroned*, detail from the *Majesty*. The central or focal point of perhaps the most memorable picture produced in Siena.

GIOTTO was the first artist to make pictures based on observation, and conforming to the demands of everyday life. Proceeding from the old Byzantine tradition which had severed its connection with human experiences and fallen into decay, he went directly to nature for his materials and painted men and women of living substance and indisputable reality. His accomplishments were tremendous, and when the last vestiges of medievalism had disappeared, the Italians, stimulated beyond our reckoning by an intellectual curiosity in all things, produced such a multitude of great artists that it is almost impossible to enumerate them.

But this dynamic readjustment of art to the forays and adventure of the spirit made no impression on the painters of Siena. In temperament, ideals, and practical affairs, the Sienese were at variance with their rivals, the Florentines. They were insular and capricious, oversensitive to the point of effeminacy, caring nothing for the new order of civilization but doting on medieval ecstasies; they were fond of cults, vacillating from Venus worship to Virgin worship, and always trying to exterminate their enemies by prayers and incantations rather than by superior force of arms. They loved the imaginative side of Christianity, and were quite capable of separating religion from conduct and of entrusting its preservation to the dreams of painters.

Duccio, their first great artist, was typical of Siena—troublesome, talented, and irresponsible—a spendthrift whose life, painting apart, was a calendar of legal infractions. Giotto's humanity served perversely to exaggerate his devotion to the Byzantine style which he practiced with a marvelous delicacy that put the Florentines to shame. He painted in tempera on panels; and his *Marys at the Tomb* is an illustration of his genius for revising the old iconography into startling designs of color and gold. He neither strove nor desired to represent the human form as an objective fact, or with the appearance of natural truth; he accepted and loved the long, stereotyped faces of the Marys, and the canonical red mantle of the Magdalen; and, by combining lines and colors in a flat pattern, painted a picture which, because of its craftsmanship, its decorative quality, and its unadulterated medieval sentiment, made his townsmen shout with delight and hail him as the Sienese magician.

[BELOW] The *Majesty* altarpiece, Opera del Duomo, Siena. Tempera on wood, 6′ 11″ x 13′ 10″, 1308-1311. Front view of one of the greatest decorations in occidental painting.

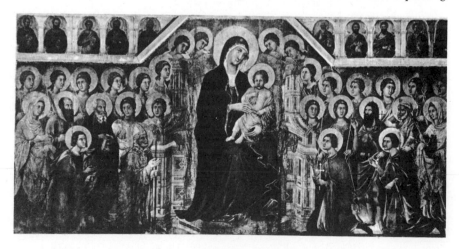

# SIMONE MARTINI

1285?–1344                    SIENESE SCHOOL

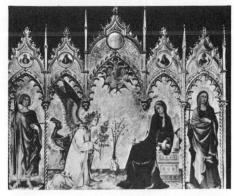

*The Annunciation*, Uffizi, Florence. Tempera on wood, 104⅜″ x 120⅛″, 1333. Color plate, page 53.

BY their tenacity in clinging to the medieval tradition, by the emphasis placed on Oriental patterns, and by an ingrained preference for the sensitive and precious instead of the dramatic side of painting, the Sienese may be said to have originated the esthetic attitude toward art. Since the thirteenth century this attitude has reappeared from time to time, but always in declining periods when traditions have run to seed and creative energy has been vitiated by a strained preoccupation with past styles. The Sienese, abjuring the humanities that revolutionized Florentine art, cultivated the Byzantine style with a mastery of execution which became almost the sole standard of appreciation, and which eventually reduced their art to a form of cabinetmaking embossed in fine gold. But this somewhat febrile enthusiasm for Oriental design, abetted by consummate workmanship, produced a form of art which, though continuously derivative, is sufficiently individual to deserve the name—the Sienese style.

The artists of Siena were not irreligious; they were, in fact, devotional painters to a man, but they found themselves in the position of appealing to an audience of connoisseurs who judged their performances by esthetic standards. It was not an accident that *The Annunciation*, by Simone Martini, should have been esteemed by his contemporaries as the most perfect expression of Sienese genius—it commands the same esteem among modern connoisseurs. When Martini, a man of many honors, painted the picture, he considered, first, the placement of the figures, the linear pattern, the effect of color against a background of gold, and the appeal of the altarpiece as a splendid object of art. He gave subordinate consideration to the subject matter and its emotional implications. As a consequence, the painting invites esthetic appreciation but does not deeply disturb the emotions: the Virgin is a resisting silhouette and the Gabriel a lovely attitude. But the painting, as a design, is the flower of medieval decoration, and one of the permanent glories of Sienese art. The altarpiece has been restored—not too expertly—and the two lateral panels are generally ascribed to Martini's brother-in-law, Lippo Memmi, who is known to have had a hand in the execution of the work.

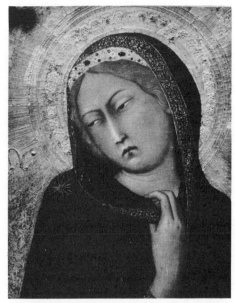

*Head of the Virgin*, detail from *The Annunciation*. An early example of the petulant delicacy characteristic of the Sienese school.

[BELOW] *Guidoriccio da Fogliano*, Palazzo Publico, Siena. Fresco, 1328. A poetic interpretation of the famous condottiere of the Sienese army, as he inspects his defenses.

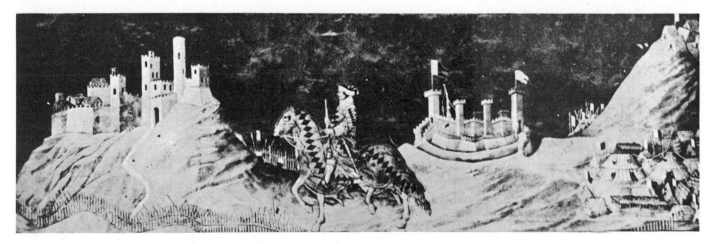

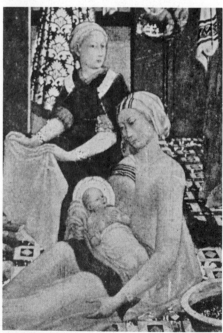

*The Birth of the Virgin*, Collegiate Church of Asciano. Triptych, tempera on wood, 7′ 3⅜″ x 5′ 2⁵⁄₁₆″. Sassetta's earliest extant picture and a masterpiece of the artless medieval genre.

Detail from *The Birth of the Virgin*. A nurse holds the infant while the maids prepare the bath. One of them is warming a towel before a fire.

# SASSETTA

1392–1450   SIENESE SCHOOL

In 1450, Stefano di Giovanni, called Sassetta, painting a great fresco from a high platform above the Porta Romana of his native town, contracted an illness that ended his career. "Stabbed through and through by the sharp southwest wind," as he expressed it, the man who had delighted his contemporaries with a picture of *St. Francis Wedded to Poverty* himself died in poverty, leaving a family without subsistence, and a name that lay buried and forgotten until the beginning of the present century. Today, reincarnated, he has passed once more into the magic circle of Sienese painting—the artist whose calm, unaffected holiness redeemed the declining medieval style from elaborate trivialities and neurotic dreams.

When Sassetta was commissioned to execute a certain picture, he said that "he would paint it in fine gold, ultramarine, and other colors, employing all his subtleties of craft and spirit to make it as beautiful as he could." The declaration is particularly applicable to the *Journey of the Magi*, a remarkable combination of craft and spirit. These figures, apparently so thoughtlessly disposed, so spontaneously proceeding, were actually grouped with the utmost deliberation, for Sassetta worked slowly, planning his effects thoroughly before he allowed his imagination to take flight. His line is clean and sharp, his colors of transparent delicacy, his spirit that of pure and glad humanity. He saw no incongruity between the Biblical subject and the way he depicted it: the Wise Men of the East are conceived as Sienese horsemen; the three marching figures might well be three happy townsmen; the hard blue sky, the bleak hills, and the bright costumes, like those in many Sienese paintings, suggest the decorative schemes of Oriental art; and the Star of Bethlehem, as big as a sunburst, is manifestly closer and more real to him than the line of flying geese. He was concerned with the presentation of a truth, something so actual and so near at hand that he could paint it with naïve informality, but with no trace of levity. Sassetta was not a great dramatic force, but he was one of the noblest and tenderest of the Sienese masters.

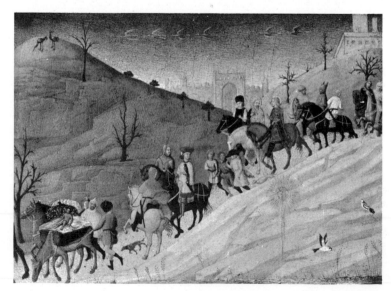

[RIGHT] *Journey of the Magi*, Metropolitan Museum of Art, New York. Tempera panel, 9″ x 12″, 1400?. Color plate, page 54.

# MASACCIO

## 1401–1428?   FLORENTINE SCHOOL

DURING the long medieval period, artists were satisfied with pictures which merely suggested objects and their relations to one another in space—they were restricted to symbols on flat surfaces, to a world of two dimensions. From Giotto to Masaccio, the trend was toward the relief of objects in space—in plain speech, toward realism. The liberation of figures from the background and the extension of painting into a new and voluminous world of three dimensions became a positive fact with Masaccio. This austere genius was the progenitor of a movement destined to include the veritable giants of art; to him belongs the honor of planting the new style squarely on its feet.

His full name, Tommaso di Ser Giovanni di Simone Guidi, was abbreviated to Masaccio, or Slovenly Tom, and the events of his short career are confused and not easy to authenticate. From his paintings, it is safe to say that he studied antique sculpture—and he knew Giotto like a book. He was favorably noticed by one of the Medici, was troubled by debts, and died in Rome in his twenty-seventh year, possibly by foul means.

In a sooty little chapel in the church of the Carmine, at Florence, Masaccio painted *The Expulsion of Adam and Eve*. It is quite probable, in conceiving the fresco, that he was inspired by the desire to show his rivals how the nude should be painted in the round, and how the inert figures of Giotto might be put in motion, but that is the smallest part of the project. Look at this miserable pair of sinners! The lines, muscles, and features, their postures and facial expressions, were drawn with the most exacting premeditation in order to make the two figures eternal effigies of shame and suffering. *The Expulsion* was peculiarly suited to Masaccio's tragic genius—not a whimpering wail, but the expression of the magnificent tragedy of Florence, a city in which men played a desperate game with life—and lost. Novelists and poets have other ways of convincing us that man is a small and pitiable creature in the universal scheme, but to Masaccio, the painter, neither weak nor daunted by the theme, there was but one choice: to strip a couple of outcast mortals to the skin and expose them forever to the world in shivering humiliation.

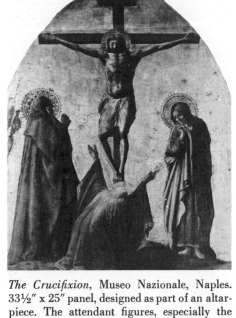

*The Crucifixion*, Museo Nazionale, Naples. 33½″ x 25″ panel, designed as part of an altarpiece. The attendant figures, especially the suppliant Magdalen, are typical of Masaccio's elemental power.

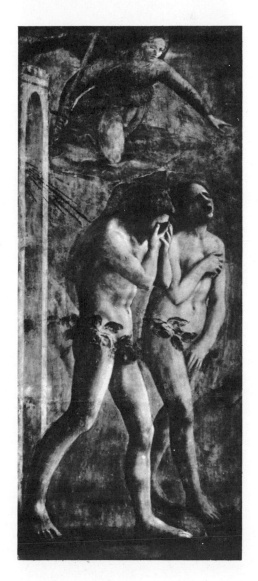

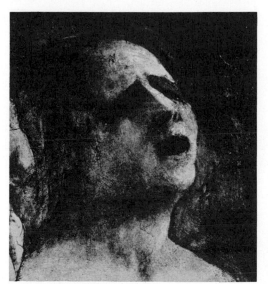

[LEFT] *Head of Eve*, detail from *The Expulsion*. The beginning of expressive plasticity in painting, as revealed later by Rembrandt and finally by Daumier.

[RIGHT] *The Expulsion of Adam and Eve*, Brancacci Chapel, Florence. Fresco, 1424-1427. Color plate, page 56.

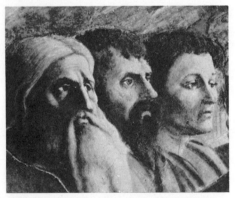

*Trinity with the Virgin,* St. John and Donors, Sta. Maria Novella, Florence. Fresco. Despite its poor condition, the painting shows Masaccio's innovations in the use of recessive space and atmospheric perspective.

*St. Peter and Apostles,* detail from *The Tribute Money.* The massive palpability of these heads was studied by the Florentine successors of Masaccio, among them Michelangelo.

DURING the middle years of the fifteenth century, every celebrated painter of Florence, from Andrea del Castagno to Leonardo and Michelangelo, came to the church of the Carmine to study Masaccio's frescoes. Today the little chapel is poorly lighted; the colors of the painting have darkened under layers of dust and candle grease; and the backgrounds, once dramatic landscapes, are clouded with a smoky gray atmosphere through which straight dead trees and slaty hills are disclosed. But with patience, the modern visitor may still behold the qualities which elicited the homage of the Renaissance masters.

*The Tribute Money,* measuring nine by four feet, in organizing power and the manifestation, by attitude and gesture, of the emotional tension of the actors, represents Masaccio at the height of his genius. The story, taken from St. Matthew, is a simple one: a tax collector came to Christ for the tribute money required of strangers, and there being no money in hand, the Lord instructed St. Peter to go to the sea, cast in a hook, take the coin from the mouth of the first fish that came up, and deliver it to the collector. The three incidents are combined in one picture—not an unusual custom with the early painters —the central and most prominent scene dealing with the instructions of Christ to St. Peter.

Here, for the first time in painting, Masaccio makes use of aerial perspective; that is to say, the figures are surrounded by light and air, not glued to a rigid background, and move freely in space with plenty of elbowroom between them. He models his characters with strong oppositions of light and shade; in his hands architecture becomes realistic and inhabitable; he lays hold of the secrets of foreshortening and of giving objects solidity by superimposing one against the other; and his landscapes have grandeur and scenic fitness. These are technical advancements of epochal significance, but Masaccio was driven to invent them by a profound human purpose. He gathered together, in one of the most effective compositions in art, a collection of individuals worthy of the names they bear, men of fierce convictions, nobly imagined, grouped around the commanding presence of Christ—the whole drawn with the ruthless simplicity and smiting power which, in a later century, were reborn in Rembrandt and, much later, in Daumier.

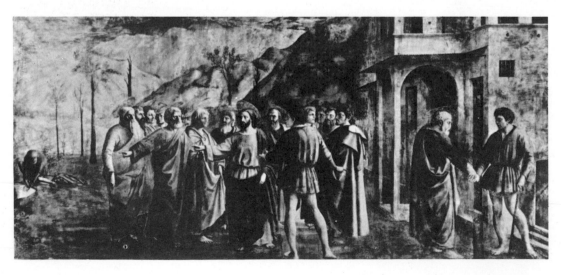

*The Tribute Money,* Brancacci Chapel, Florence. Fresco, 1424-1427. Color plate, page 55.

# FRA ANGELICO

1387–1455        FLORENTINE SCHOOL

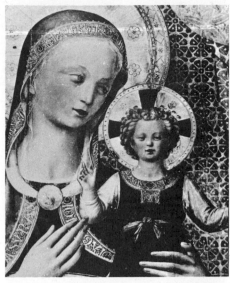

HIS real name was Guido di Pietro da Mugello; when he entered the Dominican order at the age of twenty, he was called Fra Giovanni da Fiesole; after his death and beatification, he was listed as Fra Angelico, a name synonymous in art with all that is holy and unsullied by the impurities of the flesh. How or where he learned his craft has not been definitely ascertained; but there is no doubt that as monk and painter he devoted himself with celestial propriety to the exaltation of the Christian spirit.

Fra Angelico was not heedless of the realistic movement beginning with Giotto and carried onward by Masaccio; he was as intelligent in his technical studies as he was fervent in the monastic regimen; but he was prohibited by his vows and his convictions from depicting the nude or any profane subjects. Thus, while his work steadily improved in scope and excellence from small panels to frescoes, his mind dwelt in the unworldly visions of the Middle Ages. He believed that pure and glowing colors should be reserved for the saints and God's elect; that once a painting was finished, it should not be altered—"for such was the will of God"; and it was affirmed that he would never take his brush in hand without first offering a prayer; and that "he never painted a Crucifix without tears streaming from his eyes." Such stories need not be accepted literally, but they are indicative of the soul of the great Dominican.

*Madonna and Child*, detail from the *Madonna dei Linaiuoli*. The essential purity of the artist's soul shines out in these beautifully drawn figures.

Among Fra Angelico's early devotional pictures, *The Coronation of the Virgin* is unquestionably the most exquisite in color, sentiment, and figurative design. In the symmetrical groupings and the lavish use of gold, the painting is a medieval vision, an outgrowth of the miniature style. But the delicacy and expressiveness of the drawing of the faces were new to painting and many steps removed from the rigid solemnity of Giotto. The body being forbidden, the praying monk concentrated his powers on the faces of his saints and angels, making them not only physically beautiful but symbols of the unadulterated purity of his sentiment, a sentiment so inescapable that Michelangelo, the creator of giant nudes and no admirer of flat decorations, remarked, "Surely the good monk visited Paradise and was allowed to choose his models there."

*St. Dominic*, from the fresco, *The Mocking of Christ*, 1437-1445, in a dormitory cell, San Marco, Florence. The holy monk, prayerfully rendered, might serve as a self-portrait of the artist in a moment of meditation.

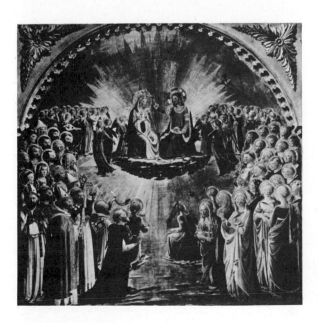

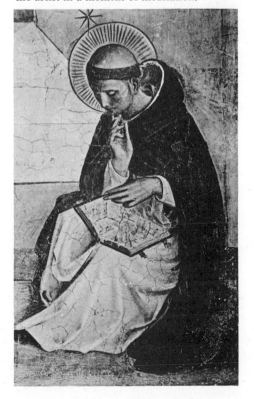

[LEFT] *The Coronation of the Virgin*, San Marco, Florence. Tempera panel, 44″ x 45″, 1435. Color plate, page 57.

# FRA ANGELICO
## CONTINUED

WHEN Cosimo de' Medici opened the convent of San Marco to the Dominicans, he summoned Fra Angelico, then in his fiftieth year, to decorate the new building with frescoes. The Dominican artist executed some fifty paintings in the cells and corridors, bequeathing to the world what Ruskin described as "the most radiant consummation of the pure ideal of Christianity in all art." In *The Annunciation*, the most famous of the series, the Virgin is seated in an open loggia resembling that of a Florentine church, with the angel Gabriel alighting before her. The fresco, nobly conceived and simply painted, shows Fra Angelico's fully developed style in wall decoration, and his observance of the traditional method of treating the subject. For centuries *The Annunciation* had been carved or painted in two sections at the entrance of churches, and the Dominican monk placed his characters in a painted architectural background with a separating column. The artist, who sometimes added texts to his paintings, inscribed on the curbstone a quotation from a twelfth-century hymn: "Hail Mother, noble resting place of all the holy Trinity." The inscription on the edge of the stone is a tactful hint to his brothers: "When you come before the image of the spotless Virgin, beware lest through carelessness the Ave be left unsaid."

There is no drama in Fra Angelico's vision of the world, no conflict between conviction and representation. No other artist was so secure in his religious message, or so untroubled in the expression of it. He was a believer, and when he painted a picture, he took it for granted that the emotions aroused in others by his images were identical in purity and intensity with his own. He had no doubts about life and no questions to ask. The issues of the spirit were decided forever in two categories—the good and the evil, and he had made his choice. He held fast to a single mood, and his paintings, collectively, are a choir of voices chanting the blessings of the Christian ideology. *The Annunciation* was as real to him as the men with whom he lived and worked, and when his brothers came upon it in the corridor of San Marco, after climbing the stairs from the refectory, he could be certain that the figure of the Virgin and the angel would inspire them, like sacred music, to a mood of exaltation.

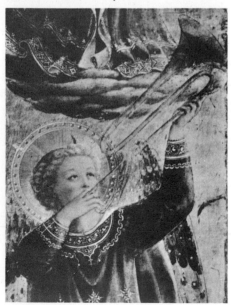

*Madonna dei Linaiuoli*, San Marco, Florence. Tempera on wood, 8' 6" x 8' 8" (open), 1433. Surrounded by a company of musicians in brilliant garments, the *Madonna of the Linen Merchants*, one of Fra Angelico's most famous pictures, carries the piety and purity of medievalism into the invigorating freedom of the Renaissance.

*Angel Musician*, detail from the *Madonna dei Linaiuoli.* The frame of the altarpiece is embellished with music-making angels whose beauty of features and design is unsurpassed in Italian art, unless by those of Signorelli, who was influenced by them.

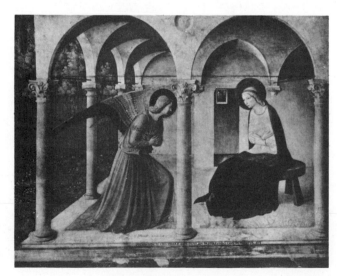

[RIGHT] *The Annunciation*, San Marco, Florence. Fresco, 7½' x 10½', 1437-1445. Color plate, page 58.

# PAOLO UCCELLO

1397?–1475    FLORENTINE SCHOOL

THE love of the early Florentine painters for their craft, and their energy in pursuing it, move the modern mind to wonder and applause. These artists had no time for the minor graces of painting, for melting color, tender sentiment, and the charm of smooth textures—they conquered the stubborn forces of life and the basic principles of art by will power and unremitting toil. The first to master the science of linear perspective was Paolo Uccello, a barber's son, and a mathematician of distinction. During his lifetime, he was set down by his more practical neighbors as a harmless crank, but inasmuch as his idiosyncrasies ran to graphs and abstractions, they were humorously condoned. Vasari reports—and there is no reason to doubt him—that Uccello would stay up all night with his studies, drawing polygons with eighty facets, and other such oddities, and exclaiming to his wife, when she besought him to go to bed, "Oh, what a delightful thing is this perspective!"

Uccello was absorbed in technical difficulties, in converging lines, foreshortenings, and receding planes. He had little interest in religious subjects, and introduced into painting, for the first time since the Pompeian friezes, battle scenes and historical circumstances. His *Rout of San Romano*, one of three panels painted for the bedchamber of a Medici, to celebrate the defeat of the Sienese by the Florentines at San Romano, in 1432, has long been admired, and justly, for its quaintness, its childlike gaiety, and its naïve playfulness. But it would be a mistake to suppose that Uccello, intent on painting a realistic battle picture, had blundered into a nursery masterpiece. He was a scholar and a precisionist, fascinated by the wonder and youth of the Renaissance; and his *San Romano*, alive with clashing planes and radiating lines, is strangely modern, a precursor of cubism in its geometrical horses. It is not dramatic by reason of its truth to nature or war—the knights are tin soldiers, the steeds are hobby horses—it is a pattern of linear science and color constructed by the most advanced technician of his time, an artist who contrived by means of clear-cut design to give movement and rhythm to his fantastic visions.

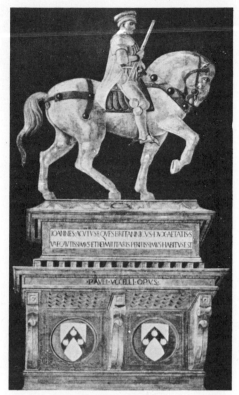

*Sir John Hawkwood*, Cathedral, Florence. Fresco transferred to canvas. 1436. A larger-than-life pictorial substitute for the customary equestrian monument, and placed above the eye level to give the artist full play in his solution of the problems of perspective.

*Head of Michaele Olivieri*, detail from *The Rout of San Romano*, and an example of Uccello's ability to combine fantastic properties with the utmost precision in drawing.

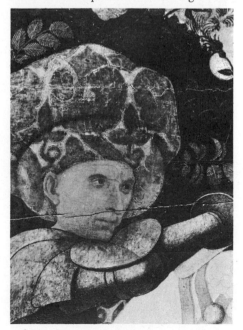

[BELOW] *The Rout of San Romano*, National Gallery, London. Tempera on wood, 6¾' x 10½', 1451-1457. Color plate, page 59. The left division, and the best preserved, of an enormous three-panel battle scene commemorating the Sienese defeat in 1432.

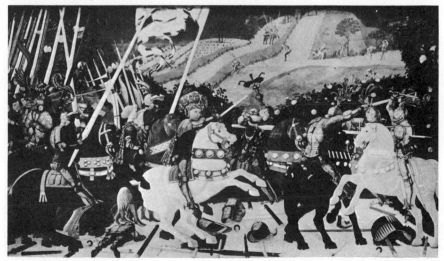

# FRA FILIPPO LIPPI

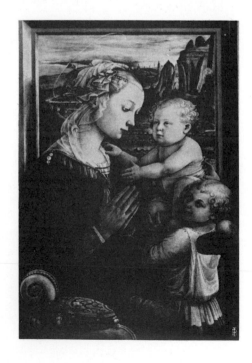

*St. Gregory,* probably a self-portrait of the artist, Accademia Albertina, Turin. 47″ x 22″. In the rendering of draperies, the errant monk was second to none, and set the Florentine standard which, later on, became academic practice.

A MONK of totally different cast from the Beato Angelico was Fra Filippo Lippi whose career was enlivened by romantic adventures. Son of a butcher and left an orphan in childhood, he was registered with the Carmelite friars; but his monastic vows interfered with his secular propensities and eventually he abandoned the community. He studied Masaccio's frescoes in the Brancacci Chapel, gained considerable money as a decorator and chaplain, but squandered his substance in frequently recurring amours, and spoke of himself as "the poorest friar in Florence burdened with the maintenance of six marriageable nieces." The story that he kidnaped Lucrezia Buti, a beautiful nun, is open to question; but the record is clear that she bore him a son out of wedlock, Filippino Lippi, and later became his wife by dispensation from the Pope. He died in mysterious circumstances—poisoned, according to one account, by a disgruntled mistress.

Thus far, there had been plenty of power in art, and humanity too, in its sterner aspects—but no worldly joy, no poetic landscape, no subtle color combinations, no pleasurable details. These deficiencies were beautifully remedied by Filippo Lippi. The jovial monk painted no profane subjects, but his religious pictures are the work of a man who lightly appraised the Madonna as a lovely thing for his brush, and left the moral and ecclesiastical worries to the priests and the orthodox artists. In the finest poem ever written about a painter, Browning tells how the preaching friars gathered round Fra Filippo Lippi and remonstrated with him for introducing flesh-and-blood experiences into his paintings. They told him "to paint the soul, and never mind the arms and legs"; they peeped over his shoulder, shook their heads, and said, "It's art's decline, my son! You're not of the true painters, great and old."

Of his easel pictures, Lippi's masterpiece is the *Virgin Adoring the Child,* now in Berlin. Here, for the first time in Italian art, we have the Madonna in the form of a young and attractive Florentine woman; here we have grace and comeliness and color—a clear light blue against a background of dark green; and here we have a depth of closely observed landscape which does not occur again in painting until the time of Correggio.

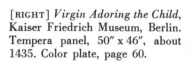

[LEFT] *Madonna, Child and Two Angels,* Uffizi, Florence. Tempera, 35½″ x 24″, 1455-1457. This particular Madonna, probably a portrait of the artist's wife, shows the painter's tender interest in young Florentine women, and his love of costumes, carefully defined, draped and colored.

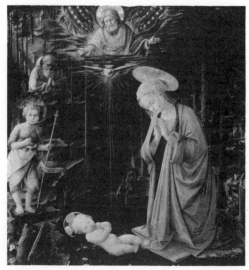

[RIGHT] *Virgin Adoring the Child,* Kaiser Friedrich Museum, Berlin. Tempera panel, 50″ x 46″, about 1435. Color plate, page 60.

# ANDREA DEL CASTAGNO

1390?–1457                                        FLORENTINE SCHOOL

FOR nearly four centuries, the name of Andrea del Castagno was blackened by the heinous charge of murder. It was believed, on the dubious authority of the old biographer, Vasari, that he assassinated his best friend and colleague, Domenico Veneziano, in order to monopolize the secret of oil painting as practiced by the early Flemish painters, but practically unknown among the Italians. Recent scholarship has disclosed that Veneziano survived his alleged murderer by four years. The foul story gained credence because it squared with other tales of Andrea's ferocious temper, and with the extant examples of his militant art. It was also recorded "that when his own works were censured, he would fall upon his critics with blows, giving them to understand that he was able and willing to avenge himself." And when he was commissioned, after the exemplary Florentine custom, to paint the leaders of a conspiracy, hanging head downward, on the walls of the Bargello, he was ever afterward called Andrea degl' Impiccati—Andrew of the Hanged Men.

Andrea del Castagno, a student of Masaccio and Donatello, was one of the foremost contributors to the trenchant realism and scientific inquiry of the Florentine style. For savage strength that makes no concessions to refinement; for hard power and toughness of fiber, he has no equal among the Renaissance masters. He was not a giant exulting in exhibitions of brutality: he was an observer of outlines, volumes, and forms in relief: and his sardonic mind reached out into the realm of tragedy. His domineering military heroes are types of august and merciless energy; his conception of Christ in his *Last Supper* is the most robust and masculine in Italian art. Andrea's figures, as shown by his *David*, the triumphant youth, stand aggressively, larger than life, legs wide apart, rough-hewn and menacing. The *David*, painted on a tournament shield, is much more decorative than the artist's usual work. It is, in fact, an ornamental picture of a new style, adding realism to the old pattern base; but it illustrates Andrea's directness, his sharp outlines, his hard bright color, and his warrior's spirit.

*David*, National Gallery, Washington. Shield on leather, 45″ x 32″ (top), after 1450. Color plate, page 61.

*Pippo Spano*, detail from the formidable, foursquare fresco at Sant' Apollonia, and forerunner of the incisely realized figures of the High Renaissance.

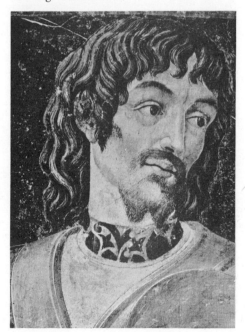

*The Last Supper*, Sant' Apollonia, Florence. Fresco, about 1436. A hard, wiry, almost brutal conception of the Lord's last meeting with his apostles. The only version of the subject that interested Leonardo—not in design but in the rugged masculinity of the participants.

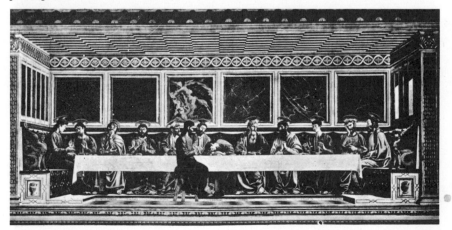

# ANTONIO POLLAIUOLO

1429?–1498                    FLORENTINE SCHOOL

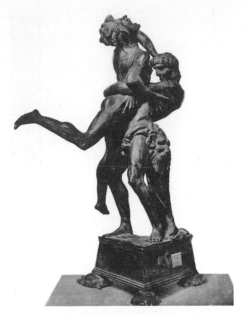

*Hercules and Antaeus*, Bargello, Florence. Bronze, 18″ high, about 1475. A study in sculpture of Pollaiuolo's obsessional concern with the nude in action. The figures, though scientifically observed, are endowed with tremendous muscular energy.

*Portrait of a Lady*, Poldi-Pezzoli Museum, Milan. Formerly attributed to Domenico Veneziano, and one of the many magnificent profile-portraits of the Renaissance. The artist's training as a goldsmith is shown in the ornamentation and the sharp, linear drawing.

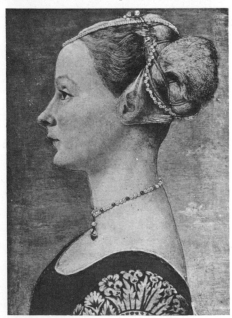

[RIGHT] *Hercules and Nessus*, Gallery of Fine Arts, New Haven. Wood transferred to canvas, 21⅜″ x 31¾″, 1473. Color plate, page 62.

THE tireless examination of the human body as a living organism and the search for realistic action, which distinguished Andrea del Castagno, were expedited by another intrepid Florentine, Antonio Pollaiuolo. Son of a poulterer, as his name indicates, Antonio became one of the most influential men of his time, uniting and practicing all the arts, or as Michelangelo expressed it, "the one and all-embracing art of design." He was a goldsmith, engraver, sculptor, anatomist, and painter; his knowledge of the nude was enormous, but it was an artist's knowledge acquired to exhibit bodily tension, flexibility, and movement in relation to themes designed to stimulate the spirit of man to deeds of arduous and incorrigible valor.

Antonio's passion for the figure led him, naturally, to subjects—mythological, for the most part—allowing him to revel to his heart's content in naked forms. To him the wildest postures bringing into prominence complex muscular articulations were as child's play, and it cannot be gainsaid that in some of his paintings he was overmastered by his frenetic zeal for experimentation. He was a pathfinder, probably the first painter to dissect corpses, and to give attention to the esthetic potentialities of anatomy; he was a great teacher as well as a great artist, and his work is the expression of the athletic paganism and the exaggerated energy of the Renaissance.

About 1460, Antonio was commissioned to adorn the grand salon of the Medici Palace with representations of the labors of Hercules. The large compositions have disappeared, but the small copies executed by the artist himself bear witness to the nervous vitality and anatomical exuberance of the originals. In the New Haven panel, the mythological strong man of the Greeks is portrayed in the act of slaying the centaur Nessus who had perfidiously carried off Deianira, the jealous bride of Hercules, after persuading her that his blood was a love charm. The picture also contains Antonio's finest landscape, which he constructed with as much patience and research as he bestowed on his nudes. The scene is a truthful portrait of the Arno valley, with the city of Florence in the distance. The centaur and the figure of Deianira are sometimes ascribed to Piero Pollaiuolo, the brother and assistant of the great Antonio.

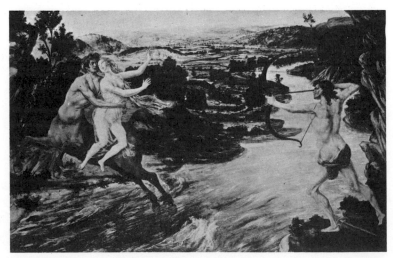

# PIERO DELLA FRANCESCA

1416?–1492                                          UMBRIAN SCHOOL

THE fame of Piero della Francesca, never seriously contested during the pass-ing ages, has lately risen to Olympian heights. His perspicuous designs, his clean harmonious colors, and his imperturbability have won the suffrage of modern zealots in composition who have extolled him to the detriment of Michelangelo. But his overemphasized detachment was purely an intellectual control over the technical science of wall painting; and he was admired by the old Italians for his "unexampled truthfulness and his hieratic nobility of thought."

Piero was a more advanced student of mathematics than his master, Uccello; he was an adept in theology and the author of a learned work on perspective. Though he passed most of his life in Umbria, he was a traveler—with a fond-ness for war. He was patronized by dukes and popes, was in Florence during the patriarchal festival of 1439, and executed extensive frescoes in the Vatican which were indecently destroyed to make way for Raphael. His mind was orderly, exact and severe; he had no room in his world for dainty sentiment and homely affections; with knowledge and assurance he refined his characters into types of poised and unapproachable grandeur.

Combining science and imagination, linear perspective, and measured rectangular planes, Piero was magnificently equipped for architectural paint-ing, and about 1465 made the most of his capabilities in the church of San Francesco. In the choir of the church he painted ten frescoes from *The Legend of the Holy Cross*, beginning the genealogy of the Sacred Tree with Adam and the Tree of Paradise. The story enabled him to compose two battle pic-tures, the first showing the Emperor Constantine's victory—following the vision of the Flaming Cross—over the Emperor Maxentius. In this work, he made no attempt at military action or the circumstances of battle. The monumental impressiveness of the fresco, which unhappily is badly damaged in part, rises from his sense of placement: the employment of banners, lances, and stark forms of sweeping colors to create the symbolical statement of a great Chris-tian triumph.

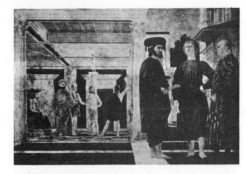

*The Flagellation*, Palazzo Ducale, Urbino. About 1469. 23¼" x 32", signed. This small panel contains the essentials of Piero's genius: his command of space and perspective; his stately figures, perfectly placed; and the ori-ental clarity of his vision.

*Three Figures*, detail from *The Flagellation*. Grave, emotionless figures totally indifferent to the horror of the adjoining scene.

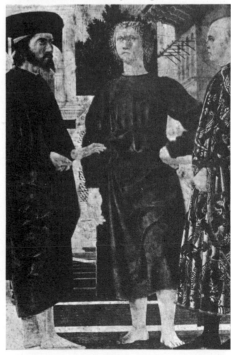

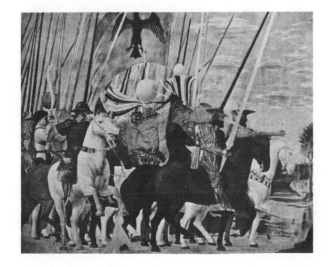

[LEFT] *The Battle of Constantine*, Church of San Francesco, Arezzo. Fresco, 1452-1466. Color plate, page 63.

# PIERO DELLA FRANCESCA

CONTINUED

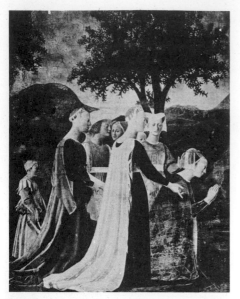

*The Queen of Sheba*, San Francesco, Arezzo. Fresco, 1452-1466. Color plate, page 64.

PIERO DELLA FRANCESCA subscribed to Christian doctrine and the sacred stories with a devotion equal to that of Fra Angelico, but from a totally different approach. The Dominican monk accepted the faith with unquestioning eagerness, whereas the theological Umbrian arrived at his convictions by an assiduous scholarship which removed all heresies. Secure in his beliefs, he saw no reason to paint clashes and alarms; and he composed his frescoes with a diagrammatic perfection that has tempted artists to search for his magic formula. Technically, he contributed as much as, or more than, any of his great contemporaries to the science of space and depth; and it was his habit to paint directly from clay models swathed in drapery so that his figures might have the roundness of sculpture. His serene, carefully charted landscapes run back into deep space; as a wall decorator combining lights, colors, and forms on a large architectural scale, he is one of the supreme masters of painting.

Piero loved festivals and parades, strange costumes, exotic headdresses, and archaic faces. His women are masked in sullen gravity, their necks unnaturally long, their attitudes majestic and defiant—in *The Queen of Sheba*, they stand prominently in the foreground, superhuman in size owing to the low horizon line and the perspective scheme. According to *The Legend of the Holy Cross*, the Tree of Eden lived to the time of King Solomon, when it was used as a bridge over a small stream. The Queen of Sheba, having a vision of the Crucifixion, warned the King that when the Saviour should be nailed to the Tree, the end of the Jewish people would be near. Piero depicted the reception of the Queen at the court of King Solomon; and in the fresco here reproduced painted the Queen kneeling in prayer as she recognized the Holy Tree which had been revealed to her in a dream. The representation of the Queen of Sheba, with her attendants, is one of the noblest and most characteristic examples of Piero's style of mural decoration.

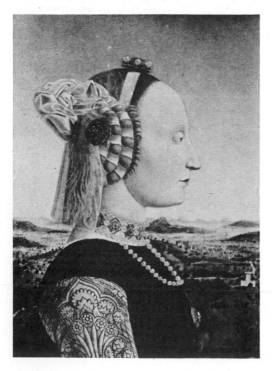

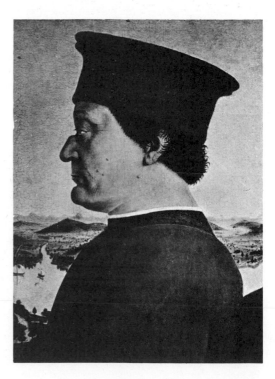

[LEFT] *Battista Sforza, Duchess of Urbino*, Uffizi, Florence. 1465-1466. 18½" x 13". Companion piece to the portrait of the Duke which faces her in a double frame, she is a high-browed, bejeweled lady painted against the landscape that she helped to dominate.

[RIGHT] *Federigo da Montefeltro, Duke of Urbino*, Uffizi, Florence. 1464-1466. The benevolent despot of Urbino, his nose broken in a duel, appears here in one of the world's great portraits—realistically unsparing, monumentally stable and appealing. The Duke was the artist's patron.

# ANTONELLO DA MESSINA

1430?–1479?                    VENETIAN SCHOOL

ITALIAN painting in its early developments was confined to two mediums: the fresco, or the application of ground colors mixed with water to a surface of wet plaster which, on drying, incorporated the paint with the lime of the wall; and the tempera method, or the application of pigments, emulsified by the yolk of eggs, to panels coated with gesso. Technical processes mean little to laymen and often puzzle the specialists—Ruskin, for instance, was under the impression that Botticelli's *Venus*, a tempera picture, was executed in oil—but to artists they are of the greatest importance.

In 1456, the Flemish artist, Petrus Christus, in the service of the Duke of Milan, had, as a colleague, a young Sicilian named Antonello da Messina, whom he acquainted with the method of oil painting as perfected by the Van Eyck brothers in Flanders. This chance association altered the direction of Italian art. Antonello, a remarkable executant, carried the Flemish method to Venice where it was adopted by Giovanni Bellini, Titian, and other masters. The new technique increased rapidly in popularity and was soon used advisedly by Leonardo da Vinci and artists of various schools. It was not the modern oil technique, but it was a radical departure from Italian tempera; and it made possible color effects and a fluency of modeling which reacted upon the artist's emotional attitude towards his work.

Antonello's connection with matters of procedure has detracted from his great accomplishments as an artist. He was a draftsman of repute and a portrait painter of high rank, shrewd in characterization, coldly truthful, and in advance of his time in his mastery of firm modeling and in relieving his heads from a dark background. Impersonal in portraiture, he was, in his religious pictures, meditative and reverent. Two of his *Crucifixion*s, one in London, the other in Antwerp, were composed on the same plan, and both contained the two stricken figures of the Virgin and St. John. The Antwerp version is the more impressive: this painting, with its motionless, realistic figures constructed with Flemish science, its spacious Italian landscape, and its two mourners, is surcharged with a finely tempered emotional quality, a feeling of subdued tragedy which, despite the detailed objective treatment of the hanging bodies, is exempt from horrors.

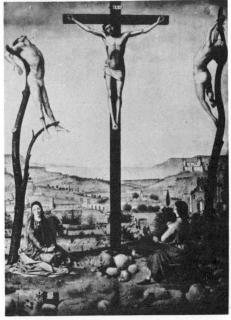

*The Crucifixion*, Museum of Fine Arts, Antwerp. Oil on panel, 23½" x 16¾", 1475. Color plate, page 66.

*St. Jerome in His Study*, National Gallery, London. Oil on panel, 18" x 14½". A recurrent subject in Flemish art which Antonello studied, and offered as a solution to problems of perspective and textures.

[LEFT] Detail from *St. Jerome.* An impersonal job, somewhat Flemish in its inclusion of small things, but neither cramped nor literal.

# SANDRO BOTTICELLI

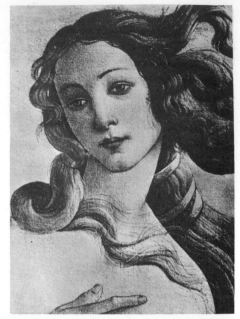

*Head of Venus,* detail from *The Birth of Venus.* A head that has come down the ages without loss of its original enchantment. Saved from prettiness by consummate draftsmanship, and saved from mere poster effectiveness by a master's idealism, it has set a standard for all portrayers of distaff beauty.

*Venus, Flora and Nymph,* detail from *Primavera,* a large composition now in the Uffizi. Conceived as a paean, in paint, to the pagan goddess, the picture eventually was celebrated as a loving tribute to the forces of fertility.

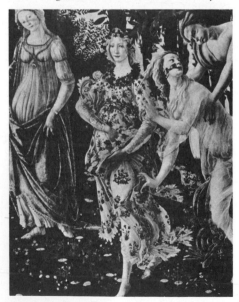

[RIGHT] *The Birth of Venus,* Uffizi, Florence. Tempera on canvas, 5′ 6″ x 9′ ¼″, about 1482. Color plate, page 65.

ALESSANDRO DI MARIANO FILIPEPI, the son of a struggling tanner, derived the name of Botticelli from his older brother and guardian who, for reasons of corpulency, was called "the little barrel." Under the name of Botticelli, he won great fame as an artist, and a good living into the bargain—and left the world a collection of paintings which have been, at one extreme, objects of mystical adoration; at the other, of cold-blooded disesteem. The causes of these conflicting assessments are fairly simple.

Botticelli was an individualist in an age of belligerent singularities. Extraordinarily gifted, and thoroughly trained in the studio of Fra Filippo Lippi, the healthy monk, he passed on to the influence of Pollaiuolo, from whom he learned the new secrets of bodily structure and movement, and precise linear draftsmanship. He resented this naturalistic tendency, but he could neither escape nor continue it. There was a vein of petulant morbidity in his soul, a dissatisfaction with life; he was not robust enough to shoulder the burden of realism; and he withdrew into his own introspections, encouraged by his patrons, the Medici, who were always discussing and misunderstanding the culture of the Hellenic Greeks.

Philosophically, he was a confused mixture of Neoplatonism, realism, and an ascetic melancholy that was almost Sienese; but as a stylist he developed in his own way. He created a personal type of young womanhood—sometimes a Madonna, sometimes a goddess—and a type of design that are indissolubly connected with his name: a long, thin face with a pouting mouth and a prominent chin, heavy golden hair, a lithe, undulating body, usually draped in a transparent gauze, and powdered with elaborate Gothic decorations. *The Birth of Venus,* painted for a Medici villa, is one of his two most remarkable pictures, the other being the *Primavera.* The *Venus* is no sensuous Grecian conception; she is timid and medieval; but the picture is rich in suggestions, calling up, with its marvelous linear design and its peculiar ornamentation, nostalgic visions which have never failed to charm those who do not enjoy realism in art.

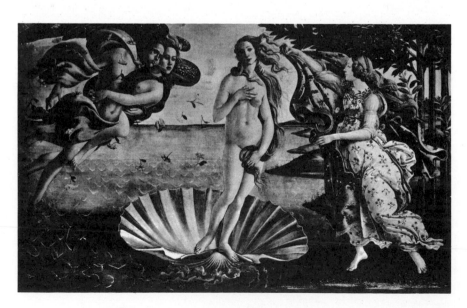

# SANDRO BOTTICELLI

BOTTICELLI, with his genius for decorative design, his intense, if not eccentric personality, his haunting, tremulous line, and his creation of languid maidens symbolical of strange and neurotic moods, was the first of the Florentine masters to lend authority to art as an esthetic escape from reality. In an age of bold practitioners, he remained apart, neither defeated nor envious, but deliberately fabricating a style of painting which, in subsequent periods of maladjustment between artist and public, has been the standard of overnourished and self-conscious individuality.

But the tanner's son was not an unsuccessful painter, and the mystical implications of his art were the by-products of his mental confusions rather than the direct results of an unsatisfactory career. He was honored by many commissions; he worked in the Sistine Chapel, and was a Medicean favorite; and his studio was the rendezvous, not only of a corps of busy assistants, but of a throng of Florentine scandalmongers with whom he could hold his own in rough-and-tumble diversions.

As Botticelli grew older, his pagan yearnings and Platonic fantasies were replaced by a belated conversion to Christian doctrine, and he became a disciple of Savonarola, heaping godless but beautiful fuel on the bonfire of vanities. The finest illustration of his religious period is *The Nativity*, with the Virgin adoring the child and the fluttering ring of angels overhead. The cryptic inscription in Greek reads: "I, Alexander, painted this picture in the year 1500, in the troubles of Italy, in the time after the fulfillment of the eleventh of St. John—in the second war of the Apocalypse, in the loosing of the Devil for three years and a half. Afterward, he shall be chained and trodden down as in this picture." The allusion is to the figures at the bottom, the angels welcoming Savonarola and the two priests who were burned with him. This is admitted to be Botticelli's last painting. Little is known of the remaining decade of his life, but he was never without money, and occasionally served on municipal committees.

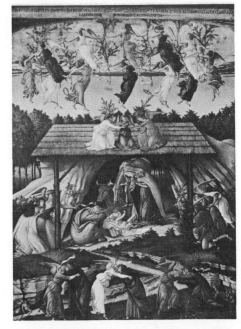

*The Nativity*, National Gallery, London. Tempera panel, 42½" x 29½", 1501. Color plate, page 67.

Detail from *Adoration of the Magi*, Uffizi. 1478. Self-portrait of the artist in the manly conception he had of himself, as one of a group of Florentine celebrities somehow participating in a biblical drama.

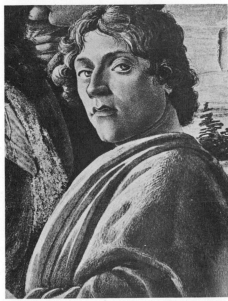

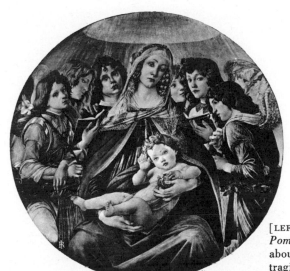

[LEFT] *Madonna with Six Angels*, also called *The Madonna of the Pomegranate*, Uffizi, Florence. Tempera on canvas, 56" in diameter, about 1485. The *Venus* of *Primavera* is now a *Madonna*, with a more tragic face.

# LUCA SIGNORELLI

1441?–1523                    UMBRIAN SCHOOL

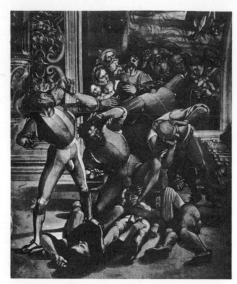

*The End of the World*, Chapel of San Brizio, Orvieto. Fresco, 1500-04. Color plate, page 68.

Detail from *The Souls of the Damned*. Signorelli, the first of the dissecting anatomists, transmutes his knowledge into nude bodies tormented by eternal punishment.

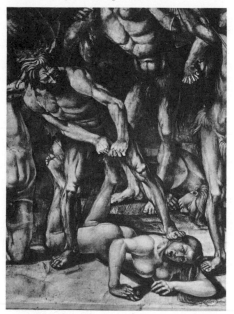

THE serenity of Piero della Francesca was changed into a world of turmoil in the art of his pupil, Luca Signorelli, one of the heroic souls of Italian painting. Signorelli was an Umbrian who moved to Florence; discovered the true direction of his genius by studying the anatomical pictures of the Pollaiuolo brothers; worked for the Medici and the Pope, but prospering none too well in the centers of culture, established headquarters in Cortona. From this town he wandered about, a traveling decorator, painting small devotional pictures and keeping his mind on a commission worthy of his prodigious capacities.

He was incessantly industrious, and his delight in the nude was inexhaustible. He was interested in the structure of the body, in the tension of muscles, and in the expression of tragic emotions by means of violent action. To pursue his studies in anatomy, he visited the graveyards at night; and when one of his sons died through a sudden casualty, he painted the corpse, shedding no tear and working with strange self-possession.

In his sixtieth year, Signorelli's lifelong ambition was realized. In the cathedral at Orvieto, he painted *The Last Judgment*, which, with Michelangelo's frescoes in the Sistine Chapel, will last forever as the greatest wall decorations of their kind in the world. Only on such a theme, and on such a scale, could he loose his terrible fury and his unprecedented powers of construction. He symbolized *The Souls of the Damned*, *The End of the World*, and *The Resurrection* by nude and draped bodies swirling through space, crashing headlong into cowering groups of sinners and contorted into inconceivable attitudes to reveal the muscular energy and the torments of the impious and the doomed. The reproduction is a detail from *The End of the World*, one of *The Last Judgment* series, and shows the lower segment of an arched composition in which a group of fathers, mothers, and nursing infants, huddled and foreshortened, are warned by monsters spouting blood and fire of the eternity of expiation awaiting their unrighteousness.

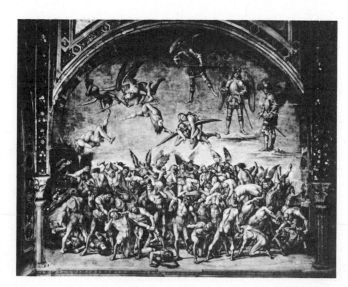

[RIGHT] *The Souls of the Damned*, the most powerful of the Last Judgment frescoes at Orvieto. One of the gigantic attainments of art, it inspired Michelangelo when he decorated the Sistine Chapel.

# ANDREA DEL VERROCCHIO

1435–1488

FLORENTINE SCHOOL

# AND LEONARDO DA VINCI

1452–1519

FLORENTINE SCHOOL

IN the second half of the fifteenth century, Andrea del Verrocchio was the most famous artist in Florence. He was one of those many-sided geniuses produced by the prodigal forces of the Italian Renaissance, renowned as a goldsmith, a master of geometry, music, and wood-inlaying, a painter and a sculptor. Unmarried and disinclined to be bothered by women, he dedicated his life to intellectual pursuits; and in his workshop the luminaries of the city foregathered to discuss art. They did not look upon art as a little thing—the whimsical aberration of minor talent; they regarded it as the ultimate attainment of mind and spirit, above science and philosophy but partaking of both. Verrocchio was not the foremost painter of his day, but in sculpture he won the distinction of having designed and modeled the noblest equestrian statue in the world, the *Bartolommeo Colleoni*, at Venice.

The only extant painting which can be attributed with absolute certainty to Verrocchio is *The Baptism of Christ*, a sinewy, labored work with a hardness of modeling that betrays the sculptor; and in its grimness and power, a characteristic product of the Florentine school of anatomists. The picture is memorable for the vaporous landscape in the distance, and for the kneeling angel at the left, whose carefully drawn hair and delicate features touched with radiance were not of Verrocchio's fiber. These additions were painted by an apprentice, a boy of seventeen named Leonardo da Vinci, who had already displayed his prowess in mathematics, music, and every branch of design.

Leonardo's loyalty to his master was the only personal tie formed in his youth. He remained in Verrocchio's workshop from his thirteenth to his twenty-fifth year—a period of learning rather than accomplishment. Here he found support for his scientific researches; here he met Botticelli, Perugino, and Lorenzo di Credi, and close by were the Pollaiuolo brothers whose nudes were the latest marvels of art. He lived soberly in his master's house; his fame was rising, and by common consent, he was the most richly gifted and enviable young man in Italy. Reluctantly, five or six years after he had become a licensed painter, he opened his own shop; for he had little interest in art as a physical exercise or as a means to a livelihood, and he disliked to finish a work within a stipulated time.

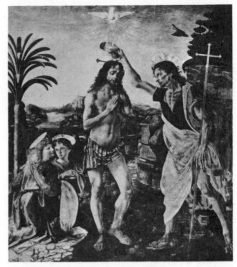

*The Baptism of Christ*, Uffizi, Florence. About 1470. 6′ x 5′. Color plate, page 69.

*Bartolommeo Colleoni*, Venice. Bronze, unveiled 1496. Acclaimed more often than any other work as the greatest equestrian statue in the world. The feral glance and iron resolution of the captain, and the incomparable construction of both horse and rider, make eyesores of most public monuments.

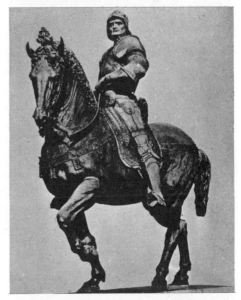

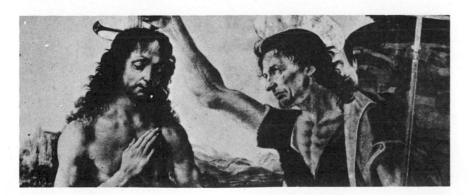

[LEFT] *Christ and St. John the Baptist*, detail from *The Baptism of Christ*. The two sculpturesque figures are certainly from Verrocchio's hand, unassisted.

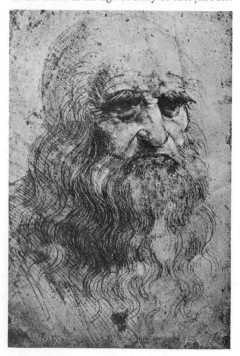

*Mona Lisa*, Louvre. Tempera panel, 30¼" x 20⅞", about 1503. Color plate, page 70.

*Self-portrait*, red chalk, Turin library. 13" x 8¼". Drawing of an exceedingly venerable old man and generally accepted as a portrait of the artist at the age of sixty or thereabouts.

# LEONARDO DA VINCI
1452–1519               FLORENTINE SCHOOL

THE *Mona Lisa* shines out among the portraits of the world with a fascination attached to no other painting. Though time has appreciably impaired the color of the picture, reducing the flesh tints to monochrome, the glory of it increases with the passing years. Fable and gossip have made the famous subject a strange and uncanny charmer, a sphinx whose smile entrapped the soul of a great artist and impelled him to build up an image of unfathomable mystery. The legend is damaged by several inconsistencies.

Leonardo was in his fifties and fearfully venerable when he engaged to paint Mona Lisa, the third wife of Francesco del Giacondo; he worked on the portrait spasmodically for four years, painting from black-and-white studies and not directly from the model, and using other sitters for the torso and the beautiful hands—the most perfectly drawn hands in Italian art. His interest in the subject was neither protracted nor sentimental; he had found in nature a face which helped him to realize in paint an ideal type towards which he had constantly moved since his earliest efforts. Into this picture he projected all of himself and all his arts—his subtlety of modeling, his elaborate and dazzling refinement, his scientific precision, his psychological penetration, his puzzling composure, his infallible knowledge of structure. In comparison, most portraits of the world seem flat and lifeless.

The figure is as solid and as permanently established as the rocks behind it, yet plastic, and free to bend and breathe and move; and the smile is achieved by imperceptible variations in the lines of the eyes and mouth. The smile is not peculiar to Mona Lisa; it is written in the faces of the archaic goddesses of Greece and in the sculptures of Verrocchio. With Leonardo it was a means to make the face convincingly real and emblematic of the deepest emotional states, the face of a more sentient being, a more highly organized intelligence. The emotional life of art is insoluble; it can no more be explained than the life of a tree, a woman, or any organic thing. In most portraits, the face is merely the sum total of the features in which the forces of life are held in suspension; in *Mona Lisa*, the Florentine artist created a face which actually and in all its parts is the reflection of a living spirit. For this reason the world has indulged in endless conjectures on the specific nature of the reflection—has tried to solve a mystery that Leonardo was satisfied to state.

[RIGHT] Detail from *Mona Lisa*. In the painting of hands, among other subjects, Leonardo was never surpassed, and these are the most exquisitely modeled of all his efforts.

# LEONARDO DA VINCI
## CONTINUED

No man labored more steadfastly than Leonardo da Vinci to destroy mysteries, or to enlighten the world by discoveries proceeding from observation and experiment. Profoundly religious, he was the enemy of superstition and magic; disillusioned and skeptical, he was at the same time a poet who loved all outward shapes and forms—children, stern old men, enchanting women, horses, flowers, mountains, and moving waters, one who tracked down every outward manifestation of life to the secret sources of its energy. His *Notebooks* reveal one of the finest brains ever put in a human head, the brain of the artist-scientist or, it may be said, the universal artist. It is conceded that he was the founder of engineering and the study of geology, that he was a biologist, hydrographer, geometrician, master of optics, inventor of ballistic machines, and the designer of an airplane. Recently, Italian engineers constructed some two hundred working models of his various inventions!

But to the modern world, Leonardo's fame rests upon his paintings which, unfortunately, are far from numerous. He defined painting technically as modeling, "the task of giving corporeal shape to the three dimensions on a flat surface." The modeling of forms by the subtle flow of light into dark; the scientific analysis of atmospheric effects; the psychology of the emotions, and the relation of gestures and facial expressions to the deepest feelings—such things possessed him and led him to endless experimentation.

In his early thirties, Leonardo painted the *Madonna of the Rocks*, now in the Louvre—the London version was executed much later with the help of a colleague. Departing from conventional treatment, he placed a young Florentine woman, an angel, and two naked children in a grotto patterned after the caves of the Arno which he had examined with the eye of a geologist. But the conception is devoid of incongruity. Science, observation, and sentiment are exquisitely blended; the design is flawless, and the faces are refined to the highest degree of enchanting loveliness. The pointing hand of the angel is a gesture taken from an old symbolism in which the presence of God was indicated by the extended finger. The picture has darkened in tone, and time has added a hardness of surface to the once impeccable finish; but it remains, in all the elements which constitute great painting, one of the world's masterpieces.

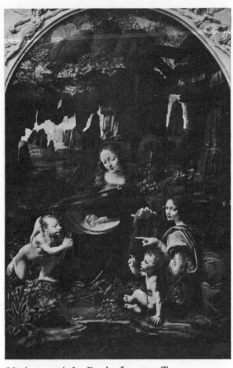

*Madonna of the Rocks*, Louvre. Tempera panel, 6′ 2⅞″ x 3′ 7⅝″, about 1487. Color plate, page 71.

*Infant St. John*, detail from *Madonna of the Rocks*. Children fascinated Leonardo, and the kneeling saint with his wise, oldish face was accepted by Raphael as the model for all painters.

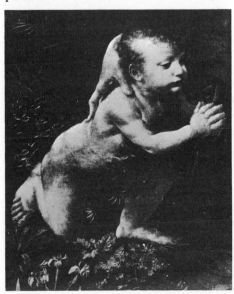

[LEFT] *Adoration of the Magi,* Uffizi, Florence. Panel, 7′ 11¾″ x 8′ 1″. Commissioned in 1481, and never completed. The most complicated, and probably the most influential, of the artist's paintings because of the richness and variety of its pictorial elements.

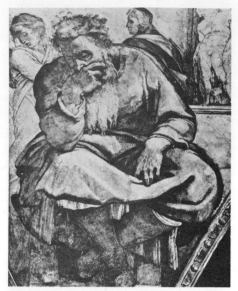

*Jeremiah*, Sistine Chapel, Rome. Fresco, about 1510. Color plate, page 72.

*Tomb of Lorenzo de' Medici*, New Sacristy, San Lorenzo, Florence. 1520-1533. The two nudes, *Dawn* and *Evening*, the supreme sculptured achievements since the Greeks, are the incarnations of some tragic mood — perhaps eternal despair, or shame, for the warring sons of men?

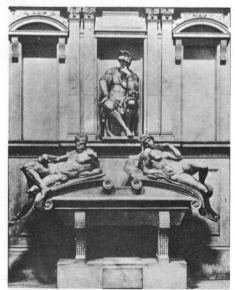

IN THE flower of his physical and mental development, and ready to acknowledge no limit to his capacities, Michelangelo agreed to decorate the ceiling of the Sistine Chapel for Pope Julius II. The magnitude of the undertaking can hardly be conveyed by words: there were ten thousand square feet of plaster to be painted—not merely covered but organized into an architectural design calling for 343 figures, some 225 of which ranged from ten to eighteen feet in height. For nearly four years he was the Pope's prisoner. Day after day, month after month, he lay on his back, his head swathed in a towel, and with astounding delicacy of finish painted the creation and fall of man, the collective effects to be seen from below at a distance of sixty feet.

This architectural design combines single figures and groups of figures in compartments opening into the vault of heaven, with God the Father a majestic being, who, in spite of his tremendous bulk, sails lightly through space as if impelled by some celestial means of locomotion. The gigantic representations include the temptation of man and the expulsion from Paradise, rows of prophets and sibyls, athletic nudes bursting with vitality, the genealogy of Christ, and episodes symbolical of the redemption. In this world, heaven's—and art's—first law is wonderfully observed, and the danger of overpowering monotony avoided by the diversity of postures and by changes in the scale and number of the figures grouped together.

The decorations in the Sistine Chapel constitute the greatest singlehanded work of art that man has ever produced. So transcending is this achievement that it reduces most of the paintings of the world to miniatures and granulated fragments. As art rises to the pinnacle of human capacities, it must stand or fall, in size, power, and importance, by comparison with the Sistine decorations. Consider the *Jeremiah*! If this patriarch should spread his arms, the momentum generated would atomize a whole breed of Darwinian mortals. He is, needless to say, a member of the Florentine artist's race of supermen, a figure created with such omnipotent mastery as to defy the attempts of the most skillful draftsmen to reproduce its simple volumes and condensed powers; in attitude and expression, the Lord's prophet and Michelangelo's spokesman meditating his lamentations on the doomed human race.

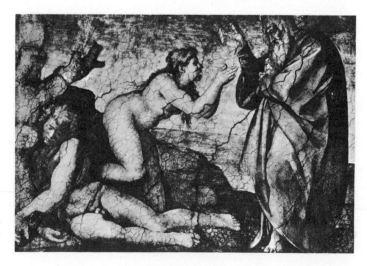

[RIGHT] *Creation of Eve*, Sistine Chapel, Rome. Fresco, about 1509. The mother of the human race is called into being by the Creator.

# MICHELANGELO BUONARROTI

f the creation of man had possessed the minds of artists since the
Michelangelo respected the story but treated it in his own way,
Mosaic account in terms of his own experiences. He created his
placed within it a race of men constructed with all his science
and animated by the noblest outpourings of his soul. His world is wholly an-
thropomorphic and inhabited by superior beings. Landscape is abolished; the
vegetable kingdom symbolized by a bunch of herbs; Paradise a waste land
with a few rocks and a single tree. It is the story of heroic man in all phases
of his development.

"The highest object of art for thinking men," Michelangelo declared, "is
man," a statement meaning not only man in the generic but in the individual
and masculine sense. Women he sometimes painted, but formed after the pat-
tern of his men into large, heroic creatures with no references to physical love-
liness or the charms of sex. In women created on the scale of his giants, the
appeal of sex would have been nothing less than a cosmic error. He used the
human figure, male and female, as a vehicle to express his moods, his mental
habits, and every shade and depth of his emotions.

The inclusion of pagan priestesses in a Christian Church was not a blas-
phemous innovation to an artist reared in the Italian Renaissance. Michel-
angelo accepted the sibyls as great human types—one of them had foretold
that "a child shall be born who will bring peace to the world"—an utterance
construed by the ecclesiastics to signify the coming of Christ. The *Delphic
Sibyl*, cast in the heroic mold of his Biblical characters, is the most beautifully
proportioned and spiritually alert of his prophetic types. With the exception
of the scroll, there is nothing in the painting to connect the figure with the
ancient oracle of Delphi. The young woman must be taken as one of those god-
like creatures, eternally strong and young, removed from the mundane world,
but filled with the awareness of events that were to shake heaven and earth—
the creation of an artist who perpetually brooded on the mystery of life.

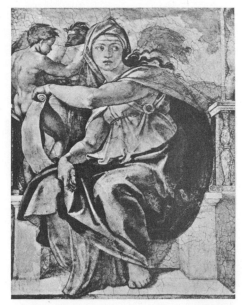

*Delphic Sibyl*, Sistine Chapel, Rome. Fresco,
1508-1509. Color plate, page 73.

*Head of Lorenzo*, detail from the *Tomb of
Lorenzo de' Medici*, Florence. The helmeted
warrior was called *Il Penseroso* by the patri-
ots of Florence, and regarded as the symbol
of one "condemned to contemplate forever the
woes he helped to cause."

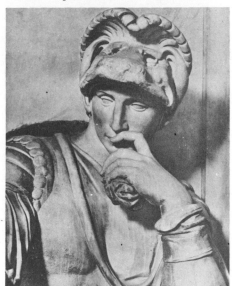

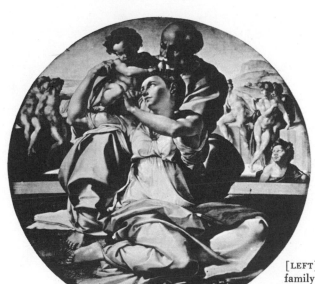

[LEFT] *Holy Family*, or the *Doni Madonna* from the name of the
family for which it was painted, Uffizi, Florence. Tempera, 46½" in
diameter. The artist's first commission, in paint, and one of his few
easel pictures. The main figures presage the Sistine frescoes.

# MICHELANGELO BUONARROTI

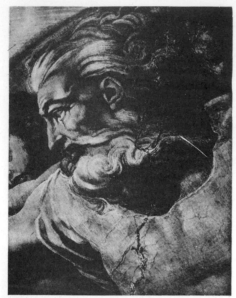

*Head of Jehovah,* detail from the *Creation of Adam,* Sistine Chapel, Rome. The mightiest conception of the Creator in the entire realm of art.

*Slave,* designed for the tomb of Pope Julius II, Florence. About 1525. The figure is unfinished not because Michelangelo sought mystical effects in unhewn stone but from the pressure of too many commissions.

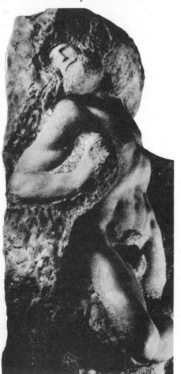

MICHELANGELO is the lord almighty of the naked figure. His great nudes have no duplicates in nature: he painted them, technically, from his fund of knowledge—from a study of the figure beginning in boyhood and carried forward by incessant industry, by anatomical dissections and struggles with the highest and hardest problems of sculpture—inventing new proportions and attitudes. If they seem completely satisfactory as human organisms, it is because they are so perfectly put together. Nothing in art is so difficult to produce or so hard to find as a completely convincing nude. In the work of almost every master, there is some perceptible weakness of structure; but there are no weaknesses in Michelangelo's nudes. They are, in truth, of superhuman construction, and to dwell with them for any length of time is to make one turn to the relaxing earthliness of less prodigious artists.

Some conception of his powers may be formed by giving thought to his Adam, painted while flat on his back on a scaffold, and painted in three days on wet plaster, without corrections or later embellishments! This superb giant is more beautifully articulated and immeasurably more vital than anything the Greeks ever did—and should the dormant figure rise to its feet and extend its compressed energies, it would be more than a match for the agents of earth. The art of painting, unable to present continuous narrative, is limited to certain instants of action or contemplation; and the reclining Adam is portrayed at the instant of receiving the life force communicated to him by the Creator. It is not likely that the world will ever again produce the equal of Michelangelo in the painting of the nude; and it is not rash to say that the figure of Adam is superior to all other nudes not only in size, power, and physical perfection but also in those qualities which are the opposite of the material.

With the Sistine Chapel, the main fabric of Michelangelo's world was completed. One might think, on beholding the vault of the chapel, that he had exhausted every imaginable human attitude; but he returned to the room thirty years later, a tired old man, and painted on the back wall two hundred more figures in *The Last Judgment* without a repetition of posture!

*Creation of Adam,* Sistine Chapel, Rome. Fresco, about 1509-1510. Color plate, page 74.

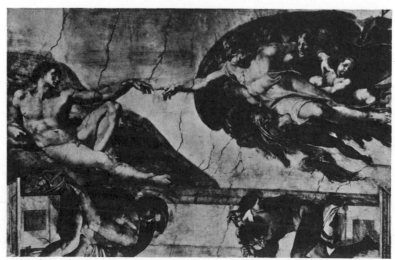

# RAPHAEL

RAFFAELLO SANZIO died on his thirty-seventh birthday, after an attack of fever; his body lay in state in his studio by the side of his unfinished *Transfiguration,* and the whole of Rome flocked in for a last glimpse of the "divine painter." During his short working life, he lived and painted in an atmosphere of princeliness, popular idolization, and critical homage such as no other artist has enjoyed; for more than four centuries, he has maintained a position in the affections of the world that no artist has displaced. To Goethe, he was the unimpeachable deity of classicism; he was the favorite of Byron and the British; to Ingres, the one and only perfect draftsman; and today, after a moment of neglect, he has been revived by the French modernists, Picasso paying him the compliment of adapting his Madonnas to portraiture.

The universal pre-eminence of Raphael in the popular imagination is based largely on his Madonnas and his *Transfiguration,* but it would be erroneous to suppose that his fame has been kept alive solely by the mass appeal of sweetness and light, or that the affection created by his Virgins, from age to age, necessarily denotes the perpetual corruption of public taste. Artists of almost every period, in searching for a balance between their experiences and the means of expression, have looked long and intently at Raphael's structures. The two approaches, the emotional and the formal, arrive, in the end, on common ground—for the artist's intention was not to make abstractions but living people of the utmost gracefulness of attitude and serenity of mood. He succeeded, and in the final analysis, because of and in spite of formal qualities, his figures are but reflections of himself.

Raphael's Madonnas differ greatly in pose and treatment, but not radically in sentiment. The *Madonna of the Goldfinch,* one of the best, was painted in his early twenties, in Florence. In design it is a simple pyramid; in emotional appeal, half classical and half Christian—a composite of the sensuous and the immaculate. This etherealized Italian woman is not of the modern world: she expresses a type of perfection arrived at by one of the most sensitive artists in history, an artist whose ideal was expressed in faultless proportions and a refinement of sentiment—in some cases, an overrefinement—which will probably never be superseded in the popular mind.

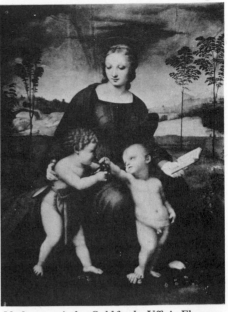

*Madonna of the Goldfinch,* Uffizi, Florence. Oil on wood, 41¾" x 29½", 1506. Color plate, page 76.

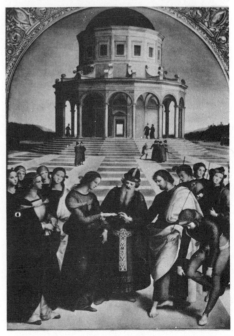

*Marriage of the Virgin,* Brera, Milan. Oil on wood, 5' 7" x 3' 10⅞". Painted in his twenty-first year in emulation of his master Perugino, from whose sketch he borrowed the polygonal temple. The work is primarily an experiment in the potentialities of space composition.

[LEFT] Drawing for *Madonna of the Goldfinch,* Ashmolean Museum, Oxford. About 1505-1506. The overlapping of the Saint's head and the Madonna's arm indicates that St. John was an afterthought. A fine example of Raphael's ability to make a quiet figure seem ready to move.

# RAPHAEL

## CONTINUED

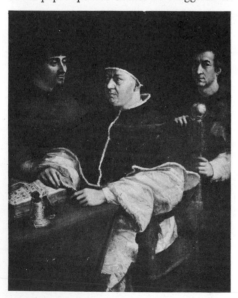

Detail from *The Fire in the Borgo*, Vatican, Rome. The powerful figures illustrate the truth of Michelangelo's sarcasm when he said, "The young man from Urbino has been lurking in my Chapel."

*Pope Leo X*, Pitti Palace, Florence. Oil on wood, 62″ x 47½″, 1518. In portraiture the gentle Raphael of the lovely Madonnas became an uncompromising master. The absolute reality and truthfulness of his rendering of his papal sponsor cannot be exaggerated.

RAPHAEL's great fame is not the consequence of his supremacy in any single department of art. His career falls, as if by exact calculation, into three divisions: his early training under Perugino whose mannerisms he absorbed and made his own; his Florentine period, from 1504 to 1508, when he molded himself in the new style by yielding to the influence of Michelangelo, Leonardo da Vinci, and Masaccio; his Roman period, from 1508 to his death, in which he developed his capacities as a mural decorator.

He has been described as the great harvester, the man who moved from influence to influence, absorbing and assembling, and transforming all that he had extracted from others into his own style, by the ineffable grace and loftiness of his personality. He was one of the most gifted painters the world has seen, and it is no wonder he was called divine. He was never disturbing; he seemed to rise with godlike ease above all others, to achieve a symmetrical completion in his life that made Michelangelo boorish and uncivilized. He could do no wrong; he was gentle to the point of effeminacy, and yet he could exercise undisputed authority over fifty assistants.

Raphael was called to Rome to decorate certain rooms of the Vatican with frescoes. He covered wall after wall with enormous historical, religious, and allegorical compositions which were accepted for centuries as the academic standard by which figures should be harmoniously disposed in space. In one of the rooms he designed and executed, with the help of assistants, *The Fire in the Borgo*, to commemorate a miraculous event in the career of Leo IV, who appeared at a window in the Vatican, made the sign of the cross, and so put out the fire. In this fresco, he was under the domination of Michelangelo, who had astonished Christendom by his decorations in the Sistine Chapel. Raphael was not by nature a dramatic artist, but so great was his versatility that he produced splendid muscular figures in action, utilizing the powerful forms of Michelangelo with a grace of gesture and a flow of drapery that were unmistakably his own. In addition to all these labors, and despite his delicate health, he was the inspector of monuments and antiquities in Rome, Bramante's successor as architect of St. Peter's, and, in his spare time, the painter of many easel pictures.

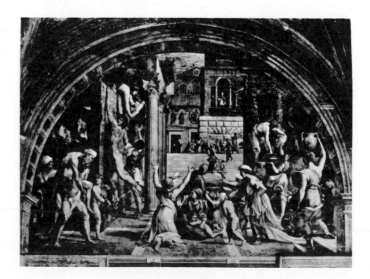

[RIGHT] *The Fire in the Borgo*, Vatican, Rome. Fresco, about 1514-1517. Color plate, page 75.

# RAPHAEL

## CONTINUED

RAPHAEL's art was constantly fertilized by the styles of other painters. He was extremely impressionable, but his receptivity was guarded by a fine intelligence, and he never abandoned himself unreservedly to a single influence. He painted as he lived, sensitive to all forms of life, but surrendering to none, and retaining in his fame a golden equanimity and a charm of manner so captivating that the world did not stop to consider that he was more pagan than Christian, and not exactly a saint in his private behavior. As a young man in Florence, he painted, with coolness and deliberation, a number of Madonnas in which purity of form and refinement of spirit are emphasized at the expense of vitality and firmness of structure; in his later years in Rome, he painted portraits—not virginal sublimations—in which classical poise is united to warm humanity. These portraits represent the highest attainments of his eclectic genius.

Raphael's development is the old story of the enrichment of a man's art by direct experiences in life. Not that his painting is a diary of his physical or emotional adventures—but his best and most original conceptions of the human form came from his relations with men and women and not from the study of other paintings. The facts of his life are not altogether clear, but the legend that he was addicted to sensual pleasures is flatly denied by his immense productivity. In a diplomatic moment, he was betrothed to the niece of a cardinal—but the engagement lingered on until his death. There is ample authority for stating that he was passionately attached to La Fornarina, the baker's daughter, the original of *La Donna Velata,* and the model for *The Sistine Madonna.* Vasari, who, for once, mentions no names, relates that "in his last illness, he dismissed the object of his attachment from his house, but left a provision for her in his will."

Whatever the identity of the model, the veiled lady remains his most majestic conception of womanhood. In contrast to the lymphatic and drooping Madonnas of his early youth, this woman is superbly erect and alluring, direct of glance, richly attired, but chastened by the veil. The composition, with its intricate weaving of lines—its beautiful pattern of folded satin grays and whites against a dark ground—is Raphael's masterpiece in portraiture.

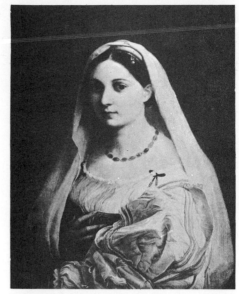

*La Donna Velata,* Pitti Palace, Florence. Oil on canvas, 32¼" x 23⅝", about 1515. Color plate, page 77.

*Self-portrait,* detail from *The School of Athens,* fresco, Vatican, Rome. "A youthful head," according to Vasari, "of exceedingly modest expression." The man next to Raphael, once supposed to be Perugino, is now identified as the wayward Sodoma.

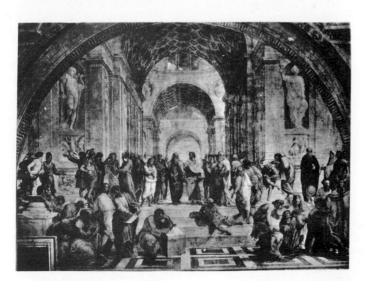

[LEFT] *The School of Athens,* Vatican, Rome. Fresco, 15' x 25', 1509-1511. Here we see the supremely eminent Raphael: the mural decorator and master of portraiture, converting the heritage from the antique into a living world of his own.

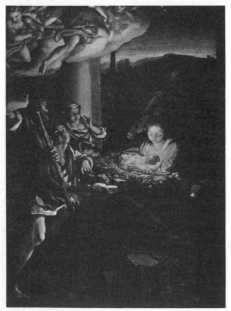

# CORREGGIO

IN his brief career, Antonio Allegri, known as Correggio from his birthplace in northern Italy, astonished his contemporaries by the boldness of his invention, his incredible skill in perspective, and the lightness and ease with which he modeled the figure. His paintings have not lost their exciting properties, remaining to this day objects of wonder and contention among artists and laymen. One might infer, from the sinuous and furtively accentuated character of his nudes, that he was a man of libidinous indulgences; but he seems, on the contrary, to have been an overworked painter of strong, Christian piety, a devoted husband and father, public-spirited, charitable, and with none of the smaller vices of envy and intolerance.

Correggio's working life was passed, for the most part, in Parma, not far from his native town. In the dome of the cathedral of that city, he painted, without having seen the frescoes of Michelangelo or Raphael, or any of the great decorations of Italy, the most audacious and complicated foreshortenings of the human figure in art. He was one of the first dome painters—but by no means the last; and his galaxies of form portrayed as in the clouds, and as seen from below, were stigmatized by the Parmese dignitaries as "a hash of frogs." Titian thought differently and remarked, "Turn the cupola upside down and fill it with gold, and even that will not be its money's worth."

Correggio adapted his gifts with impartial zeal to sacred and profane materials. When he accepted a religious commission, he considered the nature of the job and painted it accordingly, instilling into his Madonnas a gracious animation and glancing tenderness bordering on sentimentality. He was more at home in mythology where his technical cunning—his ability to modify tones in the subtlest transitions from light to dark—operated freely. Here again he considered the nature of his task, and with a curious honesty of purpose modeled his nudes into forms of radiant softness and erotic suavity. *Jupiter and Antiope* is a famous example of his art—his foreshortening, his deliberate twisting of the figure into a posture that appears to be spontaneous and casual, and the caressing, sensuous imagery provoked by the fanciful idea. Vasari's estimate of Correggio might have been prompted by the *Antiope:* "There never was a better colorist, nor any artist who imparted more loveliness or relief to his things, so great were the soft beauty of his flesh tints and the grace of his finish."

*Jupiter and Antiope*, Louvre, Paris. Oil on canvas, 6' 2⅞" x 4' ⅞", 1521-1522. Color plate, page 78.

*Nativity*, commonly known as *Holy Night*, Dresden Gallery, painted for a private chapel in 1522. Panel in oil, 8' 4¾" x 6' 2". Correggio, pagan and fleshly for the most part, here exhibits his genuine devotion in a canvas of world-wide popularity and without flourishes or contortions except in the forms of the flying angels.

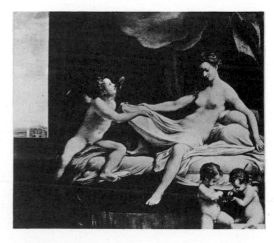

[RIGHT] *Danae*, Borghese Gallery, Rome. Oil on canvas, 5' 3⅝" x 6' 4", about 1532. The somewhat absurd and libidinous efforts of Jupiter, as treated by Correggio, are reduced to invisibility, and the subject becomes a tribute to the sensuous charms of woman.

# CARLO CRIVELLI

1430?–1493?         VENETIAN SCHOOL

By the signature on his paintings, Crivelli informed the world that he was a Venetian; by the character of his work, he was plainly a graduate of the Paduan school which bred Mantegna. In his early years he practiced his art in Venice, but an adulterous misunderstanding with a married woman caused him to repair hastily to the March of Ancona where he spent the rest of his life in solitary application to the craft of painting. He was individualistic and reactionary, painting in the old tempera medium while the younger generation was exploring the new medium of oil. He was primarily a Madonna painter, and not without local recognition, being knighted by Ferdinand II of Naples, an honor so comforting to his vanity that he usually remembered it in his signature. In his last years, his sole pleasure was in handling paint, and with curious pertinacity and remarkable skill he contrived a type of devotional picture which, though mannered to idiosyncrasy, would never be mistaken for the work of another.

Crivelli's use of the tempera medium—powdered colors tempered, or held in solution, by the yolk of eggs—has never been surpassed. This method calls for precision of touch and certainty of draftsmanship, does not lend itself to easy corrections, and when properly applied insures a brilliancy of color impossible to obtain in oil. Crivelli, with indescribable patience and delicacy—with the same sort of manual genius that distinguished Vermeer—stroked his surfaces into embossed patterns resembling the vitreous effects of enameled ware. Dry and grotesque himself, he invented a Madonna of wiry primness, and he repeated the type in all his paintings, with slight rearrangements of background. The *Virgin and Child*, here reproduced, show him perfectly: his harshness, his dry harmonies, and his decorative properties—the rich brocade, the pendent festoon of peaches and prickly pears, the fracture in the stone, the bird and the fly. Crivelli's pictures are scarce, and some of the best are in America. He is a cultivated taste—archaic, isolated and affected—but, in spite of his wryness, possessed of a quaint tenderness and charm which, with his craftsmanship, have won the admiration of connoisseurs.

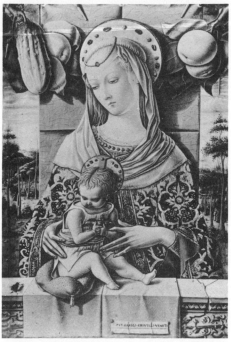

*Virgin and Child,* Metropolitan Museum, New York. Tempera panel, 14″ x 9½″, about 1470. Color plate, page 79.

*The Annunciation,* National Gallery, London. Tempera panel, 6′ 10½″ x 4′ 10½″, 1486. The delightful fancy, the lucid color, and the exquisite craftsmanship of Crivelli are displayed in all their glory. The assisting saint holds a model of the town of Ascoli, home of the convent for which the work was painted.

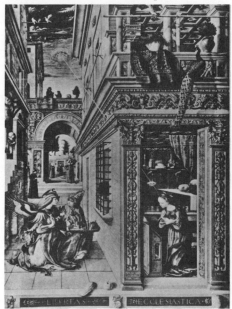

[LEFT] *Peeping Child,* detail from *The Annunciation.* A charming example of Crivelli's rendering of children, precise, understanding and devoid of false sentiment.

# ANDREA MANTEGNA

ANDREA MANTEGNA, the mighty son of a Paduan farmer, has been called the prince of draftsmen. He was affiliated with the Venetians by his marriage into the Bellini family, but to a man of his tough-minded resolution, Venice was the plague spot of painting, and he avoided the city. A student of Donatello, he was related to the Florentines by his scientific inquiries and by his perfection of design in fresco. The grandeur of antiquity was his natural heritage; he was a Roman reborn, an original artist who responded with profound reverence to the grimness and power of his ancestors. As a boy, he was initiated into antique scholarship by Squarcione, a famous teacher of Padua; more affluent, he collected classical sculptures, but his accumulated erudition was humanized by travel, and saved from pedantry by unceasing intercourse with people of all classes.

In 1474, in the employ of the House of Gonzaga, he painted, in the ducal palace at Mantua, some of the greatest secular frescoes in art. Time and bungling restorers have played havoc with these decorations and they reproduce badly. As an illustration, in print, of his immense powers, the *St. George*, a small and excellently preserved panel, will serve admirably. The subject, like the Virgin, was a challenge to the imagination of Italian artists; Uccello conceived the dragon slayer as a naïve hero of the nursery; Raphael painted him as an unsoiled Apollo attended by a girlish praying Madonna; Donatello carved him in marble as a noble youth.

To Mantegna, the subject came as naturally as a portrait of one of the Gonzagas. The young *St. George*, a Christian knight who suffered martyrdom in the reign of the pagan emperor Diocletian, released his passionate interest in the ancient world; but in representing the youth, he scorned the accruing symbolism—the attempts to identify the dragon with the dark forces of paganism—and painted a young Mantuan of the period. The picture shows the disciplined haughtiness of Mantegna's portrait characterizations, the astringent perfection of his draftsmanship, his deep winding landscape, an optical illusion created by his skill in perspective, and the Caesarian detachment with which he examined his fellow men and imparted to them the composure of antique marbles.

*St. George*, Academy, Venice. Oil-tempera, 26″ x 12⅝″ about 1462. Color plate, page 80.

*Condemnation of St. James*, one of six frescoes painted in the Eremitani Chapel, Padua, and destroyed in World War II. Though less than twenty-one when assigned to the job, Mantegna had already mastered his archaeological, or Roman, style.

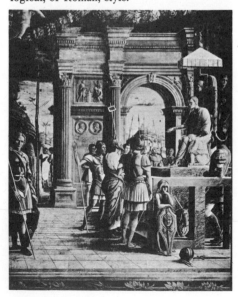

[RIGHT] *Ceiling*, Camera degli Sposi, Palazzo Ducale, Mantua. Fresco, 1469-1470. Although Mantegna painted this on a flat surface, he has created, by sheer technical genius, the illusion of a perfectly rounded dome, and his figures seem to be actually floating in space. The frescoes antedate Michelangelo's Sistine ceiling by forty years and Correggio's dome by fifty.

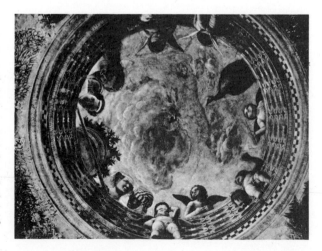

# ANDREA MANTEGNA

### CONTINUED

IN HIS twenty-fourth year, Mantegna, an exceptionally mature young man, was commissioned, together with fellow pupils from the workshop of Squarcione, to decorate in fresco a chapel in a church at Padua. The six ecclesiastical subjects assigned to the young Paduan were duly executed and, though archeological in style and intensely Roman in feeling, remain without doubt the greatest mural paintings ever designed by an artist in the first years of his manhood. Unhappily, in World War II, the murals were bombed to pieces by the Germans, and the extant work of Mantegna, never too numerous, was irrevocably reduced.

With the destruction of these murals, and with recent reports of the precarious condition of the secular frescoes at Mantua, it is plain that every well-preserved example of Mantegna's art becomes increasingly valuable and important. One of the finest paintings in existence, not only as an illustration of the Paduan's genius at its topmost point but also as a technically faultless specimen of his craft, is *The Adoration of the Shepherds*. This small panel, less than twice the size of the color reproduction on page 81, is the particular pride and joy of the Metropolitan Museum, a masterpiece in the best of health and almost as lucid and fresh as it was the day it was finished more than five hundred years ago.

Though emulous of the monumental gravity of the ancients, Mantegna was, at the same time, an ardent Christian deeply moved by the account of the Nativity and the adoration of plain men. He had already evolved his conception of plain men, lean, angular, shoeless men, and he brought a pair of them into the scene in an attitude of worship. It was his purpose to portray the devotional aspect of the Christian incident with the timeless strength he admired in the old Roman builders, and how he succeeded and how he contrived in this small panel to create the illusion of vastness and infinite space is one of the miracles of art. The rambling landscape was purely imaginative, a synthetic device employed in the interest of depth and grandeur, and the separate elements of the scene—the rocks, trees, and figures—have the stability of architectural forms in an elaborate structural design. It has been said that the air of antiquity hangs over the picture. There is some truth in the observation, but it is equally true, and much more significant, that over it also hangs the air of eternity.

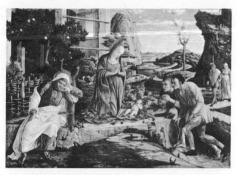

*The Adoration of the Shepherds*, Metropolitan Museum, New York. Oil-tempera, 15¾" x 21⅞", 1450-1460. Color plate, page 81.

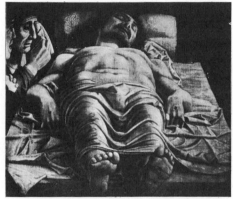

*Dead Christ*, Brera, Milan. Oil-tempera on canvas, 32" x 27", after 1500. One of the most astounding examples of foreshortening and naturalism in the history of painting.

*Meeting of Count Ludovico and Cardinal Francesco Gonzaga*, fresco from the Camera degli Sposi, Mantua. 1472-1474. Mantegna has painted the illusion of a classical pavilion, with the figures out of doors and the countryside for a background.

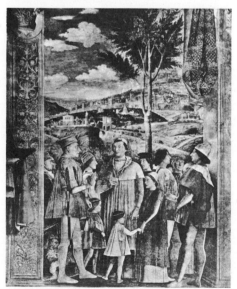

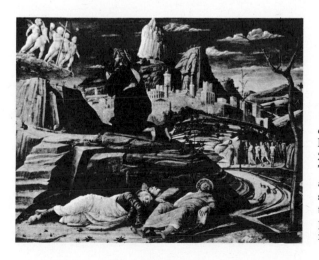

[LEFT] *Agony in the Garden*, National Gallery, London. Oil-tempera, 24⅝" x 31½", after 1464. The harmony of figures and landscape and the sharply defined, sculptural forms should be compared with a similar painting by Giovanni Bellini.

# GIOVANNI BELLINI

1430?–1516                                    VENETIAN SCHOOL

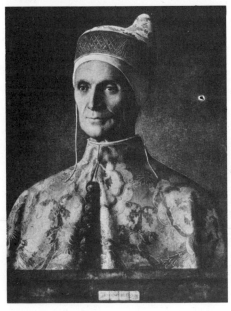

*Portrait of a Youth*, National Gallery, Washington. Oil-tempera, 12½″ x 10¼″, about 1490. Color plate, page 82.

Detail from *St. Francis in Ecstasy* (opposite page), copyright The Frick Collection, New York. A closely observed detail, with the sunlight breaking over the topmost forms and illuminating the entire scene.

*Doge Leonardo Loredano*, National Gallery, London. Oil-tempera, 24″ x 17½″, about 1503-1504. A late work and about as impressive a portrait as the hand of man has produced—noble in characterization, beautiful in color, and faultlessly executed.

THE consolidation of the Venetian school of painting is centered in one family—the Bellini, father and sons. Jacopo, the father, was an eccentric old gentleman who wandered through Italy sketching architecture, animals, mountains, cities, and Madonnas. Attracted to Padua, famous at the moment for its academy of classical instruction, he met Andrea Mantegna to whom he gave his daughter in marriage. From the school at Padua, but particularly from Mantegna, Jacopo Bellini acquired a scientific knowledge of painting that he imparted to his sons, Gentile and Giovanni.

Gentile Bellini gained renown for his religious decorations and his portraits, but his position as one of the founders of Venetian art rests mainly upon his processional pictures. The most illustrious of the family and the first of the Venetian masters is Giovanni Bellini who lived long and passed through many stages of development, painting Madonnas, portraits, allegories, altarpieces, landscapes, and pastorals. If his fame has been overshadowed by his pupils, Giorgione and Titian, and by Tintoretto and Veronese, it is because his followers profited by his discoveries and carried them forward to a higher degree of perfection.

The rulers of Venice were patriotic souls, jealous of their city and not a little conscious of their own superiority. They asked of painting that it advertise the state and take into account the nobility of its political guardians—they employed artists to preserve their portraits in a style befitting their official station. An artist like Mantegna they could not countenance—he was too searching and acidulous in his observation; they wanted a man whose portraits were pleasing to the eye and not contradictory to their own opinions of distinction. They found their man in Giovanni Bellini, a mild-mannered artist who could be depended on to paint truthfully but without harshness, and whose inclination was to discover in his subjects the pacific integrity of his own nature. In his *Portrait of a Youth* he combined the gravity and linear qualities of his Paduan training with his own richness of color to produce a portrait that might hang with those whose names were inscribed in the Book of Gold, the roll of the Venetian nobility. Bellini's portraits are exceedingly rare. For this one, 10¼ by 12½ inches in size, Andrew W. Mellon paid $280,000.

[RIGHT] *Miracle of the True Cross*, Academy, Venice. Finished in 1500, 134⅛″ x 179½.

# GIOVANNI BELLINI

## CONTINUED

GIOVANNI BELLINI was a man of uncommonly good sense and reasonableness. Nothing failed to excite him but he was never excited immoderately; he was incapable of the tragic passions but he was above violence and banality. As painter to the state, he was never perfunctory, and in his use of light and color to bind his forms together into a harmony of tones, he anticipated Rembrandt. As artist and practitioner, he was serenely prosperous from youth to extreme old age, and when the scheming Titian attempted to obtain his official post, he was annoyed but not vindictive.

Trained in the Paduan school, Bellini matured slowly, painting during his first period in the old tempera method with the hard draftsmanship of his brother-in-law, Mantegna. With his gradual mastery of the oil medium introduced in Venice by Antonello da Messina, in 1473, he developed his own style, softening the outlines of his drawing and increasing the scope and richness of his color; in short, defining the tendency of the Venetian school. With the exception of the early and rather mediocre work of the guilds, religious painting had never been very marked in Venice; but Bellini revived and nurtured this branch of art and became its greatest, if not its only exemplar.

Beginning with his sixtieth year, his humanity tempered by many successful tilts with life, wise, tolerant, benign, and not unmindful of the surrounding splendor, he painted a long succession of Madonnas, many of which, circulating in the form of villainously colored postal cards, have repelled a critical public unacquainted with the originals. These half-length Virgins, of which the *Madonna of the Trees* is perhaps the finest specimen, differ but slightly in posture and expression. The wonder is that Bellini could have maintained such uniformity of craft and inspiration in painting so many of them. It was a sacred obligation—a point of honor as artist and churchman—and he created a new type of Madonna, one of the rarest achievements in art. They are all sisters, neither mystical nor deeply affecting, but self-possessed, delicately sweetened, and splendidly Venetian without being luxurious or worldly. Much of their distinction must be attributed to their color, a fusion of reds, greens, and blues with subtle distributions of light. Bellini, whom Dürer, in 1506, pronounced "the grand old man of art, and the best and most courteous painter in Venice," painted and repainted a young Venetian woman, and finally arrived at an ideal that satisfied his conception of the Madonna.

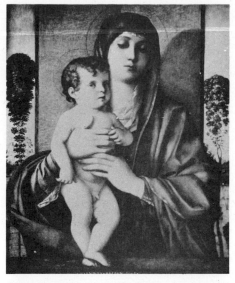

*Madonna of the Trees*, Academy, Venice. Oil-tempera, 29″ x 22¾″, painted in 1487. Color plate, page 83.

*Madonna with Saints*, Sta. Maria dei Frari, Venice. Oil-tempera, 2½′ x 6′, 1488. The grandest and most formal of Bellini's altarpieces, with the elaborate architectural framework a part of the design. The Virgin is serene and regal, the saints as pompous as doges.

*Angel Musician*, detail from *Madonna with Saints*, Frari, Venice. A familiar motif in Renaissance painting, with the sensuous and ethereal combined.

[LEFT] *St. Francis in Ecstasy*, Frick Collection, New York. Oil-tempera, 48⅜″ x 55″, about 1480. Before Bellini, landscape had been largely a decorative backdrop; with this picture it became an independent, or all-pervading unit, an actuality in three dimensions with the human element a subordinate integer.

# GIORGIONE

1478?–1510   VENETIAN SCHOOL

*Concert Champêtre*, Louvre, Paris. Oil, 43¼" x 54⅜", about 1505-10. Color plate, page 84.

WHEN the merchants of Venice had sampled the pleasures of self-glorification, they indulged the art of painting, and it flourished as no art had flourished before. It abandoned the guild for the dealer, spreading from the church to the schools, and from the palace to the private house; it ceased to be the servant of architecture and circulated in the form of the easel picture; it appeared as portraiture, pageantry, legend, and pastorals—anything that was happy and voluptuous and untouched by the harsher realities—it shone in the naked bosom of Venice like a cluster of jewels.

The name of Giorgione rings with the sound of gold; his art charms us with the golden gleams of magic. This young Venetian—he died in early manhood—relieved painting of its archaic shackles, and with no anxieties over the naked body, painted with a freedom of expression that has influenced all subsequent schools. One of his indisputable masterpieces is the *Concert Champêtre*, a landscape with figures: at the left, a large nude woman holds a crystal jug over the mouth of a well; at the right, a seated nude of the same generous proportions fingers a shepherd's pipe; in the center a young courtier, splendidly clad, strums a lute while his companion in sylvan garb looks on serenely. This literal description signifies nothing save the illogical and unrealistic nature of the picture—not in the environs of Venice or anywhere else did young ladies roam the countryside in a state of undress. But the work does not offend our sense of fitness, nor is anyone conscious of its representational incongruity.

The *Concert Champêtre* is called the *Pastoral Symphony* because the harmony of light and color and form seems to affect us like a musical composition. A glowing envelope of light and air drifts over the scene binding the figures to the landscape, and the color is embedded in the forms—in the golden nudes, the red costume of the lute player, the light that breaks among the trees, the faint blue hills, and the streak of clouds. In the *Pastoral Symphony*, Giorgione has perpetuated the spirit of youth so typical of the Venetian Renaissance. The spirit of youth is not dead—it never dies; it is present in varying degrees in every human being, but with Giorgione it was the whole of life, and he gave to it a perfection of expression, a unity of form and mood, which no other painter, unless it be Renoir, has ever approached.

*Madonna with Saints*, Duomo, Castelfranco. Oil, 6′ 6¾" x 4′ 9⅛", about 1500. Painted for the cathedral of the artist's home town, with the Virgin almost elevated out of eyeshot. St. Francis, on the right, is contrasted to St. George, the warrior, and the whole is a study in harmonious relationships rather than an illustration.

[RIGHT] Detail of upper portion of *Madonna with Saints*.

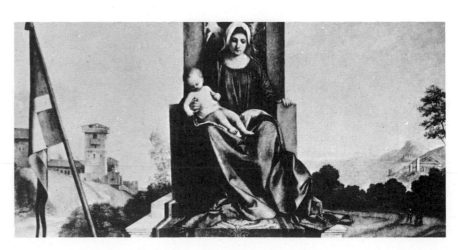

· 36 ·

# GIORGIONE
## CONTINUED

GIORGIONE's life is veiled in uncertainties and romantic enterprises which, though consistent with the tone of his art, have not been substantiated by historians. It is within the bounds of probability that his name was Giorgio Barbarelli, the illegitimate son of a highborn Venetian and a peasant girl; that he was as famous in the arts of love and music as in painting; and that he died of the plague communicated to him by his mistress. Whatever he may have been in reality, his work personifies the springtime and early summer of the Venetian ideal of physical perfection. He was the founder and perhaps the greatest exponent of the art of painting as designed to insinuate itself, with the most exquisite refinements of the attributes of the human form, into the world of the senses. His pictures tell no story and avoid the implications of action and movement: they are the embodiment in form and color of lyrical moods.

Giorgione's *Sleeping Venus*, in all that it purports to be, is the most famous nude in Occidental painting, the Venetian counterpart of the Greek goddess of love, but enhanced by pictorial elements beyond the capacities of sculpture. The painting is a young poet's dream, the vision of the hedonist who, by the magic of his personality, transformed his sensual experiences into a harmony of supreme loveliness. To say that he turned the miracle by means of light and color is to repeat a half-truth; beyond a doubt he was one of the great colorists with a faultless perception of balanced tones—but he succeeded where other great colorists were left in the studio. Titian, in direct rivalry, created a stately courtesan; Goya a brilliant portrait of a wanton duchess; Manet, in *Olympia*, an exhibition picture.

No other painter has been able to imitate, much less experience, that completely unforced delight in the sensuous world which was expressed in its purest and most natural form by Giorgione. His *Sleeping Venus* remains the model of all artists endeavoring to externalize their conceptions of sensuous beauty. He refined the lines of the body, adjusted the contour, and gently idealized the proportions into a figure that has become a type form of nudity. He achieved a perfect harmony between the physical fact of nakedness as he had experienced it and his abstract, or poetic conception, of the ideal nude, the goddess of the Venetian dream.

Detail from *The Tempest*, Academy, Venice. The walls and moat of Castelfranco, as essential to the harmonious ensemble as the passive figures.

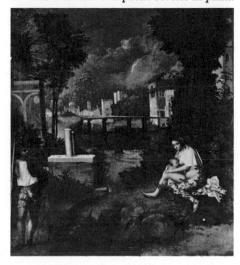

*The Tempest*, Academy, Venice. Oil on canvas, 32½" x 28¾", about 1508. Also called *Soldier and Gypsy*, but the titles of Giorgione's pictures are of minor importance. The nursing mother is oblivious of the approaching storm, and the courtly young man is discreetly unobservant. The work is a poetic reverie in paint.

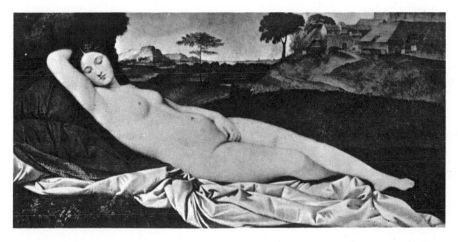

[LEFT] *Sleeping Venus*, Art Gallery, Dresden. Oil on canvas, 43" x 68¾", about 1508-1510. Color plate, page 85.

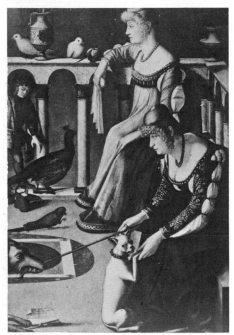

*The Dream of St. Ursula*, Academy, Venice. Oil on canvas, 8′ 11″ x 8′ 9″, about 1495. Color plate, page 86.

*Two Courtesans on a Balcony*, Museo Correr, Venice. Oil on canvas, 64¾″ x 37″, about 1510. These two sisters in sin, so truthfully depicted, were called honest women by Ruskin, and they may well have been; but their rich costumes and appurtenances would indicate that their honesty was of a most successful order.

[RIGHT] *English Prince Taking Leave of His Father*, (L) *and Greeting Ursula* (R), Academy, Venice. Oil panel from a continuous scene, 20′ x 9′, about 1495. The culmination of the Venetian narrative style in which the episodes, however princely or religious, were treated as everyday circumstances.

# VITTORE CARPACCIO

1450?–1522          VENETIAN SCHOOL

LATE in the fifteenth century Leonardo da Vinci came to Venice. Though something of an aristocrat himself, and accustomed to court life, he was not prepared for the extravagance and pageantry of the Venetian scene. He saw the Doge marching with costumed servitors into St. Mark's, a magnificent affair— and one of thirty-six annual processions; crews of girls racing on the Grand Canal; chambermaids bedecked in Oriental finery; palaces inlaid with mosaics; facades emblazoned with frescoes; flags, banners, and parades. It was exquisite and exciting, but a little spectacular and indiscriminate for a Florentine. He also saw the processional pictures of Gentile Bellini—the stately crowds and marching priests, the background of light and air painted with a scenic truth far surpassing the realistic efforts of his Tuscan confreres.

Carpaccio, the follower of Gentile Bellini, was a painter of Venetian genre. His subjects, as often as not, were taken from legends, but his treatment of them was delightfully contemporary, and he is famous alike as a historian of manners and a most excellent designer of narrative pictures. His St. Ursula series, executed for the School of St. Ursula in Venice, an orphanage for girls, depicts nine episodes in the life of the Princess of Brittany who agreed to marry an English prince with the provision that the English king and his people should embrace Christianity and provide her an escort of eleven thousand virgins for a pilgrimage to Rome. The proposal was accepted, the pilgrimage accomplished, and the Pope's blessing received; but it was revealed to Ursula in a dream that the expedition was doomed, and on the return of the pilgrims to Cologne, all met their death at the hands of the Huns.

Carpaccio painted the legends with no special religious convictions, introducing, wherever possible, the pageantry which endeared him to his public. He painted the saint as if she were a charming Venetian girl, and the scene in which the angel appears in a dream to announce her martyrdom—Plate 37— is the closely studied bedroom of a young girl in the morning light. It is an intimate glimpse of a chaste interior, carefully designed in a pattern of horizontal lines and rectangles, with all the properties discreetly exposed—the crown at the foot of the bed, the slippers, the framed Madonna and the candle— the peaceful chamber of a maiden saint, the appropriate background for the legendary miracle painted by a master of space composition and the gentler effects of light and air.

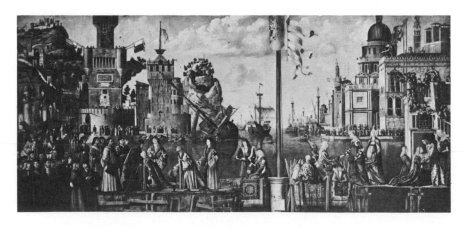

# TITIAN

## 1477–1576   VENETIAN SCHOOL

FEW artists have been so fortunate in natural endowments as Tiziano Vecellio, known as Titian. He was industrious without being hasty or temperamental; he loved the good things of life but never descended to gluttony; hard and avaricious in business, he was liberal in domestic expenditures, hospitable, an entertaining host, at home with kings, courtesans, and prelates; he was never too old to learn; his life was disturbed by no troubles of hand or soul; he experienced no suffering; he was honored beyond any other painter of his time and active to his ninety-ninth year when the plague carried him off.

In the last decade of his life a change came over the old Titian. The pleasures of the flesh were ended; mistresses could do him no good, and reflections on approaching death revived the poetry that had lain so long in abeyance. No more painted tokens to the glory and loveliness of Venice; no longer a painted ideal of composed and lordly manhood! The Renaissance had passed, and Italy had been ruined by barbaric rulers whom his brush had ennobled. The poetry returned but with a deeper humanity—his brush trembled with the shuddering touch of tragedy. His eyes failed him, and he began to paint in a style that astonished his public. Outlines grew more and more indistinct, and color gave way to luminous veils of tone; he applied his paint in broad streaks which, at close range, revealed nothing, but at a distance blended into forms of startling animation—a method foreshadowing modern Impressionism.

In the Munich version of *Christ Crowned with Thorns*, actuated by some belated spiritual impulsion, and mastering, no one knows how, the elements of movement in design, Titian rose above pageantry and painted a great dramatic composition. The figure of Christ is modeled in the blood-red light shed by the flickering torches—a tragic form brought out of the darkness by a concentrated illumination worthy of Rembrandt—and the clubbing brutes around him are portrayed with wonderful realism and energy. With this picture, Titian, the invincible portrait painter, the creator of bacchanals and tributes to pagan deities, enters the company of the religious masters.

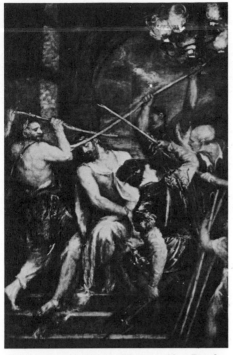

*Christ Crowned with Thorns*, Alte Pinakothek, Munich. Oil on canvas, 110″ x 70″, 1570. Color plate, page 87.

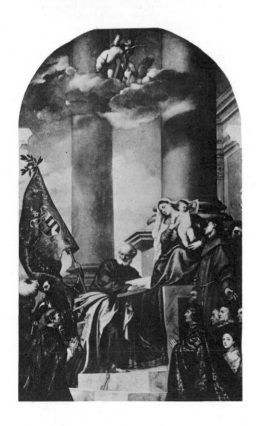

*Pesaro Madonna*, Frari, Venice. Oil on canvas, 1519-1526. A comparatively early work marking the arrival of the artist as a religious painter. Traditional in the inclusion of saints and donors, and an imposing example of Venetian decoration.

[LEFT] *Self-portrait*, Kaiser Friedrich Museum, Berlin. Oil on canvas, 38″ x 30″, about 1550. Not flattering but formidable. The visage and personality of a man who coped valiantly with a crafty world.

· 39 ·

*Portrait of a Man in a Red Cap*, Frick Collection, New York. Oil on canvas, 31″ x 26¾″, 1513-1515. Color plate, page 88.

WITH the Venetians as a school, but with Titian in particular, painting ceased to be the expression of collective religious interests and became a speculative profession. When royal and wealthy clients displaced the guilds, the great body of artists followed the only course open to them, and delivered their pictures into the hands of agents. Titian, one of the shrewdest of painters, faced the changing conditions with a cold eye, and engaged as his publicity director Pietro Aretino, who for more than a generation piloted the artist through diplomatic entanglements and the hazards of royal patronage. But to Titian's credit, it must be said that he never truckled to the blackmailer who represented him, and never debased the quality of his work for the sake of a fat commission.

With the separation of painting from architecture and the rise of the easel picture, the popularity of the portrait increased by leaps and bounds, and Titian made himself king of this domain. He did not flatter his sitters; he cast them all in the same mold, made them conform to his own ideal of aristocratic superiority, finishing his canvases without models, slowly altering form and features into a type of physical excellence that should be a credit to Venice and to art. He was most successful in portraits of men; he preferred women in the nude.

The *Man in a Red Cap* is a superb illustration of Titian's earlier style of portraiture. This young noble with the exceptionally broad shoulders—a device of the artist's to emphasize masculinity and to give largeness and stability to his designs—is painted with the utmost simplicity and with no trickeries. He is a living presence, the essence of princeliness—everything that is tawdry or bourgeois has been omitted; he is a lord, or at least he satisfies the romantic conception of a lord, and he has the dignity and the commanding touch of melancholy with which Titian adorned his manly heroes. His identity is of no importance, his occupation irrelevant. He is a member of Titian's gallery of portraits which embody the aristocratic complacency of Venice and which appeal to the deep-seated pride and romantic aspirations lurking in the human breast.

Detail from *Venus of Urbino*, Pitti Palace, Florence. Oil on canvas, about 1538. Head of Eleonora Gonzaga, Duchess of Urbino and wife of the wealthy patron of the artist.

[RIGHT] *Venus of Urbino*, Pitti Palace, Florence. Oil on canvas, 46½″ x 65¾″, about 1538. The Duchess of Urbino posed for the head, a shapely courtesan for the body. The composite was satisfactory to both—and to posterity.

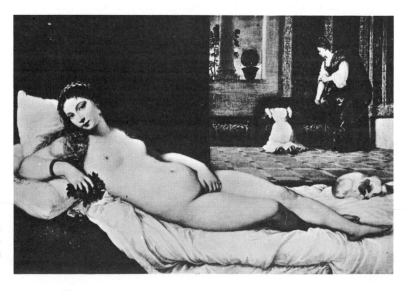

# TITIAN

GIORGIONE was the first of the Venetians to discover the realm of poetic sensuality in painting, and this fragrant realm Titian, his successor, cultivated for thirty years, the first period of his long career. It was new, it was popular, it was profitable; and he exploited it with canny diligence, painting mythological scenes and groups of draped and undraped figures assembled for no purpose that bears realistic analysis. Typical of this early poetic style is the popular canvas ambiguously catalogued as *Sacred and Profane Love.*

In his last period, after the age of eighty, he returned to nudes and mythologies. Success, honors, fame, friends, money—these had not spoiled him, and he retained his capacity for steady toil. But the poetic vein of his early years was worked out, and he was now the professional master who had carried craftsmanship to enigmatical splendor. The nudes and myths of the final years are voluptuous things designed for an aristocratic clientele—for dukes, cardinals, and Philip, of Spain, enamored alike of naked legends and sanctities.

This *Venus and Adonis* is one of some ten or twelve versions of an old theme re-worked for the fashionable trade, and one of the best. Titian had no talent for narrative composition, and the story, considered as a dramatic incident, will move no one to breathless excitement. Shakespeare, you will remember, in his hot-blooded youth, treated the story—the goddess of love attempting to detain a comely young hunter—in his most impassioned, not to say erotic, style. To Titian the octogenarian, the subject was only the pretext for stunning nakedness and the modeling of flesh by means of minute gradations of tone. He remarked that he painted flesh in layers according to the plan of nature when she wrapped the body in coverings of skin. With each layer, or coat of paint, lights were intensified, shadows warmed with color, tones fused and blended to produce an ensemble of extraordinary richness. The light seems to radiate from the interior of the forms, the color to penetrate deeply into the solid objects, and the whole to be bathed in atmospheric luster.

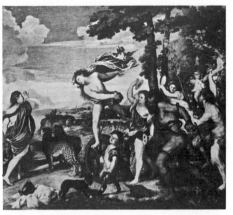

*Bacchus and Ariadne*, National Gallery, London. Oil on canvas, 65″ x 73″, 1523. The wine god in the act of leaping from his chariot to console Ariadne, now forsaken by her false lover, Theseus.

Detail from *Bacchus and Ariadne*, National Gallery, London. 1523.

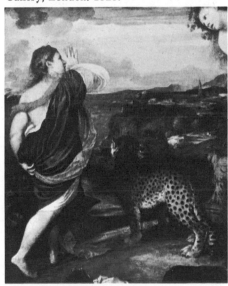

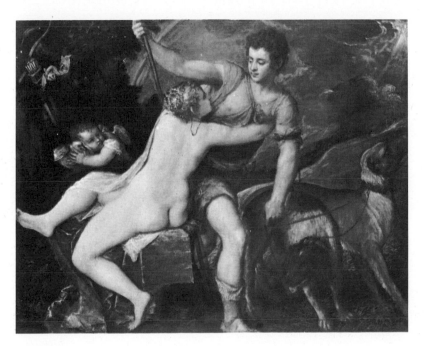

[LEFT] *Venus and Adonis*, Bache Collection, Metropolitan Museum, New York. Oil on canvas, 73″ x 80″, 1554. Color plate, page 89.

# PAOLO VERONESE

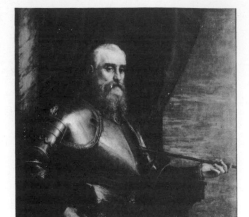

*Portrait of Agostino Barbarigo*, The L. E. Holden Collection, The Cleveland Museum of Art. Oil on canvas, 44½″ x 45¾″, about 1565-1570.

*The Nobleman in Green Silk*, detail from the *Feast in the House of Levi*. Generally accepted as a self-portrait of Veronese, who was brought before the tribunal of the Inquisition on the charge of introducing irreligious elements into the picture. He replied, "When I find a hole in a painting that needs filling up, I put in anything that pleases my fancy."

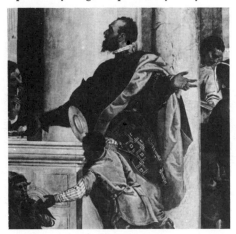

THE maturity of Venetian splendor was celebrated by Paolo Caliari, ordinarily known as Veronese, from Verona, the town of his birth. This artist painted the physical side of man with a truly magnificent touch, filling his religious commissions with portraits and people of his own time for the sake of elegance and display; and creating, with his smoothly rounded forms, his romantic costumes, and palatial settings, an art addressed wholly to the pleasures of sensuous ornamentation. Youth and old age did not enlist his immense facility; he preferred to portray the city of Venice at the culmination of her charms, and to paint men and women at the maximum of their voluptuous development. Changing the golden notes of the earlier artists into crisper tones of gray and silver, Paolo raised ceremonials, allegories, and feastings to a decorative amplitude unattained by any other painter. He loved the healthy, unrestrained atmosphere of Venice: the blond and sportive nudity, the frank enjoyment of good things, the nobles who behaved like nobles, the gorgeous architecture, and the freedom accorded to the artist.

Paolo Veronese painted only a few small pictures; he was at his best in large spaces where, with confounding ease, he composed throngs of characters in an architectural framework. He produced several great paintings of banquets, one of which, *Feast in the House of Levi*, a commission for a monastery, haled him before the tribunal of the Inquisition. Although the monasteries were not averse to joyous representations of sacred themes, in this case, it seems, he had gone too far in his worldliness and in his literal interpretation of Scripture. Taking his text from St. Mark who records that "as Jesus sat at meat in the house of Levi, many publicans and sinners sat also together with Jesus, for there were many and they followed him," the artist brought into the painting, according to the complaint, "fools, drunken Germans, dwarfs, and other oddities," not to mention his friends and other sinners. "I think that Christ was in that house with his Apostles," Paolo answered, "but there were some spaces to be filled, and I adorned them with figures of my own invention." Failing to appease the Holy Office by his explanation, he was reprimanded and ordered to paint, within three months, figures of more circumspection—a mandate he obeyed with his usual generosity of spirit.

*Feast in the House of Levi*, Academy, Venice. Oil on canvas, 18½′ x 42½′, 1573. Color plate, page 90.

# PAOLO VERONESE
### CONTINUED

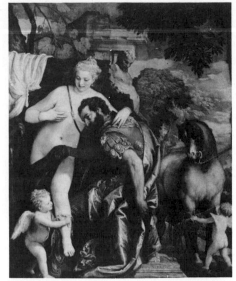

*Mars and Venus*, Metropolitan Museum, New York. Oil on canvas, 81″ x 63⅜″. Color plate, page 91.

THE maturity of Venetian splendor was celebrated by Paolo Caliari, ordinarily known as Veronese, from Verona, the town of his birth. This artist painted the physical side of man with a truly magnificent touch, filling his religious commissions with portraits and people of his own time for the sake of elegance and display; and creating, with his smoothly rounded forms, his romantic costumes, and palatial settings, an art addressed wholly to the pleasures of sensuous ornamentation. Youth and old age did not enlist his immense facility; he preferred to portray the city of Venice at the culmination of her charms, and to paint men and women at the maximum of their voluptuous development. Changing the golden notes of the earlier artists into crisper tones of gray and silver, Paolo raised ceremonials, allegories, and feastings to a decorative amplitude unattained by any other painter. He loved the healthy, unrestrained atmosphere of Venice: the blond and sportive nudity, the frank enjoyment of good things, the nobles who behaved like nobles, the gorgeous architecture, and the freedom accorded to the artist.

Paolo Veronese painted only a few small pictures—in his *Mars and Venus*, comparatively modest in size, the figures are larger than life—and was at his happiest in huge spaces, where, with confounding ease, he composed throngs of characters within an architectural framework. The *Mars and Venus*, ostensibly mythological in subject matter, was only a pretext for the uninhibited expression of his abounding paganism. The subject has no realistic validity, no basis in everyday experience, for not even in Venice did an artist encounter, ready to hand, the essential ingredients of classical allegory. But as the embodiment, not only of the painter's specific preferences in opulence but also of the Venetian ideal, the picture is pre-eminently truthful. Technically, it is so astounding, so close indeed to perfection, that no reproduction can do much more than fill the beholder with a desire to see the original. The beautifully modeled Venus with the yellow-gold hair, the submissive, formidable Mars, the playful Cupid, the gorgeous coloring and the little studio horse—all these, in conjunction, produce a form of painting the hedonic majesty of which may never be seriously contested.

A detail from *Adoration of the Magi*.

[RIGHT] *Adoration of the Magi*, one of several versions of the subject which is treated with a decorative splendor that is more Venetian than biblical.

[LEFT] *Madonna and Child*, another detail from the *Adoration of the Magi*.

# TINTORETTO

1518–1594    VENETIAN SCHOOL

*Presentation of the Virgin*, Santa Maria dell' Orto, Venice. Oil on canvas, 169" x 189", about 1552. Color plate, page 92.

Detail from the *Presentation of the Virgin*. A prophetic figure, painted with remarkable spontaneity, emphasizes a line of cripples and beggars seeking comfort in the glory of the Consecration.

THE Venetians called Tintoretto the "Thunderbolt" because of his terrible energy and frightening impulsiveness. He was not unconscious of his supreme strength; he knew precisely what could be done under given conditions and he was not a man of dilatory habits. He was one of the world's most prolific painters, his enormous works, in area, amounting to ten times the product of Titian's fertile brush—his *Paradise*, in the Ducal Palace, completed when he was seventy, measures seventy-five by thirty feet and contains five hundred figures! Many of his pictures, owing to rapidity of execution, are marred by inferior parts and by deteriorations in color; but judged by his best work, a vast quantity of which survives in good condition, he remains one of the most original and astounding painters of all time.

Tintoretto is the great draftsman of the Venetian school, the only painter rivaling the Florentines in monumental design; and it may be said with justice that what Michelangelo accomplished with the single figure, he accomplished with groups of figures. His range was as remarkable as his energy; he painted all sorts of historical and mythological subjects, innumerable portraits, and many religious themes, and in the best of them we find a deeper humanity than in the works of the other Venetians.

When Titian represented the Virgin appearing before the high priest to be consecrated, he painted a sumptuous decoration—a parade; Tintoretto, a born dramatist with a mind that went straight to the heart of a situation, painted the scene as if he had been an eyewitness of the dedication of the young girl's life to the service of God. He chose the moment of highest effectiveness: the little Virgin silhouetted against the sky, and observed from below by three mothers and their children, with a row of cripples and beggars, at the left, to symbolize the forthcoming redemption. Always audacious, he designed the picture on a recessional plan, and flooded it with startling lights. By his ability to compose groups of figures in a world of three dimensions, and by his mastery of light and movement, Tintoretto gave a greater impetus to the modernization of painting than any other Venetian, and his influence has been transmitted by the Spanish, Flemish, and French schools to artists of the present time.

[RIGHT] *Flight into Egypt*, Scuola di S. Rocco, Venice. Oil on canvas, 166" x 228½", about 1583-1587. The Holy family pauses at sunset in a landscape that is idyllic in contrast to the agitated background of *St. George Killing the Dragon.*

# TINTORETTO
CONTINUED

JACOPO ROBUSTI's father was a dyer—hence the son's nickname, Tintoretto, or "the little dyer." As a boy, Tintoretto showed such pronounced aptitude for art that he was received by Titian as a pupil, but at the end of ten days was sent home, once for all. The story is that the master, then in his fifty-sixth year, dismissed the dyer's son in a fit of jealousy; but it is more reasonable to suppose that when he had observed the originality and independent spirit of the boy, he decided that it would be impossible to discipline him. Whatever the issue, they parted company, and thereafter, Titian was never known to say a good word about the rising young artist.

Tintoretto was a man of simple and regular habits, happily married, the father of seven children, and a most agreeable companion. He seldom traveled out of Venice, could not be lured into fashionable society, minded his own business, and took no nonsense from anyone, not even Aretino, Titian's publicity man, whom—it is said—he drove from his studio at the point of a gun. When not employed on some colossal decoration, he locked himself in his workshop, surrounded by plaster casts and ingenious contrivances of his own invention, including wax models, lighting apparatus, and musical instruments. At the beginning of his career, he exasperated his competitors by accepting commissions for next to nothing, and by submitting, instead of cartoons, enormous, full-size paintings which could not well be rejected.

The Venetians said that Tintoretto had three pencils: one of gold, one of silver, and one of iron. He could be tempestuous and overwhelming in his larger works, but in more intimate vein, he was capable of lyrical tenderness and charm. At the age of sixty, he painted for the Doges' Palace four mythological scenes in which the nude is used with a decorative quality unsurpassed in art. The lightness and incomparable grace of the floating Venus as she bestows the chaplet and ring on Ariadne, the health and silvery splendor of the three figures, the absence of sensual languors and emphasized seductions, the flowing design, the dignity and grandeur of the nude bodies—these are the attainments of a great master. John Addington Symonds said of the *Bacchus and Ariadne* that it is "if not the greatest, at any rate, the most beautiful picture in existence."

*Bacchus and Ariadne*, Ducal Palace, Venice. Oil on canvas, 57½" x 61¾", 1578. Color plate, page 93.

*St. George Killing the Dragon*, National Gallery, London. Oil on canvas, 62" x 39", about 1555. A scene made dramatic by the impetuous action of figures and animals alike, and by the visionary landscape which seems to be alive.

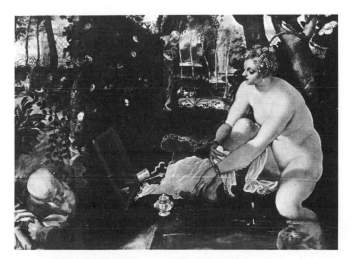

[LEFT] *Susanna and the Elders*, Gemäldegalerie, Vienna. Oil on canvas, 56½" x 75½", about 1560. Combining in perfect harmony most of the elements of great painting: an incomparable nude, full-figured yet light and chaste; a balancing landscape, and small objects delineated with the artist's "affection for reality," as he called it.

# TINTORETTO

*Nativity*, Scuola di S. Rocco, Venice. Oil on canvas, 213″ x 173″, 1576-1580. The second scene in the artist's story of Christ, and like no other version of the event—not overborne by suffering and not overornamented in the Venetian style.

THE Venetians as a school were not dramatic painters. They were concerned with the stateliness and processional splendor of life, not with the agonies and oppositions—the conflicts besetting the courage and frailties of man. Their splendor was troubled and their stability of mood violently unsettled by the appearance of Tintoretto, who burst upon them like an exploding shell, in much the same fashion as his saint descended upon the executioners in his *Miracle of St. Mark*. He was essentially a dramatist, an artist of Shakespearean instincts and capacities, with the power to create illusions of action, to make imagined scenes as real as direct experiences. When he sinned, it was in the grand manner, on the side of redundancy and with the rhetorical gestures accompanying great pictorial genius. But he was always the artist: unconcerned about public opinion, above virtuosity and the rendering of the human body to exhibit a knowledge of the nude; and in the words of Ruskin, "He never put people in hell, as did Michelangelo, because they found fault with his work."

Tintoretto considered the subject of each picture as a new adventure in life —an event unfolding before his eyes and demanding its own design and method. He was a religious man in a city not exactly noted for piety, and when the Reformation was shaking Italy and destroying the old tradition of art, he mustered all his powers of anatomical design in defense of the Catholic conception of following Christ.

The *Miracle of St. Mark*, one of his masterpieces, was painted in his thirtieth year. The subject was taken from the story of a Christian slave in Alexandria, who was condemned to death by his pagan master for praying at the shrine of St. Mark; while the sentence was being carried out, the saint descended from heaven and shattered the torturing instruments of the executioners. It was a subject on which Tintoretto could lavish the whole of his dramatic equipment: his ability to paint the human figure convincingly in attitudes which could not be observed in nature; his seizure of the most exciting instant in the episode when the eyes of the spectators were concentrated on the prostrate body; and by the aid of flashing, golden lights and the grouping of the figures, his power to communicate a sense of terrifying reality to a miraculous event.

Detail of the Virgin Mary from the *Nativity*. Painted to be seen at a distance, in loose, telling strokes.

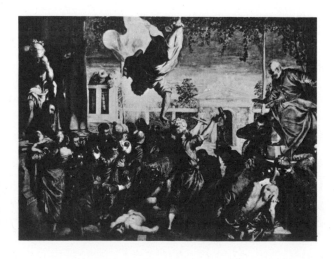

[RIGHT] *Miracle of St. Mark*, Academy, Venice. Oil on canvas, 162½″ x 214″, 1548. Color plate, page 94.

# CARAVAGGIO

THE son of a Lombard stonemason, known historically as Caravaggio from his home town, was a born painter and in addition to his birthright, was endowed with fighting courage and a clear-eyed, uninhibited, original way of looking at the world. He studied art in Milan, learned something of the luminosity of Titian's final style, and went to Rome to make his fortune. This he accomplished in a succession of brawls and contests, none of them in the nature of constitutional belligerency but to prove the masculinity of his calling and the validity of his point of view. The Renaissance had ended, and Italy was divided into two camps: the Mannerists who expounded the more obvious qualities of Michelangelo and Raphael, and the Eclectics who sought to make a new art by combining the best elements of their predecessors.

"A hell on both your houses!" the young Lombard shouted defiantly, and proceeded at once to build a new structure. He would paint, he said, from everyday experiences, and his experiences included trafficking with the lower orders of society—fortune-tellers, gypsies, strolling players, and shady characters of all sorts; and he would paint saints and martyrs as if they were his boon companions and not studio idealizations. He spoke with the authority of a great artist before he was twenty-five and became the leader of a new school generally known as realists, or naturalists—a school nothing less than revolutionary, with an influence running from Ribera and the Spaniards to Rembrandt and Hals, and from Courbet and Manet to the "ash-can" school of the Americans. Caravaggio killed a man in a duel, escaped from prison, and in attempting to return from Naples to Rome on foot, died of sunstroke in the burning summer heat.

He was a man of simple reverence and strong religious convictions, but he was weary of the worn-out conventions of religious art, and all art, and by substituting his own first-hand observations, brought painting down to realities. He adhered to the classical form of composition but invented his own lighting effects, placing his figures in dark rooms and throwing a trap-door or ceiling spotlight upon them in order to gain the maximum intensities of chiaroscuro. His *The Calling of Saint Matthew*, executed in his twenty-fourth year, is one of three pictures dealing with the life of the saint, an incident caught at its most dramatic moment when Christ enters the room to issue the divine command.

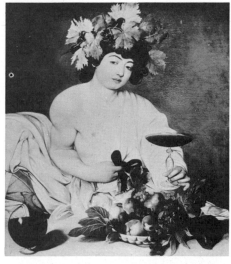

*Youthful Bacchus*, Uffizi, Florence. Oil on canvas, very early, about 1592. Plainly a *tour de force* to display the artist's incredible facility. The piece of still-life, in technical brilliancy, has seldom been equaled.

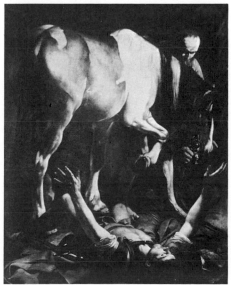

*Conversion of St. Paul*, Santa Maria del Popolo, Rome. Oil on canvas, 90″ x 69″, about 1601. Presented without a trace of idealism and in the artist's conviction that he could paint biblical scenes more veraciously by making the characters everyday people.

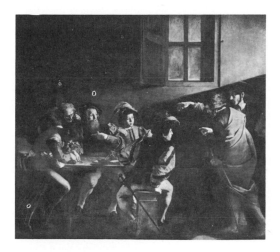

[LEFT] *The Calling of St. Matthew*, Church of San Luigi dei Francesi, Rome. Oil on canvas, 129″ x 137″, about 1593. Color plate, page 95.

# FRANCESCO GUARDI

1712–1793                                    VENETIAN SCHOOL

*The Piazzetta, Venice,* Collection Wadsworth Atheneum, Hartford. Oil on canvas. Color plate, page 96.

Pen and sepia drawing for *The Piazzetta, Venice.* A fine specimen of the delicacy and architectural sureness of Guardi's sketches.

FRANCESCO GUARDI died a few years before Napoleon strangled and ruined the city of pleasure. But in Guardi's lifetime, Venice had surrendered most of her glories to procurers and foreign mercenaries. Her proud and cultivated sensuality which, in the days of meridian prosperity, had been kept free from debauchery, had fallen into viciousness and decay, and the city was known politely as the brothel of Europe. In spite of the disintegration, the legendary Venice lived on, the "dream city," as Turner called her, the midnight hunting-ground of Lord Byron, the trysting place of fortunate lovers, and the goal of all travelers. And the legendary Venice, in the face of all that has happened to Italy, lives today in the imaginations of artists and romantic sightseers the world over.

Guardi was the first artist of prominence to paint Venice from the point of view of the sightseer. He had an eye for the picturesque—for palaces enveloped in colored mists, for architectural effects, and the Grand Canal at the end of day. He set the example for the endless procession of painters from Turner to Whistler and the modern amateurs who have gone to Venice to study the wonders of light and atmosphere, and to paint the gorgeous embroidery of the old buildings.

But Guardi had a signal advantage over the average sightseer: he knew his city and he had the leisure and the artistry to discover arresting scenes which escaped the eye of tourist-painters at the mercy of guides. He was, in a way, a landscape painter. In a floating studio erected on an old gondola, he moved from canal to canal, sketching and painting in the open air. He was not a student of atmospheric tones, nor did he paint the intensities of natural light in the manner of Constable; but he consciously aimed at swift, instantaneous impressions of his city, and to a certain extent, approximated the evanescent lights and broken tones of the modern impressionists. Guardi produced more sensational pictures but none of more sterling merit than *The Piazzetta.* The perspective of the view was violated to include more architecture, but the general effect is one of unstudied accuracy. It is a souvenir of Venice, the first of its kind, painted with taste and tact; it is an example of Venetian local color that has outlived the perennial flow of sentimental pictures inspired by the dream city.

*View of Venice,* Fogg Museum of Art, Cambridge, Massachusetts. With an eye extraordinarily sensitive to natural phenomena and with a certainty of placement, Guardi opened the door to modern Impressionism.

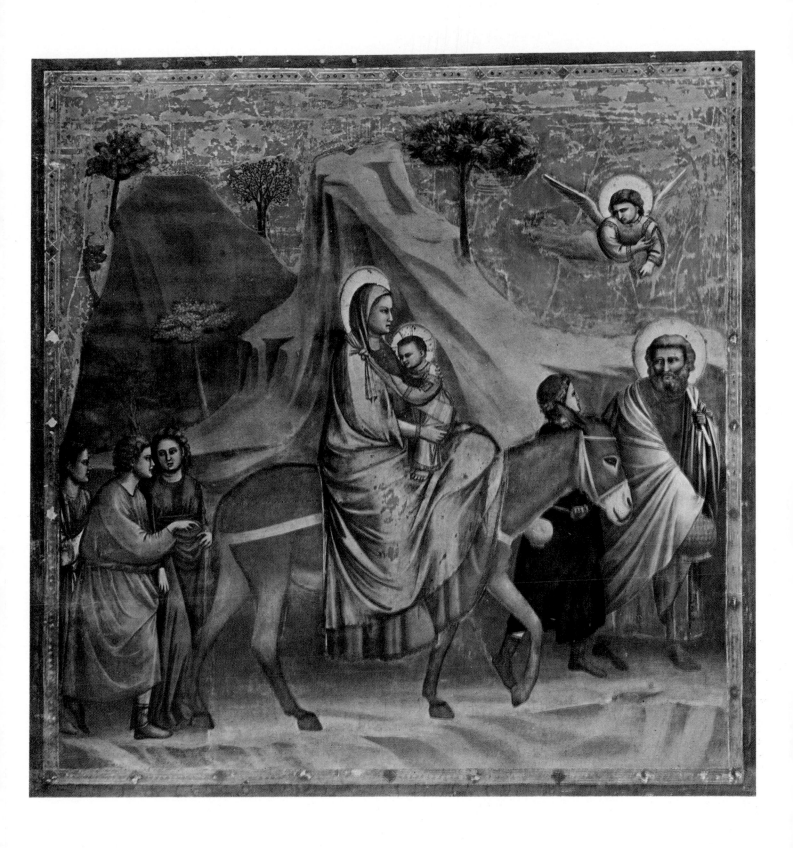

1. *The Flight into Egypt* · GIOTTO · Arena Chapel, Padua. Text, page 1.

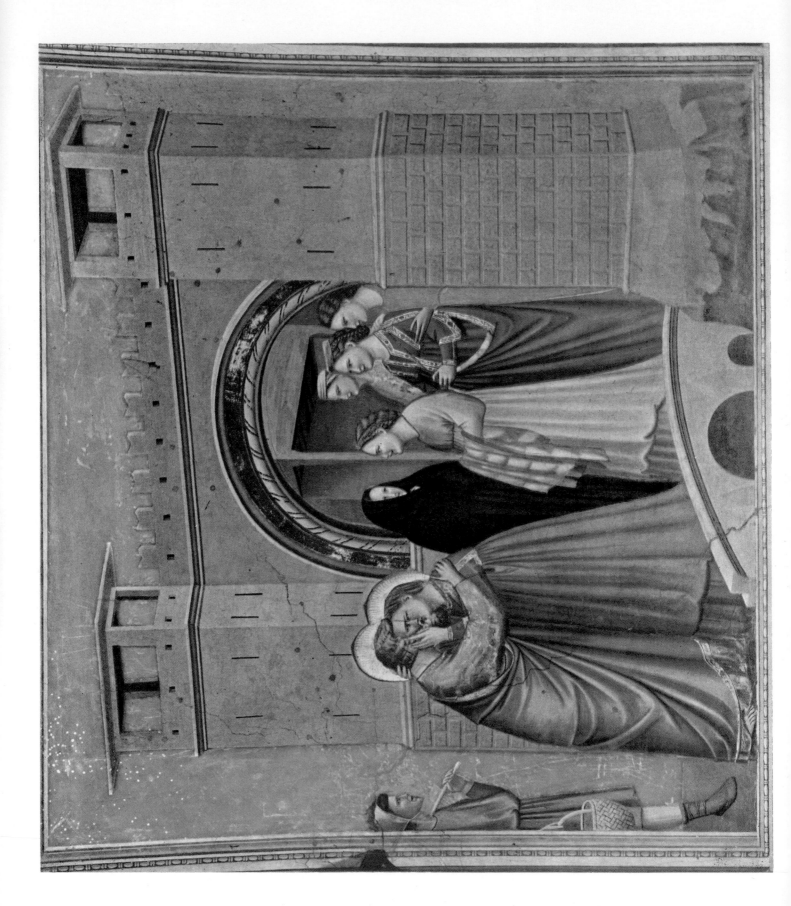

2. *The Meeting of Joachim and Anna* · GIOTTO · Arena Chapel, Padua. Text, page 2.

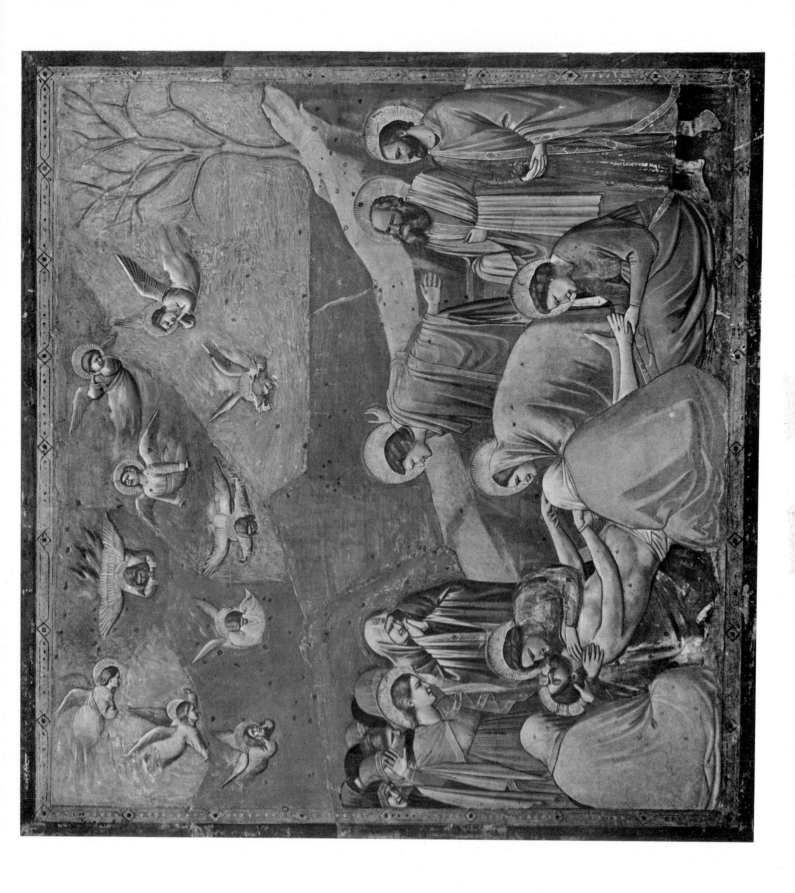

3. *The Deposition* · GIOTTO · Arena Chapel, Padua. Text, page 3.

· 51 ·

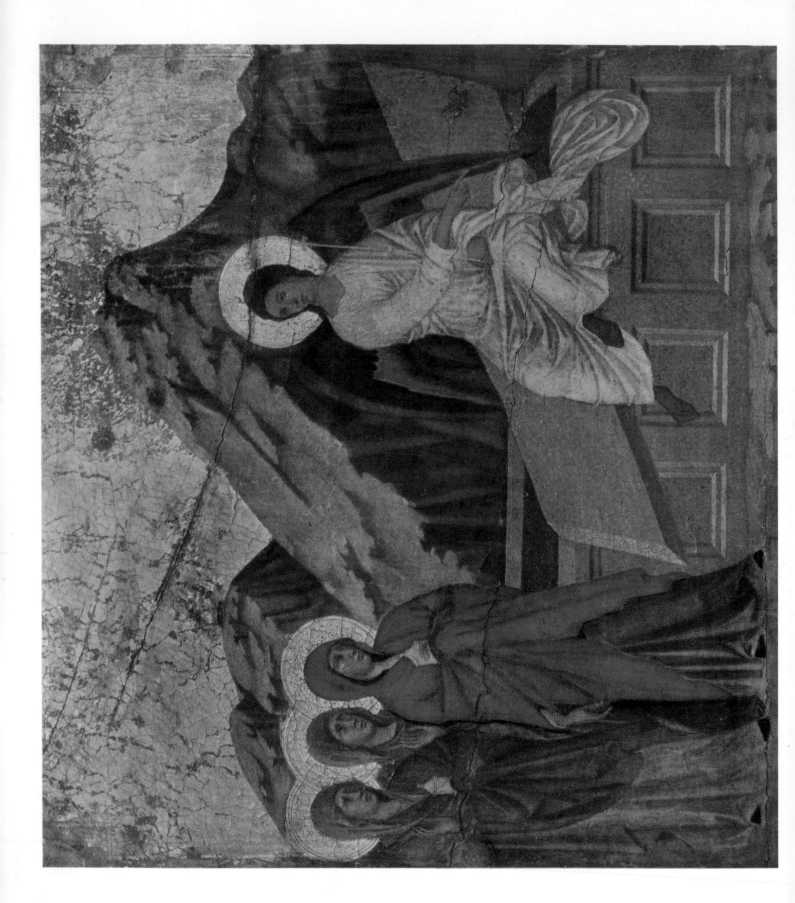

4. *The Marys at the Tomb* · DUCCIO DI BUONINSEGNA · Opera del Duomo, Siena. Text, page 4.

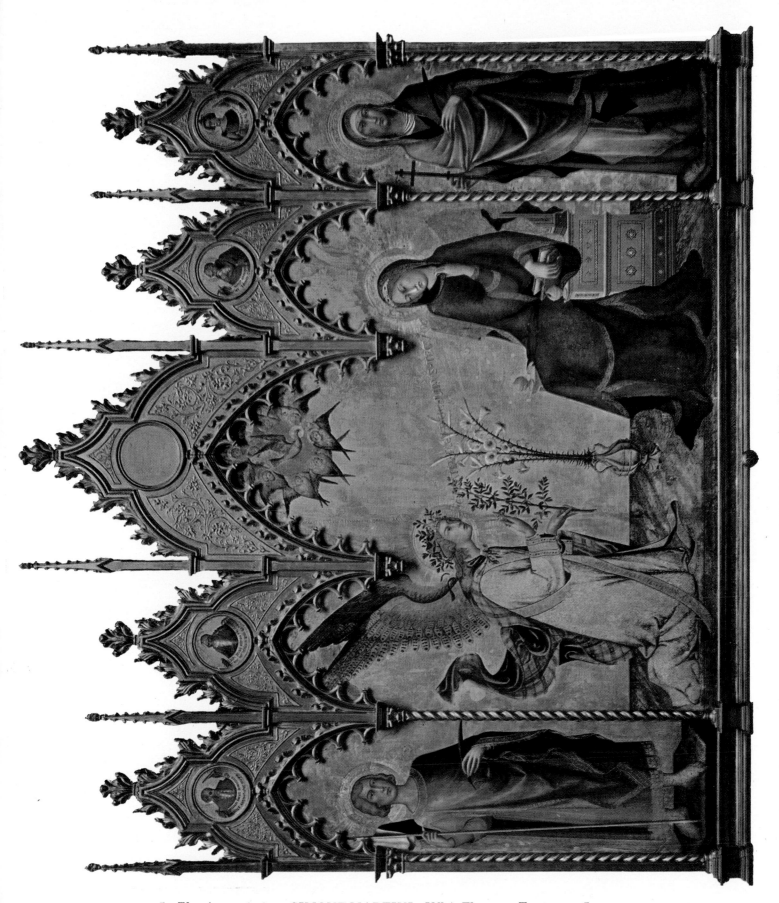

5. *The Annunciation* · SIMONE MARTINI · Uffizi, Florence. Text, page 5.

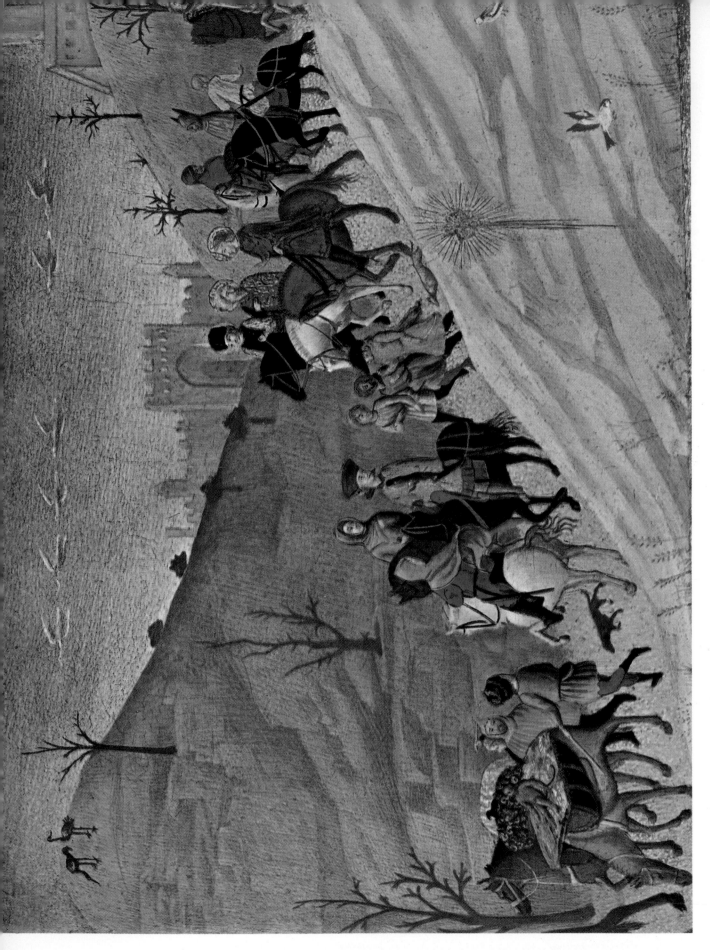

6. *Journey of the Magi* · SASSETTA · Metropolitan Museum, New York. Text, page 6.

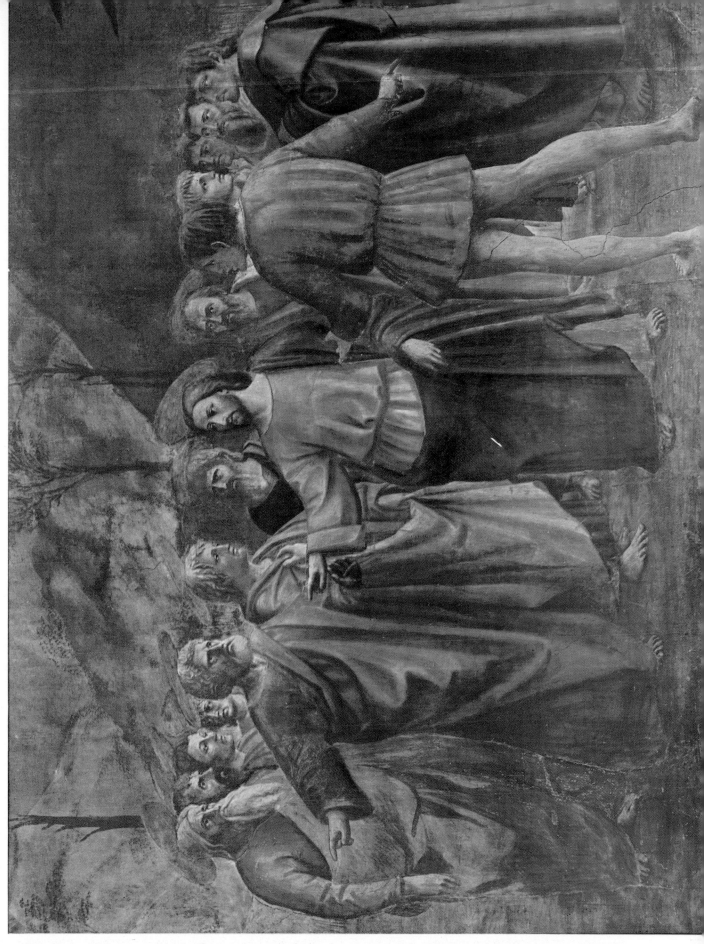

7. *The Tribute Money* · MASACCIO · Brancacci Chapel, Church of the Carmine, Florence. Text, page 8.

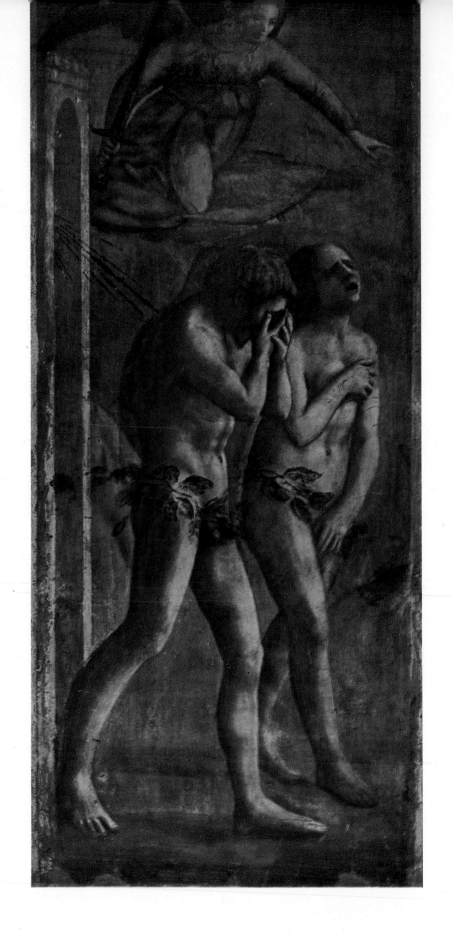

8. *The Expulsion of Adam and Eve* · MASACCIO · Brancacci Chapel, Church of the Carmine, Florence. Text, page 7.

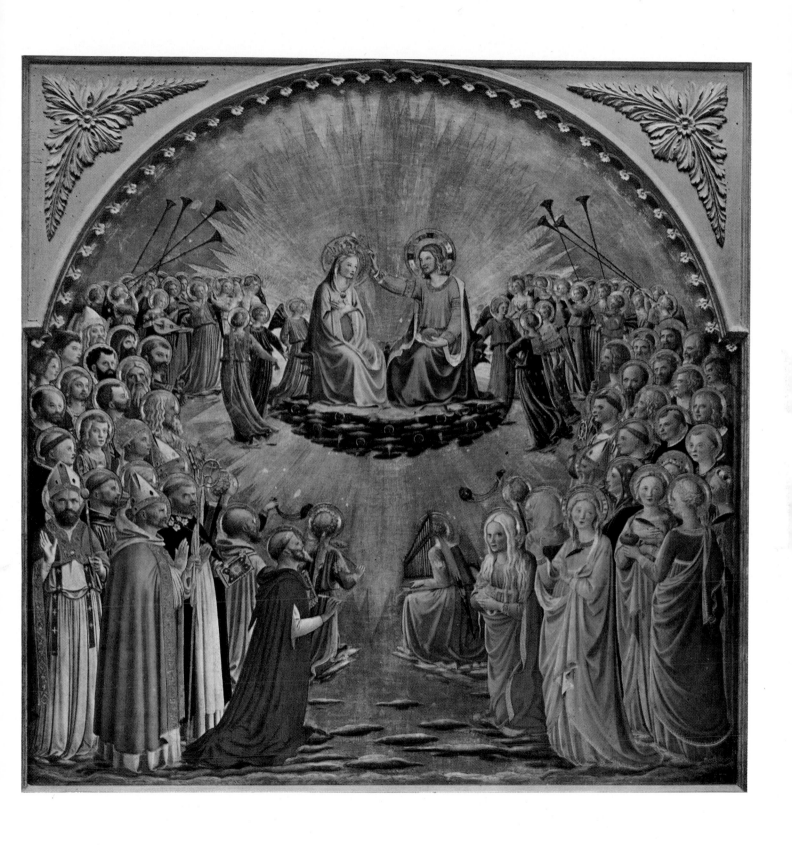

9. *The Coronation of the Virgin* · FRA ANGELICO · San Marco, Florence. Text, page 9.

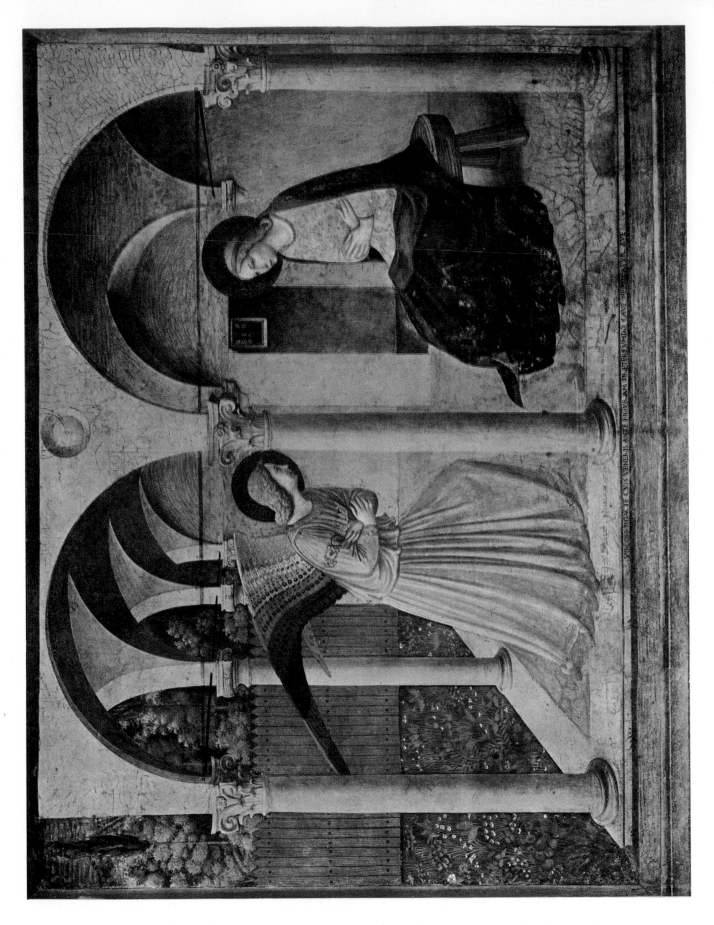

10. *The Annunciation* · FRA ANGELICO · San Marco, Florence. Text, page 10.

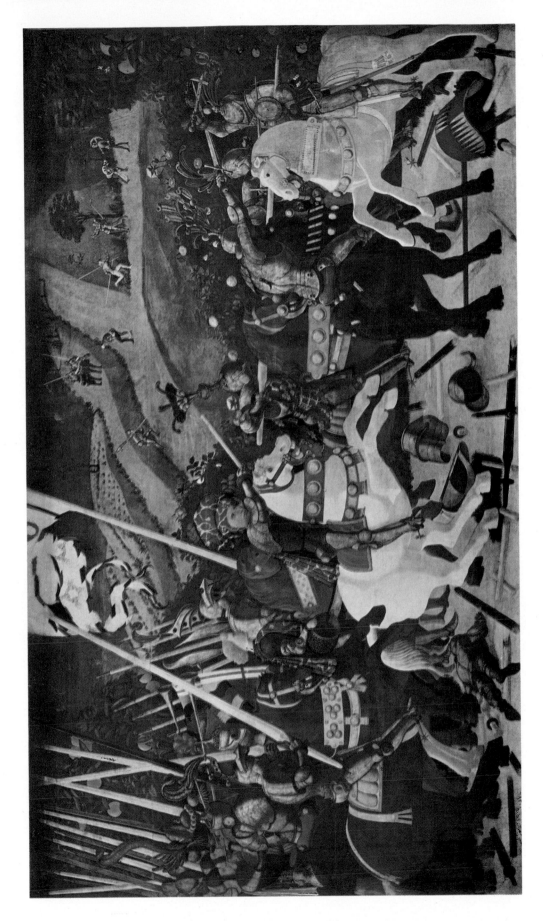

11. *The Rout of San Romano* · PAOLO UCCELLO · National Gallery, London. Text, page 11.

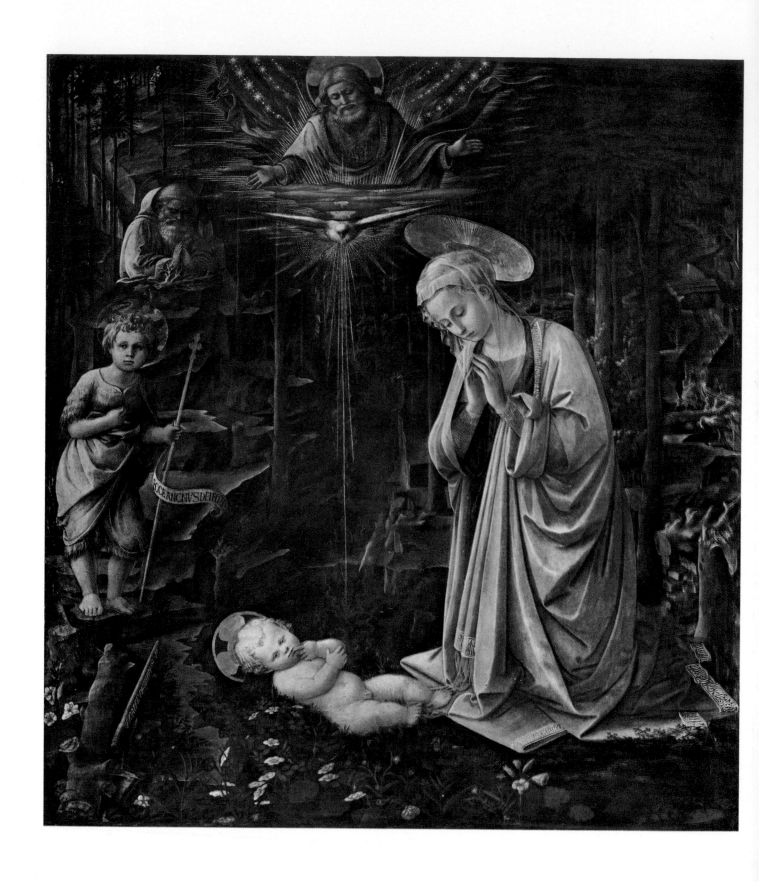

12. *Virgin Adoring the Child* · FRA FILIPPO LIPPI · Kaiser Friedrich Museum, Berlin. Text, page 12.

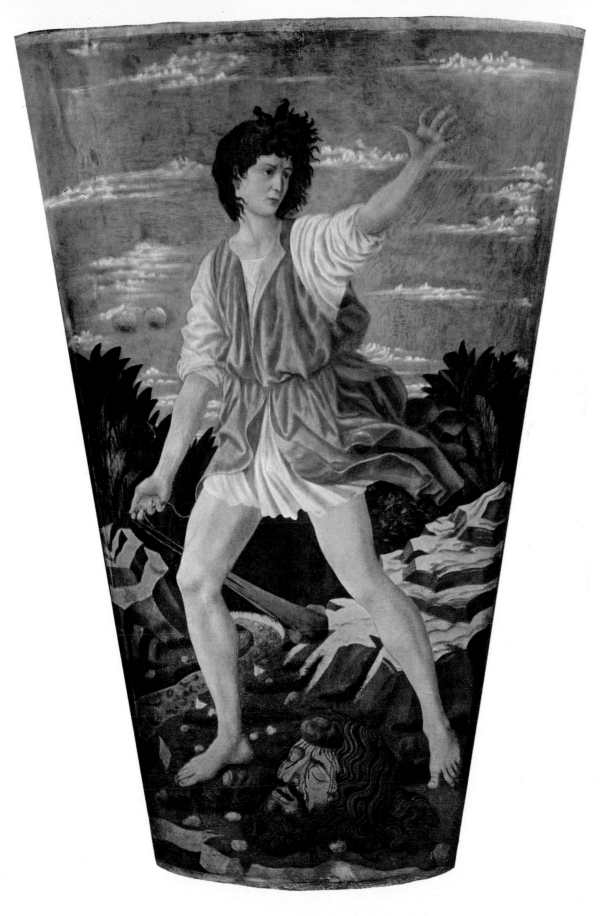

13. *David* · ANDREA DEL CASTAGNO · National Gallery, Washington, D. C. Text, page 13.

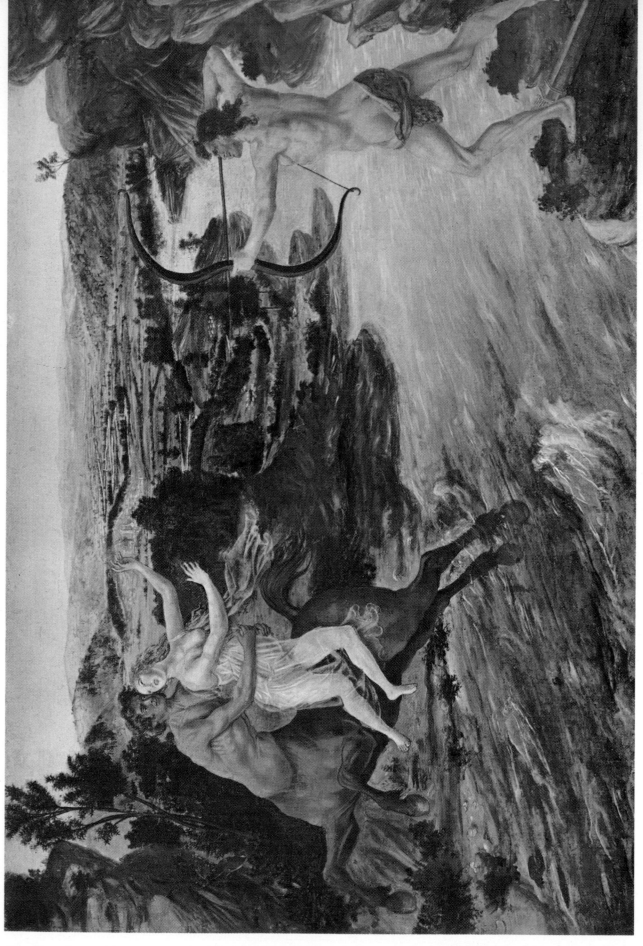

**14.** *Hercules and Nessus* · ANTONIO POLLAIUOLO · Gallery of Fine Arts, New Haven. Text, page 14.

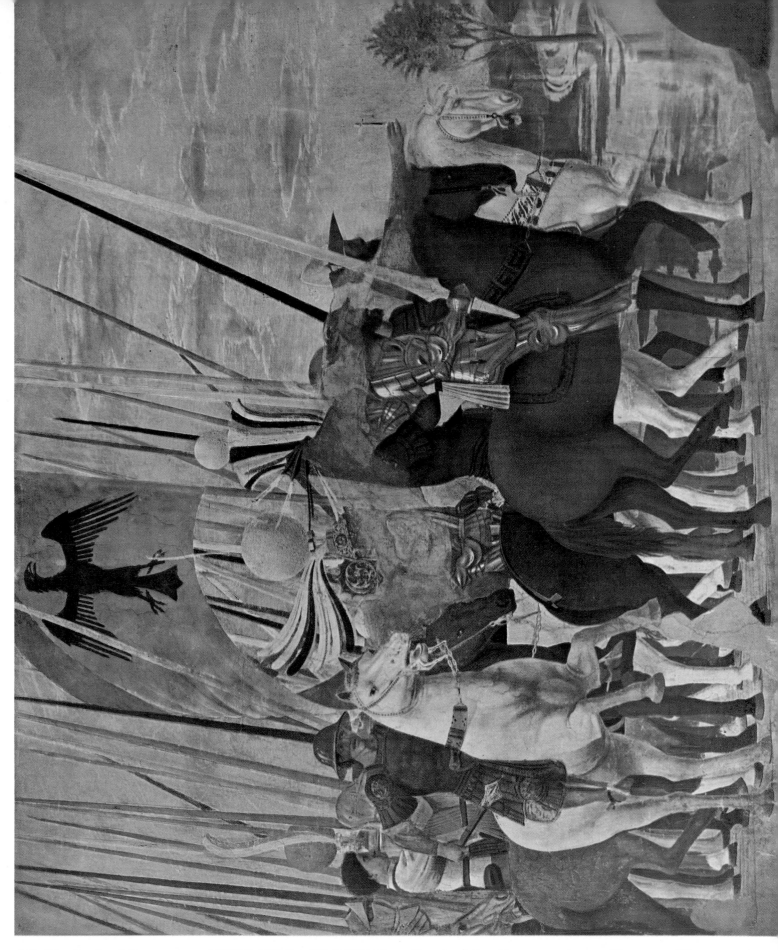

15. *The Battle of Constantine* · PIERO DELLA FRANCESCA · Church of San Francesco, Arezzo. Text, page 15.

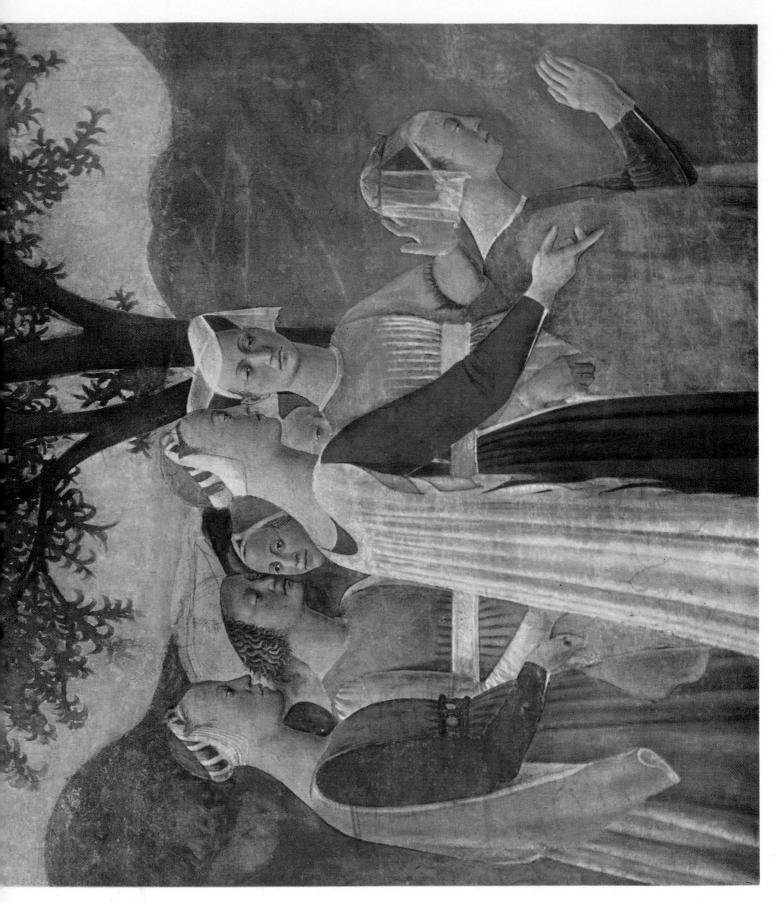

16. *The Queen of Sheba* · PIERO DELLA FRANCESCA · Church of San Francesco, Arezzo. Text, page 16.

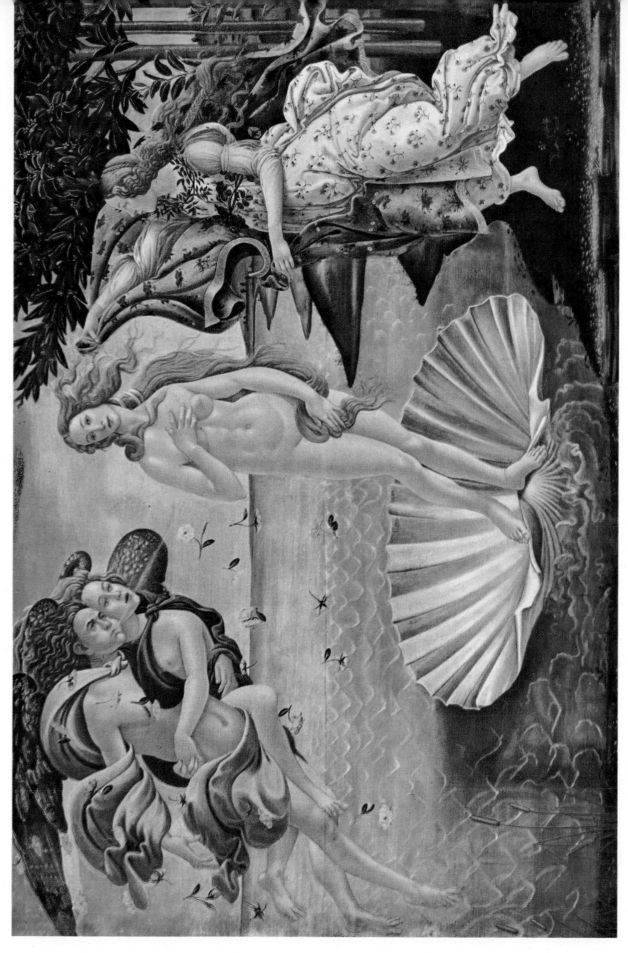

17. *The Birth of Venus* · SANDRO BOTTICELLI · Uffizi, Florence. Text, page 18.

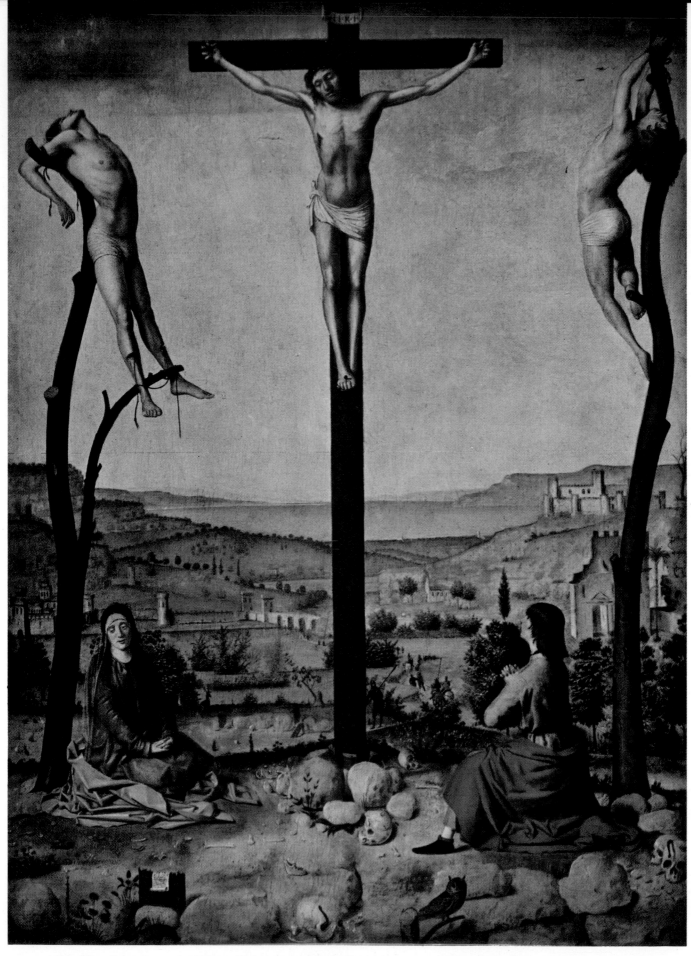

18. *The Crucifixion* · ANTONELLO DA MESSINA · Museum of Fine Arts, Antwerp. Text, page 17.

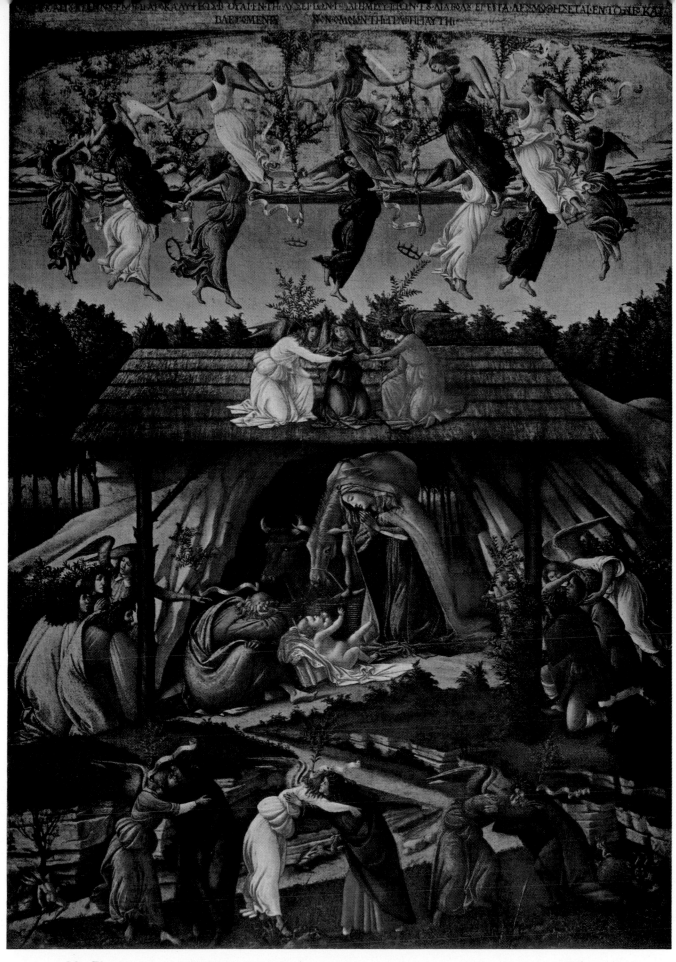

19. *The Nativity* · SANDRO BOTTICELLI · National Gallery, London. Text, page 19.

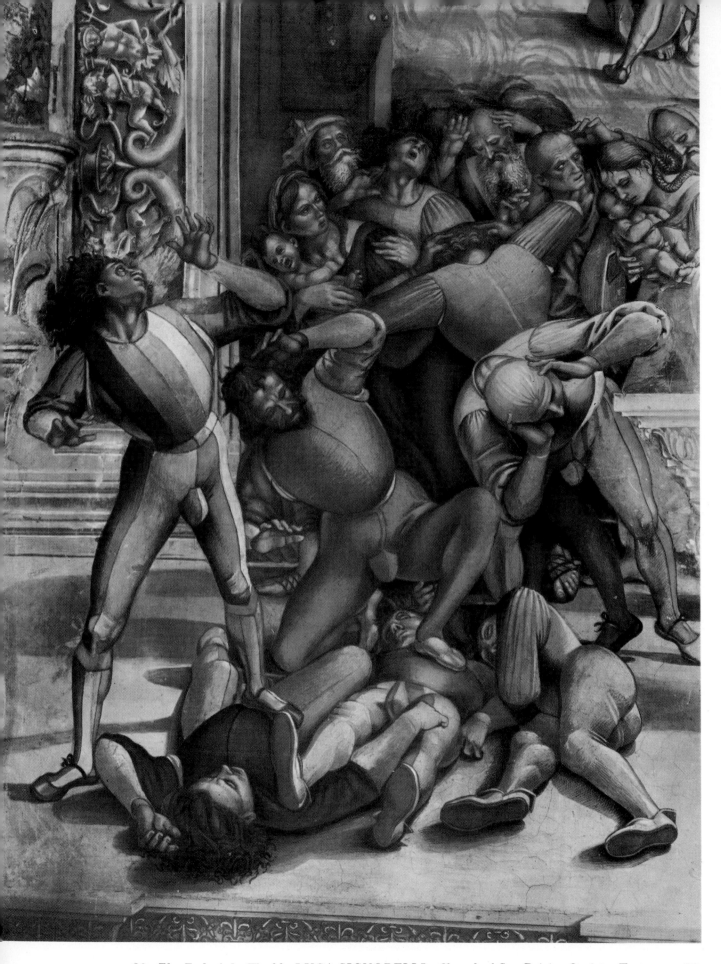

20. *The End of the World* · LUCA SIGNORELLI · Chapel of San Brizio, Orvieto. Text, page 20.

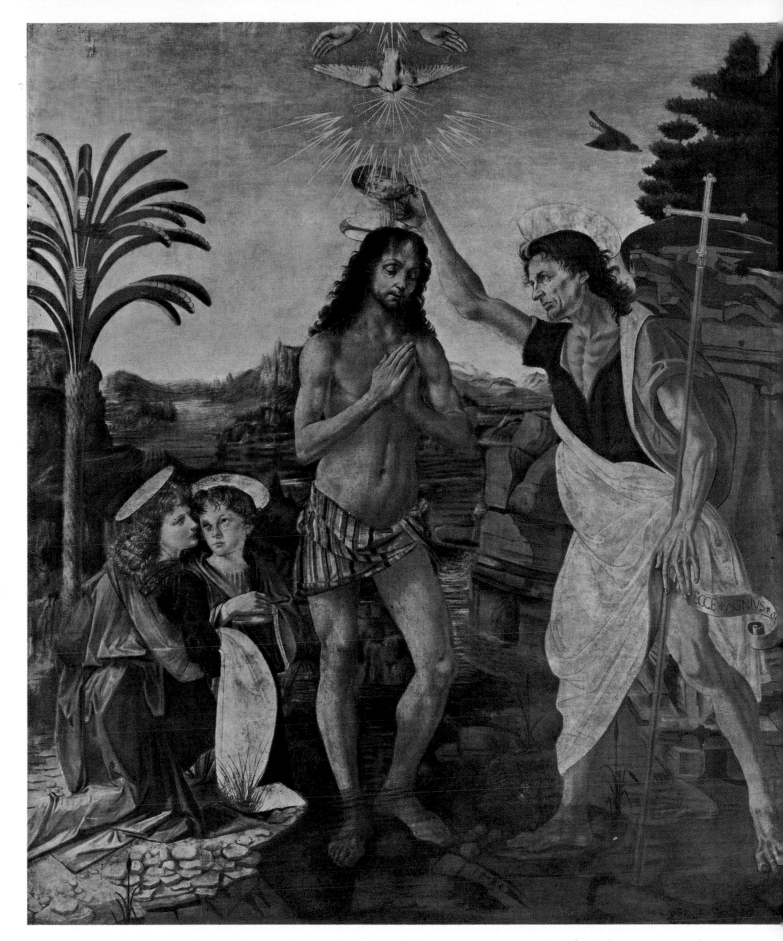

21. *The Baptism of Christ* · ANDREA DEL VERROCCHIO and LEONARDO DA VINCI · Uffizi, Florence. Text, page 21.

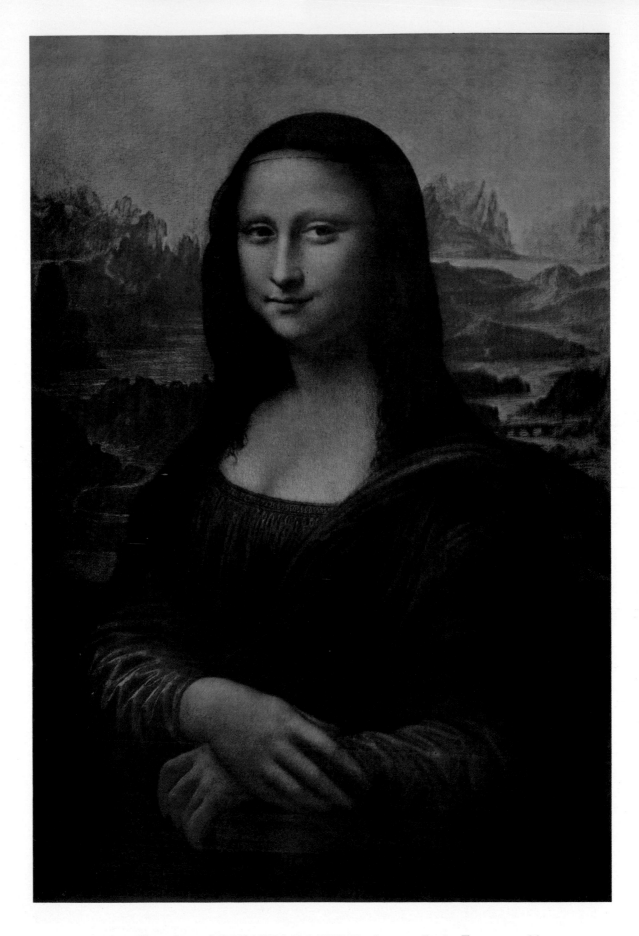

22. *Mona Lisa* · LEONARDO DA VINCI · Louvre, Paris. Text, page 22.

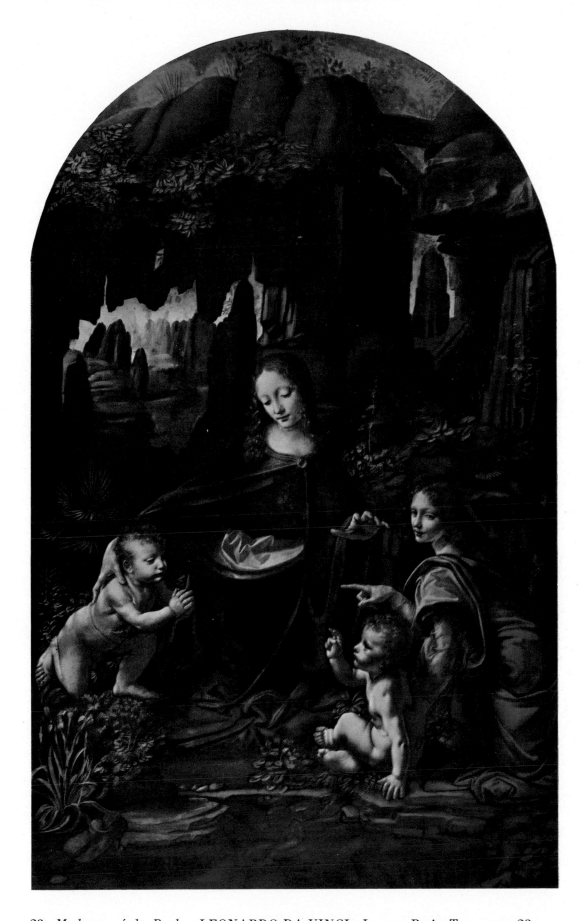

23. *Madonna of the Rocks* · LEONARDO DA VINCI · Louvre, Paris. Text, page 23.

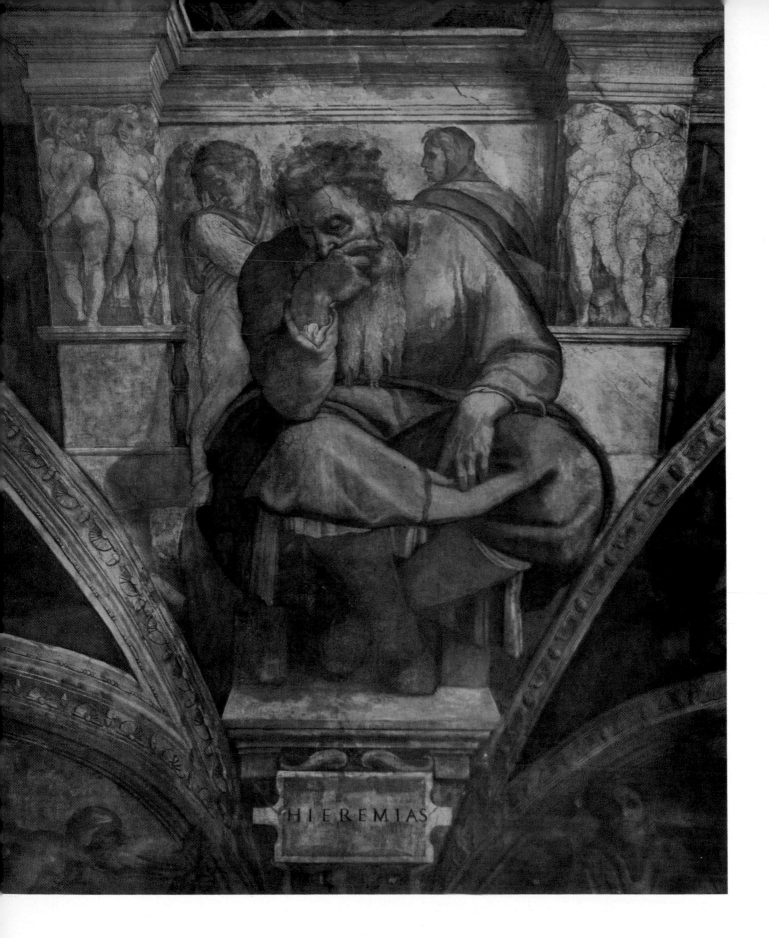

HIEREMIAS

24. *Jeremiah* · MICHELANGELO BUONARROTI · Sistine Chapel, Rome. Text, page 24.

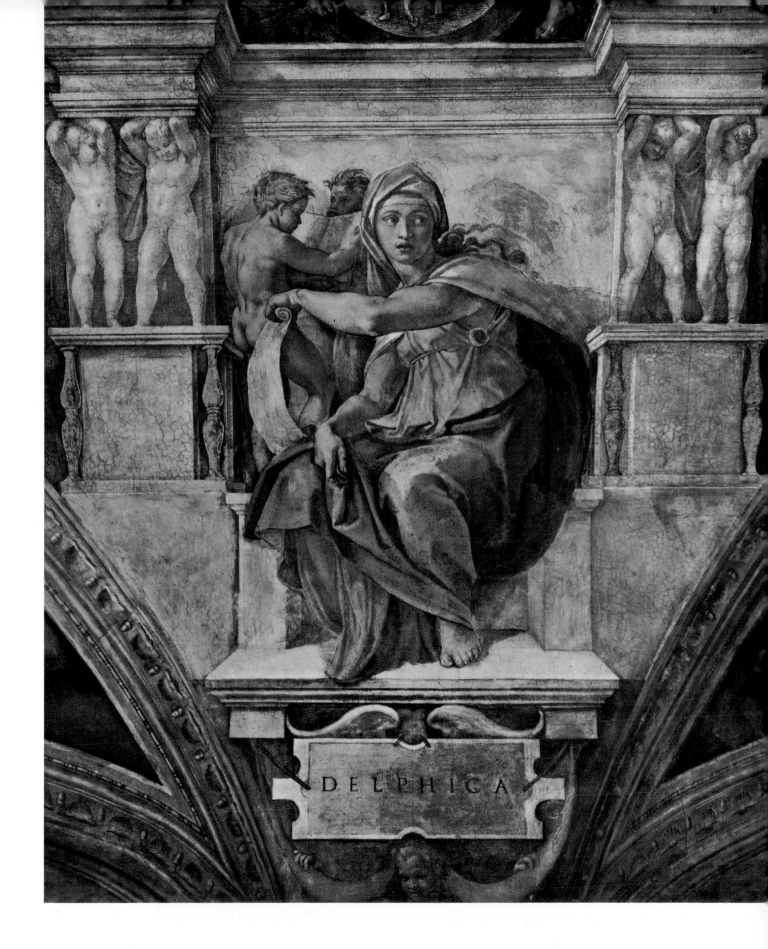

25. *Delphic Sibyl* · MICHELANGELO BUONARROTI · Sistine Chapel, Rome. Text, page 25.

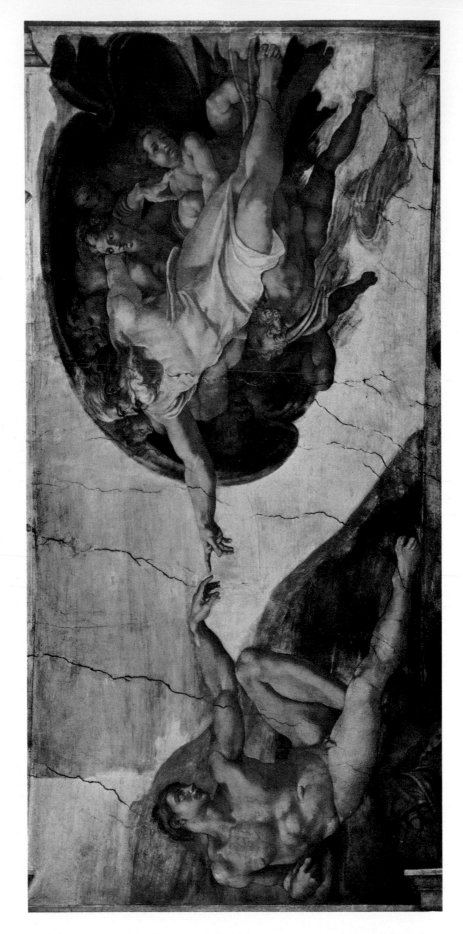

26. *Creation of Adam* · MICHELANGELO BUONARROTI · Sistine Chapel, Rome. Text, page 26.

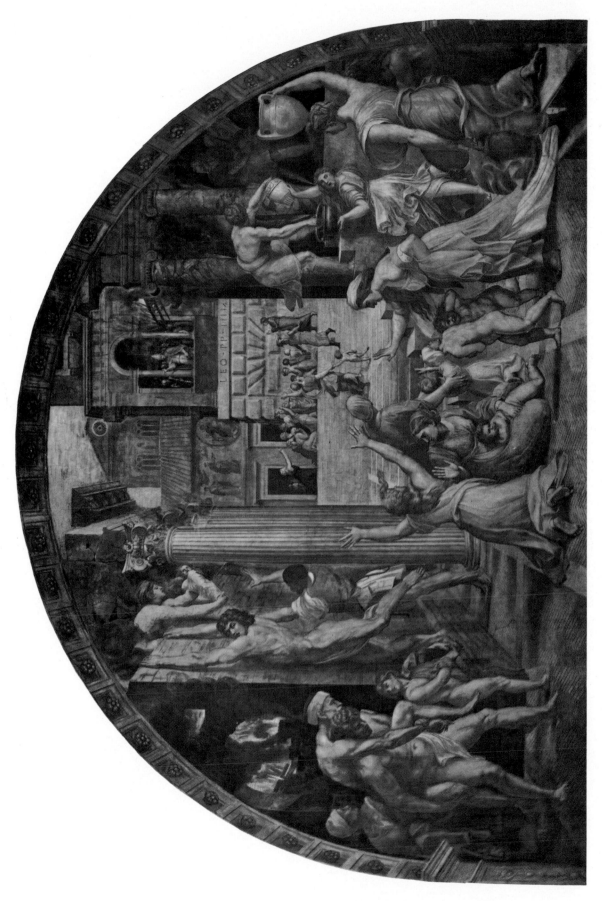

27. *The Fire in the Borgo* · RAPHAEL · Vatican, Rome. Text, page 28.

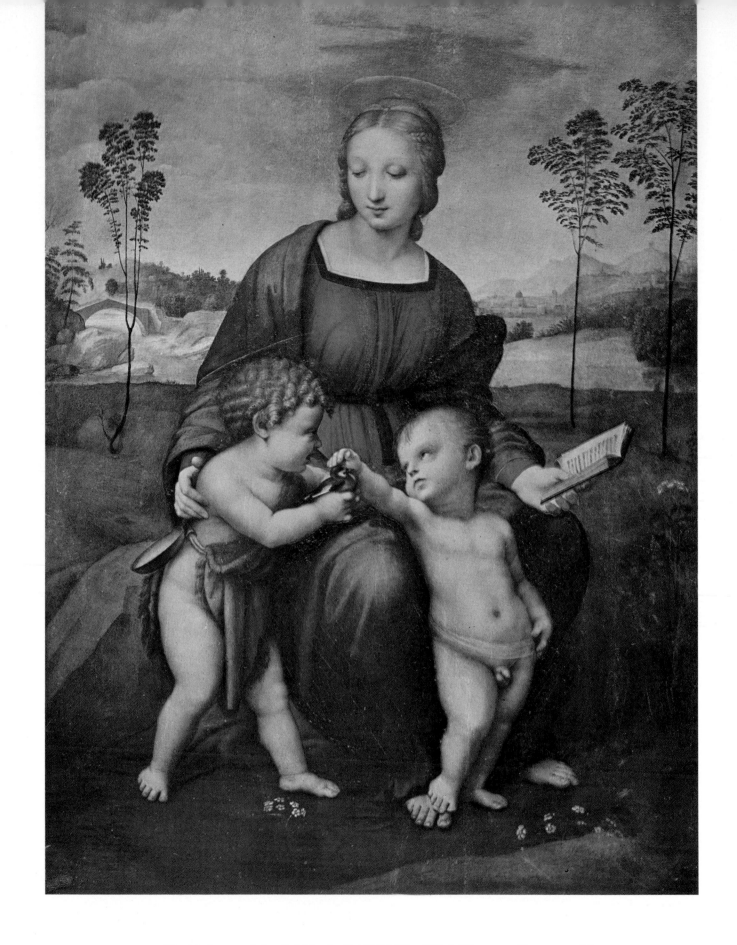

28. *Madonna of the Goldfinch* · RAPHAEL · Uffizi, Florence. Text, page 27.

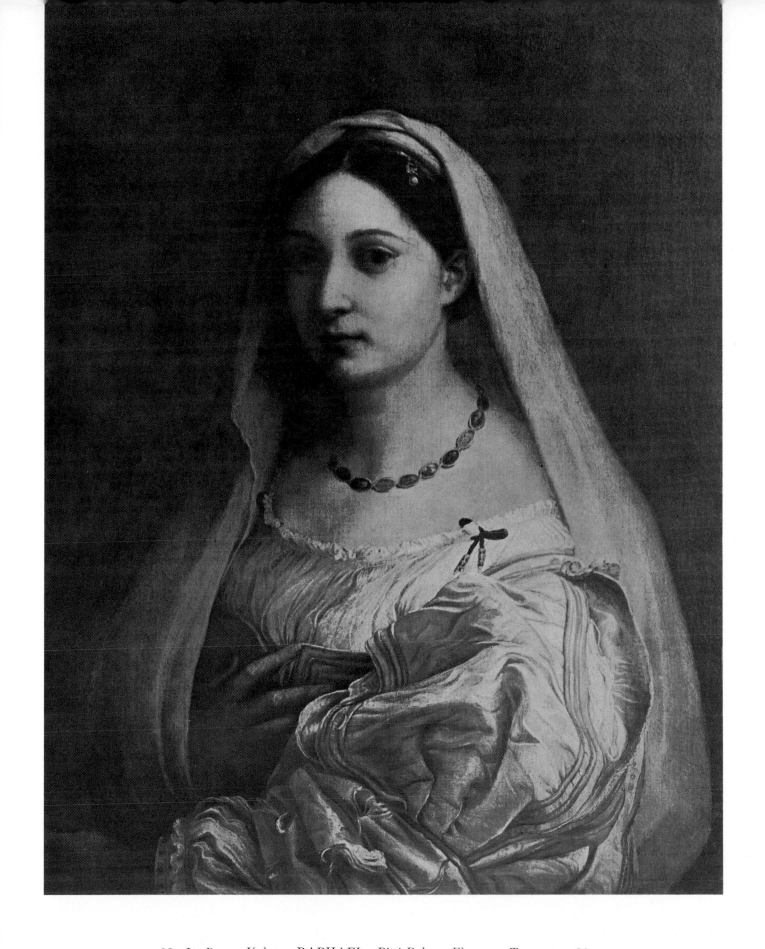

29. *La Donna Velata* · RAPHAEL · Pitti Palace, Florence. Text, page 29.

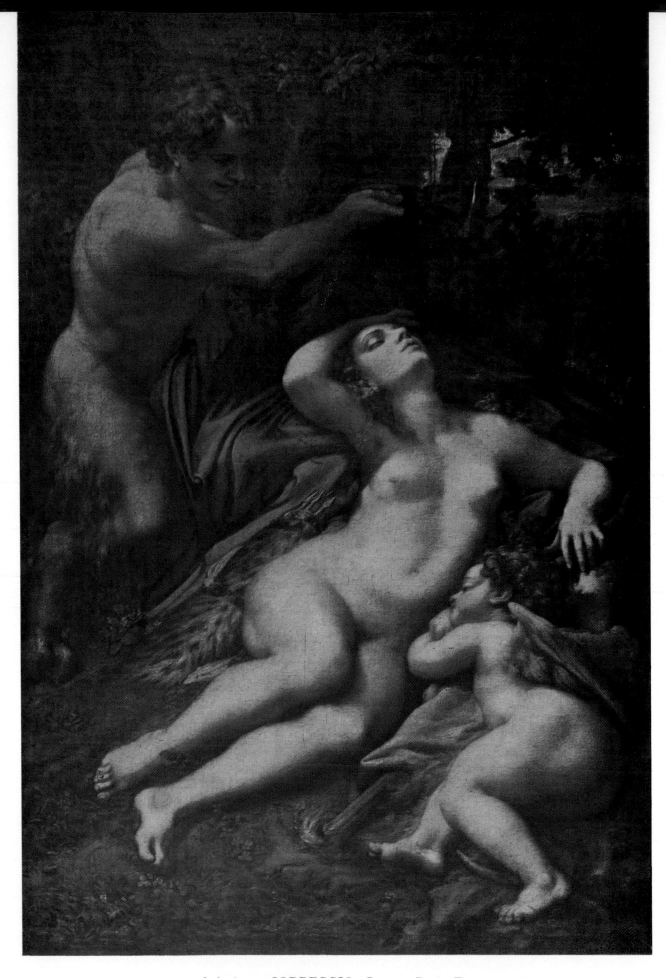

30. *Jupiter and Antiope* · CORREGGIO · Louvre, Paris. Text, page 30.

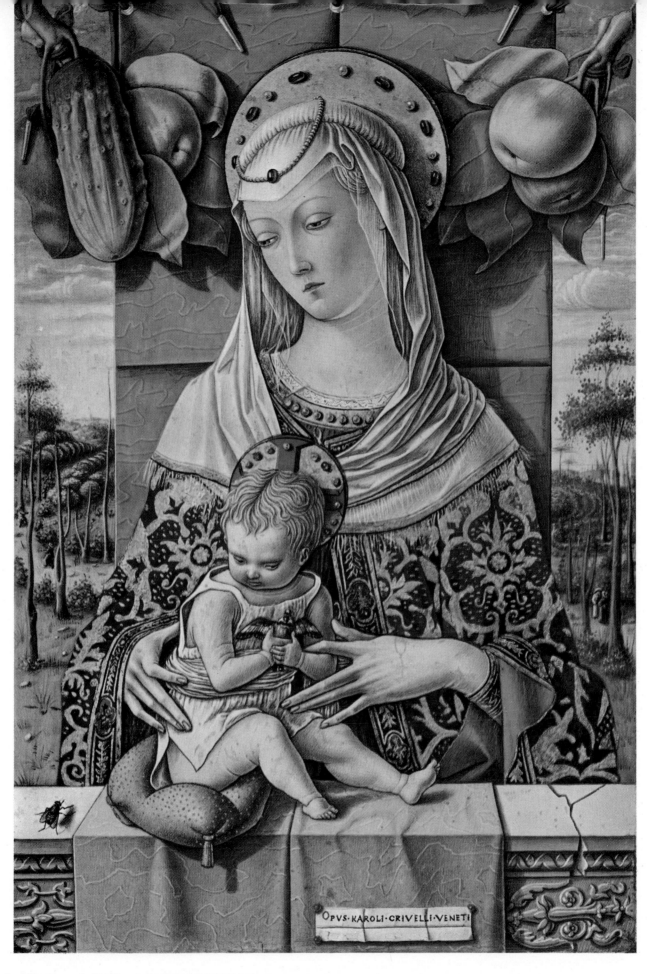

31. *Virgin and Child* · CARLO CRIVELLI · Bache Collection, Metropolitan Museum, New York. Text, page 31.

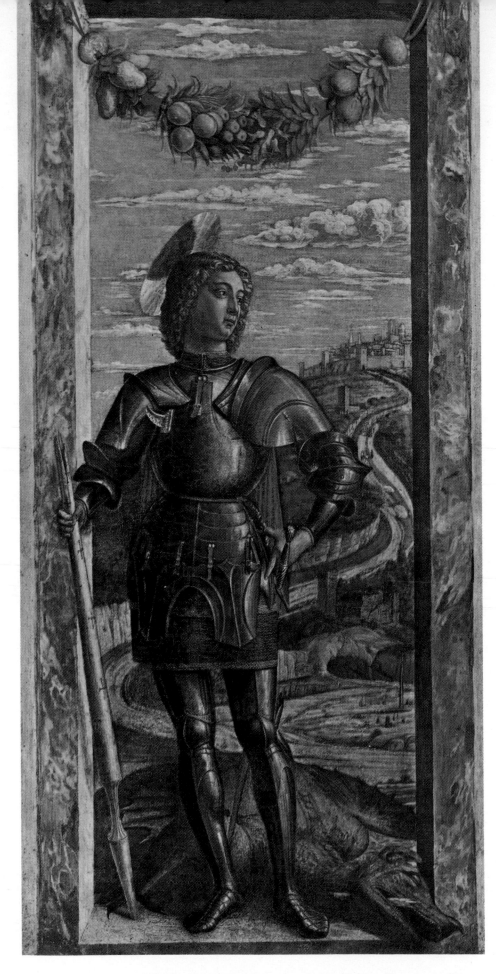

32. *St. George* · ANDREA MANTEGNA · Academy, Venice. Text, page 32.

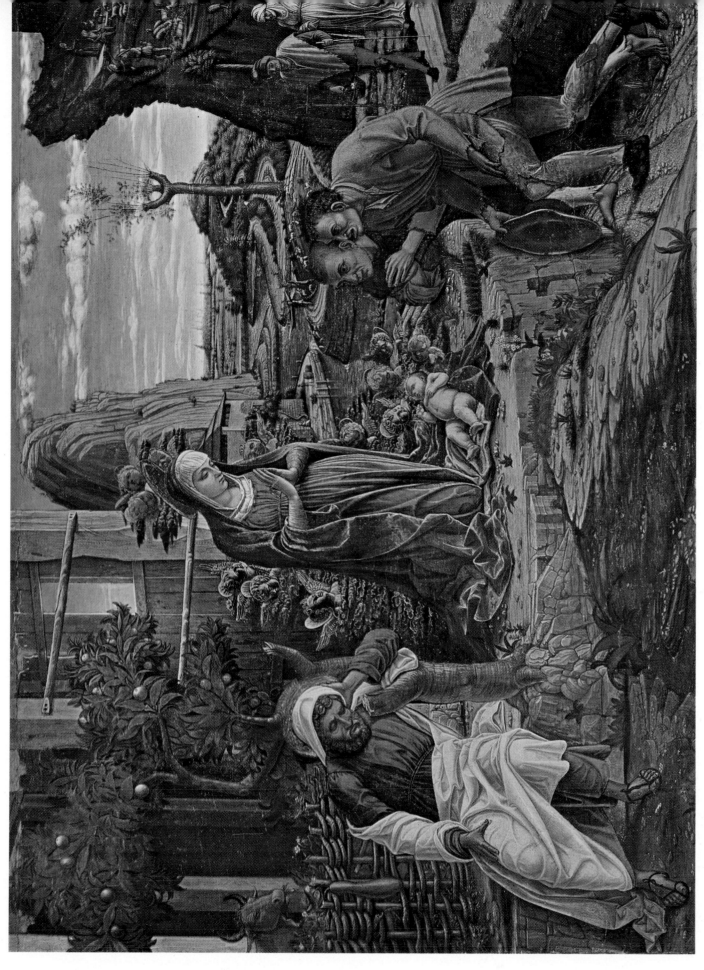

33. *The Adoration of the Shepherds* · ANDREA MANTEGNA · Metropolitan Museum, New York. Text, page 33.

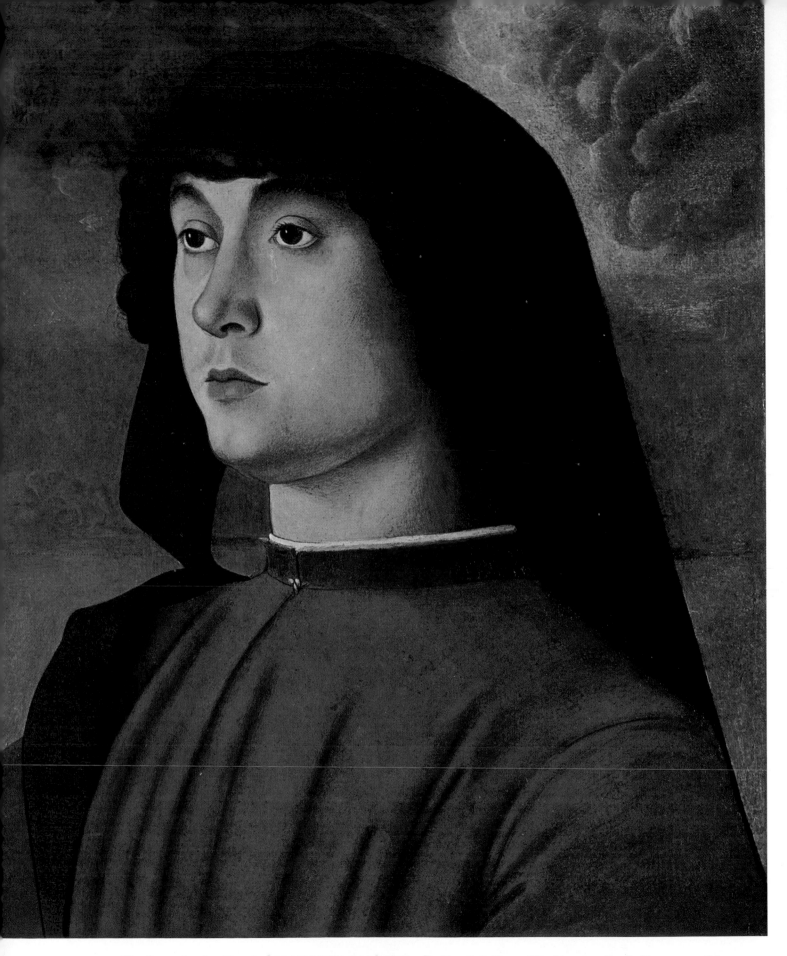

34. *Portrait of a Youth* · GIOVANNI BELLINI · National Gallery, Washington, D. C. Text, page 34.

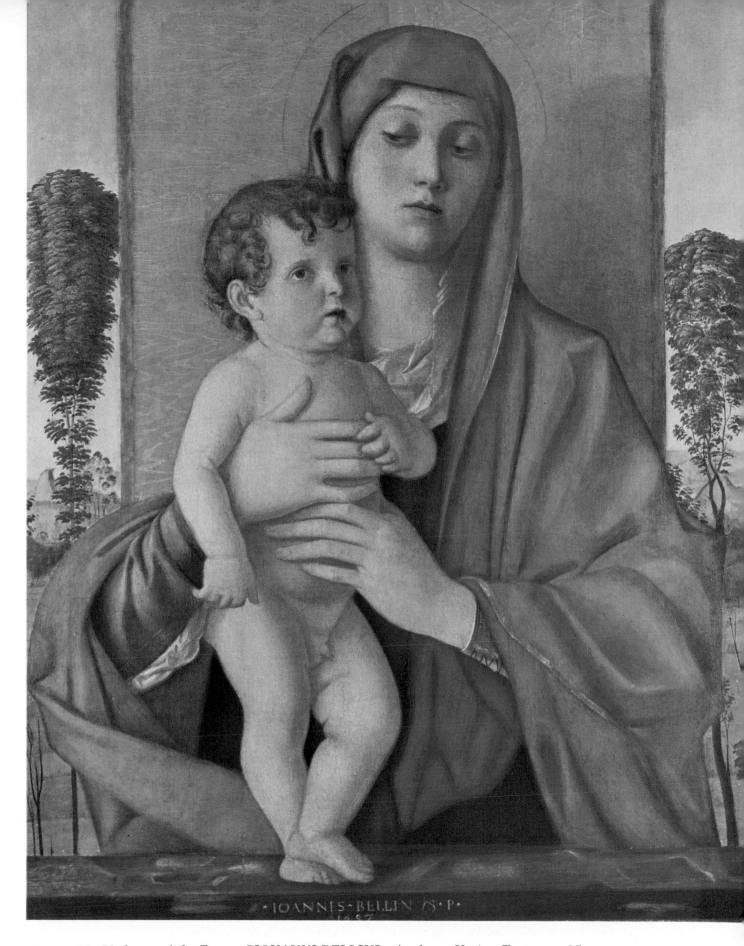

35. *Madonna of the Trees* · GIOVANNI BELLINI · Academy, Venice. Text, page 35.

36. *Concert Champêtre* · GIORGIONE · Louvre, Paris. Text, page 36.

37. *Sleeping Venus* · GIORGIONE · Art Gallery, Dresden. Text, page 37.

38. *The Dream of St. Ursula* · VITTORE CARPACCIO · Academy, Venice. Text, page 38.

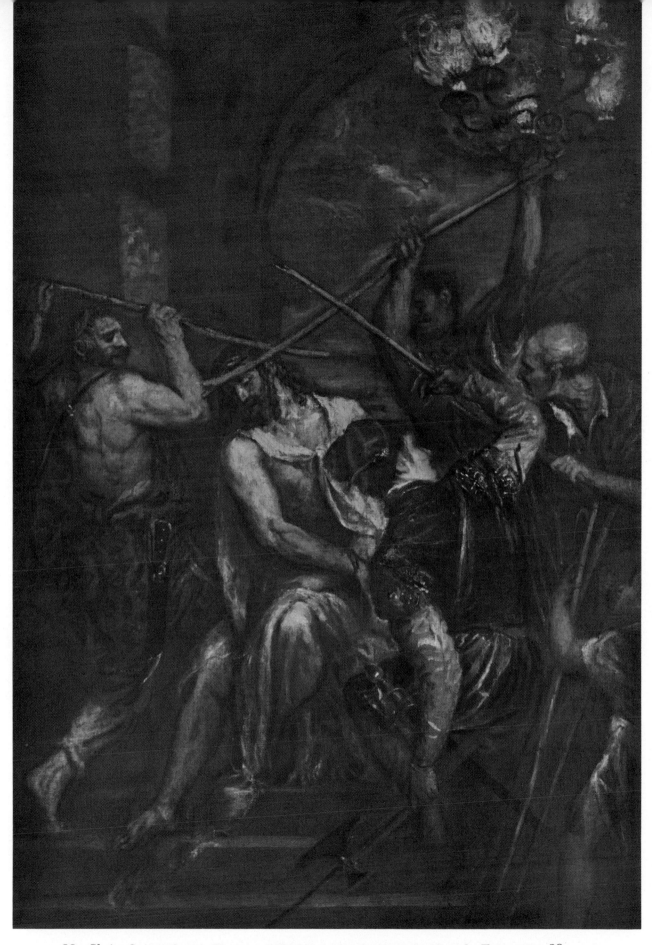

39. *Christ Crowned with Thorns* · TITIAN · Alte Pinakothek, Munich. Text, page 39.

40. *Portrait of a Man in a Red Cap* · TITIAN · Frick Collection, New York. Text, page 40.

41. *Venus and Adonis United by Love* · TITIAN · Bache Collection, Metropolitan Museum, New York. Text, page 41.

42. *Feast in the House of Levi* · PAOLO VERONESE · Academy, Venice. Text, page 42.

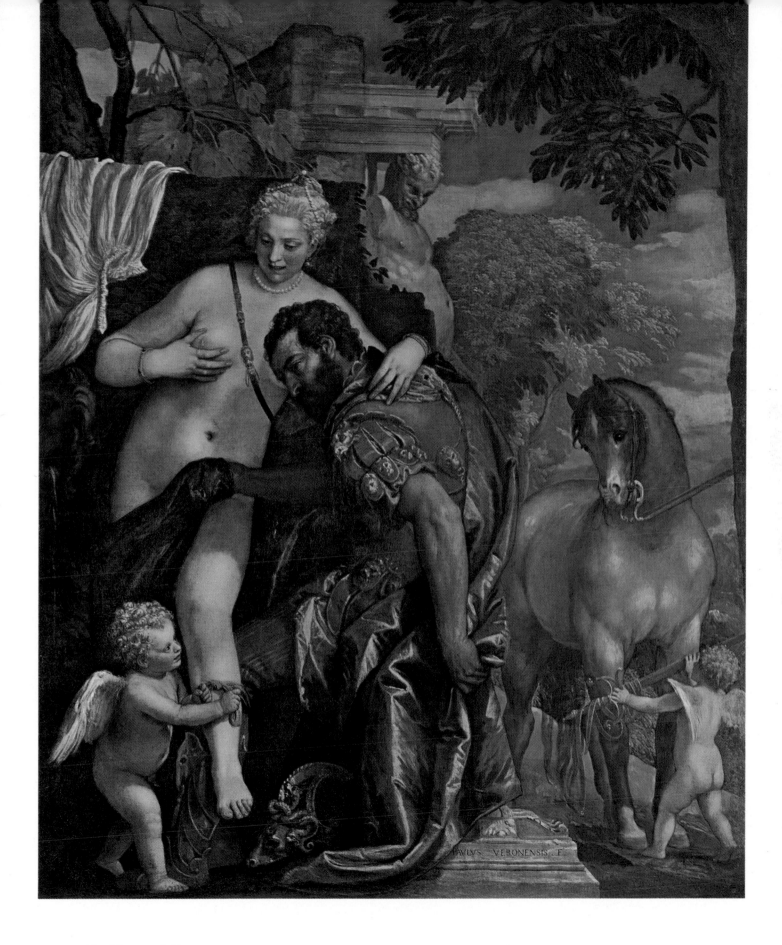

43. *Mars and Venus* · PAOLO VERONESE · Metropolitan Museum, New York. Text, page 43.

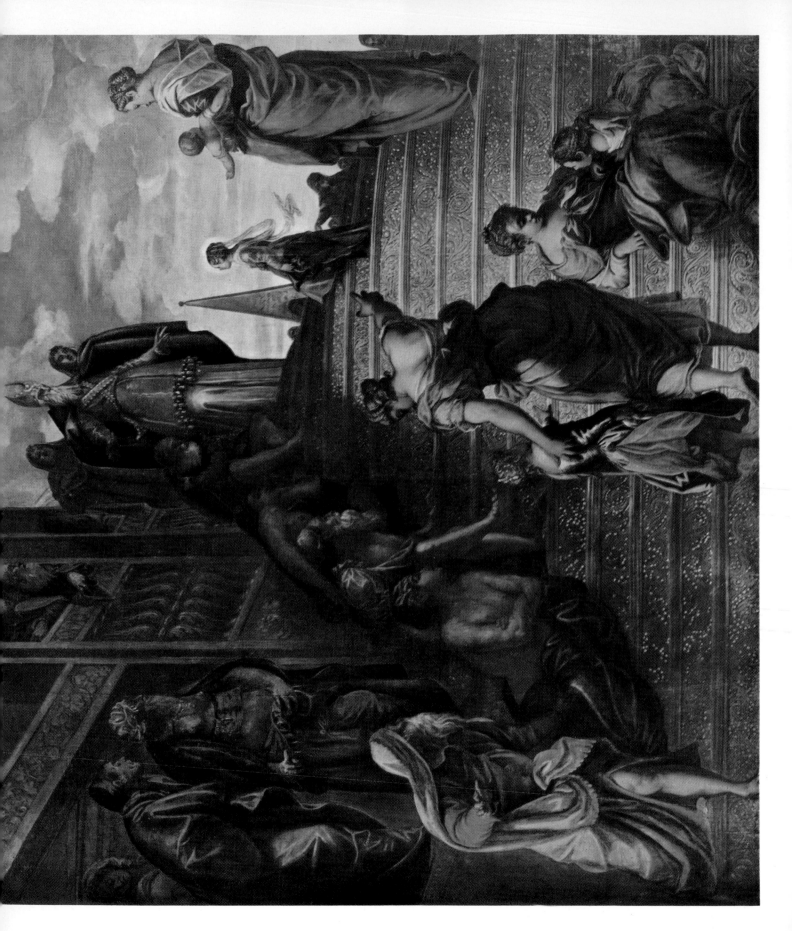

44. *Presentation of the Virgin* · TINTORETTO · Santa Maria dell' Orto, Venice. Text, page 44.

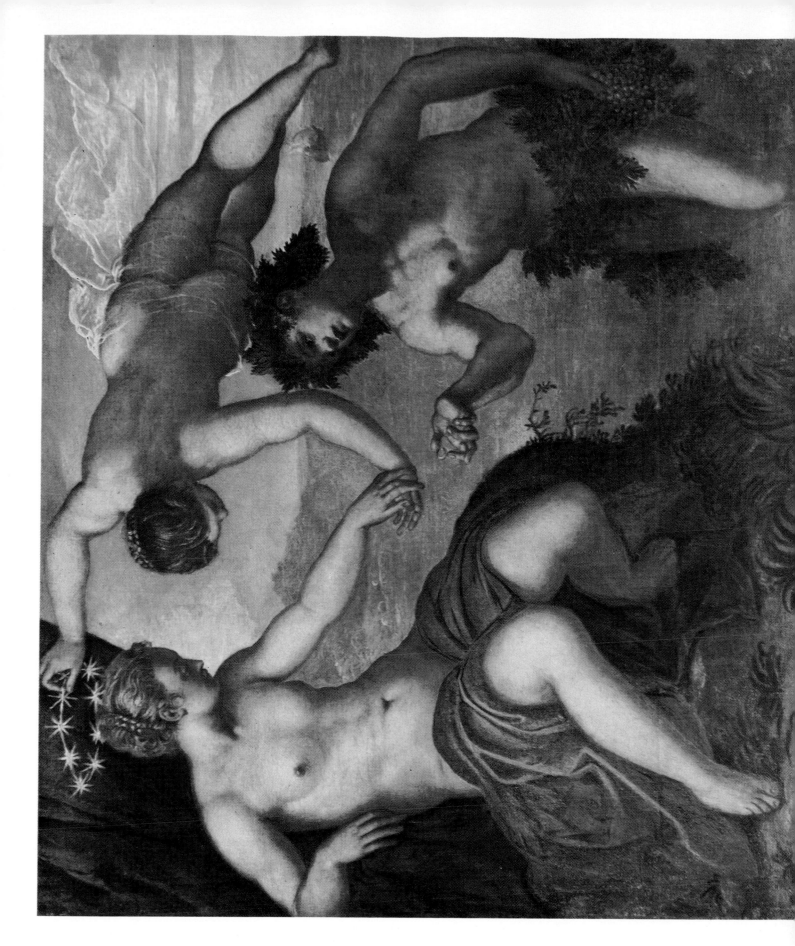

45. *Bacchus and Ariadne* · TINTORETTO · Ducal Palace, Venice. Text, page 45.

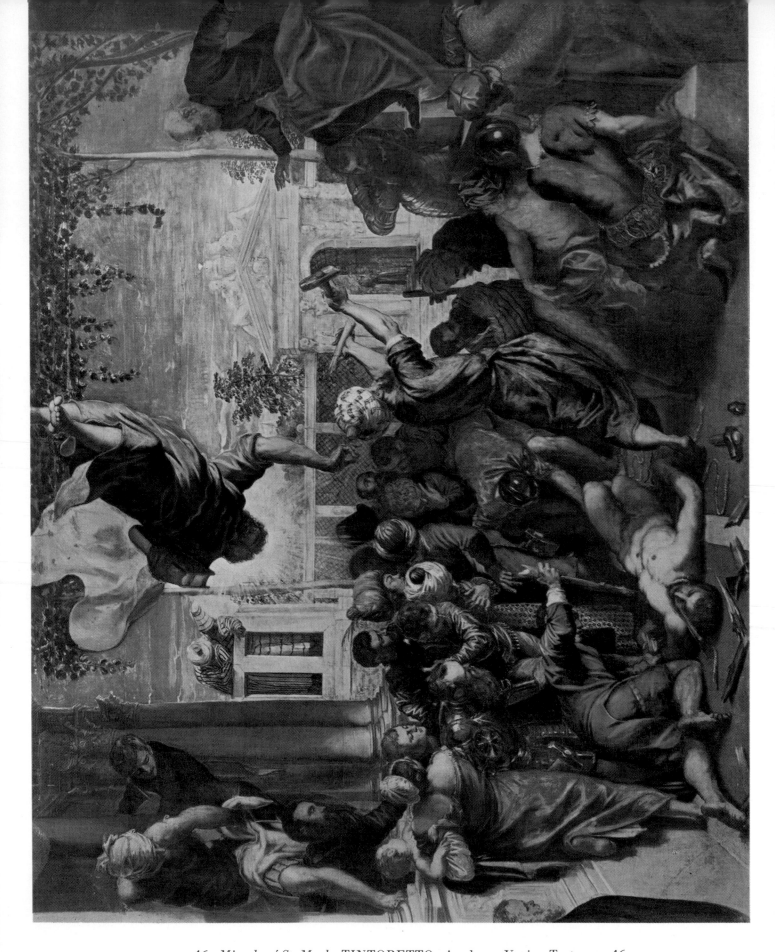

46. *Miracle of St. Mark* · TINTORETTO · Academy, Venice. Text, page 46.

47. *The Calling of St. Matthew* Detail · CARAVAGGIO · Church of S. Luigi deì Francesi, Rome. Text, page 47.

48. *The Piazzetta, Venice* · FRANCESCO GUARDI · Wadsworth Athenaeum, Hartford. Text, page 48.

# JAN VAN EYCK

1385?–1441     FLEMISH SCHOOL

*John Arnolfini and His Wife*, National Gallery, London. Oil-tempera on wood, 33" x 22½", 1434. Color plate, page 129.

TOWARD the close of the fifteenth century, the early Flemish artists, employed at the French court, suddenly opened their eyes to the world of nature. They saw French illuminators working from life, and this naturalistic influence was exactly what the Flemish painters needed. They were plain people with no cultural pretensions, and they had to dig for their materials in the native clay of their own environment. About 1420, when the old school of manuscript illuminators had reached its climax, the Van Eyck brothers arrived—two painters in oil, the greatest artists of the early Flemish awakening.

Little is known of these famous brothers and less of the painters preceding them; but certainly their beautifully finished art did not spring full-blown from the pages of the sacred manuscripts. They were craftsmen of imagination—with the power to transmute the old familiar concomitants of life into forms that are strange and enchanting. Their attention reposed on the ordinary business of living; and in their penetrating curiosity in everyday things, we must look for the secrets of their enormously effective painting.

Jan van Eyck, the younger brother, was primarily a portrait painter, and a constructive artist of the first rank. In the organization of the smallest components of the face into a living countenance, and in bringing together the minute aspects of all sorts of objects without losing his way among the details, he has never been equaled. His *John Arnolfini and His Wife*, five hundred years old and as fresh as if painted yesterday, is one of the prizes of the National Gallery, and one of the most desirable paintings in the world. According to a former director, this picture of an Italian representative of the Medici at Bruges, an acrid little shrimp of a man and his timid wife, is the one painting, above all others, which the majority of visitors would love to carry away. Part of the picture's charm lies in the piecemeal discovery of the exquisitely painted details: the string of amber beads against the back wall, the oranges, the mirror with its frame decorated with perfectly distinct miniatures of the Passion of the Lord, the one burning candle, and the extravagant signature in Latin—*Jan van Eyck was here, 1434*. The picture is an example of the beautiful rendering of plain things, of the ability of a great artist with his simple humanity, his delight in visible realities, and his honest love for little domestic appurtenances, to give distinction and harmony to a form of life far removed from the strenuous intellectualism of the Southern Renaissance.

[BELOW] Detail from *John Arnolfini and His Wife*, National Gallery, London. The Gothic signature above the mirror authenticates the work: "John van Eyck was here 1434." Tenderness of feeling, minuteness of drawing, and softly blended color make this little masterpiece a joy forever.

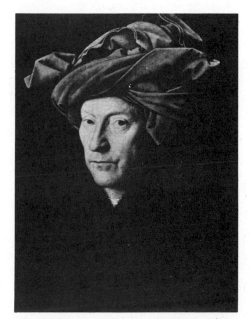

*Portrait of a Man*, National Gallery, London. Oil-tempera on wood, 10¼" x 7½", 1433. This small painting, by the most scrupulous inclusion of details, reveals a subtle insight into character and a material perfection of form.

# JAN VAN EYCK

CONTINUED

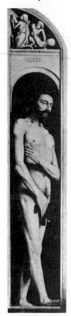

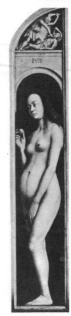

THE Van Eyck brothers were not the first to use the oil medium, as was formerly believed, but they were the first to make the medium clear and tractable—to mix oil with colors as opposed to the old method of using oil and varnish as a glazing protection for a tempera underpainting. Before a century had elapsed, this new process was adopted by Leonardo da Vinci and all the Venetians; and in Spain, Velasquez carried the process a step further, discarding the tempera base and painting in oil pigments alone, a precedent which has held to the present time. But no artist or school of artists has matched the clean and brilliant color, the perfection of the finished surface, and the durability of the Flemish masters.

Besides perfecting a new means of painting, the Van Eycks explored and conquered the mechanics of picturemaking, mastered and taught linear and atmospheric perspective, and revolutionized the medieval notions of landscape. While the Italians were wrestling with space construction for one hundred and fifty years, always theorizing and endeavoring to formulate laws for the position of objects in the picture planes, the Van Eycks, without esthetic fuss and by sheer accuracy of observation, solved most of the technical problems of painting. Truly, jointly and severally, they were phenomenal brothers.

But craftsmanship with the Van Eycks was not a technical exhibition divorced from purpose. Both were religious men, and Jan, the more secular and worldly—he was an emissary of the Duke of Burgundy to Spain—used his skill to depict the psychological secrets of people, and to paint Madonnas far exceeding in characterization the conventional types of his predecessors. By linear computation his pictures are of small size, the *Arnolfini* painting measuring 30 inches by 20 inches, and the *Ince Hall Madonna*—8¾ inches by 6 inches! The latter, valued today at $250,000 and purchased by the Australian gallery from the collection at Ince Hall, near Liverpool, is a microcosm of early Flemish art. Notwithstanding the damage done to its surface by alien varnishers, it reveals in its red, blue, and gold coloring, its wonderfully realized details, its humanized figures, and its atmospheric perspective the hand and soul of the man who established the Flemish tradition as one of the main branches of the tree of art. The picture is signed in Latin in the background near the window: *Completed in the year 1433 by Jan van Eyck of Bruges.*

*Ince Hall Madonna,* National Gallery of Victoria, Melbourne. Oil-tempera on wood, 8¾" x 6", 1433. Color plate, page 130.

*Adam and Eve,* left and right shutters of the Ghent altarpiece. The matter-of-fact realism of the figures, in an otherwise exalted scene, is unmistakable evidence of the hand of John van Eyck.

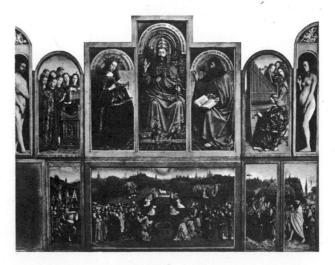

[RIGHT] *Adoration of the Lamb,* Altarpiece, St. Bavon Cathedral, Ghent. Oil-tempera polyptych, completed 1432—largely by Hubert van Eyck with some assistance from his brother John. An apocalyptic vision enchantingly unfolded with the processions converging at the altar of the Lamb, and above them Christ the King of Heaven, a piquant Virgin Mary, John the Baptist, and choirs of angels.

# ROGIER VAN DER WEYDEN

1400–1464                                    FLEMISH SCHOOL

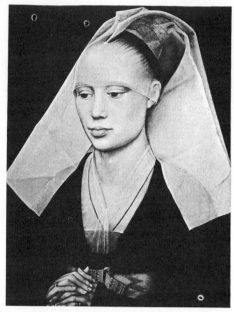

THE profession of painting, in the healthy industrialism of fifteenth-century Flanders, was rigorously administered by the guilds, a system insuring the highest standards of workmanship and the prosperity of accredited practitioners, but tending towards uniformity of style and subject matter. When a lady of quality wished to have her portrait painted, she consulted a licensed master, selected from his samples an appealing specimen of posture and costume, and arranged for sittings. The master made drawings of the lady's face, and then, in the privacy of his workshop, executed the portrait after the specimen chosen by his patron.

Rogier van der Weyden was a product of the guilds, trained in sculpture and the handling of metals, and a licensed master of painting at the age of thirty-five. But he was a man of exceptional cultivation, a French-speaking Fleming who had lived in France and traveled in Italy; and after painting religious pictures he added portraiture to his attainments, bringing to this field the insight and refinement of feeling characteristic of his devotional pieces. Though he accepted the realism of his period and many of the conventions of the guilds, he was not bound by inflexible practices; he was, in many respects, the most imaginative artist of the early Flemish school, not interested in making literal maps of faces but in revealing the psychology of his sitters. Thus his *Portrait of a Lady*, which in other hands might have been only a stereotyped woman in a wimple, becomes one of the glories of Northern art. The sharp, clean edges; the features outlined with a sculptor's precision; the headdress and arrangement of the hair; the rings and the lady's hands, disproportionately small—everything is brought together in a striking pattern, intricate but extremely lucid, to convey, not a stock guild likeness, but his own conception of the dignity and refinement of a woman of high birth.

Van der Weyden was the most popular portrait painter of his time. His fame spread through France and Italy and beyond the Rhine; he founded a large and flourishing school at Brussels where he was officially named town painter; and on his death, the municipal council voted a pension to his widow.

*Portrait of a Lady*, National Gallery, Washington, D.C. Oil-tempera on wood, 14½″ x 10¾″, about 1455. Color plate, page 131.

*The Magdalene*, detail from the *Deposition*. In attitude and facial expression, this figure is revered as the incarnation of anguish

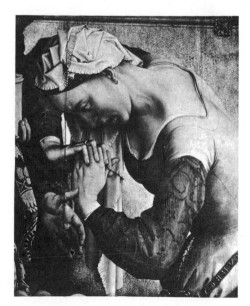

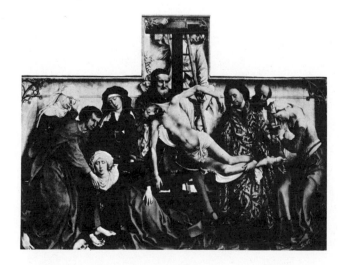

[LEFT] *Deposition*, Prado, Madrid. Oil-tempera on wood, 85¾″ x 102″, about 1435. The greatest of seven similar *Descents* influenced by it. Against a background of gold, the sculpturesque Flemish figures, subtly refined, with delicate feet and hands, are brought to life in a sublime exposition of tragic feeling.

# HANS MEMLING

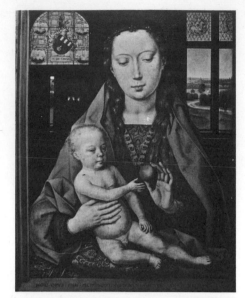

*Madonna and Child* or *Madonna with the Red Apple*, Hospital of St. John, Bruges, left panel of diptych. Oil-tempera on wood, 17¼" x 13", 1487. Color plate, page 132.

*Martin van Nieuwenhoven*, donor of the *Madonna with the Red Apple*, right leaf of diptych. Oil-tempera, 17¼" x 13", 1487. A stolid burgher made attractive by consummate craftsmanship and a mathematical design developed from the golden section.

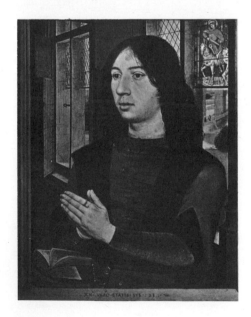

EARLY Flemish painting was the direct offspring of the Gothic miniatures—sacred manuscripts, missals, and Books of Hours illuminated by the monks—and notwithstanding its rapid advancement in color and craftsmanship, retained the stamp of the miniature until Rubens returned from Italy in the seventeenth century. Continuing the medieval tradition, it was naturally of a religious character, and remained so throughout its entire development. The Renaissance, striking at the roots of the medieval order, destroyed Christianity in Italian art, but in the north countries revived it. The early Flemings found no incompatibility between their homely pieties and the teachings of Christ; no irreconcilable differences between their matter-of-fact sensuality and the principles of the Roman Church.

The indigenous flavor of the early school, which was carried to its height by the Van Eycks, was maintained by Robert Campin, Rogier van der Weyden, Petrus Christus, and Hans Memling, the last, by reason of the appealing delicacy of his portraits and the quaint, medieval tenderness of his religious pieces, being one of the most cherished artists of his time. Memling, a German by birth, spent the better part of his working life at Bruges, where his pictures are lavishly displayed today. He was a craftsman of the first order, refining the hard surfaces of his school with the precise, gentle touch and the bright colors of the illuminators of sacred texts. Emotionally he was a man of a single mood; in design he was an artist of a single pose.

The finest and maturest of Memling's Virgins, and in truth, the whole of his religious spirit, is exemplified in the Bruges picture known as the *Nieuwenhoven Madonna,* from the donor whose portrait adorns the other wing of the diptych. The figures were stationed and proportioned in the picture space with mathematical care, and the Virgin, in pose and expression, resembles all his others. She sits bolt upright, the head elongated, the forehead high, and the eyes downcast. The picture is characteristic of the artist's modesty and charm: there is never a hint of tragedy or suffering in his art—he was a man of reticence and unaffected shyness. In Memling's religious paintings the delicacy of feeling and tenderness of expression are genuine qualities; but his conceptions, promoted by his successors, were overladen with sweetness and sentimentality.

[RIGHT] *Adoration of the Magi,* Hospital of St. John, Bruges. Oil-tempera on wood, central panel of triptych, 17¾" x 26", 1479. A pious conception faithfully studied like a genre subject, and the somewhat static arrangement of figures broken by ingenious variations of lines and forms.

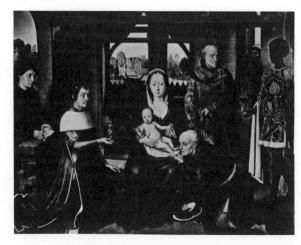

# PIETER BRUEGHEL

1525?–1569          FLEMISH SCHOOL

IN THE sixteenth century, the Flemish painters went down into Italy and acquired just enough of the heroic style to ruin the native tradition that the Van Eycks and their followers had so patiently erected. Unable to assimilate Renaissance culture, or to fathom the principles of mural design, they loaded their own honest realism with theatrical profusion and imitation splendor— the mixture being the more unsightly because of its mechanical competency and glassy, smoothness—and charmed the florid tastes of the Antwerp burgesses. In the thick of this foolish Italianism, Pieter Brueghel the Elder appeared.

It is one of the enigmas of art that Brueghel should have remained in dark neglect for more than three centuries. When he was mentioned at all, he was curtly dismissed as Pieter the Droll, or Peasant Brueghel, a Rabelaisian buffoon with a malodorous interest in diableries and the animalistic pastimes of the boorish rabble; a successor of Bosch, the bogey-artist who persisted in the grotesque ideology of the Middle Ages.

Brueghel possessed most of the essentials of the great artist. His concern with life was broad and anthropological: he was interested in people, the whole business of living, from the intimate habits of peasants to the industrial and spiritual dilemmas of his beloved Antwerp. Many of his pictures are alive with figures—crowds, processions, and cataracts of men and women; like Giotto and Daumier, he delved into the homely stuff around him and converted it into dramatic art. In his first period, his favorite subjects were the orgiastic relaxations of peasant life, carousing spectacles he had experienced and enjoyed, and which he painted with deliberation from sketches. His figures were not thrown together in the haphazard fashion of the illustrator, but conceived as parts of an elaborate design of black and white masses enlivened with color. Paintings such as *The Wedding Dance*, with its large, reeling forms and solidly constructed bodies, have had a pronounced influence on American genre painting of the present time. But the picture, despite its subject, has little joviality. It was painted at a tragic moment in history, when the Flemish peasants, with bestial grimness and outgushings of coarse vitality, sought collective release from the Spanish butchery of the Low Countries.

*Peasant Wedding Feast*, Vienna Gallery. Oil-tempera, 3′ 8⅞″ x 5′ 4⅛″, 1568-1569. One of several celebrations of the joys of gluttony painted by Brueghel with bursting vitality.

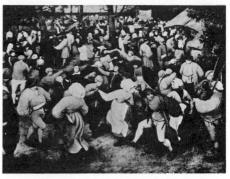

*The Wedding Dance,* Institute of Arts, Detroit. Oil-tempera, 3′ 11″ x 5′ 2″, 1566. Color plate, page 133.

Detail from *Peasant Wedding Feast*, Vienna. The bagpiper, knees protruding, stares unintelligently at the energetic concentration on food and drink.

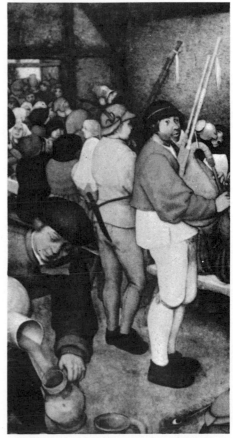

# PIETER BRUEGHEL

## CONTINUED

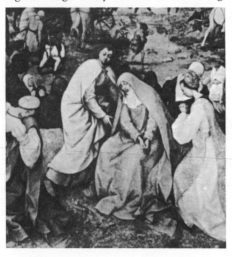

*The Fall of Icarus*, Museum of Fine Arts, Brussels. Oil-tempera, 29″ x 44⅛″. Color plate, page 134.

Detail from *The Road to Calvary*, Vienna Gallery. St. John and the Holy Women comforting the Virgin Mary—all lost in the throng.

*The Road to Calvary*, Vienna Gallery. Oil-tempera on wood, 48½″ x 65½″, 1564. Nominally religious, the painting is actually a record of the victims of the tribunal of the Inquisition as they straggled to the wasteland outside Antivery where the condemned were tortured to death. The figure of Jesus, fallen under the cross, may be seen in the middle distance.

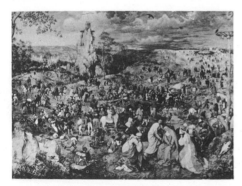

[RIGHT] *The Blind Leading the Blind*, Museum, Naples. Oil-tempera, 2′ 9⅞″ x 5′ 5⅞″, 1563. Brueghel made several sketches of blind beggars, but none is as heart-saddening a commentary on the human struggle as this.

NOT less remarkable than Brueghel's psychological studies of Flemish peasantry are his allegories and ironical landscapes. He painted local versions of *The Hireling Shepherd* and *The Parable of the Blind* which have the force and significance of *The Pilgrim's Progress*, and religious panoramas which, though devotional in approach, are astonishingly unorthodox in treatment. Into such subjects as *The Massacre of the Innocents* and *The Carrying of the Cross*, he interpolated realistic examples of the unspeakable cruelties of the Spanish terror. Unfortunately, his powerful originality was mistaken for ignorance or the vulgar fancies of a rustic who had strayed into painting.

When a very young man, Brueghel rambled over the Alps and down to the Mediterranean, not to imbibe the sacred waters at the fountainhead of culture, but as a lusty, intelligent artist seeking respite from the miseries of his own land. If the Southern painters impressed him at all, it was only to strengthen his conviction that he had nothing in common with their prophets and Madonnas. He was a Northerner to the marrow of his bones, but he was not unreceptive to the charm of Italian landscape which he captured in many sketches.

It has been suggested that *The Fall of Icarus* "is the record of Brueghel's response to some moment of lyrical exaltation when the Mediterranean first flashed on his gaze as he made his way down the Alps." The explanation makes sense as far as it goes; for the picture has a quality and pervasiveness of lighting peculiar to none of his other works. But in all that matters, the work is typical of his ironical humor. In the foreground, on a piece of land by the sea, a Flemish plowman is serenely cutting a furrow; near by, a shepherd gazes amusedly at the heavens; at the right, in the middle distance, visible by two sprawling legs, Icarus, the great mythological upstart, son of a fabulous inventor, disappears beneath the waves. It is the greatest conception of indifference in painting—an indifference which seems to flood the landscape, reducing the whole notion of classical mythology to a couple of lower extremities, the active indifference of a Northern master to the art of the South. With a sense of humor that descended neither to envy nor burlesque, Brueghel pleasantly thumbed his nose at the Mediterranean art which was enslaving his countrymen.

# PIETER BRUEGHEL
## CONTINUED

IN ALL his paintings, Brueghel was a contemporary observer of life. The last phases of the medieval tradition, with its minute horrors and episodic tortures, undoubtedly affected his early engravings, but from the time of his first paintings, he was an artist of independent vision. He knew how to set figures in motion, to emphasize the telling details of his characters without impairing their largeness and bulk; and to bring into view crowds, even multitudes, with no damage to unity of masses. As he grew older, he began to contemplate the world in wider perspective, to withdraw from the intimacies of persecutions and peasant orgies into a larger, more imaginative statement of his individuality. In his last years, he painted a series of landscapes which, all things considered, are the most comprehensive expression of his memorable genius.

It hardly seems possible that Brueghel, with no antecedent suggestions, could have taken landscape, hitherto a decorative adjunct to figure painting, and, at one stroke, have made it an art in its own right. His work in this field, in construction, depth, and the relation of the natural background to the occupation of man, is equaled only by the cosmic, autumnal scenes of Rubens. He could not conceive of landscape except in human terms, and his renderings of it, broadly speaking, are harmonious adjustments of nature to the moods and activities of man.

Brueghel projected a series of twelve landscapes to be called the Months, only five of which were completed. All have descriptive titles—*Dark Day, January; Hunters in the Snow, February; Haymaking, June; The Harvesters, August; Return of the Herds, November*—and all are built on the same plan, a long diagonal outlining of high foreground from which the spectator looks back into vast distances. *Hunters in the Snow* is the most remarkable of the group. Here is winter with its stillness, its austerity, and its frozen expanses, but presented in relation to the snug houses, and the labors and sports of man. This landscape is a beautiful example of Brueghel's method of constructing pictures in a series of recessive planes; and in its use of snow as a background for figures and natural forms revealed sharply as silhouettes, it is unrivaled in Western painting. It has been rightly said that the hunting scene "opens up a new and wonderful chapter in the history of art."

*Hunters in the Snow*, Kunsthistorisches Museum, Vienna. Oil-tempera on wood, 3′ 10″ x 5′ 3¾″, 1565. Color plate, page 135.

Detail from *Hunters in the Snow*, Vienna. The men and hounds returning from the chase, sharply silhouetted and perfectly placed in one of the best occidental snow scenes.

Detail from *The Land of Cockaigne*, Vienna.

[LEFT] *The Land of Cockaigne*, Alte Pinakothek, Munich. Oil-tempera, 1567 (signed). Illustration of an old Flemish tale. Schoolmaster, peasant and soldier in gorged contentment —and a running pig with a carving knife in his back.

# PETER PAUL RUBENS

*Rape of the Daughters of Leucippus*, Alte Pinakothek, Munich. Oil on canvas, 88½" x 83½", 1615-1617. In the painting of the nude in action, in the complicated relating of the forms, and in the animation of every part and detail, the skill of man cannot exceed this abduction in which Castor and Pollux make away with a couple of brides.

*Elevation of the Cross*, Antwerp Cathedral. Oil on wood, 181¾" x 134¼"; 1610-1611. Painted after his long sojourn in Italy, and signalizing the formation of his powerful Flemish style.

At the age of fifty-three, Rubens, diplomatist, scholar, most celebrated of painters, and four years a lonely widower, married Helena Fourment, the daughter of a silk merchant of Antwerp. "I chose a young, middle-class woman," he wrote, "who would not blush to see me take up my brush; and to tell the truth, I loved my liberty too much to exchange it for the embraces of an old woman." The young wife was barely sixteen, and known by her beauty as Helen of Flanders. She incarnated that splendid type of Nordic goddess whom he loved to paint; and certainly she did not blush to see him take up his brush, for he painted her again and again—as Mary Magdalene and the Virgin; gorgeously dressed and bejeweled, with her lovely children—she had six; and in the nude as Susanna, a nymph, and the central figure of *The Judgment of Paris*.

In this strong, blond woman, Rubens found a wife after his heart's desire, but he did not squander his strength in her huge embraces: he seemed indeed, after his second marriage, to paint with the ardency and dazzling power of one suddenly come into eternal youth. *The Judgment of Paris*, a presentation of the female nude—assertively Flemish in its billowy opulence—as viewed from the back, front, and side, is one of the greatest of his numerous masterpieces, the most honest and uncompromising, the most glowing and substantial expression of the sensuous world that has ever been conceived. No other painter suggests so little and expresses so much—tells everything with such lucidity and resplendent candor.

Rubens loved the nude but he was not obsessed by its sexual enticements; nor did he create seductive animals to burn the desire of those who would find in art an erotic stimulus. The nude is a part of his philosophical scheme, a system including the health, the movement and the generative forces of the organic world. His passion for life and his love for strapping, sun-warmed nakedness were submitted to the sternest intellectual discipline and reduced to a synthesis of law and order in which no form protrudes suspiciously. There is no heated concentration on faces, breasts, or thighs; no sly beckonings to come and behold salacious poses; no artful evasions—the organized sensuality is clean and pure. His conception of the fullness and richness of life could never have been expressed in the forms of thin women; he needed size, health, and luxuriantly developed, wide-girthed bodies in a world of three dimensions—everything that was the opposite of the mean, the stunted, and the dieted.

[RIGHT] *The Judgment of Paris*, National Gallery, London. Oil on wood, 57" x 75", 1632-1635. Color plate, page 136.

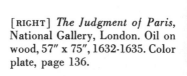

# PETER PAUL RUBENS

To satisfy his flamboyant tastes, Rubens labored with an energy that was truly gigantic, operating his business on the large-scale productive methods of the modern capitalist. His house in Antwerp was a palatial structure with art galleries, a vast studio, and quarters for his pupils and assistants. Peacocks and hunting dogs roamed the lawns; there were formal gardens, fountains, grottoes, and stables for his blooded horses. Over the portico was engraved the old familiar exhortation from Juvenal: "Let your prayer be for a sound mind in a sound body." He had the finest balance and the widest sympathy of any man who expressed himself in paint.

Rubens conducted his life with conventual austerity. He was up at four o'clock the year round, and after hearing Mass, worked in his studio as long as the daylight lasted. He ate and drank very little, avoided intemperance in all its forms, and regarded obscenity with prudish abhorrence. His nights were given over to his learned friends and to the study of antique carvings in which field he became one of the foremost authorities in Europe. He was a solid family man—and no biographer has connected him with an intrigue or compromising gallantry.

After eight years of study in Italy and Spain, Rubens returned to his native land, pushed his Italian impressions into the background, and began to produce pictures of permanent value. He married and settled down to a life of domestic happiness, hard work, and every reward and honor a man could desire. His bride was Isabella Brant, large, handsome, eighteen, and undeniably Flemish. There hangs in Munich one of the earliest of his great portraits, himself and Isabella painted shortly after their marriage. They are seated, holding hands in a bower of honeysuckle, splendidly dressed, Rubens in a doublet of yellow-brown, black velvet breeches, orange stockings, and a Henri Quatre hat; his wife in a black jacket, a blue satin bodice embroidered in gold, a violet skirt, and a yellow petticoat. The picture, though reminiscent of the early Flemings in its details and textures, was painted with a boldness, plasticity, and brilliancy of color that shocked and aroused his lethargic fellow artists. It is a sumptuous picture and warmly human in its characterizations; a fine, compact, circular design; an invaluable document; a noble tribute to a happy marriage.

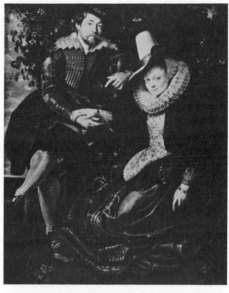

*Rubens and His First Wife*, Alte Pinakothek, Munich. Oil on canvas, 5' 10⅛" x 4' 5½", about 1610. Color plate, page 138.

*The Arrival of Maria de' Medici at Marseilles*, Louvre, Paris. Oil on canvas, 13' x 9' 8", 1622-1625. The sixth of 36 panels designed for the Luxembourg Palace. The fat Queen Mother, in a labyrinth of nudity and symbolical hocus-pocus, makes a landing. Neptune directing and Undines in attendance.

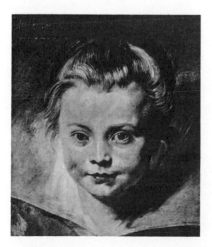

*Head of a Child*, Liechtenstein Gallery, Vienna. Oil on wood, 1616. Not even Leonardo could surpass Rubens in capturing the pure humanity of the child. This portrait (possibly his eldest daughter, Clara Serena, by his first wife), marvelously drawn, invokes the wonderment and physical beauty of the child without resorting to idealization.

# PETER PAUL RUBENS
### CONTINUED

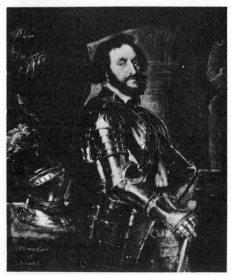

Detail from *Thomas Howard, Earl of Arundel.*

*Thomas Howard, Earl of Arundel,* Isabella Stewart Gardner Museum, Boston. Oil on canvas, 55″ x 46″, 1629. The second Earl had a stormy public career and was frequently locked up. His claim to fame rests on his magnificent collections of antiques. Rubens, who visited him in London, painted him in gorgeous array, with the decoration of a Knight of the Garter and the baton of Lord High Constable.

[RIGHT] *The Flemish Kermis,* Louvre, Paris. Oil on wood, 4′ 10⅝″ x 8′ 6½″, about 1636. Color plate, page 137.

IT was not the purpose of Rubens to imitate the Italians but to rival them; to extend the closed, or classical, type of composition into a freer and more pliable instrument, one congenial to his own rich and expansive nature, one by which Flemish earthiness and the strong savor of material abundance might be fused into a comprehensive organism of refreshing nakedness, blooming color, healthy passion, and dramatic energy. His genius was of such an order that "no undertaking," he said, "however vast in size and diversified in subject, ever daunted my courage." He painted masterpieces in every department of art except still life, which was too tame for his human touch. To satisfy his universal interests, he required the whole of art—the nude, the saint, the huntsman and the child, the fields and the frolicking peasants, historical pomp and domestic contentment; his magnificent vision demanded warmth and color, golden brown and lush vermilions too strong for less hearty souls.

Rubens composed his pictures by the rhythmical interplay of lines and volumes, vanquishing the Italians on their own ground. He wove his figures into undulating whirls and spirals leading far back into deep space and returning to complete the movement. By means of strong, supple bodies drawn with a brush, and with incomparable draftsmanship, and so postured and joined and interrelated as to convey in the highest degree the energy and movement of living forms; by figures palpitating with vitality; by scenic accessories rich in color and as fresh as wild flowers, he created his own world. "This prodigious life!" Delacroix exclaimed. "This powerful impetus without which there can be no great art! I love his emphasis, his perfectly articulated figures, strained or relaxed! The Venetians are shallow beside him!" His ability to organize pictorial space into a complex and perfectly lucid harmony of forms cannot be sufficiently praised. Rubens was moved to expression by the joyous aspects of life which he possessed in greater abundance than any other artist. The spirit of color and movement and physical freedom runs through all his paintings; the spirit that circulates through the *Kermis,* painted in his last years—that marvelous dance of life, the riot of animate matter, the furious song of organic energy.

# ANTHONY VAN DYCK

1599–1641                                    FLEMISH SCHOOL

THE glittering career of Anthony Van Dyck contains all the ingredients for the libretto of a romantic opera. At sixteen he was a child genius discovered by Rubens; at nineteen a full member of the guild of painters, at Antwerp, and the star pupil and assistant of the Flemish master; at twenty-one court painter to James I of England. Lured by warmer suns and the splendor of Titian, he journeyed to Italy, tarrying on the way for a love affair with a beautiful country girl. Prepossessing and brilliant, he was admitted to the innermost circles of Italian aristocracy, and painted the beautiful ladies and haughty cavaliers of the houses of Cattaneo, Doria, Spinola, and Grimaldi. Returning to the homeland, he put on, not the mantle, but the studio smock of Rubens; it fitted him to perfection, and he sailed for England, with the master's blessing, to enter the service of Charles I.

In England he was knighted and lodged extravagantly at the King's expense; and his portraits of Charles won him more honors and commissions than his slender constitution could support. The court was at his feet and he satisfied all his subjects without ruffling the surface of their personalities. Sir Anthony now, he burned the candle at both ends; his health and work declined, and at the instigation of friends who wished to save him from his favorite mistress, Margaret Lemon, he married Lady Mary Ruthven. But it was too late. Debts piled up; he employed a corps of assistants and operated a portrait factory—the strain was more than he could bear, and in his forty-second year death caught up with him.

Van Dyck, by disposition and the texture of his gifts, was a virtuoso, one of the most consummate performers in painting. His art was inspired by no lofty convictions, but it was informed by a serious and absorbing passion—the portrayal of elegance. He lived, as he worked and planned his career, in surroundings excluding the ordinary and plain-spoken humanities. *The Marchesa Grimaldi*, from his Genoese period, when he was a devotee of Titian, is darker in tone and firmer in structure than his later works, but a representative specimen of his accomplishments. In this, as in most of his paintings, characterization is of secondary importance. The Marchesa's haughtiness, her face and figure, the blackamoor slave, and the Corinthian setting—all these are used in collaboration to create an atmosphere of elegance which to him was an aim and an ideal.

*The Marchesa Grimaldi*, National Gallery of Art, Washington. Oil on canvas, 97" x 68", 1623. Color plate, page 139.

*The Betrayal of Christ*, Prado, Madrid. Canvas, 3½' x 2½", 1621-1625. An early work, painted in Italy under Venetian influence, and with the types of Rubens, but done with religious feeling.

[LEFT] *Studies of Negro Heads*. Jakob Goldschmidt Collection, New York. Van Dyck, like his master Rubens, was fascinated by Negro models and painted them with remarkable insight and rapidity.

# ALBRECHT DÜRER

1471–1528          GERMAN SCHOOL

THE pictorial genius of the North is epitomized in Albrecht Dürer. It is possible to observe in his career, with a fullness of detail and a clearness of outline not to be found in any other German painter, the effect of race and environment on classic method. He came to maturity at a portentous hour in the history of his race: when the Italian Renaissance, in its northward progression, was spreading the humanities of freedom, intellect, and scientific curiosity; when, as leader of his profession by right of transcendent endowments, he was faced with the decision of warming his imagination at the retrospective fires of the classic past, or of yielding to the invigorating influences of the Reformation. He was not a man to make decisions lightly: nourished on moral issues and foursquare in his devotion to native sentiments and Protestant imagery, he was also capable of testing the riper culture of the South. He studied Italian painting with a scientific interest in procedure, writing books on human proportions; in intellect and expressive cunning, he had but one rival, the cosmopolitan Leonardo da Vinci; and his intellect warned him that art was above the accidents of time and place—yet in every quality that is great and enduring, his art is completely impregnated with the Germanic spirit.

During his residence in Venice, Dürer gathered all his faculties into a deliberate effort to acquire an Italian style—and almost succeeded. On his return to his home at Nuremberg, he discovered himself, and his paintings of the Italianate period are largely remembered as witnesses of the extent to which intellectual curiosity and purely technical interests can warp natural genius. In his last years, speaking his native language with every resource of powerful enunciation, he painted his famous *Hieronymus Holzschuher*. In spirit and execution, this is a Northern painting, a Germanic production; in meaning and final significance as a work of art, it belongs in the highest circles of portraiture with the master workmen of all time. It has a love of detail that is typically German, and Dürer's heritage as a Gothic composer; no Italian would have dared to render, or could have rendered, the hair and beard with such a multiplicity of separate lines; but the detail is used decoratively and subordinated to the general structure—a marvelously assertive head, with a linear fineness and broad massing swept into a personality of lifelike penetration.

*Portrait of Hieronymus Holzschuher*, Kaiser Friedrich Museum, Berlin. Oil-tempera on wood, 19″ x 15″, 1526. Color plate, page 140.

*Portrait of Dürer's Mother*, Berlin Print Room. Charcoal, 16⁹⁄₁₆″ x 11¹⁵⁄₁₆″, 1514. Drawn a few weeks before her death by a man who knew infallibly where every line belonged. A gaunt, tired, aged woman with a life of care written on her face.

[RIGHT] *Hare*, Albertina, Vienna. Watercolor. 1502. Hare or rabbit, the most famous rodent in art and imitated time and again without profit.

# ALBRECHT DÜRER

### CONTINUED

DÜRER is one of the most estimable personalities in the pages of history. In his own profession he has a seat among the immortals, and in his righteous adherence to an exalted purpose, he was a superman. A self-portrait drawn at the age of twelve leaves no doubt that he was the greatest child prodigy in painting; he was famous at twenty, and at twenty-seven, completed his sixteen designs for the Apocalypse, the beginning of a long series of drawings and engravings which, in his own lifetime, were pronounced by connoisseurs as the work of "the greatest mind that ever expressed itself in line," a verdict posterity has not reversed. As triumph succeeded triumph, and his fame traveled to Flanders and to Rome, he comported himself with nobility of bearing, but with the unassumed modesty of his boyhood when, as one of eighteen children, he was learning his father's trade of goldsmith. The warmth of his nature shines out in every page of his letters from Venice and his diary of his journey in the Netherlands; and when he was tempted by foreign principalities with subsidies insuring him a life of pomp and luxury, he remained at Nuremberg, where his position was analogous to that of Rubens at Antwerp and Raphael at Rome.

Dürer was conscious of his personality and careful of his fame, as one who foresaw immortality and the responsibilities of pre-eminence. He was excited to no vanity when he was called upon to demonstrate before Giovanni Bellini that his miraculous painting of hair was done with ordinary brushes; and when Raphael signified that it would be an honor to exchange drawings, his head was not turned. Of his craft and his humanity, he had no misgivings; but on his intellectual side he was disturbed by the lofty generalities of Renaissance thought, the inviting theories causing men of the arts and letters to plume themselves as figures of the universe rather than creatures of place. Thus, in his early self-portraits, the most glorious of which is here reproduced, he visualized himself, not as a local craftsman, but in features and expression after his own conception of Christ. This was not an act of sacrilege or arrogance. Dürer was famous for the beauty of his person, and he created his own image in the light of what he aspired to be; and his life was rigorously governed by the spiritual rectitude and purity of conduct that he believed necessary to the artist who planned his works as lasting reflections of the highest reaches of the human spirit.

*Portrait of the Artist as a Young Man*, Prado, Madrid. Oil-tempera on wood, 20¾″ x 16½″. Color plate, page 141.

*Das Grafse Rasenstuck*, Albertina, Vienna. Watercolor, 1503. Dürer's interests, like those of Leonardo, were boundless, and this study shows the searching observation and the linear fidelity he lavished on plants.

[LEFT] *Landscape with Houses*, Berlin. Watercolor, 1494. From the sketchbook of Dürer the traveler.

*Four Apostles*, Alte Pinakothek, Munich. Oil-tempera on wood. Left, John and Peter; right, Paul and Mark. 1526. Each panel, 81″ x 36″. Color plate, page 142.

# ALBRECHT DÜRER
## CONTINUED

WHEN Dürer was in Italy, the old chronicler, Vasari, wrote him down in the following comment: "It is indeed certain that if Albrecht Dürer, so highly endowed, so assiduous, and so varied in his powers, had been a native of Tuscany; had been in position to study the treasures of Rome, as we have done, he would have been the best painter in Italy, as he is the most renowned among the Germans." Dürer was not stung by the condescension; but his own pictures, compared with the easy flow of the Italian rhythms, appeared to him as somewhat graceless and rigid, and he undertook to paint in the Southern style. His results were not unworthy, but they were inferior to his models, and he was too big a man not to acknowledge the discrepancy. Taking his patriotism in both hands, he returned to Nuremberg, having written to a friend, "How I shall freeze at home, longing for the sunshine of Venice!"

Dürer's genius lay in his departure from classic conventions, in his realization of the supreme importance of ordinary human experience in the making of an original art. A Lutheran, he had attempted, in Italy, to depict the Christian faith in a foreign language, in symbolical forms evolved by the Catholic painters. In his last picture, summing up the knowledge of a lifetime, he painted his *Four Apostles*, the crowning achievement of Germanic art, and the greatest Protestant picture in the world. The two panels were not commissioned; they were presented to the city of Nuremberg "as a warning," the artist wrote, "against evil and falsehood, and an eternal admonition to truth, uprightness, sincerity and Christian love." Later, they were stolen by Maximilian of Bavaria and taken to Munich.

Dürer's intention was not to rival the Italian masters. The picture was painted in humility and superhuman gravity as an expression of his Christianity and his devotion to the Protestant cause. One of the panels represents John and Peter, the other, Paul and Mark; figures conceived and executed in the great style, but a Northern style with Dürer's human characterizations raised to monumental simplicity and grandeur, figures which would not shrink in stature if put beside the Prophets of the Sistine Chapel. It was this work that Goethe had in mind when he wrote: "In truth and nobility, and even in beauty and grace, Dürer, if one really knows him in heart and mind, is equaled only by the very greatest of the Italian masters."

*St. Jerome in His Study.* Print. 1514. One of the three most famous copper engravings by the loftiest mind that ever controlled this form of art. The old Saint is reading in a chamber of varied lights and surfaces, with his dog and pet lion resting near him.

[RIGHT] *Melancolia.* Print from copper engraving of 1514. The spirit of intellectual inquiry brooding over the limitations of the human mind, and accompanied by depressing symbols — the hourglass and bell, the sword and the instruments to measure the span of life.

# LUCAS CRANACH

1472–1553            GERMAN SCHOOL

THE great Dürer, returning reluctantly to the northern climate after the Venetians had feted him, lamented the ignominious position of the German artist at home; but his contemporary, Lucas Cranach, had no fault to find with the painter's lot. Cranach, unhampered by Olympian aspirations, was the founder of the Saxon school, essentially Gothic like Dürer, contentedly local, and also a great artist when the demands on his lightheartedness were not exorbitant. At the age of thirty-four, he was appointed court painter to the Elector of Saxony, at Wittenberg, where he lived long and prospered, active in art and commerce. He married the daughter of a wealthy patrician, and his loyalty and charm gained him the monopoly of the sale of medicine and patent rights on the printing of the Bible, a valuable privilege since he was a reformer and a close friend of Martin Luther. He was described by a famous humanist as "an artist who worked more rapidly than any other, who was always with a brush in his hand, and was never idle, not so much as a single hour."

Cranach painted many religious subjects, but his secular works are even more numerous. He loved to play with classical themes, and his elfin ventures into mythology are among the most diverting pictures in art. His favorite subject was Venus, whom he painted innumerably, and always in the spirit of comedy. In his *Judgment of Paris*, the goddess of love wears only a large red hat and a golden chain; her rivals are exhibited in golden chains and wisps of gauze, and Mars, a squat dolt, is dressed in a suit of armor. It used to be said that Cranach tried to imitate the classics and succeeded only in being indecent or preposterous. Nothing could be farther from the truth. He knew little about the Italians and cared less—he had a sense of humor and indulged it cleanly. He introduced the comic element into nudity without becoming bawdy or trivial—and no other artist of the first rank was equal to the performance.

*The Nymph of the Spring*, a mildly satirical fling at an old subject, is one of his painted family: they are all alike—utterly lacking in self-consciousness, as if they had worn nothing from birth but a necklace and bangle. Throw the emphasis in one direction or the other, and the effect is obtrusively naïve or shamelessly carnal. Cranach invented his own type of nude, and not a meaty German *Mädchen* by a long shot, but a slender high-waisted girl with a broad forehead, oblique eyes, and a small mouth and chin, and he painted the type with mirthful imagination and native candor.

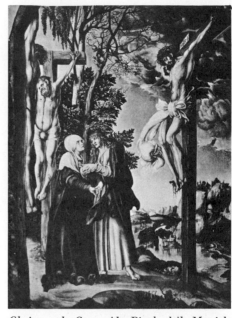

*Christ on the Cross*, Alte Pinakothek, Munich. Oil-tempera on wood, 55″ x 39½″, 1503. The ghastly figures on the crosses and the landscape were strongly influenced by Grünewald; the mourners, like all of Cranach's women, are without self-consciousness.

*Venus*, Frankfort Museum. Oil-tempera panel, 14⅜″ x 9¾″, 1532. The artist's favorite mythological subject and his semi-comical fling at the classical goddesses. The naïve, elongated, soft-contoured nude is his own development from the Cologne school.

[LEFT] *Nymph of the Spring*, Clarence Y. Palitz Collection, New York. Oil on wood, 18¾″ x 28¾″, after 1537. Color plate, page 143.

# LUCAS CRANACH

*Self-portrait*, Uffizi, Florence. Oil-tempera on wood, 26¼" x 19¼", 1550. Cranach in his best portrait style—grim and firm but not wooden, detailed without being trivial, unmistakably solid and Germanic.

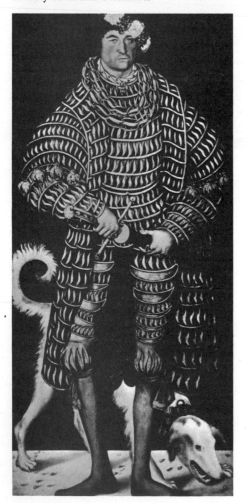

IT is a common belief that German painting is an inflexible language, strong in psychology and the revelation of character, but destitute of charm and gracefulness of form. There is some truth in the notion, as in most adages; but if the pictures of Cranach are to be accepted as the criterion, then German painting is the opposite of all that has been conventionally urged against it. Where, for instance, could one find a portrait of a child, which, if placed beside the *Saxonian Prince,* would stand the test of point-by-point comparison? Not in French painting where the reading of character is sacrificed to formal elegance; not in Italian art which is all on the side of the high and mighty; not in Great Britain where structure is compromised by sentiment—nowhere except in those wonderful portraits which Rubens painted of his own children. For the little *Prince,* in clear-cut, straightforward drawing, is only a step behind Dürer and Holbein; and in delicacy of workmanship, sympathetic understanding of personality, and rarest of all—in the most sensitive shades of pure charm—it makes no concessions to the child studies of any painter.

Cranach has been a misrepresented master. His flexuous, large-browed nudes have been used against him by all sorts of people to whom humor in nudity is equivalent to lewdness or the debasing of classical standards. But the man was an artist of the first rank, and the charm of his personality was expressed in his varied art with the tenderness and affection that endeared him to the great Emperor at the Augsburg conference, to the unbending Electors, the court, and the women and children of the court. Only less gifted than his two great countrymen, he was eminent in all departments of painting from religious subjects to portraits of human beings and animals. According to a friend and admirer, his paintings of stags "were so natural that strange hounds barked when they saw them." And in all his work and his fame, he remained an honest, industrious German, incapable of the omnipotent detachment of Holbein, and gracing all his characters with his own quiet personality. Even the little *Prince,* portrait likeness that it undoubtedly is, has the family resemblance—the wide brow and the small mouth and chin that he painted into a type to express the charm of his own spirit.

[LEFT] *Portrait of Duke Henry the Pious of Saxony,* Art Gallery, Dresden. Oil-tempera on canvas transferred to wood. 72½" x 33". Cranach painted many of the German reformers and their princely adherents. Duke Henry, hard of face, long of foot, and decorated to the point of burlesque, is not the most pleasing of the gallery.

[RIGHT] *Portrait of a Saxonian Prince,* National Gallery, Washington. Oil-tempera, 17⅛" x 13⅛", 1516-1518. Color plate, page 144.

# HANS HOLBEIN, THE YOUNGER

1497–1543                                                    GERMAN SCHOOL

THE most gifted member of a family of artists, son of the famous Holbein, the Elder, of Augsburg, Hans, the Younger, takes his place in art as the most objective of all portrait painters, if not the greatest. It is a debatable question whether the younger Holbein's career was deliberately centered on portraiture, but the fact remains that during his residence in England he created a memorial gallery of visual images which have made Henry VIII, his court, his wives, and his men, living presences in history, and not mere names. Oblivious of race, breeding, or sentiment, he painted the variations of character with impenetrable detachment. The only artist to be mentioned with him in the impersonal rendering of individuality is Velasquez; but the Spaniard, an aristocrat indentured to a king, unwittingly imparted to his dwarfs and infantas the dignity of his own person.

In the works of all portraitists, Holbein excepted, there exists a certain family resemblance. During the actual business of painting, the artist's personality, and even his physical characteristics, enter into his conception of his subject, the most obvious example being El Greco, whose people are but slight modifications of himself. Holbein, trained in the crafts, followed the general direction of the Rhine schools in his objective portrayal of the minute distinctions in human faces. There is no evidence in all his works that he lost control of himself or gave vent to his emotions. His portraits were based upon painstaking linear studies which, by universal consent, represent the absolute perfection of economy and skill in the drawing of heads.

His *Portrait of His Family*, painted in 1528 after his first residence in England, has been called "the most beautiful picture of the German school." The work was executed on paper, and the original background, an interior, was cut out when the picture was pasted on wood. The woman—of striking charm in an early drawing—has the reddened eyelids and the expression of a mother who had struggled to support her children, and the faces of the children are not happy faces. In its grouping, the painting recalls the Italian Madonnas with the Christ child and the young St. John, but the resemblance was accidental. Holbein painted his wife and children as he found them, dispassionately, but with all his powers of characterization, modeling the heads with the delicacy of a great sculptor working in bas-relief.

*Family of the Artist*, Museum, Basel. Paper on wood, 30″ x 25″, 1528. Color plate, page 145.

*The Madonna of Burgomaster Meyer*, Museum Darmstadt. Oil on wood, 58″ x 41″, about 1526. The family of Holbein's first patron kneeling before the Madonna. By using beautifully constructed portraits, the artist created a new type of votive picture.

[BELOW] *Christ in the Tomb*, Museum, Basel. Oil on wood, 79″ x 12″, 1521. An appalling masterpiece of realism, the body greatly lengthened, the suffering mercilessly rendered. Painted in the artist's twenty-fourth year and, according to tradition, from the corpse of a drowned man.

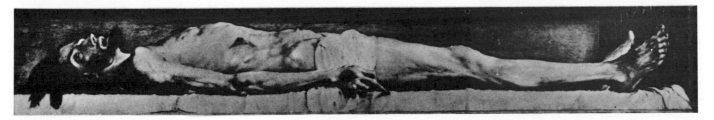

# HANS HOLBEIN, THE YOUNGER

## CONTINUED

*Erasmus of Rotterdam*, Louvre, Paris. Oil on wood, 16½″ x 12½″, 1523. Color plate, page 146.

THE delineation of character is the distinguishing contribution of German art. It dominates portraiture and is conspicuous in the most imaginative religious pictures: in Dürer's *Four Apostles*; in Holbein's one great work for the Roman Church, *The Madonna of Burgomaster Meyer*; and in the stupendous *Crucifixion* by the mystic, Grünewald. In Holbein, precision of observation is carried to its apex—not the optical search for intensities of light and dark as in Velasquez and the minor Dutchmen—but the grasp of the relations and differentiations of human features: the line of the profile, the shape and curve of the mouth, the depth and turn of the eye-socket—the components of the face as they co-operate to produce individuality.

In Holbein's art, the exact nature of a specific head was of first importance—before design, solidity, atmospheric light, or color saturation. This is not to say that his pictures do not hold together; they do—a little rigidly compared with those of Titian and Tintoretto—but without the supporting devices of contrasting lights or subtle colors in juxtaposition. He seized upon general outlines and significant details, the infinitesimal variations of structure, and compacted them into an inevitable form which established, once for all, the face and character of Erasmus, of his family, or the vacuous countenance of Anne of Cleves, the playing-card Queen whom Henry VIII dismissed as "a Flemish mare."

In his nineteenth year, seeking employment in Basel, Holbein was commissioned by a printer to make the marginal illustrations for *The Praise of Folly*, a book written by a little Dutch scholar named Erasmus who had come down from Rotterdam at the behest of his publisher. In the ensuing friendship between scholar and artist, Holbein painted, at twenty-six, several portraits of Erasmus, among them the masterpiece now in the Louvre. No other artist ever modeled the human head with such imperceptible gradations of tone, or contrived to present in such sharp relief the essentials of the individuality of his subject—the trenchant features of the foremost intellectual of his day, and the hands that penned his treatises. In the refinement of contour, the precision of craftsmanship, and the analysis of character, Holbein's *Erasmus* is unequaled in portraiture.

*Self-portrait*, Uffizi, Florence. Colored chalks, 9″ x 7″, 1543. Drawn shortly before the artist's death with a ruthless integrity that softened the features of nobody, not even himself.

[RIGHT] *King Henry VIII*, Corsini Gallery, Rome. Oil on wood, 32½″ x 29″, 1539. The most sumptuous of the portraits of King Henry, but done without concealing the size, grossness and cruelty of the monarch's face.

# HANS HOLBEIN, THE YOUNGER

## CONTINUED

AT Basel, Holbein had painted murals and religious pieces, but his ambitions in wall decorations were thwarted by the rising hostility against the representation of saints, and the vandalism of the iconoclasts. It was fortunate for art that circumstances prevented further excursions into large-scale compositions, and that he was obliged to direct his activities into other fields. In 1526, armed with a letter from Erasmus to Sir Thomas More, he departed for England. "The bearer of this letter, Holbein," the scholar wrote, "is the man who painted my portrait. Here the arts are shivering with cold, and he is going to England to pick up a few shillings."

The decision changed the course of Holbein's life and art. He was welcomed by the English, and with the exception of two visits with his long-suffering family in Switzerland, he lived in London until the plague cut him down in mid-career. He was a cold-blooded businessman of painting; he gave little of himself in his friendships, espoused no cause, flattered no queen or minister of state, and retained his position by a portrait art of perspicuous and undisputed greatness. First, under the protection of Sir Thomas More, he painted the clergy; when More was retired, he attached himself to an organization of German merchants; in the last decade of his life, he was the court painter of Henry VIII. He transmitted the divorcing monarch's face and bulk to posterity; painted the frail Jane Seymour who died at the birth of Edward VI; was despatched to Flanders to examine the nubility of Anne of Cleves whose obtuseness he rendered decoratively; and was never without the custom of some nobleman, courtier, lord, or lady, whose faces are familiar to everyone.

In all these portraits, Holbein displays nothing of himself save his style and his imperturbable objectivity. He is one of the few artists capable of portraying, with convincing veracity, types alien to his own race and upbringing. His English subjects are unmistakably British—from the structure of their jaws, one can almost hear them speaking with an accent. They are never animated; they are pompous and reserved—but they are alive, and their nobility was conferred upon them by the artist's mastery of a great style. *Edward VI*, the last of several portraits of the only and adored son of Henry VIII, is beautiful evidence that Holbein's portraits, among all those painted by great artists, are the clearest and most precisely individualized.

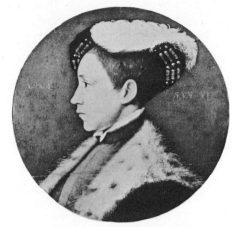

*Edward VI as Prince of Wales*, Bache Collection, Metropolitan Museum, New York. Oil, 12¾" in diameter, about 1543. Color plate, page 147.

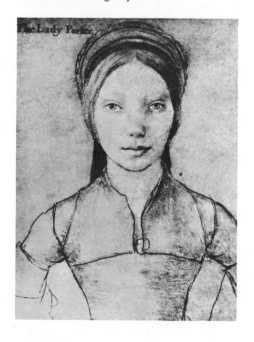

*Lady Elizabeth Parker*, Windsor Castle. Chalk drawing, about 1540. An English face unquestionably, but, for reasons hard to define, an appealing face, designed, without flattery, to balance the strange eyes.

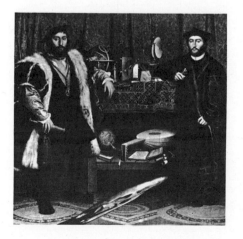

[LEFT] *The Ambassadors*, National Gallery, London. Oil on wood, 81¼" x 81½", 1533. A showpiece made for the British. The French Ambassador and his friend, the Bishop of Lavour, are presented with great dignity amid furnishings depicted with dazzling skill. The huge, foreshortened skull is a pictorial translation of the word Holbein.

# MATHIAS GRÜNEWALD

1480?–1530?                                        GERMAN SCHOOL

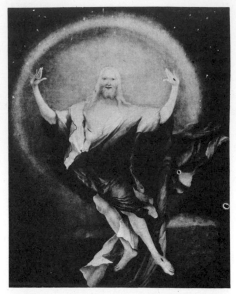

Detail from the *Resurrection*, outside, right-hand panel of the Isenheim altarpiece, Colmar. The Lord rises from the tomb by divine power, his dead-white arms silhouetted against a brilliant nimbus of glory.

No artist ever saw a man crucified, yet thousands have painted the Crucifixion. The great Italians, consciously seeking the union of spiritual and formal perfection, achieved a decorative grandeur in which the subject was separated from the emotions of living men; the medieval artists, concentrating on the manifestations of torture, created gruesome images from which the modern mind recoils in horror. But an obscure German from the middle Rhine, unafraid of corporal agonies and possessed of appalling mystical insight, painted one of the supreme masterpieces of art, above and apart from all others, the most profoundly moving conception of the most tragic theme in art. Grünewald never saw a man crucified, but he painted the scene as if he had been a follower of Christ, an eyewitness at Calvary, and reincarnated in German flesh, surrounded by suffering and acquainted with the attitudes of men and women in the throes of suffering, he invested the tragedy with its full significance.

Less is known of Grünewald than of any other artist of the first rank. It is told on good authority that "he lived a solitary and melancholy life and was wretchedly unhappy in his marriage"; and his fame rests on the altarpiece painted for the monastery at Isenheim and now in the Colmar Museum. When unfolded, the work, a polyptych of eleven wings, represents in brilliant, luminous colors, scenes from the life of St. Anthony, the patron saint of the monastery; the Annunciation, Nativity, and Resurrection; when closed, one great picture appears, the *Crucifixion.*

The body of Christ, flayed, covered with bruises, bleeding and distorted, hangs on the cross erected on a rocky plateau; on one side stands John the Baptist whose prophetic words are inscribed in Latin—*He must increase, but I must decrease.* On the other side, in a group which has the dramatic intensity of an observed convulsion, the Virgin, all in white, sinks into the arms of St. John robed in scarlet, while between them, the kneeling Magdalen raises her clasped hands toward the cross. Before this work, formal criticism is helpless. The strained attitudes and the physical torture, which might have been ghastly and medieval, are sublimated into an effect which can only be described as beautiful and overpowering. The altarpiece is one of the great shrines of art, and painters who journey to Colmar to study its form and color are converted by the tragedy of Calvary.

Detail from *Holy Night*, central panel of the incredible Colmar altarpiece. The Virgin, with flowing red-gold hair and robed in blue and gold, holds the newborn Child.

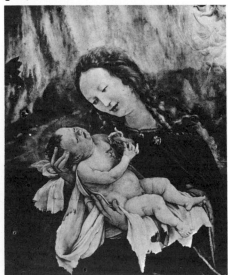

[RIGHT] *The Crucifixion*, Museum, Colmar, Alsace. Oil, 8′ 9½″ x 10′ 1″, 1510-1511. Color plate, page 148.

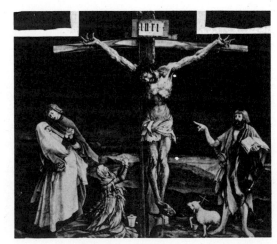

# HIERONYMUS BOSCH

1450?–1516?                                                FLEMISH SCHOOL

HIERONYMUS VAN AEKEN, commonly known as Jerome Bosch, took one of his surnames from the original nest of the family at Aachen, Aix-la-Chapelle, and the other from Hertogenbosch, Bois-le-Duc, where he was probably born and where he certainly lived and died. Esteemed in his own time for his fantastic variations of popular scenes, he was superseded, after his death, by the pseudo-classical devotees of the Italian Renaissance; forgotten in the eighteenth and nineteenth centuries; and only a few years ago restored to his position as one of the greatest of Flemish masters. His rehabilitation, in part, may be ascribed to the laudations of the Surrealists who discovered in him the highest authority for their own private nightmares and symbolical paraphernalia. Documented references to his life are meager and open to contention. He was mentioned in the registers of a semi-monastic fraternity for which he staged mystery dramas, and it is on record that he designed stained glass windows for a church and painted a *Last Judgment* for Philip the Fair. No further commentary on his career is to be had except his thirty extant paintings, one a self-portrait, and a batch of remarkable drawings.

Bosch appeared during the last convulsive superstitions of medieval thought —when the fears of death, haunting rich and poor alike, were personified in grotesque forms and diabolical imagery, most of it the indecipherable clap-trap of a departed day. Helping himself to the accumulated emblems of witch-craft and inventing many of his own, he created pictures which astonish, delight and mystify the modern beholder. He is often construed as an icono-clast, or heretic, far in advance of his period, hurling cryptic satirical dramas and profound pictorial attacks at his benighted countrymen, but this conception is specious and unproved. Bosch was known to be an orthodox Catholic and his diabolical machinery, though critical and irreverent, was not necessarily of malicious purport. It is enough that he was a great artist with a Rabelaisian sense of humor, and that he opened the modern avenue leading to Breugel and Rubens.

*The Ship of Fools,* painted about 1500, represents the old Flemish sorcerer in one of his best moods. The canvas was inspired by a contemporary book of the same title, an account of the voyage of wayward men and women, secular and religious alike, to the Isle of Folly, in order to indulge their carnal devia-tions, and a subject lending itself perfectly to Bosch's imaginative powers. In addition to its burlesquing of ludicrous medieval follies, the painting is a rare example of the artist's technical skill—his sharp execution and the beautiful surfaces which shine out like enamels.

*The Ship of Fools,* Louvre, Paris. Oil on wood, 22" x 12⅝", after 1500. Color plate, page 149.

*Christ Bearing the Cross,* Musée des Beaux Arts, Ghent. Oil on wood, 29" x 32", after 1500. A howling, bloodthirsty mob surrounds the abject figure of Christ in a close-up treat-ment similar to Bosch's *Christ before Pilate.*

[LEFT] Detail of *Christ Bearing the Cross,* Ghent. The hideous faces, viewed at close range, suggest that the artist must have known, somehow, Leo-nardo's caricatures.

# FRANS HALS

1580?–1666    DUTCH SCHOOL

*Vrouw Bodolphe,* Stephen C. Clark Collection, New York. Oil on canvas, 4′ x 3′ 2½″, 1643. Color plate, page 150.

*Hille Bobbe,* or *Malle Bobbe,* Kaiser Friedrich Museum, Berlin. Oil on canvas, 30″ x 25½″, about 1650. Though executed after his best energies had been debauched by drink, the portrait of the old witch of Haarlem, with her imbecile grin and the symbol of lunacy perched on her shoulder, remains a bravura job of the first rank.

[RIGHT] *Women Regents of the Old Men's Home,* Museum Haarlem. Oil, 66″ x 98″, 1664. Painted in monochrome when Hals was an old man of eighty, the tired bloodless faces, the thin hands, the upstanding pride—all done with a sympathy and capacity surpassed only by Rembrandt.

THE most independent and completely nationalistic outburst of painting in history is the Dutch school, which began with Frans Hals and passed out of existence in the seventeenth century—an outburst indeed, for the whole movement was born and buried in little more than two generations. In this brief period, Holland was overrun with painters, thousands of them; far more than she could use, and a good picture would hardly fetch the price of a square meal. Before the formation of the Republic, Dutch painting was indistinguishable from Flemish; it was a bastard Italian product, absurdly pretentious and utterly empty—but practically extirpated by the Reformed Church. The impetus to a self-sufficient art appeared with the struggles of Holland against Spanish oppression: a part of her energy and unparalleled powers of resistance was diverted into painting. The final peace with Spain was not signed until 1648; all the important artists were born before that date, and all painted to the roar of the cannon and the marshaling of troops. It takes courage to paint in such circumstances.

Hals had plenty of physical courage, but of moral courage, not a shred. By profession he was a painter; in other respects, a pot-walloper of genius. An insatiable drinker in a society of guzzlers, he painted, drunk or sober, with enormous vigor and equal integrity; at his best, with magnificent self-control; at the other extreme, in slipshod streaks and patches—but never as a hack or a pander. Moved by no strong prejudices or convictions, Hals portrayed people of all degrees and kinds, but was most successful with fishwives and tavern heroes. He was a man of sudden intimacies and friendships formed on short notice. At a single glance, he caught the personality of his subjects and the social stratum in which they moved, and he developed—how, no one quite knows—a technical instrument to preserve his impressions. *Vrouw Bodolphe* is an example of his more exact and reserved style, and of his unrivaled ability to bring his sitter out of the picture plane and close to the spectator, as if to abolish all formalities of presentation. It is a swift impression of a woman, but a true and lasting one, a character and a type painted throughout with care and finish, but retaining the liveliness and spontaneity of a preliminary sketch.

FOR two centuries after his death, the works of Hals were held in such low repute that his most famous paintings were sold at auction for a few shillings. The rehabilitation came with Manet, Whistler, and Sargent who championed the old toper of Haarlem for two reasons. His technical agility and the unforced naturalness of his style were leveled, as a counterblast, against the stilted artifices of the academicians—there is no more deadly weapon with which to slay the custodians of a threadbare tradition than a rediscovered old master. Second, his point of view was that of an impressionist: he seized upon a specific instant in the life of his sitters, and reproduced, as expeditiously as possible, a visual image of nature, a portrait image unsullied by his own philosophies.

How Hals acquired his fluid style of painting is not altogether clear. He was born at Antwerp where his parents were living as refugees to escape the Spanish terror; and it is more than likely that he was, in his student days in the Flemish city, associated with Rubens. But the most important factor in the formation of his personal style was his mode of living in Haarlem. Hals was dissolute and ungovernable, and was forced by necessity to develop a technique enabling him to knock off a portrait at one sitting after a night's debauch, and to paint in adversities which would have killed a man of less stamina and conviviality. The death of his first wife from a beating he had given her did not deter him; he married a second and brought up ten children, among them seven sons whom he trained in his own occupation. Some of his best pictures date from his bankruptcy, while his second wife lay dying; in his eighties, an inmate in an almshouse, he painted group portraits of the governing boards.

In a mood of Bohemian heartiness, Hals painted *A Man with a Beer Keg*, responding, with a lighter palette and a careless certainty of touch, to the facial animation of a jovial tippler. He painted all sorts and conditions of life from sharpshooters of the military guilds to half-cracked women with parrots, but his most extraordinary technical performances were inspired by his cronies. In his realistic manipulation of paint, Hals has a place of his own in art. In his ability to capture what is known as a speaking likeness, to map out the features of his subject in broad half-tones, adding lights and shadows in swift strokes which seem to hit the mark by drunken good luck, but which were actually laid on with an infallible sense of fitness, he has never been excelled.

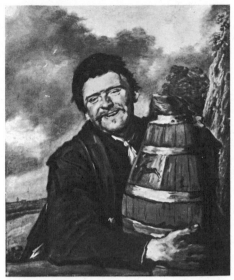

*A Man with a Beer Keg*, Henry Reichhold Collection, Detroit. Oil on canvas, 32½″ x 26½″, about 1635. Color plate, page 151.

Detail from *A Banquet of the Officers of the Civic Guard*, Haarlem.

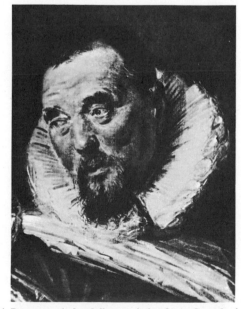

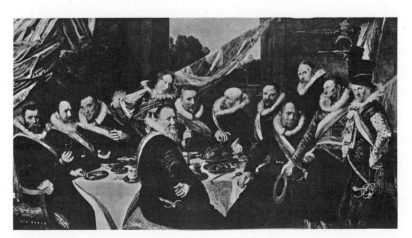

[LEFT] *A Banquet of the Officers of the Civic Guard of St. George*, Museum Haarlem. Oil on canvas, 69″ x 130″, 1616. The first of a series of pictures made for the amateur archers of Haarlem, and a great group composition by any standard. The solid fighting men who repulsed the Spaniards are immortalized in Hals's swift new style.

# REMBRANDT VAN RIJN

1606–1669                                       DUTCH SCHOOL

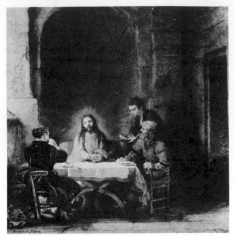

*The Supper at Emmaus,* Louvre, Paris. Oil on wood, 27″ x 25½″, 1648. Color plate, page 152.

REMBRANDT's life is the growth of the human spirit toward complete freedom; in the end, he attained that freedom, but at the price of poverty, ostracism, and enormous self-discipline. His art is the record of the fundamental experiences of mankind, of things which most deeply concern the groping human race. The great Italians were lofty souls who viewed their fellow men from afar; the minor Dutchmen looked too closely and saw only the surfaces; Rembrandt, neither detached nor literal, was concerned with humanity that had been sorely tried, with the marks of suffering, and the imperturbable repose that comes to man after he has conquered his afflictions. He rose from the humblest station in life, outdistanced all competitors as a successful portrait painter, and then renounced fame in order to liberate himself from money-grubbing. His acquaintance with sorrow ripened as he surveyed death: three of his children died in infancy; while the Dutch musketeers were haggling over *The Night Watch,* his wife, Saskia, wasted away. Bankrupt and forgotten, he lived in the ghetto of Amsterdam, attended by his loyal housekeeper, without pride, resentment, avarice, or servility—a free man, one who approached his subjects with unconditional purity of spirit.

Rembrandt was not an orthodox Protestant, but he accepted the faith of his times, and discovered in the Bible—the only book he ever read—dramatic stories which, on reflection, seemed to inculcate spiritual states inherent in all races. *The Supper at Emmaus,* painted in 1648, is one of the great pictures of the world, the culminating expression of the unifying purpose behind his work—the consciousness of the tragedy of human life. The story, from St. Luke, tells how two disciples met Jesus after the Resurrection and did not know Him, and how, at Emmaus, the Lord "took bread and blessed it, and their eyes were opened, and they knew Him, and He vanished out of their sight." Rembrandt painted the scene, with its mystical implications, in human terms to show the effect of the presence of Christ on His humble followers; and with his miraculous power over light, bathed the characters in an atmosphere of tone that is truly supernatural. No other artist, not even Leonardo, succeeded in presenting the Lord as a living entity, a man of resignation and sorrows, but at the same time, instinct with divinity. No other painter approached the subject with such gigantic humility, and with a technical knowledge that advanced with the artist's capacity to diagnose the inscrutable burdens of the soul.

*Self-Portrait with Saskia,* Dresden Gallery. Oil on canvas, 64″ x 52″, about 1634. Painted shortly after the artist's marriage, in honor of his bride, and one of his few pictures expressing the joyous side of life.

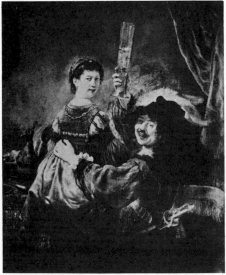

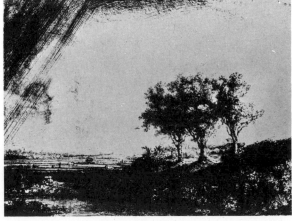

[RIGHT] *The Three Trees,* etching. 1643. After the death of his wife, the greatest of all etchers turned to nature for consolation. In *The Three Trees,* he conveyed the freshness of a landscape after a passing shower.

· 120 ·

# REMBRANDT VAN RIJN

AT THE age of twenty-six, Rembrandt seemed to possess all the qualities requisite to popular success. He competed with the tribe of portrait servants of Amsterdam and swept them from the field; at a time when canvases went for next to nothing, he commanded high prices for his work, receiving commissions from shooting fraternities, syndics, or officers of the guilds, and private traders of means. Three times in his life he painted group portraits of men; first, in *The Anatomy Lesson*, a memorial for the surgeons' guild and an error of genius—superlative in its craftsmanship, but conforming, in its glassy tightness, to the pleasure of his clients. After *The Anatomy Lesson*, he enjoyed a decade of prosperity, turning out popular pictures to indulge his wife's love of finery and his own passion for collecting, and reserving his best energies for religious pieces.

In 1642, he painted his second portrait group, *The Night Watch*, an experiment that pleased nobody, least of all the civic guards who ordered and rejected it on the ground that it did not do justice to their military visages. It is not his mightiest work, but it is fabulously dramatic in its organized confusion and its red and gold forms blazing out of a subterranean murk. After *The Night Watch*, the tide of popular favor turned against him, but he pondered his vicissitudes with curious equanimity. His wife died; his housekeeper was publicly reprimanded for "living in concubinage with Rembrandt, the painter"; he was sold out, and became wholly dependent on his son in the most disreputable quarter of Amsterdam.

While involved in these calamities, Rembrandt was pouring the light of his genius into the cavernous spaces of the soul; and through the influence of a wealthy dyer, an old pupil, he was commissioned to paint the group portrait of *The Syndics of the Drapers' Guild*, his last work of this kind, and the greatest work of the kind in existence. It netted him nothing—the money was seized by creditors in satisfaction of old claims. He painted the *Syndics* with the same soul-examining fervor and psychological insight that went into his conception of Christ. The men are portraits, solid bourgeois governors in big hats—the most massive heads ever painted—no misshapen jaws, no loosely hinged parts, no weaknesses anywhere. But he painted into them the full force of his humanity; and the depth and strength and wonder of the group come from the new and personal valuations he put on the old human stuff.

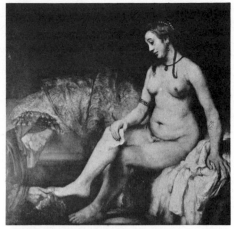

*Bathsheba*, Louvre, Paris. Oil on canvas, 56" x 56", 1654. The model was Hendrickje Stoffels, the saintly peasant consort of the artist, presented not only as a wonderfully plastic nude, but as an emblem of mutual sorrows.

Detail from *Bathsheba*, Louvre. The language of paint can go no further—not only in technical perfection, but in the shaping of the nobility of a human head.

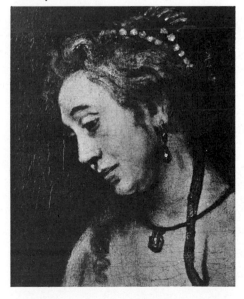

[LEFT] *The Syndics of the Drapers' Guild*, Rijks Museum, Amsterdam. Canvas, 71" x 109", 1661-1662. Color plate, page 153.

# REMBRANDT VAN RIJN

*Portrait of Himself*, National Gallery, London. Oil on canvas, 33½″ x 27″, 1659. Color plate, page 154.

IN REMBRANDT's portraits of himself, the world has the full history of an artist who won and lost the material satisfactions of life, but gained, at last, the ineffable comfort that settles on the soul of man when he has finished a great work; when, without malice or reserve, he has given expression to his burdens, and thus put them from him. As a youth, he made countless studies of his face, his intention being to show how the human countenance reflects the various moods and passions; but all that is visible in those first studies is a tousled, bull-necked young man acting before a mirror. Next, he painted himself at the flood of his prosperity, proud and cavalier, and once, holding Saskia on his knee, with laughter in his face—his only happy portrait. In his last years— for his imaginative life matured slowly, with his tribulations and the absolute self-discipline enabling him to disregard everything extraneous to his purpose —he arrived at the highest reaches of his genius and painted, in 1659, the *Portrait of Himself* here reproduced.

It might be said of this picture that the language of paint is incapable of further expansion; that it is impossible with pigment to achieve greater weight and massiveness and plasticity, in the sculptural sense; or a more perfect revelation of character—a character who stands like a rock before the world, disillusioned but spiritually uncontaminated. The picture is the work of the greatest master of tone in all painting. Rembrandt understood, as no artist before or since, the architectural value of light and dark masses, the structural wholeness of forms composed of tones instead of contours and precise outlines. With a few colors and tints, reds and browns, grays running into blacks, deep golden yellows and olive greens, he created pictures of supernatural luminosity. This picture is low in key, but it seems to be scooped out of an unfathomable mixture of radiance and shadow. After its completion, Rembrandt worked on with unremitting discipline, pushing the medium of paint farther and farther, laying the soul bare with a few strokes of the palette knife. In 1668, he painted the last of his self-portraits, a mask of colored mud laughing at the world which had tried so many times to beat him. When death came, the following year, it brought him no greater peace than the peace he had already won.

*Return of the Prodigal Son*, Hermitage, Leningrad. Oil on canvas, 104″ x 81½″, about 1688. The old biblical verities came back to him, and Rembrandt thought of himself, as he neared the end, as the returning prodigal.

[RIGHT] *Portrait of a Rabbi*, National Gallery, London. Oil on canvas, 30″ x 26″, about 1657. After the artist had been declared bankrupt in 1656, his friend, the Rabbi, gave him spiritual comfort and material aid.

# JAN STEEN
### 1626–1679    DUTCH SCHOOL

THE Dutch regarded the painter as nobody in particular. Why should they pay homage to a man who worked at an easel, they asked, and not to the soldier or the sailor who worked next door to death? Why should they attach importance to an occupation which could be practiced, as Frans Hals had proved, when a man was in his cups? As a result of this disesteem, the artist was forced into odd jobs in order to eke out a living, and Jan Steen, who should have been a popular idol, left five hundred unsold pictures to posterity—and the museums. There were too many painters in Holland.

Steen, with the exception of Rembrandt, is the greatest of the Dutch figure painters. He was born at Leiden, and as a student at the famous university of that town, painted—before he knew what he was about—mythological contraptions of singular juvenility. He studied painting with Van Goyen whose daughter he married; and although he was exceptionally productive and asked next to nothing for his pictures, he could not subsist by art alone. He lost money as a brewer at Delft, lived precariously in Haarlem, and in his last years managed to make ends meet by keeping a tavern in his native town, painting spasmodically, and not too carefully, between drinking bouts.

Steen was not merely a Dutch craftsman with a thirst for strong drink. He was an artist of pronounced intellectual capacities, a serious student of manners, and one of the best designers in Northern art. He painted the human comedy of Holland with sympathy and humor, and occasionally in a satirical spirit which has caused him to be ranked, not undeservedly, with Hogarth. He painted the interiors of wealthy houses and the coarsest tavern scenes, local versions of the Prodigal Son and the Prodigal Father, apothecaries, doctors with a bedside manner, festivals, and—as a good Catholic—religious subjects. Some of his individual figures, especially his seated women, have a largeness of form and, despite the rowdy context, a majesty worthy of Rembrandt and Rubens. *The Eve of St. Nicholas*, a Christmas pleasantry in which a lavishly indulged child is contrasted with a blubbering boy in whose shoe the holiday saint has left only a birchen rod, is characteristic of Steen's comic spirit, and of the draftsmanship and designing ability which lift him to the pinnacle of Dutch realism. The ease with which he brings figures together, without confusion or forced relationships, has won the attention of artists from Reynolds to the modern Americans.

*The Eve of St. Nicholas,* Rijks Museum, Amsterdam. Oil on canvas, 33½″ x 28″, 1663. Color plate, page 155.

*Oostwaard the Baker and His Wife,* Rijks Museum, Amsterdam. Oil, 15″ x 12″, 1658. Occupational scene with the fine, clear tonality and characterizations of Steen at his best. The artist loved children and put his own small son into the act.

[LEFT] *The World Upside Down,* Art Gallery, Vienna. Canvas, 41³⁄₁₆″ x 57⅛″, about 1663. Steen, a tosspot himself, painted the effects of drunkenness many times, usually dragging in a deacon or a nun to clear his conscience. The central figure, the relaxed young lady, pictorially and physically, is beautifully illuminated.

# JACOB VAN RUISDAEL

1628–1682                                    DUTCH SCHOOL

*The Wheat Field,* Metropolitan Museum, New York. Canvas. 40″ x 51″. Color plate, page 156.

*Ansicht des Damplatzer mit der Alten Wage, Amsterdam,* Kaiser Friedrich Museum, Berlin. Canvas, 20¼″ x 25½″, about 1670. One of Ruisdael's rare efforts at architectural painting, a carefully composed scene under a light sky for so somber an artist.

Detail from *The Cemetery.*

DUTCH landscape painting is a reflection of tranquillity; it does not employ nature as a vehicle to express the spiritual strife of man, and creates no vast scheme of relationships in which the accidents of light and shade are systematically flouted—it is a pleasure to the eye and as relaxing as a quiet polder. The Dutch loved their country—they had fought too hard for their possessions not to prize them—and while the love of nature and material possessions will not, of itself, produce art, the honesty and enthusiasm of their best men resulted in an effectiveness of presentation that is unquestionably creative.

Ruisdael, the most celebrated of the landscape school, has survived a long list of nature painters who, in their own day, appeared to be more original and important. This lonely, unlucky Dutchman, born in Haarlem, knew what he was about—as Constable, who copied him, expressed it, "He *understood* what he was painting." The wonder is that he had the time or the heart for the tireless observation that went into his pictures. He signed his paintings and etchings at the age of seventeen; at twenty was admitted to the painters' guild of Haarlem, and some years afterward, was duly licensed to practice at Amsterdam. From the character of his late seapieces and dark mountain torrents, he must have traveled in Norway—but that is conjecture. He was little appreciated by his countrymen and died in the poorhouse.

Ruisdael's landscapes are grave and somber. *The Wheat Field,* one of the best, is less dour in mood and lighter in tone, but compared with modern landscapes, devoid of positive colors. It never occurred to him to paint the earth in bright attire—he was a gloomy soul. But *The Wheat Field* has in abundance the understanding of nature Constable admired; the varied shapes and contrasts in the cloud formations, and precise knowledge of the growth of trees and the terrain of the fields. Ruisdael did not paint directly from nature, but from sketches and studies; nor did he, like his fellow Dutchmen, undertake to give a transcription of a particular locality. He took his sketches home to his hovel and from them, by the most careful planning—in his last years, by a formula—painted a landscape faithful to the general topography of Holland, but expressing the substantial plainness, the size and expanse, of his imaginary world—and the unobtrusive loneliness that pursued him. His English followers added freshness and sparkle to his designs, but none could match the old Dutchman in his ability to deliver the poetry of nature in homespun garments.

[RIGHT] *The Cemetery,* Detroit Institute of Arts. Canvas, 56″ x 74½″, about 1652. The second and more dramatic version of one of the most poetic landscapes ever painted. A purely imaginative work illustrating the power of nature to destroy man's handiwork.

# PIETER DE HOOCH

1629–1677                             DUTCH SCHOOL

BY some Dutch paradox, or possibly as a mark of his indomitable good sense, the Hollander wanted nothing heroic in his art. There had been, before Frans Hals, a snobbish attempt at classicism in the Italian manner, but that was only a minor flurry in a thoroughly indigenous and domestic movement. The Dutch burgher welcomed an art which was a substitute for nature, and brightened the dull interior of his house with small, intimate pictures of things nearest his heart. Whatever subject the artist might select, he was called upon to paint it within a limited field of vision and with minute objective accuracy. The illusion of surfaces engendered by the expert representation of natural light was so captivating and popular that it became the staple of all painters. The two masters of the craft of supermaterialism were De Hooch and Vermeer.

When it is related that De Hooch, the son of a Rotterdam butcher, was a footman in the house of a rich merchant; that he married a girl from Delft and painted his best pictures there; and that he died in Amsterdam in poor circumstances, nothing remains to be said—the rest is romance and speculation.

But there is nothing vague or speculative about the quality of De Hooch's paintings. His aim was as explicit as arithmetic, as transparent as a Dutch window. He set himself to the task of presenting figures in the calm light of day, sometimes in courtyards, again within doors, but always from outside illumination. In view of his astonishing results, his task would seem to have been an elementary problem, but technically, it was far from simple. Take his *Interior of a Dutch House,* for example, a masterpiece-in-little. De Hooch had no literature to help him, no dramatic action or lofty purpose: without technical perfection the picture would have been stale and unprofitable. A man like Van Gogh might stagger through a spiritual agony and still leave a residue of excitement—but half measures would have ruined De Hooch. Proceeding from a remarkable sense of scale and fitness—the picture is small in size and the figures in just proportions—he arranged the group in a felicitous lighting and intensified the lights and darks to enforce the architectural setting; and he painted surfaces and textures with mathematical neatness and precision—with a spotless craft in keeping with the rendering of a Dutch interior. The picture, in technique and in subject, is a model of decorative cleanliness, a glimpse of Dutch life that is completely satisfying.

*Interior of a Dutch House,* National Gallery, London. Oil, 29″ x 25″, about 1658. Color plate, page 157.

Detail from *Game of Skittles,* Cincinnati.

*Courtyard of a Dutch House,* National Gallery, London. Oil, 29″ x 23½″, 1658. One of two versions of a Delft courtyard. Designed in architectural terms, with the figures stationed in a clear, luminous atmosphere.

[LEFT] *Game of Skittles,* Cincinnati Art Museum. Oil, 29½″ x 25″, about 1665. The artist was not concerned with human passions. The figures are calm and composed; everything is tidy, immaculate and deftly arranged.

# JAN VERMEER

1632–1675          DUTCH SCHOOL

THE duplication of natural values or tones, which accounts for the unblemished clarity of De Hooch's pictures, was carried to the uttermost limits of tactile skill by Jan Vermeer, universally remembered by his cognomen, Vermeer of Delft. Of the life of this man, one of the most coveted of all painters, the records are scant in the extreme. There is nothing to indicate that he ever left his native town; he married at twenty and had eight children; his paintings brought comparatively high prices, but owing to his slow method of working, the size of his family, and his habit of buying paintings, he was always on the ragged edge and died in bankruptcy.

So seductive is Vermeer's craftsmanship that within recent years his works have been appraised in terms of the greatest masters. His paintings are among the rarest treasures in art: only thirty-six have come to light, and should a new one be discovered, it would make a bedlam of the auction market. But rare as he is in the number of his extant works, he is even rarer in that property of paint known as quality. Scarcity and quality, an invincible combination! Technically speaking, he painted by concentrated observation, with a preternatural ability to distinguish values and tones. He looked at his model, *The Cook*, in this instance, examined the fall of light and dark on her face and figure, apprehended the gradation in atmospheric density from the highest light to the deepest dark; and then, with brushes and paint, translated the array of appearances into an equivalent scale of colors. A thousand little Dutchmen did the same thing; and so did Velasquez, but on a larger scale and with more imposing models, and with a broad stroking—all of which made naturalistic appearances more grandiose and dignified.

Vermeer worked closely, weaving his pigments and blending his tones into a harmony of blues and yellows, into a surface which has the luster of ivory, the texture of enamel, the virginal purity of cool water. So delicately fused are his pigments that all evidence of the human touch has disappeared, as if nature herself, in some subtle mood, had crystallized her colors in glazed patterns. Thus his *Cook*, a piece of Dutch genre, has an indefinable quality that charms the eye and a richness of surface and texture suggesting a precious object which should be framed in pure gold and displayed in a cabinet of sealed glass.

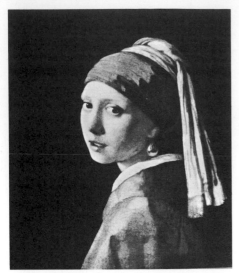

*Head of a Young Girl,* Mauritshius, The Hague. Oil, 18½″ x 16″, about 1670. Technically impeccable, in tones of blue and yellow, this head is a masterpiece beyond price.

*The Artist and His Studio,* Czernin Gallery, Vienna. Oil, 4′ 4″ x 3′ 8″, after 1670. Vermeer's only self-portrait—and a back view at that. The painter at his easel, with his model bedraped in exotic style, in a room with the usual properties, a brocaded curtain, a map, and a tiled floor.

[RIGHT] *The Cook*, Rijks Museum, Amsterdam. Oil on canvas, 18″ x 15″, about 1657-1660. Color plate, page 158.

# JAN VERMEER

VERMEER's canvases have that quality of surface described by Proust in his study of a morbid writer who despaired of his art because he could not, with all the resources of the written word, rival "the perfection of a little patch of yellow in one of Vermeer's paintings." His subjects are small interiors: in his earlier works, a room with a tiled floor, a gray wall hung with a map or a picture—one that he had purchased at the expense of the family larder; to the left, a window, and in the middle, a woman standing at a table, pouring milk or reading a letter; in his last period, seated girls, one wearing a hat with red plumes, another—here reproduced—wearing a decorative Chinese hat.

In the fastidious adjustment of tones, Velasquez alone is Vermeer's equal; but in the projection of forms in serene space, the Spaniard comes off second best. How long Vermeer worked on a painting will never be known, but it must have been the labor of months to effect the distribution of light which made it possible for him to separate a head, no larger in area than a postage stamp, from the background of the wall. His technical ingenuity defies analysis, one writer having advanced the theory that he used a system of mirrors in order to observe from a single point of view the reflections and intensities of light in every part of the room. His textures are such perfect replicas of surfaces that his table covers and stuffs strike the eye, not as painted illusions, but as actual materials preserved in amber glazes. Vermeer's attainments in this direction cannot be praised too lavishly. He resembled a diamond cutter in his manner of working and in his handicraft, adding globule to globule of paint to fashion a jeweled object, just as the lapidary, with infinite skill, adds facet to facet to bring out the splendor of an expensive substance.

Vermeer's art makes small claims on the imagination; nor has it exerted perceptible influence on the larger developments of painting. It would seem, in its decorative color and beautiful compactness, to have been aloof and isolated—yet it was part of a natural tendency, and it contains the quintessence of a period. His *Girl with a Flute* is the last word in craftsmanship and the last word in the glorification of materiality—a golden note in the Dutch chorus of honest rejoicing in their possessions.

*Girl with a Flute*, National Gallery, Washington. Oil, 7⅞" x 7", about 1660. Color plate, page 159.

*Woman Reading a Letter*, Rijks Museum, Amsterdam. Oil, 19½" x 16", after 1670. In a perfectly adjusted pattern, Vermeer, the master of natural tones, raises a little picture to monumental stature.

[LEFT] *View of Delft*, Mauritshius, The Hague. Oil, 35½" x 46", about 1658. Vermeer's single outdoor canvas, and an immortal compliment, in tones of crystalline purity, to his native town.

# MEINDERT HOBBEMA

1638–1709                                            DUTCH SCHOOL

[ABOVE] Detail from *The Water Mill with the Great Red Roof*, Art Institute, Chicago.

[BELOW, RIGHT] *The Water Mill with the Great Red Roof*, Art Institute, Chicago. Canvas, 31¾″ x 43⅛″, before 1670. Color plate, page 160.

[BELOW, LEFT] *Avenue at Middleharnis*, National Gallery, London. Canvas, 1689. Known in reproductions the world over. Not only a triumph of perspective, but a severe geometrical design almost unique in northern painting.

THE Dutch demanded in their pictures, not the fighting but the things fought for; not the heroic but the homely; not the battlefield but the quiet meadow and the millpond. It was a democratic art conceived and executed by plebeians to satisfy the tastes of the masses; a domestic art appropriate as garniture for small interiors; a materialistic art dealing with the agreeable aspects of everyday things. Dutch painting was a mirror of Holland, the most perfect reflection of a country, perhaps, that has been thrown upon canvas—so perfect indeed that, once the inventory had been taken, there was no further need for art, and Hobbema, who died in 1709, was the last Dutch painter of importance.

The events of Hobbema's life and the chronology of his paintings are inextricably confused. It is generally agreed, from the similarity of their styles, that he was a pupil of Ruisdael; it has come to light that he was married at the age of thirty and was the father of four children; that he lived in penury in Amsterdam not far from another poor man, Rembrandt; and that he died in destitution and filled a pauper's grave.

Hobbema's working life was spent in a little corner of the Dutch countryside, which he mastered with a completeness of observation that has never been approached except by the old Mississippi River pilots who studied every snag and ripple from St. Louis to New Orleans. Day after day, in all seasons and weathers, he examined the trees and undergrowth, the clouds and atmosphere, the streams and stagnant water, in every complexion of light and transparency. And his memory was something to put other visual memories to shame; for his pictures, which seem so literal and closely observed, were not painted on the spot but in his workshop by force of visual habit. He knew the red-roofed mill by heart; and by the trustworthy rule of trial and error finally painted a version of it which aroused within him sentiments comparable to those experienced in the presence of the scene itself. Among the thousands of Dutch landscapes of unremembered quaintness and sentimentality, the *Water Mill* lives forever, affording the modern mind both a release from the ferments and tragedies of Italian art, and a refuge from a mechanistic civilization—not a romantic dream out of Watteau, but a sturdy world of restful production.

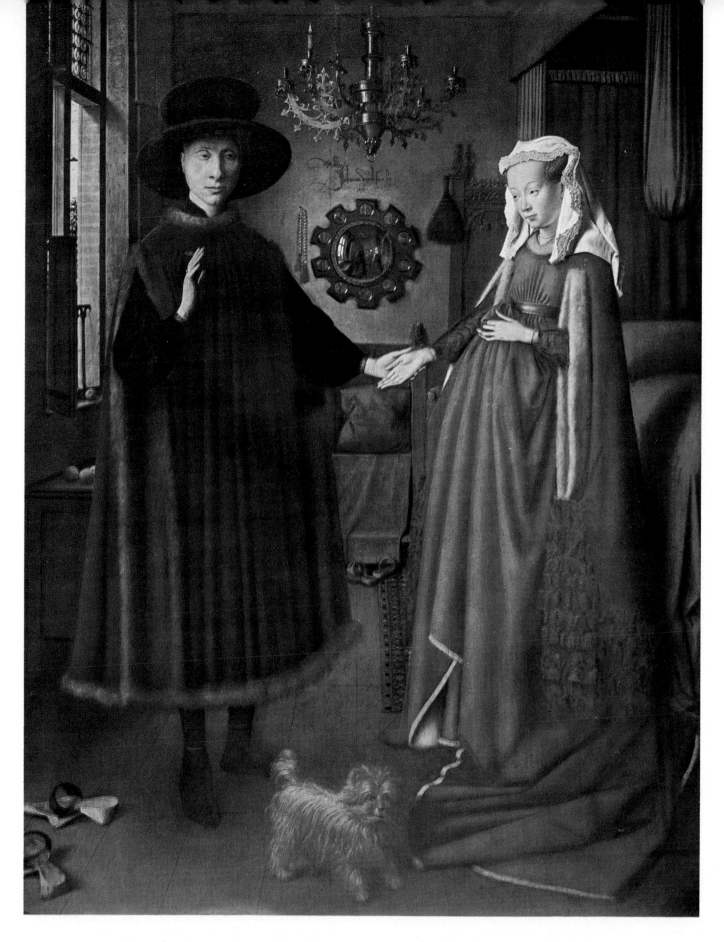

49. *John Arnolfini and His Wife* · JAN VAN EYCK · National Gallery, London. Text, page 97.

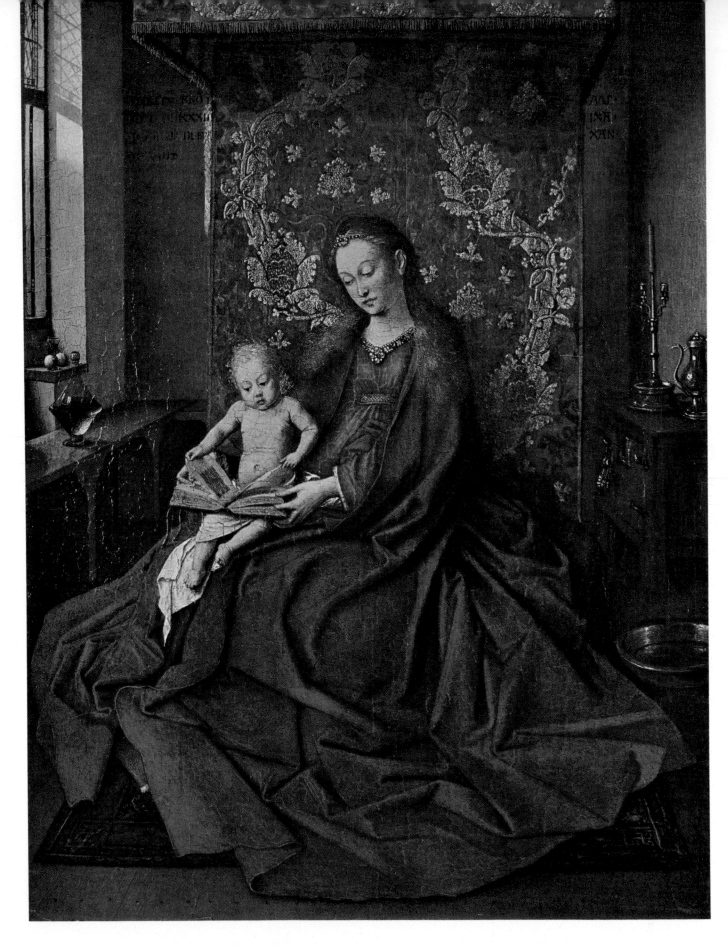

50. *Ince Hall Madonna* · JAN VAN EYCK · National Gallery of Victoria, Melbourne. Text, page 98.

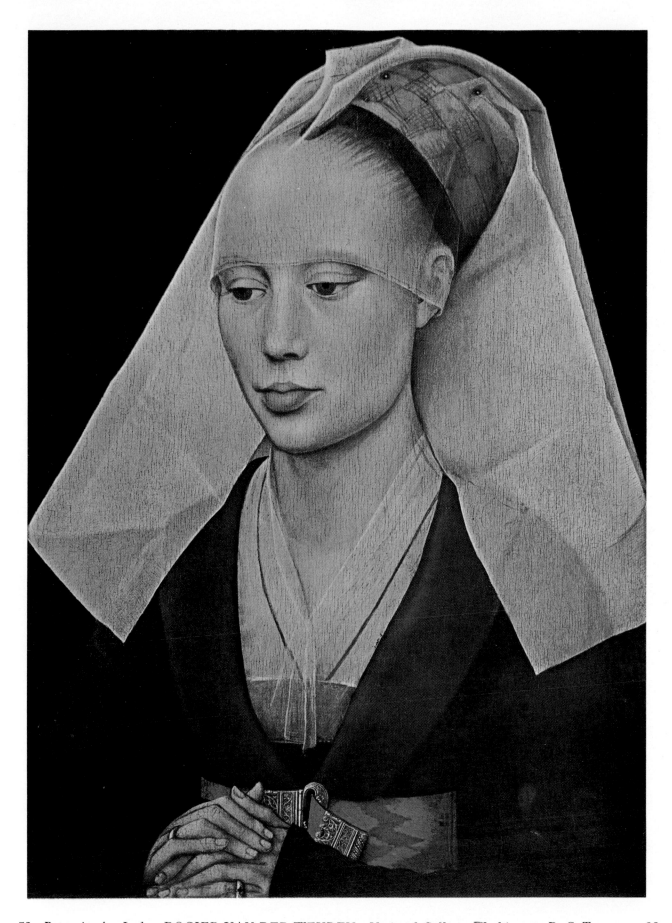

51. *Portrait of a Lady* · ROGIER VAN DER WEYDEN · National Gallery, Washington, D. C. Text, page 99.

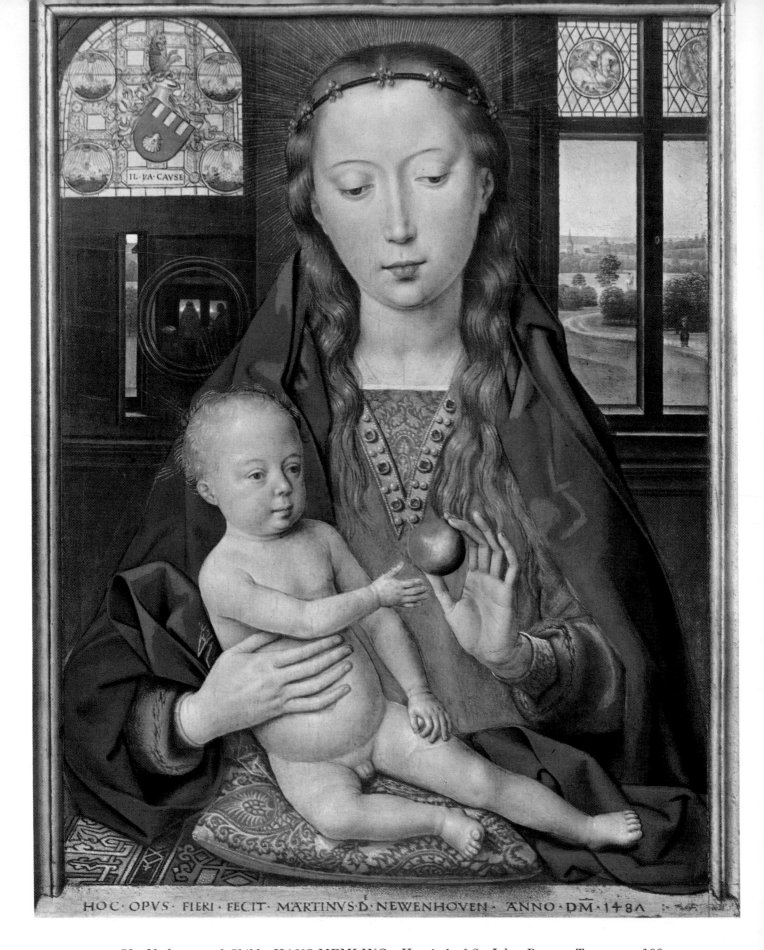

HOC · OPVS · FIERI · FECIT · MARTINVS · D · NEWENHOVEN · ANNO · DM · 148Λ

52. *Madonna and Child* · HANS MEMLING · Hospital of St. John, Bruges. Text, page 100.

53. *The Wedding Dance* · PIETER BRUEGHEL · Institute of Arts, Detroit. Text, page 101.

54. *The Fall of Icarus* · PIETER BRUEGHEL · Museum of Fine Arts, Brussels. Text, page 102.

55. *Hunters in the Snow* · PIETER BRUEGHEL · Kunsthistorisches Museum, Vienna. Text, page 103.

56. *The Judgment of Paris* · PETER PAUL RUBENS · National Gallery, London. Text, page 104.

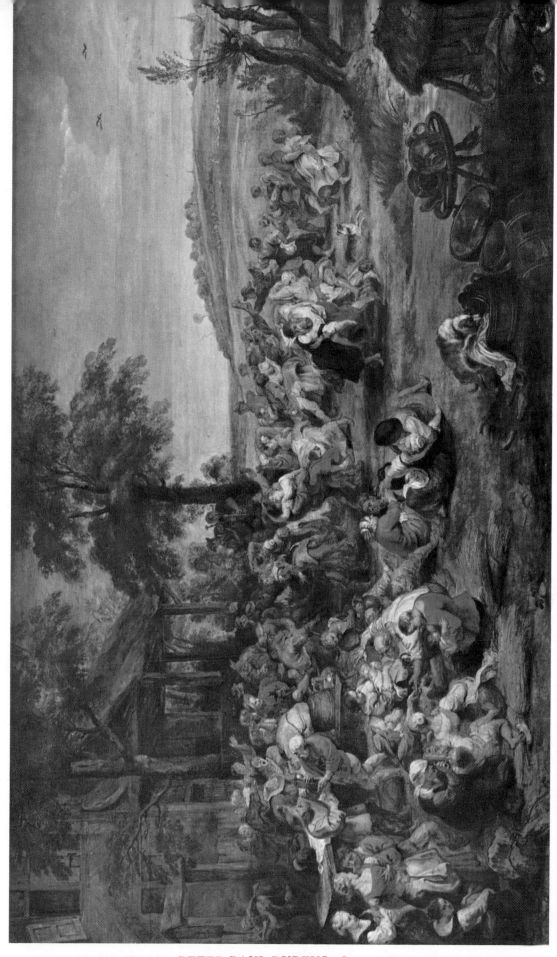

57. *The Flemish Kermis* · PETER PAUL RUBENS · Louvre, Paris. Text, page 106.

58. *Rubens and His First Wife* · PETER PAUL RUBENS · Alte Pinakothek, Munich. Text, page 105.

**59.** *The Marchesa Grimaldi* · ANTHONY VAN DYCK · National Gallery, Washington, D. C. Text, page 107.

60. *Portrait of Hieronymus Holzschuher* · ALBRECHT DÜRER · Kaiser Friedrich Museum, Berlin. Text, page 108.

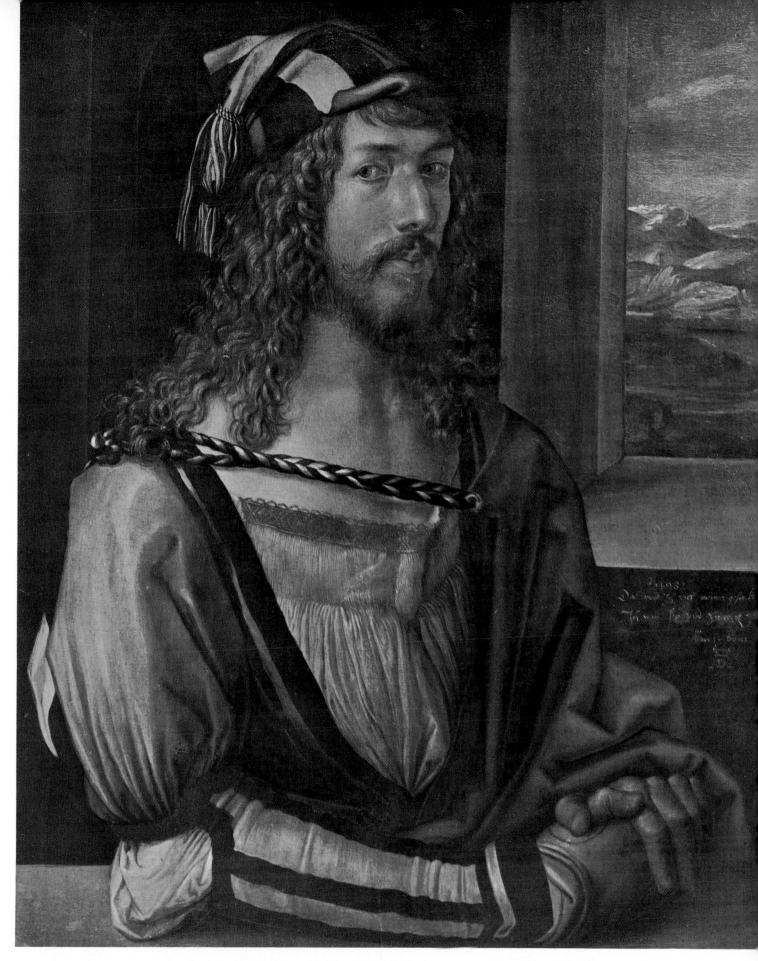

61. *Portrait of the Artist as a Young Man* · ALBRECHT DÜRER · Prado, Madrid. Text, page 109.

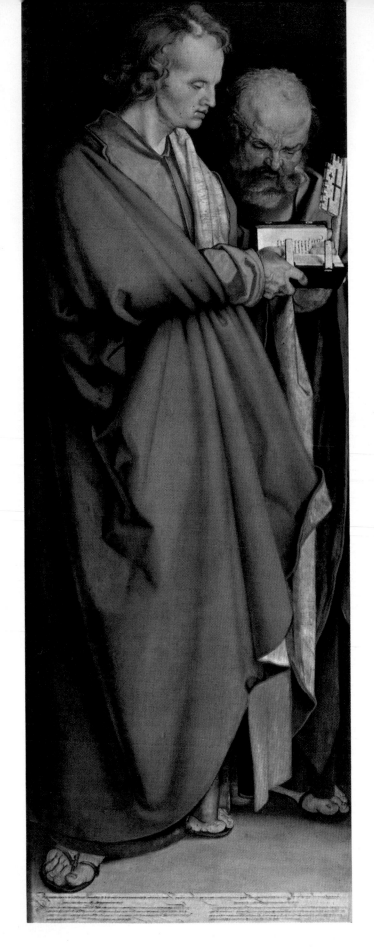
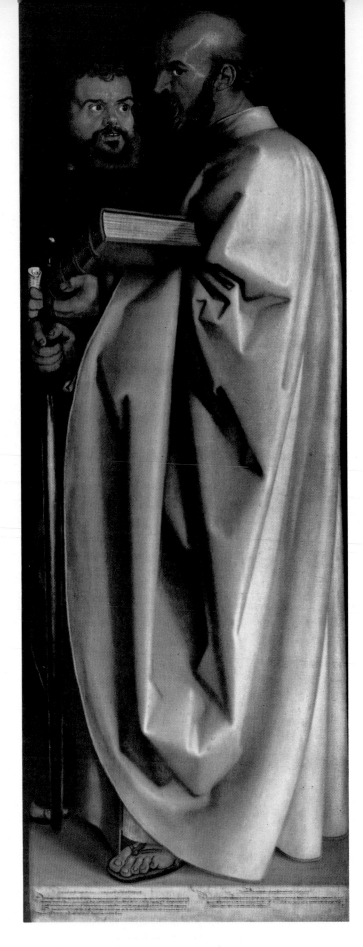

62. *Four Apostles* · ALBRECHT DÜRER · Alte Pinakothek, Munich. Text, page 110.

**63.** *Nymph of the Spring* · LUCAS CRANACH · Clarence Y. Palitz Collection, New York. Text, page 111.

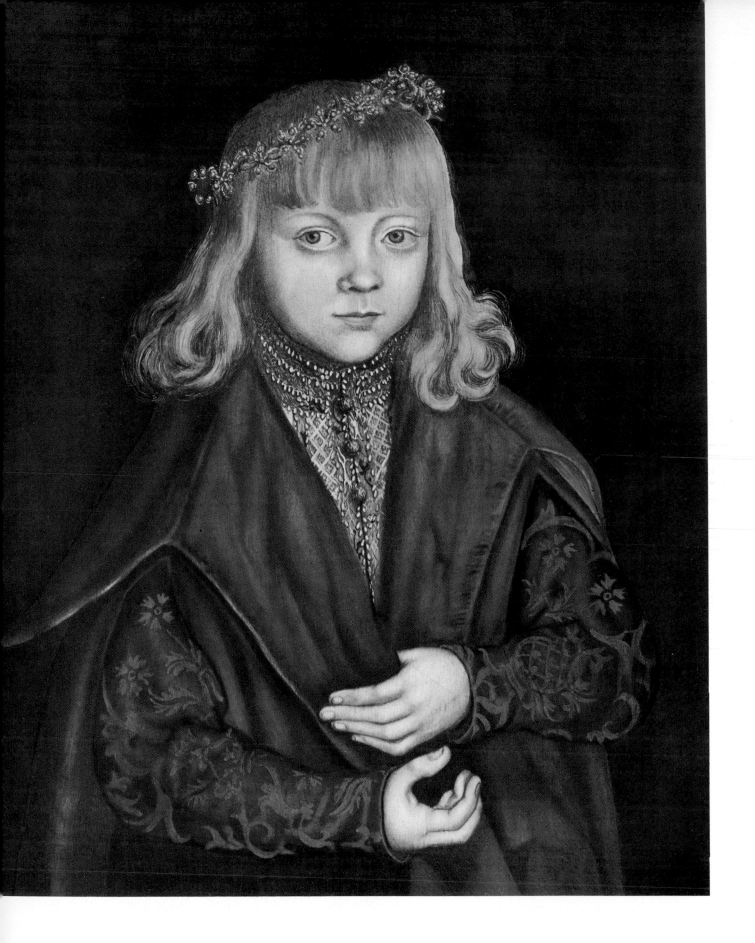

64. *Portrait of a Saxonian Prince* · LUCAS CRANACH · Ralph Harman Booth Collection, Detroit. Text, page 112.

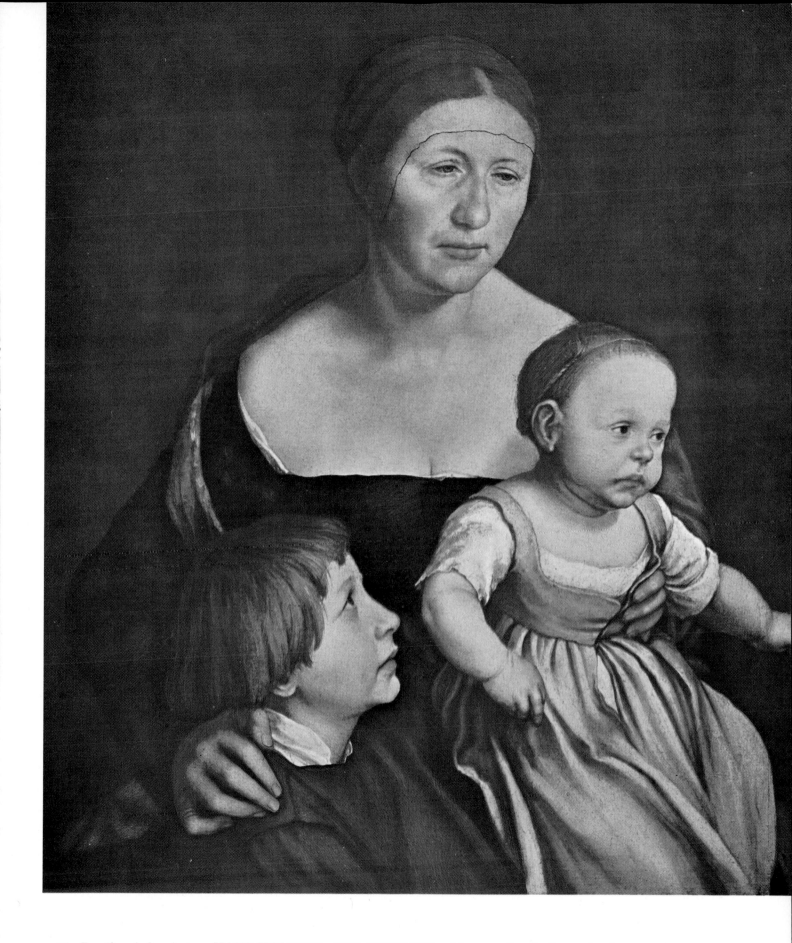

65. *Family of the Artist* · HANS HOLBEIN, THE YOUNGER · Museum, Basel, Switzerland. Text, page 113.

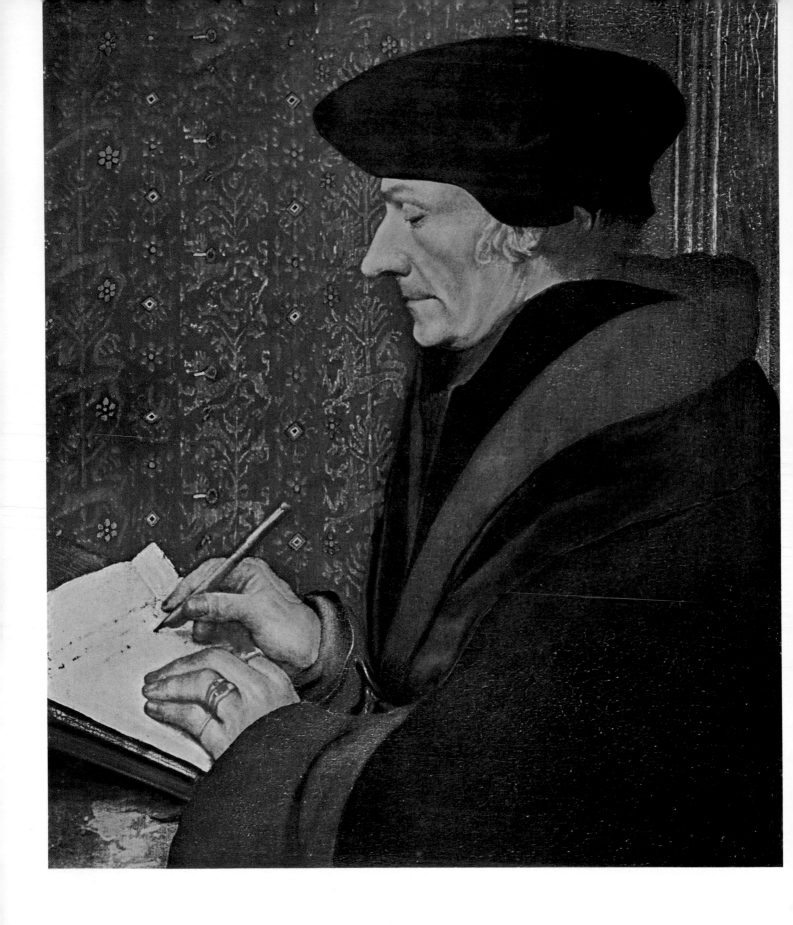

66. *Erasmus of Rotterdam* · HOLBEIN, THE YOUNGER · Louvre, Paris. Text, page 114.

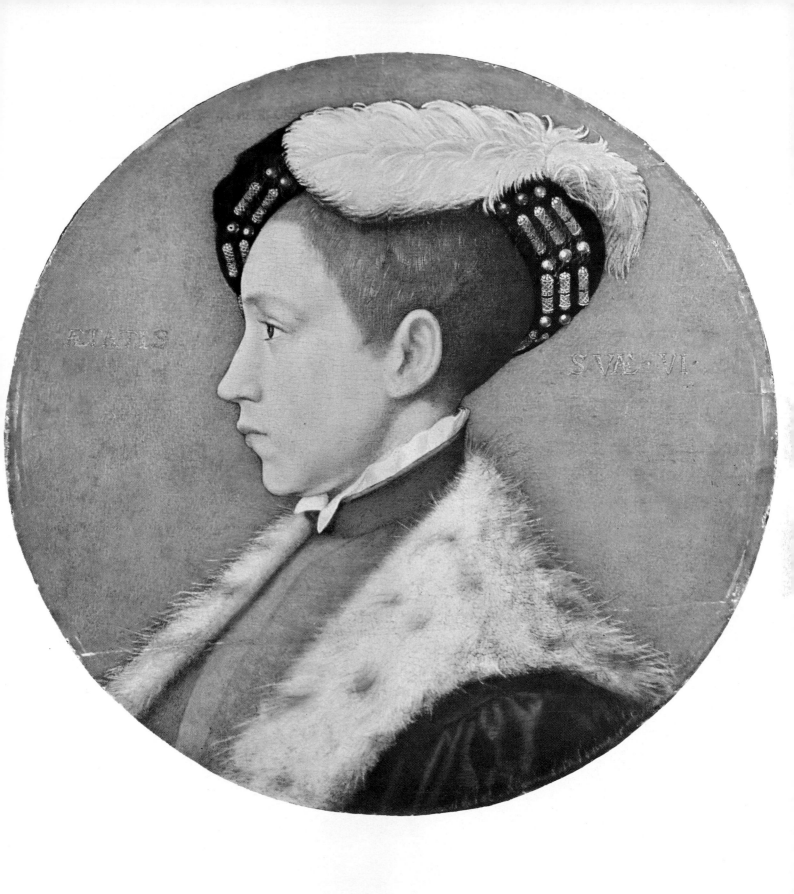

67. *Edward VI as Prince of Wales* · HOLBEIN, THE YOUNGER · Bache Collection, New York. Text, page 115.

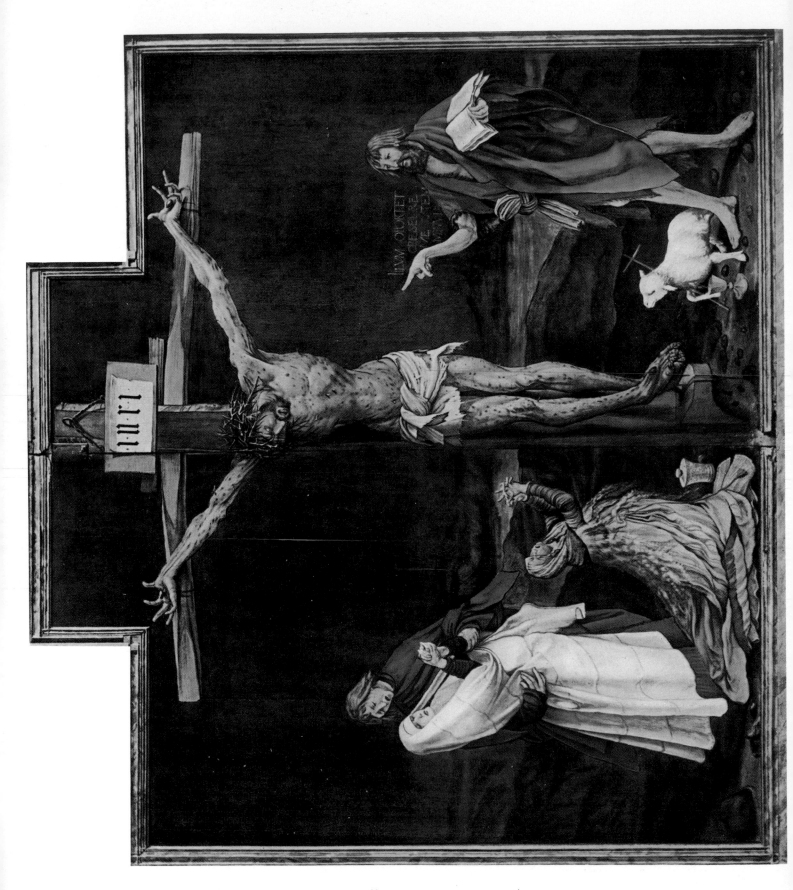

68. *The Crucifixion* · MATHIAS GRÜNEWALD · Museum, Colmar, Alsace. Text, page 116.

69. *The Ship of Fools* · HIERONYMUS BOSCH · Louvre, Paris. Text, page 117.

70. *Vrouw Bodolphe* · FRANS HALS · Stephen C. Clark Collection, New York. Text, page 118.

71. *A Man with a Beer Keg* · FRANS HALS · Henry Reichhold Collection, Detroit. Text, page 119.

· 151 ·

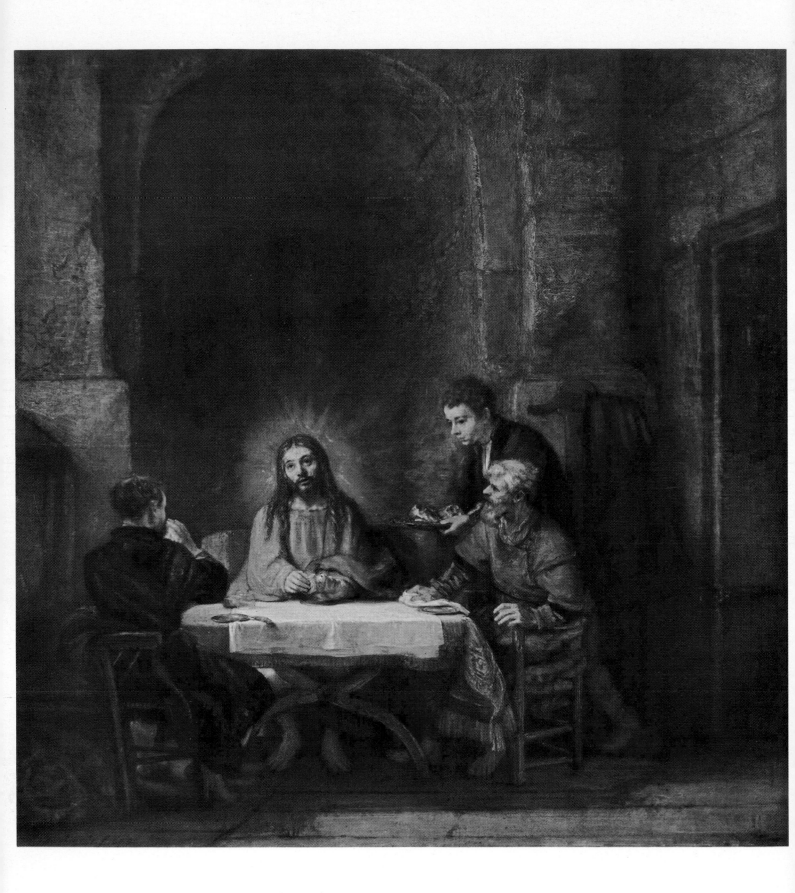

72. *The Supper at Emmaus* · REMBRANDT VAN RIJN · Louvre, Paris. Text, page 120.

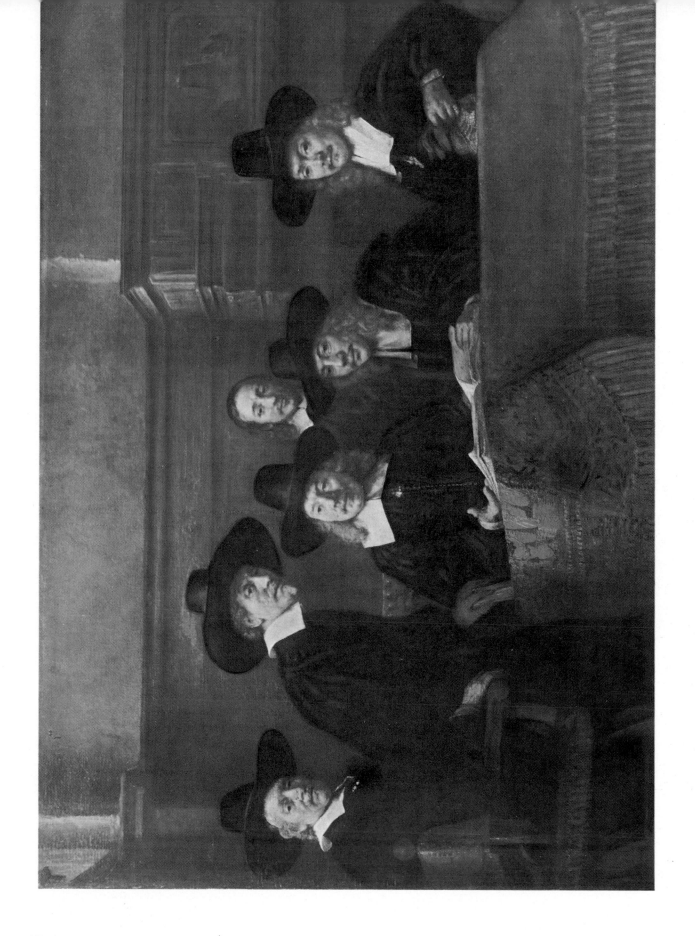

**73.** *The Syndics of the Drapers' Guild* · REMBRANDT VAN RIJN · Rijks Museum, Amsterdam. Text, page 121.

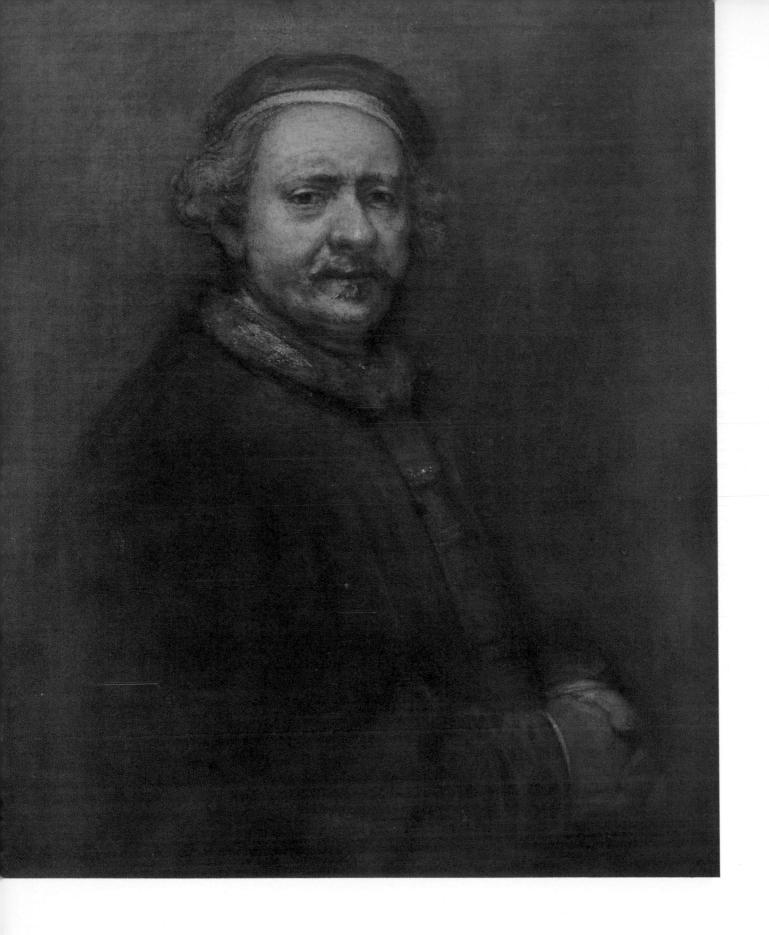

74. *Portrait of Himself* · REMBRANDT VAN RIJN · National Gallery, London. Text, page 122.

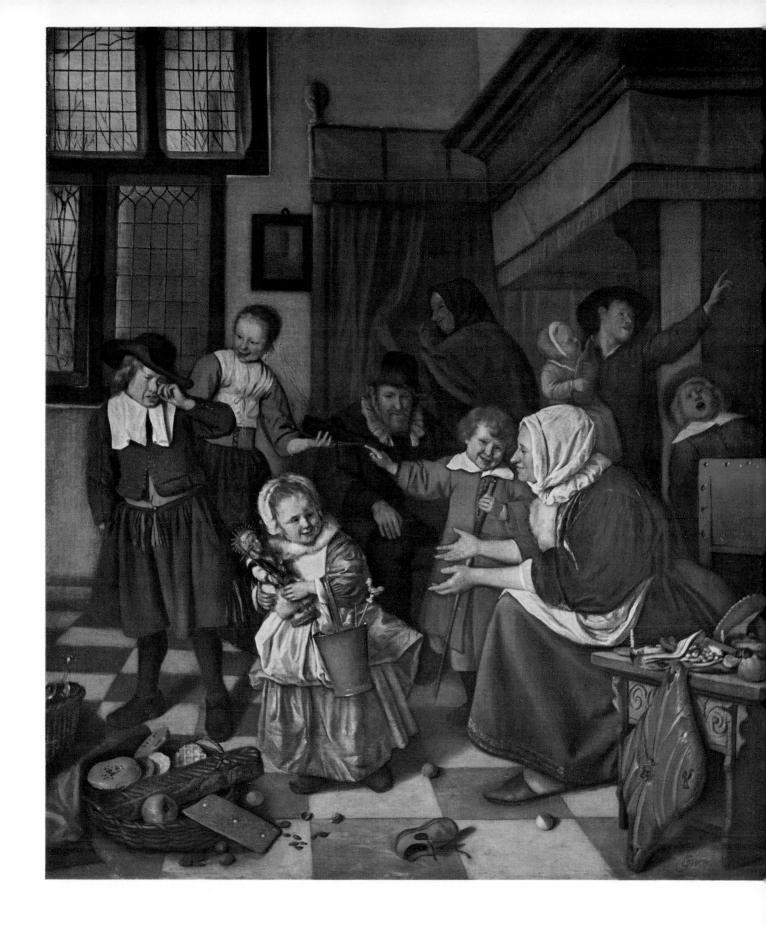

75. *The Eve of St. Nicholas* · JAN STEEN · Rijks Museum, Amsterdam. Text, page 123.

76. *The Wheat Field* · JACOB VAN RUISDAEL · Metropolitan Museum, New York. Text, page 124.

77. *Interior of a Dutch House* · PIETER DE HOOCH · National Gallery, London. Text, page 125.

78. *The Cook* · JAN VERMEER · Rikjs Museum, Amsterdam. Text, page 126.

79. *Girl with a Flute* · JAN VERMEER · National Gallery, Washington, D. C. Text, page 127.

80. *The Water Mill with the Great Red Roof* · MEINDERT HOBBEMA · Art Institute of Chicago. Text, page 128.

# EL GRECO

### 1541–1614 SPANISH SCHOOL

THE glory of Spanish painting is confined to three men, all accidents of genius, and the first, a Greek from the island of Crete. Under the name El Greco, the first is one of the great portrait artists of the world, but he seldom painted a woman. He cared nothing for the charms of flesh or the Venetian ideal of physical splendor which he discarded on his arrival in Spain—in no circumstances would he allow his stern penetration to be compromised by the insidious appeal of sentiment. His men are Spaniards unmistakably, but they are more than racial personages: they are the creatures of his own hieratic vision of humanity. Drawn by a master of the structure of the head, with asymmetric variations to enunciate individual character, they have the strength of the spirit, not of the flesh. The cheeks are hollow; the skin is stretched tight over the skull; and the eyes, set within deep, bony sockets, are streaked with high lights or alive with ascetic desperation. His men are martyrs or conquerors: in their gaunt visages he traces the weariness and the final exhaustion of the body in surrendering to the mystical vision, or the savage meditation of those entrusted with the flagellation of heretics.

El Greco's *Niño de Guevara,* painted in 1596, or thereabouts, after his disconcerting methods had brought an equal measure of fame and disapprobation, is the most daring in color and the most formidable in characterization of all his portraits. The subject, a prince of the Church, aristocrat, and cardinal of Toledo, was the Grand Inquisitor in an age when the Spaniards mortified the flesh and destroyed all things in order to win spiritual freedom. In this work, the artist has, of necessity, avoided the gray tonalities associated with many of his canvases; and has represented the cardinal in all his pomp and ecclesiastical ostentation, relieving the red of the sanctified vestments—a red used sparingly by other painters and a problem to printers, but reproduced in these pages with absolute fidelity—by the lavish display of white lace. To the modern world, accustomed to El Greco and his great influence on recent art, the portrait has the unconventional grandeur of a timeless image; to the Spaniards of the sixteenth century, the picture was menacing and unholy. Some years after the death of El Greco, the portrait was studied by Velasquez when he was honored by the commission to paint Pope Innocent X.

*Cardinal Niño de Guevara,* Metropolitan Museum, New York. Oil, 51¼″ x 76⅜″, about 1600. Color plate, page 185.

*Descent of the Holy Spirit,* Prado, Madrid. Oil, 50″ x 108¼″, about 1608. Painted in the last period when the human body was strained beyond life size to express intense emotion.

[LEFT] Detail from *Descent of the Holy Spirit,* Madrid. The Virgin between the two Marys and two disciples.

# EL GRECO

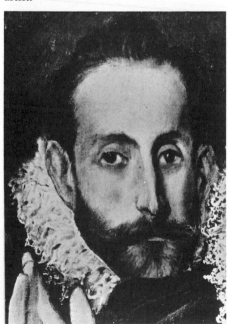

*Burial of Count Orgaz*, Santo Tomé, Toledo. Oil, 141¾″ x 189″, 1586. The artist's most renowned work, and a masterpiece of intricate designing. St. Augustine and St. Stephen come down from heaven to bury their devotee, the Count.

AFTER Domenikos Theotokopoulos, the Cretan, arrived at Toledo from his travels in Italy, he wandered no more. He was at home in Toledo, and though he was always looked upon as an uninvited guest, and nicknamed, with a tincture of Spanish superiority, El Greco, he was, one might almost say by foreordination, to express certain states of the Spanish soul in symbols of such high-pitched intensity as to be offensive even to a race accustomed to melodramatic immolation. Breathing the rank religious air of Spain as naturally as a native, El Greco devoted his art mainly to the service of the Church, but he also painted a gallery of portraits and several landscapes filled with thunder and lightning and zigzag terrors.

Obsessed with notions of movement and the play of rhythmical forces—an obsession soberly pursued by experiment and calculation—El Greco pushed the art of painting to the limits of expressiveness, taking unheard-of liberties with natural shapes and contours, and lashing his attenuated forms into scenes of incredible agitation. His *Toledo in a Storm* was painted during his last period, 1604-1614, when he was in full command of his volcanic style. It is the first pure landscape in Spanish art, and in controlled vitality and bizarre, dramatic force, it is hardly surpassed in any art. A man of his temperament could not have painted his adopted home in a quiet mood—when the city rose from the crest of a great hill like a mirage; he must paint Toledo when the elements were at war with man in a dark background overhung with greenish clouds and illuminated by spectral flashes. Nor could he respect the topography: he must alter it to suit his own purposes, moving the Cathedral from the center of the town to the hillside below the Alcazar, widening the ravine of the Tajo, and eliminating many of the twisted streets. With a few basic lines he binds the landscape together, communicating movement and threatening terror to all the parts, creating a living organism consistent with his perception of the convulsive Spanish world.

Detail from *Burial of Count Orgaz*, Toledo. Traditionally known as a self-portrait of the artist.

[RIGHT] *Toledo in a Storm*, Metropolitan Museum, New York. Oil, 41¾″ x 47⅝″, about 1608-1610. Color plate, page 186.

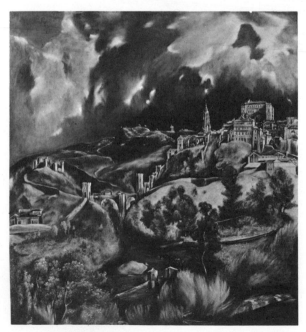

# EL GRECO
## CONTINUED

DURING his sojourn in Italy, El Greco was only a young man well schooled in the styles of Tintoretto and Veronese; in Spain he suddenly shed his Venetian trappings and arrayed his genius in the most audacious and individual manner of painting that has ever been affected. His transformation has been attributed to two causes: first, that he was astigmatic and could not see straight; second, that he was an ambitious outsider seeking a short-cut to fame. Both explanations are untenable. The Greek painter's eyesight was normal enough in Venice; and had he been intent on popular success, he might easily have found it by continuing to paint like the Venetians, since the great patron, Philip II, was enamored of the Adriatic decorators.

The truth is that El Greco, though ambitious for fame, would have it only on his own terms; that he forfeited royal patronage and made no effort to regain it, preferring by right of conviction to work for the Church. It is likewise true that he was an experimenter in search of the maximum of expressiveness in paint; and that, in his final stages, his violation of natural shapes and his distortions of the human body, in the interest of the hysterical religiosity of Spain, carried him beyond the tragic into the dubious borderland of the sensational and the ghastly.

The Greco-Spaniard, whose elongated anatomies and flaring designs have borne heavily on modernist art, was essentially a spiritual interpreter. When he was not excessively agitated, or reflecting the Jesuit fanaticism of his day, he was one of the most powerful and moving of religious painters. In this *Pietà*, one of several, the flame burns clean and pure and lights up the tragic region of the spirit of which he is one of the masters: the figure of the Lord, though attenuated beyond the natural scale, is saved from distortion by the context which called for emphasis on suffering divinity. There are no textural distinctions in the picture and no traces of the sensuous touches of the Venetian school; the physical restrictions of the figures have been abolished or changed into symbols through which the tragic emotion is made articulate. By his mystical inclinations, his refusal to consider the physical side of man, and his strange iconography, El Greco becomes the spiritual brother of the old Byzantines who expressed the tragedy of the Crucifixion in a language of symbols.

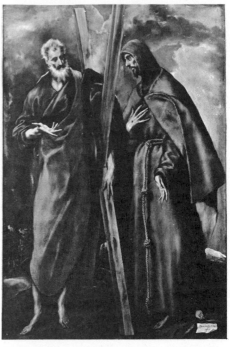

*Saint Andrew and Saint Francis*, Prado, Madrid. Oil, 44½″ x 65¾″. An example of El Greco's attenuated style developed in Spain.

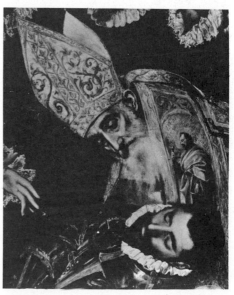

Detail from *Burial of Count Orgaz*, Toledo. The Count, livid in death, in the arms of the venerable St. Augustine.

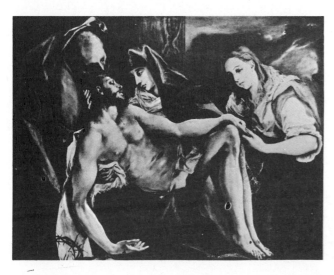

[LEFT] *Pietà*, Comtesse de la Béraudière Collection, Paris. Oil, 57⅛″ x 47¼″, painted about 1588. Color plate, page 187.

# DIEGO RODRÍGUEZ DE SILVA Y VELÁSQUEZ

1599–1660

*The Maids of Honor*, Prado, Madrid. Oil, 108¾″ x 125″, 1656. Color plate, page 188.

Detail from *The Maids of Honor*, Madrid. The artist himself, painting the scene as reflected in a large mirror.

THE descent from El Greco's far-flung visions into the lucid objectivity of Velasquez's world is sudden and refreshing. There are no soul troubles in Velasquez, no troubles indeed of any sort: the religious tragedy of Spain, the decaying glory of the Empire, the rebellion in Holland and Portugal— none of these caused him a moment of uneasiness. Cooped up in the King's closet, painting at the King's pleasure and compelled to bow to the criticism of His Majesty, he lost neither his distinction nor his independence, never shirked his job, and never complained of the monotony of his servitude. His work is abnormally free from passions and philosophies: he is the most reserved, the most disinterested of men—and for those to whom art is the scientific statement of the facts of the visible world, the faultless painter.

At the age of nineteen, Velasquez, a Portuguese aristocrat born in Seville, was happily married and the most gifted painter in Spain. He was spared the long immaturity and dark introspections of so many artists; his aim from the outset was verisimilitude—to see clearly and record convincingly. At twenty-four he was Philip's painter, and for thirty-six years, or the rest of his life, a fixture at court, delineating over and over again the green-sick, stunted infantas and the King, with his long yellow hair and underhung jaw. His domain began and ended at the royal palace, and he asked no better.

Velasquez approached his subjects in the spirit of scientific purity, examining them in his studio with spectroscopical precision. He was a master of the logic of light and shade; his perception of atmospheric values was inhumanly acute. He did not copy nature; he subtracted irrelevancies from the field of vision and presented simplified objects in the clear light of day. *The Maids of Honor*, of 1656, judged by the fulfillment of its purpose, could not conceivably be changed or surpassed. It is a representation of the artist's studio as seen by himself in a mirror: the Infanta occupies the center of the stage attended by her maids, dwarfs, and dog; in the background, Velasquez stands at his easel, and on the wall, in a mirror, the King and Queen are dimly reflected. The complicated lighting was child's play to the Spanish magician; the costumes are painted with magnificent simplicity, and every intrusive trifle is removed. It is a scene as natural as life, but much more concentrated, an intensified version of nature, a harmonious resolution of appearances painted with a brush that never faltered.

[RIGHT] *Los Borrachos*, Prado, Madrid. Oil, 88½″ x 65″, about 1628. The wine god and tipsy peasants. An early work that shows the master's dead-shot realism.

# DIEGO RODRÍGUEZ DE SILVA Y VELÁSQUEZ

THE emoluments from Velásquez's royal appointment were meager, but the honors were abundant. Though of noble birth, he was constrained to associate with the dwarfs and buffoons, and was paid the same salary—but there were perquisites. He had a studio, rent free, in the royal palace; from the royal kitchen came baskets of bread and onions and wine for his wife and daughter; he escaped the censorship of the Inquisition and was permitted to paint a nude, one of two in Spanish art; and he had leisure for travel. In his last years, as a crowning honor, he was created Marshal of the Palace, with jurisdiction over festivals and tournaments; but the burdens of the post were too much for him and he died under the strain of preparing a nuptial fête for the Infanta Maria Teresa.

Never was an artist more contented with his environment. Velásquez's world began and ended with the court of King Philip IV, and day after day he studied and painted the Hapsburgs: the long yellow hair, the underhung jaw and the dead fish eyes of His Majesty; the little Prince Baltazar Carlos on the galloping barrel of a pony; and when the Prince died, the Infanta Maria, on whom he lavished, in a cool, unemotional way, all his affection.

He painted the Princess again and again, and always without flattery or exaltation. As an example of his art at the fullness of its development, and of the art of portraiture carried to objective perfection by an infallible observer, the head from the Bache Collection could hardly be excelled. Velásquez was fifty-four when the head was finished, the girl about fifteen, and deeply attached as he was to her, when she sat for him she was just another problem in values and illumination. A specialist in values and illumination, he regarded the girl as an object receiving and reflecting light, and he delineated her with scientific precision, putting practically nothing of himself into the picture and nothing more of the sitter than the externals of her head—no intimations of joy or sorrow, only the heavy Hapsburg features and the incredible hair with the butterfly decorations that enchanted Whistler. And it was Whistler who said: "When the Infanta entered the studio she became a model by accident. When Velásquez dipped his brush in light and air, she became a great work of art, a harmony in rose and gray"—with a few flecks of royal silver thrown in for good measure.

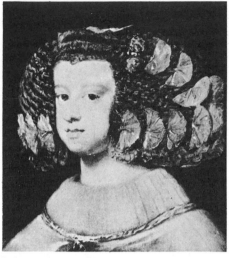

*Infanta Maria Theresa,* Bache Collection, Metropolitan Museum, New York. Oil, 25¾" x 21⅝", about 1653. Color plate, page 189.

*Don Balthasar Carlos as a Hunter,* Prado, Madrid. Oil, 40½" x 75¼", about 1635-1636. The second of a series of studies of the little prince who assumes the fading dignity of a washed-up dynasty.

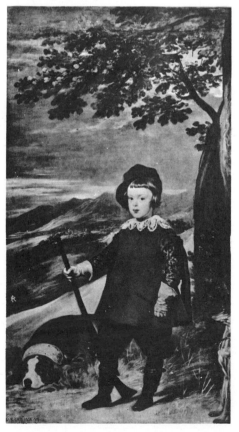

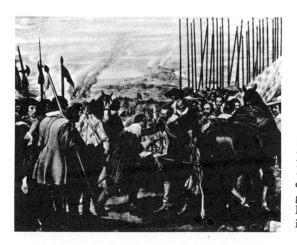

[LEFT] *The Surrender of Breda,* Prado, Madrid. Oil, 144½" x 120¾", about 1634-1635. The conquered Dutch commander graciously offers the keys of Breda to the leader of the Spanish lancers.

# DIEGO RODRÍGUEZ DE SILVA Y VELÁSQUEZ

## CONTINUED

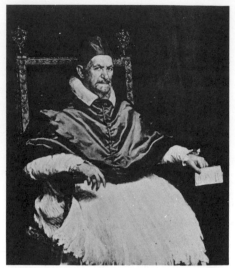

*Pope Innocent X*, Doria Gallery, Rome. Oil, 47¼″ x 55″, 1650. Color plate, page 190.

*View from the Villa Medici, Rome*, Prado, Madrid. Oil, 15¾″ x 17¼″, 1650-1651. One of two sketches of the famous gardens, and the artist's second and last painting of landscape.

COMMISSIONED by the King to purchase paintings and sculptures for the formation of an academy of art in Spain, Velasquez made a second voyage to Italy in 1649, heralded by his fame as a great court functionary. Accompanied by a faithful slave, he landed in Genoa and proceeded to Venice and Rome, buying, as he traveled, pictures by Titian, Tintoretto, and Veronese, but ignoring Raphael of whom he held a poor opinion. He was received at the Vatican with pontifical ceremony, and without delay was ordered to paint the portrait of His Holiness, Innocent X. The work, influenced in color and design by El Greco's *Cardinal Niño de Guevara* (Plate 78), was finished with the despatch of a pre-eminent technician in his final and boldest style. By royal prohibition, Velasquez could not accept vulgar money for any of his paintings, but the Pope honored him with a medal and a golden chain—in the eyes of an aristocrat of spotless pedigree, the highest recompense.

To Sir Joshua Reynolds, *Innocent X* was "the finest picture in Rome"; to Velasquez, it was just another portrait. He was not swayed by the character or station of the Pope; neither the sensual nor the spiritual came between him and his brush—he was interested in objects as material things and painted them for their own sake. Relying entirely on his eye for just proportions and the accuracy of values, he painted directly from nature and was the first artist to use an exclusively oil technique, a medium favorable to swift stroking, freedom of handling, easy corrections, and the realization of a single aspect of his model in an atmosphere of shifting lights and shadows.

When Velasquez fixed his eye on a head, he observed lights and shadows merging one into the other to form a spheroid; these lights and shadows he translated, with an inexpressibly sensitive touch, into paint—and so just was his reading of values that the tones on the canvas contained precisely the same amounts of light and dark as the equivalent planes on the model, hence taking their proper position in space to produce a facsimile of the sitter. By this procedure he wrought such marvels as *Innocent X*—as perfect an illusion of physical life as is possible in paint—an image compounded of transitions of color so exquisitely clear and so deftly joined that the Italians, beholding the solid likeness and the impalpable thinness of the pigment, cried out, "It is made of nothing, yet there it is!"

[RIGHT] *Venus and Cupid*, National Gallery, London. Oil, 69½″ x 48½″, about 1657-1658. The female nude was proscribed by the Spaniards, but Velásquez broke the rules and produced the famous "Rokeby Venus."

# FRANCISCO JOSÉ DE GOYA Y LUCIENTES

1746-1828                                                                SPANISH SCHOOL

WHEN Goya was born, almost a century after the death of Velasquez, the whole of Europe, led by France, was preparing a battle royal for the new freedom. He lived beyond four-score years, and from his childhood when he was discovered—so the story goes—drawing with a lump of charcoal on the walls of his native village, to his exile in Bordeaux where, a dark old man, gouty and stone-deaf, he drew from memory those great lithographs of the bull ring, he drenched the decaying soul of Spain with a torrent of vitality. In the energy and scope of his assault on art, in the restlessness of his imagination and the invigorating assertiveness of his life, he was the forerunner of the new freedom in painting. Spain was rotten in body and soul, a shattered civilization, bankrupt mentally and physically. Art was dead—since Velasquez there had not been a name worth recording. Goya had virility—he was the father of some twenty legitimate children—and intellect, the only intellect in Spain; and when his powers were finally extinguished by a stroke of apoplexy, he had wrought the most comprehensive history of a period ever written in graphic form.

Goya's life is enmeshed in legends which he took the trouble neither to invent nor correct. It is known that he came from the lowest stratum of society, and by brute strength and the temerity of genius rose to the top of his profession and became the most famous character of his times; that he won the post of first court painter to the King, and painted with inexorable veracity despite his vacillating political pretensions; that his fame and sensuality led him into many intrigues; that he scoured every layer of society for his material; and that in his old age he visualized his country as a nightmare of monstrous forms. Goya's headlong seizure of life was not conducive to a reflective art, but he was, at bottom, a man of plain tastes and, in his less irascible moods, of strong domestic ties. He loved children and painted them from unlimited paternal experience, with wise, tender, credulous faces, and firm small bodies tapering down to delicate feet and ankles. He painted young Manuel Osorio, he said, to convince his friends that a Spanish child might rival the imperial distinction of the old Italians; but to show his contempt for the classics, he introduced, as Hogarth had done before him, household pets, the prominent cat being the most predacious little animal in modern painting.

*Don Manuel Osorio de Zuñiga*, Bache Collection, Metropolitan Museum, New York. Oil, 37¼″ x 50¾″, 1784. Color plate, page 191.

*The Plain of San Isidro*, Prado, Madrid. Detail of oil sketch, 37″ x 17¼″, 1787-1788. A panorama of Madrid and one of the tapestry cartoons for the King's weavers, a series of designs marking the first outburst of Goya's original genius.

[LEFT] *Family of Charles IV*, Prado, Madrid. Oil, 132″ x 110″, 1800. In the words of Gautier, "They look like the butcher and family who have just won the grand lottery prize."

*"Esto Es Peor,"* from *The Disasters of War*, a series of etchings, 1810-1812, in which Goya's reactions to the horrors of carnage are powerfully embodied.

IMPULSIVE, short of patience, and always suffering from some physical ailment, Goya was an uneven painter. When the sitter did not attract him, he knocked off a likeness as swiftly as possible, and refused to worry about the careless handling; when the subject appealed to him, the results were astounding. If a woman were ugly, he made her a despicable horror; if alluring, he dramatized her charms, giving her a wanton glance and a figure that swelled amorously to fill her flimsy clothing. He preferred to finish his portraits at one session and was a tyrant with his models—but his brush never lied. Charles IV and his family were a beastly lot—and Goya did not spare them. What mean, cruel, hideous, tragical faces—all Spanish and all vibrant with life! "Vitality!" he cried. "Ideal proportions and classic beauty be damned!"

The Duchess of Alba figures more conspicuously in Goya's art than any other woman. He knew her when she was a girl and painted her in his tapestry cartoons, his first important work; he made innumerable drawings and etchings of her stunning arrogance; painted two famous, full-length portraits of her, and included her among the comely strumpets of the court in those gay, blasphemous decorations in the church of San Antonio de la Florida. She was a godless woman of unsurpassed loveliness; she came to Goya, she said, to be properly rouged and powdered—their relations were not platonic.

The name of the Duchess is indissolubly connected with two of his masterpieces, the *Majas*, nude and dressed—*maja* meaning a gay lady or harlot, or both, who affected the costume of the *toreros*. The legend breakers deny that she was the model for the two pictures, the artist having left no supporting affidavits; but the face is there, and the figure is there, and the pictures were a part of the Duchess's collection at her death—and none other could have held Goya to so finished an enterprise. The *Majas* are equally seductive and identical in posture: in one of the pictures the Duchess wears thin, skin-tight breeches; in the other she wears nothing—the most illustrious nude in modern art. Goya painted her in defiance of the classical tradition—in cool flesh tones and without generalizing the contours of her body into the mold of the somnolent courtesan-goddesses of the Renaissance. Nor did he label her Venus or Diana—he was under no illusions when he painted her. She is a Spanish beauty, unabashed in her exposure, beautifully posed and painted—a great artist's perfect tribute to the human body he most admired.

*Self-portrait*, Academy of Fine Arts, Madrid. Oil, 15¾" x 18⅛", 1815. Goya at seventy, the conqueror of disease and adversity, a companion figure to Goethe and Beethoven.

[RIGHT] *The Nude Maja*, Prado, Madrid. Oil, 74" x 38", about 1795-1797. Color plate, page 192.

# FRANCISCO JOSÉ DE GOYA Y LUCIENTES

CONTINUED

THE Duchess of Alba died in 1802—"before her beauty had faded," Goya said; his wife died in 1804, exhausted and forlorn; his only surviving son was a weakling. The deaf old painter lived on, alone as much as possible, painting because he could not help it, or because there was nothing better to do. But his work suffered no decline; in fact, it rose to its highest point in his etchings and paintings of the horrors of war. When placed beside the work of Goya, other paintings of war pale into sentimental studies of cruelty, or trumped-up symbolism. The Spaniard was hardly "the first deliberate opponent of militarism," as he has been called—his life indicates that he had little sympathy with causes or movements—but he loathed the horrors of organized killings, and when asked why he painted such things, answered curtly, "To have the pleasure of saying eternally to men that they stop being barbarians."

Goya had an insatiable curiosity about life and the energy to indulge it; and through his own hardships, a far-reaching knowledge of the feelings of the poor and the cannon fodder. He saw barbaric scenes and his blood boiled; and he painted, not the abstract iniquity of war, but the behavior of men and women in murderous circumstances. He avoided the scattered action of the battlefield and confined himself to isolated scenes of butchery. Nowhere else does he display such mastery of form and movement, such dramatic gestures, such appalling effects of light and darkness.

In the spring of 1808, he was living in Madrid in the Puerta del Sol when Napoleon's mamelukes, under Murat, marched into the city. It was the second of May; the nobility stayed within doors and covered their heads, but the loyalists, the people, practically unarmed, resisted the invaders. The next day the bloody reprisals began and the populace was slaughtered at the city gate. Goya painted the massacre—with a spoon, it is said—and bequeathed to mankind, not the most tragic or the most touching commentary, but the most frightening curse ever uttered against the universal evil: a night scene with a ragged group frozen with the fears of sudden death; men with their hands sticking up; men hiding their faces; men clenching their fists; dead bodies in pools of blood—impotent civilians before a firing squad. A reproduction of this picture, in color, should be hung in the council chambers of the war lords of all nations.

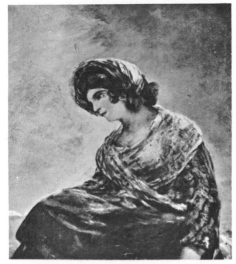

*The Milkmaid of Bordeaux*, Prado, Madrid. Oil, 26½" x 29½", 1827. Painted at eighty-one, when Goya was half-blind and needed to wear strong glasses. Using small, broken strokes, the old Spaniard invented an Impressionist technique.

*Colossus*, Metropolitan Museum, New York. Aquatint, about 1820. Gigantic fancy done in old age, when the "dream of reason conjured up monsters."

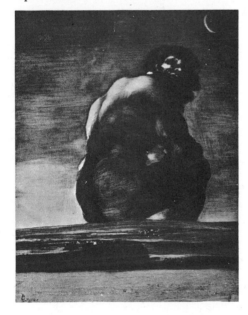

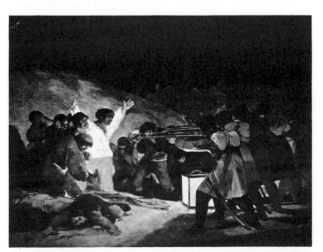

[LEFT] *The Execution, May 3, 1808*, Prado, Madrid. Oil, 135" x 105", 1814. Color plate, page 193.

# JEAN FOUQUET

1415–1481        FRENCH SCHOOL

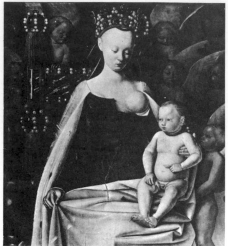

*Virgin and Child*, Museum of Fine Arts, Antwerp. Oil tempera, 32″ x 37″, about 1443. Color plate, page 194.

JEAN FOUQUET is the first unmistakably French painter. He lived in the ebbing drift of the Middle Ages, and his art was conditioned by the general Gothic movement then spreading over Europe. But instead of following the old, worn-out tradition of conventionalized saints and bloodless Madonnas—the medieval tradition of reworked effigies and abstract symbols—he opened his eyes to the world of nature. By profession he was a religious decorator, but he was specifically French in his frank acceptance of life, with a sensuous predisposition toward wine, women, well-tilled gardens, and good living. He was born in Tours where his exceptional draftsmanship brought him into the good graces of Charles VII, at whose court he illuminated sacred manuscripts and missals. He began as an illustrator in the Franco-Flemish tradition of miniature painting, but during his travels in Italy enlarged the scale of his work to include portraiture and easel pictures of secular import.

On his return from Rome, Fouquet again won the favor of Charles VII, this time through the intercession of Agnes Sorel, the ruling spirit of the court. As a token of appreciation, he painted his famous *Virgin and Child*, also called *Agnes Sorel as the Virgin*—and with reason. Agnes Sorel, the acknowledged mistress of the King, completely dominated a ruler who, before he was overcome by her beauty, was noted for his rectitude and chastity. He gave her his castles, his wealth, and his lands, elevated her to the state and position of a queen, and was subservient to her whims in the choice of his counselors.

Fouquet's conception of the Virgin was as shocking to the people of his time, as the King's overt behavior was offensive to their orthodox notions of royal decorum. The artist, they whispered, was a hireling blasphemer on all counts: he had not only embodied the Madonna in corruptive, mortal flesh; he had also painted her in the image of a sinful charmer, a throne wrecker dressed in the height of fashion and exhibiting, with virginal authority, the provocative charms which had subverted the regime of a tempted sovereign. Fouquet was neither venal nor consciously sacrilegious. He painted in genuine piety the scarlet angels and the hieratic pattern prescribed by tradition; but he was a man of flesh and blood, and it was not unnatural for him to portray the Madonna as an actual queen wearing a crown. His departure, despite the medieval formalities of presentation, was the first decisive move in French art toward the recognition of the sensuous life as a happy element in decoration.

*Etienne Chevalier, Presented by St. Stephen,* Kaiser Friedrich Museum, Berlin. Right wing of diptych containing, on the left, *The Virgin and Child.* Chevalier, the donor, and his patron saint are shown in a quiet country fashion.

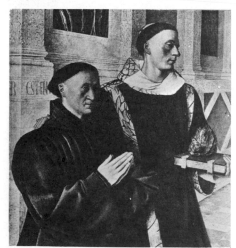

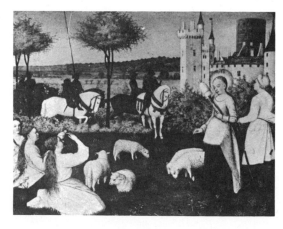

[RIGHT] *St. Margaret* from *The Book of Hours of Étienne Chevalier*, Chantilly Museum. About 1452-1460. This book, one of the great Gothic works in miniature painting, was sold piecemeal to collectors, and eventually to museums.

# NICOLAS POUSSIN

1594–1665                    FRENCH SCHOOL

POUSSIN is the first of the French academicians, and to his own countrymen, one of the monarchs of painting. Born in Normandy of poor estate, he went to Paris in his youth to study art, a starveling idealist filled with high thoughts of the historic Italians. After two unsuccessful efforts to visit the capital of antiquity, fortune smiled on him and he married the daughter of a wealthy French chef. With her dowry he built a house among the outlying hills of Rome, where he lived to the end of his days, his Virgilian placidity suffering but one disturbance—a return to Paris, by royal command, to decorate the long gallery of the Louvre. In Rome he dwelt in perpetual contemplation of ancient monuments and the Renaissance masterpieces which, he asseverated in the original bylaws of the French Academy, contained the everlasting subject matter of art.

Constitutionally opposed to the human side of painting—the emotional elements implicit in everyday experiences—Poussin extolled the intellectual life, the life of pure thought or passive reverie. He elected to deal with the far past, and in consequence, approached his subjects—demigods, Roman deities, nymphs, and Sabine women—through a classical intermediary. Immersed in golden quietude, he fondly imagined that he was one of the old Romans in daily converse with the immortals, and his life was devoted to the reorganization of immutable forms into ideal combinations.

Of late, Poussin's glory has been restored and polished, and his name today is perhaps the most sacred in the pantheon of French painting. It is not his subject matter that compels admiration, but what has been called his "peerless architectural harmonies." The subject of the *Funeral of Phocion*, taken from Plutarch's account of a valorous Greek who was ignobly put to death and clandestinely buried, would have incited Delacroix to a dramatic riot. With Poussin it is only a detail subordinated to the formal pattern in which clouds, trees, earth, and buildings seem to have been painted in sections and then stationed, once for all, in the controlling scheme. The picture was not offered as an anecdote or a description, but as the equivalent of the profound emotion aroused within the artist by his meditations on the ancient world. In its own sphere, Poussin's art is incorruptible—serene, precise, spaciously dimensioned, and beautifully consolidated—an art that inspired Cézanne and all modernists preoccupied with structure to the exclusion of human issues.

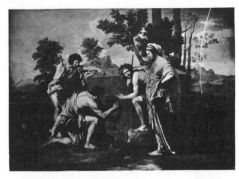

*The Arcadian Shepherds*, Louvre, Paris. Oil, 48" x 34", 1638-1639. Three shepherds and a girl pause before an old monument to read the inscription, "Et in Arcadia Ego"—I too have been in Arcady—and the brevity of life flashes upon them.

*Self-portrait*, Louvre, Paris. Oil, 28¾" x 38½", 1650. The classicist in Rome, as he wishes to be remembered, meditative like Corneille, with a profile of the muse of painting in the background.

[LEFT] *The Funeral of Phocion*, Louvre, Paris. Oil, 5' 10½" x 3' 10⅞", 1648. Color plate, page 195.

# CLAUDE LORRAIN

1600–1682                                        FRENCH SCHOOL

*The Ford,* Metropolitan Museum, New York. Oil, 39¾″ x 29¼″. Color plate, page 196.

CLAUDE GELÉE, called Claude Lorrain from his native province, was an unlettered baker with an idolatrous love for nature and for painting. Born of obscure parents and left an orphan at the age of twelve, he moved to Freiburg on the Rhine with his brother and learned the craft of engraving. He went to Italy, as the modern pilgrim goes to Paris, and wandered from town to town, working as a pastry cook and a menial assistant to artists. At twenty-seven, he settled in Rome, an awkward, clownish painter living from hand to mouth until middle age, when his pictures caught the fancy of the collectors.

On his weaker side, Claude was the victim of his friend and preceptor, Poussin, and he labored like a slave to be noble and heroic, painting landscapes of desiccated classicality, with marble edifices and the nostalgia for creeds outworn hanging over them in lethargic vapors. These pictures, aside from his new handling of space and atmosphere, do not represent his contribution to painting.

At best, Claude was a simple lyric poet, and his ability to remove his head from the classical halter and return to the things he loved is proof of the depth of his convictions. What interested him was not the growth and structure of nature, but the effects of light and atmosphere on vegetation and water. His pictures are valuable as impressions, as statements of his feelings, or more exactly, the state of bliss induced in him by his adopted country—a world, to him, undisturbed by the grime and toil of man—of pagan happiness, pleasant shade, and bucolic sentiment.

The catalogue title, *The Ford,* is but faintly descriptive; the actual subject is the luminous vista of the South. The picture demonstrates Claude's sound sense of design: the coalescence of his impressions into a general statement which arouses the wonder and unexpected thrill of a landscape stretching far away through shining vapors into infinite distance. The picture space is divided into three planes—now an academic habit: the dark foreground, half-tones in the middle distance, and a waning background filled with light; and these divisions are blurred and dissolved, one into the other, thus establishing unity of form and mood. It was Claude's constructive ability, his playing of line against line, and tone against tone, to achieve rhythmical balance, as well as his interest in outdoor phenomena, that made him the master of Constable, Turner, and Corot.

*Pine Trees and Campagna,* British Museum, London. Ink and wash, 12⅝″ x 8½″. Not remarkable in itself but as one of the earliest records of nature directly experienced.

[RIGHT] *Cleopatra Disembarking at Tarsus,* Louvre, Paris. Oil, 5′ 6½″ x 3′ 10¾″, about 1647. The figures "were thrown in for nothing," Claude said. The real subject is the distribution of sunlight—the flashes and shadows falling on waves, ships and ancient palaces.

# ANTOINE WATTEAU

1684–1721          FRENCH SCHOOL

WATTEAU, the son of a Flemish artisan, wandered to Paris in his youth, passed through ten poverty-stricken years and ten more of increasing prosperity, marred by ill-health and melancholy, and died of consumption at the age of thirty-seven. Thrown between two civilizations, he contemplated the dying majesty of the old with some regrets, and ushered in the new to the sound of lutes and the murmuring of lovers. No other artist has rendered so truthfully and enchantingly the old Parisian spirit: to him the world of the senses was more than sufficient for his diseased body and afflicted soul. His art lingers on one idea: men and women, not playing at the game of love, but whose whole existence is dedicated to love. They are dressed for the part; they exercise restraint lest the passion burn out, and avoid everything gross and uncultivated, displaying their seductions with the greatest delicacy and charm.

Watteau's technique is a frail instrument. He retained the ambers, blues, and cherry tones of Rubens, but in his drawing employed the light-and-shade method of impressionism, training his eye to observe the fluttering effects of light on faces and landscape. He filled his notebooks with sketches and composed his pictures from his stock of drawings. Natural forms he neglected to study, his trees being banks of plumage in ideal settings for his courtly lovers whom he scattered about like flowers strewn on the grass, and held together by transparent curtains of golden tones.

When Watteau arrived in Paris, the song from a popular comedy was on everybody's lips. The burden of the tune, "Come to the Isle of Cythera," haunted the young artist, and slowly crystallized into a pictorial vision of romantic love. Three times he painted the *Embarkation*; at first tentatively, but on his second trial, in 1717, influenced by a tall blonde—his model and the central figure of the composition—he brought forth the magnificent version now in the Louvre. This picture contains all that he had to say: his assembled couples, in a fantastic landscape overhung with a magical atmosphere of tone—a landscape of autumnal tints, for it is filled with the melancholy of the artist's soul—prepare to sail away to the blessed isle, an immaterial region sacred to Venus, where there is no death, where love-making is prolonged into eternity. This was Watteau's idea of heaven!

*Gilles,* Louvre, Paris. Oil, 4′ 10⅝″ x 6′ ⅜″, about 1718-1720. Leading actor of the Comédie Italienne, the counterpart of Pierrot in the Comédie Francaise, painted from sketches of the troupe which fascinated Watteau. A group portrait, and don't forget the donkey.

Study for *Figure du Printemps,* Louvre, Paris. Chalk, 12⅝″ x 10⅝″, about 1712. The artist made hundreds of sketches of this tall blonde who assumed beautiful attitudes without being posed.

[LEFT] *The Embarkation for Cythera,* Louvre, Paris. Oil, 6′ 3⅝″ x 4′ 2″, 1717. Color plate, page 197.

# JEAN BAPTISTE SIMÉON CHARDIN

*The Blessing*, Louvre, Paris. Oil, 16⅛″ x 19¼″, about 1740. Chardin preferred to engage his characters in some unforced activity. In this domestic scene, the mother withholds the soup until the smaller child has said grace.

*Boy with Top*, Louvre, Paris. Oil, 29⅞″ x 15″, 1738. This little scholar in the powdered wig, who grew up to be a top-flight bureaucrat, as you might guess, is caught in a moment of contemplation.

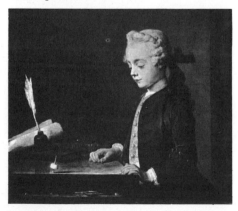

[RIGHT] *Kitchen Still Life*, Museum of Fine Arts, Boston. Oil, 13″ x 12″, 1733. Color plate, page 198.

IT has been said that the house of art is preponderantly adorned by the great masters, to the disadvantage of the humbler masters who are reserved for the kitchen. Of Chardin it might be said that he entered the house by the back door, remained for a long time with the domestics, and then moved to the front compartments to occupy a place among the elect. He was little esteemed in his licentious age, but of recent years the vogue in still life created by Cézanne has revived his art and attached to it the values of belated discovery. A plain man who lived happily among the *bourgeoisie* of Paris, he painted kitchen utensils and domestic occurrences which he transfigured into poetry. He was trained in the Dutch tradition, but in his impressionist method and his scrupulous search for style he was essentially French. He loved his subjects—his fruits and game, his friends and servants—not in the Dutch fashion as good things to possess, but in the French as good things to paint. He spent hours and days arranging his subjects, and in his later years devoted himself exclusively to still life, building up little units of solid form in special atmospheric conditions.

Chardin's technique, in contrast to that of his Dutch forebears, is strikingly modern. In his *Kitchen Still Life*, for example, there are no metallic surfaces, no glittering lights, no hard edges. "His painting is singular," remarked a friend. "He places his colors one against the other, rarely mixing them. Look closely, and everything is blurred and flattened out; go farther away, and it all comes together again. All the objects are unified, and from this there results a transparency of color which vivifies everything his brush touches." Chardin simplified what he saw, and composed, without distortions, pictures of more substance than the impressionists of the most advanced, or granulated, style. His mind was pretty literal: he could not imagine anything that lay beyond the field of vision—he was so absorbed in his pots and pans that he refused to look out of the window. But he wrought, in his own clean kitchen, magical effects from plain things; and his little masterpieces touch the emotions with the appeal of minor poetry.

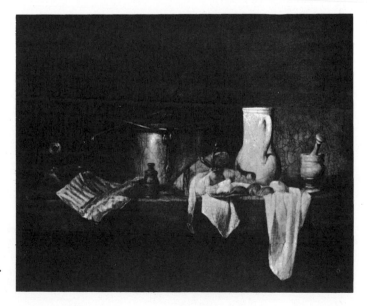

# JEAN HONORÉ FRAGONARD

1732–1806

THE pomaded elegance of eighteenth-century France found its exemplar in Fragonard, an artist who sold his decorative birthright to the enthronement of sensuality. Of precocious dexterity, he was a pupil of Chardin at the age of fifteen, but the muted kitchenware of the still-life master exasperated him, and he became an assistant to Boucher. He won the Prix de Rome, and with it the King's patronage, and some years after his return from Italy in 1761, was elected to the Academy and given a studio in the Louvre, which he maintained until thrown out by Napoleon in 1806, the year of his death. Fragonard was painter in ordinary to the fashionable women of Paris, decorating their luxurious apartments and contributing his inventive genius to the celebration of frivolity. To protect himself from intrigue, he married and had a family, but his respectability was all on the surface, and he could not resist the allurements of his wife's younger sister. During the Revolution he kept his head, thanks to David whom he had once befriended with a commission. But his occupation was gone: he was incapable of adapting his hedonistic skill to the Age of Reason; and though the young lovers in his pictures, after dallying in barns, now settled down to domestic fertility, with swarms of children, no one cared, and he died in poverty.

It was an amorous world that Fragonard painted, a world in which the blandishments of sex were cultivated into an etiquette of glamour which was the whole of life. The only serious business was the observance of the rules governing the mock-heroic conquest. *Storming the Citadel*, the second of six panels depicting the course of true love in the hearts of young girls, is a perfect illustration of the affected innocence of the game. Fragonard's women were never taken by storm: the surrender was a foregone conclusion, and the excitement lay in the studied elegance with which the gallants removed the artificial barriers. The panels were ordered by Mme du Barry but were rejected because the faces of the actors in *Storming the Citadel* resembled the Madame and King Louis XV. Fragonard painted the series with incomparable virtuosity, and with never a hint of the incautious pornography of Boucher. The innocence is unreal; the ideas are pure make-believe; the scene is a stage setting—it is all play acting in the grand manner, an art in itself, but as such a brilliant and truthful interpretation of the age of frivolity which precipitated the Revolution.

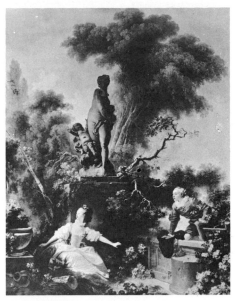

*Storming the Citadel*, Frick Collection, New York. Oil, 10′ 5″ x 8′, 1772. Color plate, page 199.

*La Lecture*, Louvre, Paris. Wash drawing, 8¼″ x 13¼″, 1775-1779. A specimen of Fragonard's delicacy and charm set down with the utmost rapidity.

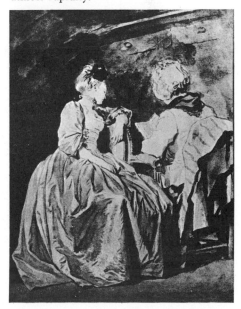

[LEFT] *La Chemise Enlevée*, Louvre, Paris. Oil, 16½″ x 13¾″, 1665-1672. The prince of boudoir artists loved to exhibit a young nude rumpling white drapery.

# JACQUES LOUIS DAVID

*Mlle Charlotte du Val d'Ognes*, Metropolitan Museum, New York. Oil, 4′ 2⅝″ x 5′ 3½″, about 1800. Color plate, page 200. The authenticity of this painting is now contested, some specialists assigning it to Constance Marie Charpentier, others adhering to the long-accepted belief that none but David could have painted it.

*The Three Ladies of Ghent*, Louvre, Paris. Oil, 40⅝″ x 51¼″, about 1818. Painted in exile at Brussels, after David had abandoned his doctrinaire style for portraiture, his métier.

[RIGHT] *The Oath of the Horatii*, Louvre, Paris. Oil, 129⅞″ x 68⅛″, 1785. The picture that made David famous, painted after his Prix de Rome scholarship, and as a counterblast to Fragonard and the "degenerate school," as he called them.

IN the frenzied epoch of the Revolution, the French politicians, governing by rationalism and ideology, drafted laws for Liberty, Equality, and Fraternity, as derived from a study of the ancients. Following the Red current of the time, the political artists, also by processes of reason, arrived at the dogma that art was "an absolute harmony of forms attained only by a knowledge of the antique; that true beauty was untouched by changes of fashion, because it was realized, once for all by the Greeks and Romans." In support of this dogma, there appeared, as if by foreordination, a painter, politician, and antiquarian all in one. His name was Jacques Louis David.

Winning the Prix de Rome in his fifth competition—he attempted suicide after his fourth failure—David went to Italy and was converted at once to the neoclassic fetish. In 1784, his *Oath of the Horatii*, a perfect reflex of the tastes of his compatriots, was welcomed with a political clamor rarely accorded to a work of art. David became the leader, and with the Revolution, the Caesar of painting. Never before or since was art so completely dominated by the will of one man—his authority was so despotic that his enemies were compelled to imitate him or lose their heads. The terrible events of the Revolution made no impression on him. From a reserved seat in a window he made a sketch of Marie Antoinette on her way to the scaffold; when it was announced that eighty people had been guillotined in a morning, he inquired disappointedly, "No more than that?"

Yet David, by fanatical diligence, acquired a hard mastery of painting that amounted almost to genius. He drew from models, but his drawings were based upon precedent and rigid prescription to conform to arbitrary or ideal proportions supposed to be pure Greek. His huge Roman legends and Napoleonic space fillers are museum relics of dictatorial confidence; but in portraiture, confronted with a living problem on a modest scale, his classical apparatus was humanized, and he continues to hold a high position. There is no romantic softness in *Mlle Charlotte du Val d'Ognes*, painted in 1800 and no uncertainty in the painting. The costume, which David designed as appropriate for his Empire furniture, is arranged in the classical folds of Greek statuary, and the figure is modeled in the antique style; but in other respects, the sitter is a French girl of the period, so posed and clothed and drawn as to remain, in the artist's words, "untouched by the changes of fashion."

# JEAN AUGUSTE DOMINIQUE INGRES

THE successor of David was his pupil Ingres, a name uttered more frequently of late than in the days of impressionism and the colorists who profited by Delacroix's example. Not that Ingres imitated the dictator, but like David, whom he called "the only master of his age," he was a worshiper of the past, and an academician of the first water. He too won the Prix de Rome, lived for a score of years in the Eternal City, and, had circumstances permitted, would have buried himself in Italy for the rest of his long life, working among the hallowed deposits of the Renaissance. He was an overbearing egoist, capable, by turns, of an ascetic devotion to his art and of unseemly lecheries. His best work was done before the age of thirty-five; but he painted with undiminishing productivity to his death, suffering continually from the temptations of the flesh.

Ingres painted portraits, nudes, and a few compositions in the nature of classical allegories. The last are no credit to him—whatever else he was, he was not heroic—and his seraglios of sleek, naked girls with sinuous contours refined with unprecedented skill established a criterion of nudity to which the Salon painters at the end of the nineteenth century aspired in vain. Ingres liked to think of himself as a Greek, the sole heir of the age of gold; in point of fact, he was the progenitor of a very modern school of painters occupied not with human values but with those unpredictable combinations of form and structure which occur to inventive minds.

All that entitles Ingres to his niche in history is expressed in *Mme Rivière*, painted—it hardly seems possible—in his twenty-fifth year. This picture, planned and executed to perfection, has been commended by artists of all denominations. Delacroix—no lover of Ingres—called it, with his fine perception, a Chinese ornament—and there is an Oriental quality in the linear rhythms which flow and converge with no loose ends; contemporary writers, awed by its wonderful textures, labeled it Gothic; others thought it classical in its detachment; today it is called an Ingres. It is admired by a whole school of painters, including Picasso, who regard Ingres as the great modern master in removing all sentiment from portraiture, and in presenting the human figure as a pattern which arouses, not the ordinary human responses, but that rare state of satisfaction known as the esthetic emotion.

*Mme Rivière*, Louvre, Paris. Oil, 35¾″ x 46″, 1805. Color plate, page 201.

*François Bertin*, Louvre, Paris. Oil, 37⅜″ x 45¾″, 1832. The founder of the *Journal des Débats*, in all his sagacity and amplitude.

[LEFT] *L'Odalisque à l'Esclave*, The Walters Art Gallery, Baltimore. Oil, 40″ x 30″, 1839. A later version of the old subject, a languorous nude in a Turkish setting.

# JEAN AUGUSTE DOMINIQUE INGRES

*Self-portrait*, Metropolitan Museum, New York. Oil, 26¾" x 33½", 1804. A severe, exceedingly competent, pseudo-classical job done under the spell of David.

THE immediate inspiration of *Le Bain Turc* was a graphic account of the ablutions of the girls of the harem in one of Lady Mary Worthley Montagu's letters from Constantinople, but the basic source of generation was neither Turkish nor literary. It was a subject uppermost in the mind of the artist from adolescence to senility: the female nude—the younger and more seductive the better—an obsessional preoccupation with the refinement of nakedness that prompted Baudelaire to remark, "The distinguishing characteristic of the art of M. Ingres is his devotion to young women." The devotion was not Platonic, nor was it consistent with the Greek ideal as he fancied—he was unfamiliar with Greek art save for a few colonial intaglios and some commercial pottery. It was a scrupulous, searching, undeviating perception of contours and saliences, and the employment of all his powers to express these perceptions in forms of imperishable beauty.

With Ingres the subject was merely a pretext—a release for his predilections and an excuse for the exercise of craftsmanship carried to the pitch of genius. He was not concerned with emotions or ideas, and was incapable of converting a given theme into a circumstantially convincing picture. In truth, as illustration, *Turkish Women at the Bath* is a shock to one's credulity, and as a composition it is far from felicitous. It is obviously a congested exhibition of languorous nudes, each with a face taken from Raphael's early madonnas, but sensualized and softened. These strictures, however, do not matter. The art of Ingres is dependent on other virtues and on a single-minded attitude toward his subjects which, in its best manifestations, is close to perfection. Psychologically, there is no difference between his approach and that of his followers such as Bouguereau, Cabanel, and Alma-Tadema, but he was a man of genius while they were only conscientious hacks. *Turkish Women at the Bath* contains passages in which two or three figures are rhythmically joined with much of the ease of Raphael, his master; and individual figures which, by the interweaving of lines, the infinitely sensitive adjustment and planning of contours, and by the suppleness of the flesh, arrive at a formal impeccability seldom seen in painting since the Renaissance.

*The Stamaty Family*, Louvre, Paris. Pencil drawing, 14⅝" x 18½", 1818. In Rome, in his earlier life, Ingres made a living by his portrait sketches, sharp-edged, impeccably drawn likenesses now treasured by collectors.

[RIGHT] *Turkish Women at the Bath*, Louvre, Paris. Oil, 43" in diameter, 1862. Color plate, page 202.

# JEAN BAPTISTE CAMILLE COROT

1796–1875                                                    FRENCH SCHOOL

*La Trinité des Monts,* Louvre, Paris. Oil, 29⅛″ x 18″, about 1826-28. Painted on an early Italian tour and a superlative example of his use of light and atmosphere in a solidly composed landscape.

COROT, the happiest of painters, was born in the midst of the French Revolution, but the paroxysm left no mark upon him. In politics a conservative; in art, a disciple of Claude, this simplehearted, generous man lived his fourscore years in that blissful state of nature apostrophized by Rousseau. He wandered through life without a care, or an enemy, a gypsying dreamer—and incidentally a terrific worker producing some twenty-five hundred canvases—and when, at last, the journey was over he said, with a faith that amused his Bohemian friends, "that he hoped to go on painting in heaven." To him the antique was a closed book, and he set little store by the Renaissance masters; he traveled in Italy, but only to study the landscape, shutting his eyes on the celebrated wonders, and refusing to enter the Sistine Chapel. He painted with a song on his lips, for the joy of it, striving neither to be famous nor astonishing.

Unquestionably Corot's great work was done in his early years. In his first period, he painted both in Italy and in France those lucid and uncluttered landscapes known to students as classical compositions, though he never thought of them as classical—landscapes which, by reason of their firmness of structure, their tranquillity and dignity, communicate his strongest and most controlled feelings before nature. Those masculine conceptions hidden until recently in private collections are not so widely known as the more popular work of his later years—the bowers of gray and silver, the filmy leafage painted under the influence of photography. Corot never regained the artistry of his first period; he made an effort to return to it, but his photographic pictures brought him a handsome income and he was princely in his benefactions to the indigent members of his profession.

*La Rochelle* was painted in 1851, after the death of his mother. Robustly constituted, the grief-stricken Corot wandered along the western seacoast of France to the ancient port of La Rochelle out of which he made a stainless harmony of light, sea, and sky. Apparently effortless in its structure and its scattered figures, the picture was carefully designed to preserve the quiet atmosphere of the old town, and to fulfill Corot's dream of a permanent landscape which, like those he had seen in Italy, was immune to the accidents of time and fashion.

*La Méditation,* formerly Robert Treat Paine Collection, Boston. Oil, 18¼″ x 13⅜″, about 1840-1845. Painted in his second period when he inserted studio figures into outdoor settings.

[LEFT] *La Rochelle,* Stephen C. Clark Collection, New York. Oil, 28″ x 19¾″, 1851. Color plate, page 203.

# EUGÈNE DELACROIX

*Liberty Leading the People*, Louvre, Paris. Oil, 128″ x 102⅜″, 1830. Color plate, page 204.

MODERN French painting begins with Eugène Delacroix. He was born into an age of revolt, a world of political insurrections and unparalleled discord among the artists; the time had come to slay the academic incubus, and having one of the finest minds of the century, he found himself, when a very young man, the leader of the radical forces. When the plague of the house of David lay upon art, Delacroix came forward in a blaze of color, and was named the champion of individual freedom in painting. He rooted out the sham classicism which was choking French art to death, introducing action, turbulence, and brilliant color. There is something of Delacroix in all his successors; he had intellect and ideas, and a program that has been dismembered into a hundred schools and subdivisions. He failed in his attempts to destroy the academy, but he stands in relation to modern painting as France once stood in relation to the whole world, and as the commanding figure stands in one of his most thrilling pictures: *Liberty Leading the People.*

Delacroix was not opposed to historical themes or classical subject matter—he reveled in both, with catholic tastes and liberal judgments; he was opposed to the sterility of the Salon bureaucrats who tried to paint in the classic style. Nor did he condemn the efforts of the official artists to glorify the state—he was a patriot himself, willing to sweat and suffer for the traditional glory of France. His passion for freedom, which exemplifies the most heroic elements of French culture, was inflamed by the revolt of 1830, when the Republican cause of France was delivered from the Bourbon dynasty. To commemorate the deliverance, Delacroix, his imagination gloriously excited, painted one of his great pictures, invoking the symbol of liberty, the sacred genius of his nation, to flaunt the tricolor and lead the veterans and the children to·victory. It is one of the few pictures in history in which a symbolical figure is successfully incorporated with realistic action. Because of its political implications, the painting received official recognition, but the academic crowd, deploring the modern treatment, howled in derision and called it a mockery of art.

*Portrait of Chopin*, Louvre, Paris. Oil, 15″ x 18⅛″, 1838. The large-scale energy of Delacroix brilliantly condensed in a portrait worthy of the old Venetians.

[RIGHT] Detail from *Liberty Leading the People.* One of the most inspiring heads in modern art—Graeco-French—and the emblem of freedom everywhere.

# EUGÈNE DELACROIX
## CONTINUED

DELACROIX entered the arena as a fighting antagonist, an heroic symbol lending a Napoleonic touch to French art. By the force of his courage and by his daring campaign to create a new tradition, he shifted the base of procedure from the effigies of the academic morgue to the healthy athleticism of Rubens. The official mouthpieces, trembling for the security of their jobs, screamed with vituperation and called his *Massacre of Scio* the "massacre of painting!" He became, for a time, as he said, "the abomination of art," but he was delighted with himself; and instead of throwing mud at his accusers, he aggravated their spleen with more canvases, and for the benefit of those with the wit to understand, kept a Journal in which, with the most exquisite French, he expressed his ideas of art.

Delacroix, whose absorbing purpose was to stage a drama, historical or literary in origin, is not in high favor in these days of abstractions and still-life compositions, but without his example and his contributions to the science of color, there would probably be no modernist art. He was a great colorist, hating grays and drabs, and handing on to the Impressionists his palette of broken tones, a brilliant palette including a full orchestra of tones all singing together with an intensity and animation sometimes concealing the raggedness of his drawing and the violence of his stretched and lurching figures.

In 1832, in the company of the French ambassador, he journeyed to Morocco; in the following year we find him in Spain; and on his return to Paris, he exhibited a number of canvases inspired by his travels. These greatly enhanced his reputation, for the French have always loved the exotic, and his African studies set the fashion for Oriental subjects which became one of the staples of Parisian art, the latest manifestation being the Moorish pictures of Matisse. In his thirty-sixth year, he painted the Chicago version of the *Lion Hunt*—another version hangs in Boston—a superb illustration of his decorative style and, in many of its details, of the plasticity of his forms. Obviously he was influenced by Rubens, who executed, with assistants, at least five enormous hunting scenes, two of them depicting fiendish Orientals slaying lions, crocodiles, and other savage beasts. But the Flemish derivations are not excessive and the picture contains the riotous energy, the dramatic action, the incomparable color—in short, the living qualities which establish Delacroix among the leaders of modern painting.

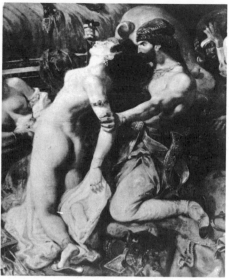

Detail from *Sardanapalus*, Louvre, Paris. The parts of this big canvas are better than the machinery of the whole, and here is a passage to set by the side of his master, Rubens.

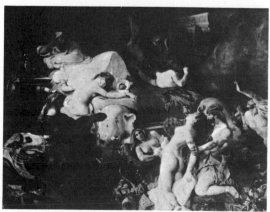

*The Death of Sardanapalus*, Louvre, Paris. Oil, 194⅞" x 155½", 1827. The last Assyrian king collects his wives, eunuchs, servants and even his horses and dogs, and makes a grand funeral pyre of his palace.

[LEFT] *Oriental Lion Hunt*, Art Institute, Chicago. Oil, 38½" x 30", 1834. Color plate, page 205.

# EUGÈNE DELACROIX

## CONTINUED

[ABOVE] *Orphan at the Cemetery*, Louvre, Paris. Oil, 25⅝″ x 21¼″, 1823. Representing the artist in a tranquil mood—a student of the Renaissance Italians.

[BELOW, RIGHT] *Dante and Virgil in Hell*, Louvre, Paris. Oil, 94⅞″ x 74″, 1822. Color plate, page 206.

[BELOW] *Lion and Serpent*, courtesy of Paul Rosenberg, New York. Oil, 24″ x 20″, 1858. The color and dramatic vitality of Delacroix in an oriental subject.

DELACROIX was a patrician and a scholar, the most prodigiously endowed artist of the nineteenth century. He was as generous in his praise of the Dutchmen as of the Italians; he proclaimed the genius of Goya and Daumier, and defended the rights of all honest artists, whether he liked them or not. A spectacular figure, incapable of vulgarity and the most distinguished conversationalist in Paris, he was the consummate product of French culture. Of delicate health and extremely nervous, he was forced to conserve his strength, but his work, in bulk, compares favorably with the most productive artists. With feverish intellectual curiosity, he gathered ideas from Dante, Scott, Byron, and Shakespeare; from mythology, the Crusades, the Revolution, and contemporary events; he painted portraits, battle pieces, animals, genre scenes, and murals, and he painted religious themes.

By orgies of unnatural toil, Delacroix restored the heroic elements to painting—his whole life was a magnificent gesture toward Rubens and the lords of the Venetian Renaissance. His later works—and they grew larger and more involved with time—beyond peradventure are the most accomplished decorations of his century, but they are more flamboyant than real, and the massive figures strain and lurch to fill the mold of Rubens. His finest and most dramatic things were done in the first period, before his frenetic attempts to expand himself into the stature of the Flemish giant.

Delacroix came into the arena with his *Dante and Virgil*, a work of incalculable force for a youth of twenty-three, and a work which, after the lapse of time, remains close to the masterpieces of the higher spheres. While engaged on the picture, he had *The Divine Comedy* read to him, painting like one possessed, and introducing his most effective type of design—a group of strongly lighted, centralized figures surrounded by darkened spaces. The scene, inspired by the Fifth Circle of the Inferno, represents Dante and Virgil, his guide, crossing a Stygian marsh on a ferry propelled by one of the damned. The passage is obstructed by souls of the sullen and the slothful, who were doomed to steep for an eternity in the brackish waters. One of them, in mortal life a rich Florentine of notorious greed, and an enemy of the poet, seizes the boat threateningly, and is repulsed by Dante with an uplifted hand and a colloquial imprecation beyond the powers of Delacroix to record.

# HONORÉ DAUMIER

### 1808–1879                                    FRENCH SCHOOL

SAVE for a few portraits, and pictures of the poor and miserable to whom he was bound by his own experiences, and by the feelings of loneliness and oppression which bind together all human souls, Daumier's art was that of an underpaid practitioner attached to French journals. Born in Marseilles, he was brought to Paris in childhood by his father, a glazier who succeeded at nothing. From his seventh year he took life in his own hands, choosing the career of artist. He lived in the gutter and in the Louvre, studied Rembrandt and Michelangelo, worked from nature, and was always modeling in clay and wax. At twenty-one, having mastered lithography, he joined the staff of a radical sheet, and served a term in jail for a caricature of Louis-Philippe. Unchastened, he resumed his post, and till his death earned his bread as a social satirist. In 1848, about the time of his marriage to a seamstress, he began to paint in oils, achieving classic nobility in his first trials—but his canvases were rejected as incompetent. He bore his defeats stoically and returned to his lithographs, sometimes drawing on eight stones simultaneously in order to be free to paint. The strain was great and he was never free; his eyes failed him, and in his declining years he could not get fifty francs for a water color. He died totally blind and without a sou, in a little house that Corot, anonymously, had taken for him.

Daumier used no professional models—the working population of Paris was his model, he said. Without the trappings of antiquity, without heroic achings, he trained his vision on the commonest things and discovered new valuations of life. Lowly travelers stirred his compassion, and he painted them in many oils and water colors, always in the same postures, but with increasing simplification. The greatest is the *Third-Class Carriage*, an unfinished painting, rather low in tone, the color running from the subtlest mixtures of deep reds and greens into a rich monochrome. The figures in the compartment are real—not decorated pilferings from the old art—figures with incisive bulk and the force of things experienced and habitually pondered over, filled with the artist's pity and the weight of his magnanimity, with the substance poured into them by a great soul. In hands reduced to outlines but beautifully drawn, in coarse peasant faces, in bodies as solid as the clay from which they were fashioned, Daumier tells the story of the dreariness of one aspect of French life—and more, the whole story of suffering humanity.

[ABOVE] *The Friends of Peace*, Wiggin Collection, Boston Public Library. Lithograph. Daumier gained a meager living by his satirical drawings of public enemies, in uniform and in politics.

[BELOW, LEFT] *Third-Class Carriage*, Metropolitan Museum, New York. Oil, 35½″ x 25¾″, about 1860-1870. Color plate, page 207.

[BELOW] *La Soupe*, Louvre, Paris. Pen-and-wash and water-color drawing, 14″ x 11″. For expressive power and rhythmical action rendered with the utmost economy of line and tone, the *Soup* is unparalleled in modern art.

# HONORÉ DAUMIER

## CONTINUED

*The Washerwoman*, Metropolitan Museum, New York. Oil, 13⅛″ x 19⅝″, about 1861-1863. Color plate, page 208.

*Head of Clown*, Sidney Brown Collection, Switzerland. Oil, 6¼″ x 8¾″. Character and volume indicated in the most fluent style since Rembrandt.

DAUMIER brought his great work to its conclusion before the zeal for technical speculation had alienated art from humanity. In his art there is not the slightest evidence of any cult of special meanings or unintelligible theories—it is the art of a thoroughly healthy mind. He is classic in the true sense of the term, setting up no technical barriers between himself and the world. He entered emotionally into French life and developed the meanings of his land and kind. His subject matter, gathered from the humblest orders, is so elemental that it has been aspersed as commonplace. It is anything but that: he painted men and women with whom he had worked and known privation, and he painted them with a depth of feeling unapproached by his countrymen.

But Daumier's supremacy is not altogether a matter of feeling—a man does not make art solely from the depths of his compassion. He was driven by a purpose and guided by superior knowledge; he had the vehement preferences and interests which keep a man's attention centered on his fellows. His knowledge was the integrated experience of life—of poverty, sorrow, religion, manners, politics, and art manifestations—which he had put to a humane purpose and presented in relation to his personal judgments of value. It was common knowledge intensified by sustained observation. He knew, from lifelong habits of vision, and his training in sculpture, the infinite number of planes composing the body, and of this number the few indispensable to the simplest rendering of condensed bulk and solidity. He picked out essentials and exaggerated them to his own ends: in his caricatures, to gain ironical effects; in his paintings, to express emotions of tragedy and heart-wringing pathos as intrinsically spiritual as the religious states evoked by the old Italians.

With Daumier it was not a question of painting all things with facility and charm, but of painting a few subjects with tremendous power, modeling them sculpturally in planes of tone, with the planes brushed together into a compact whole. From the window of his old house on the Quai d'Anjou he saw women scrubbing clothes by the riverside, women as poor as he was; he observed and painted them—one of them many times—in the same attitude and with the same burden. *The Washerwoman*, of 1861, with the background of ancient buildings, is Daumier's conception of Parisian life—or that part of it which moved him most profoundly.

[RIGHT] *The Uprising*, The Phillips Collection, Washington. Oil, 40½″ x 34¼″, about 1850. Generally accepted as a Daumier but with reservations in certain quarters. Probably an incident in the revolution of 1848.

81. *Cardinal Niño de Guevara* · EL GRECO · Metropolitan Museum, New York. Text, page 161.

82. *Toledo in a Storm* · EL GRECO · Metropolitan Museum, New York. Text, page 162.

83. *Pietà* · EL GRECO · Comtesse de la Béraudière Collection, Paris. Text, page 163.

84. *The Maids of Honor* · DIEGO RODRÍGUEZ DE SILVA Y VELÁSQUEZ · Prado, Madrid. Text, page 164.

85. *Infanta Maria Theresa* · VELÁSQUEZ · Bache Collection, Metropolitan Museum, New York. Text, page 165.

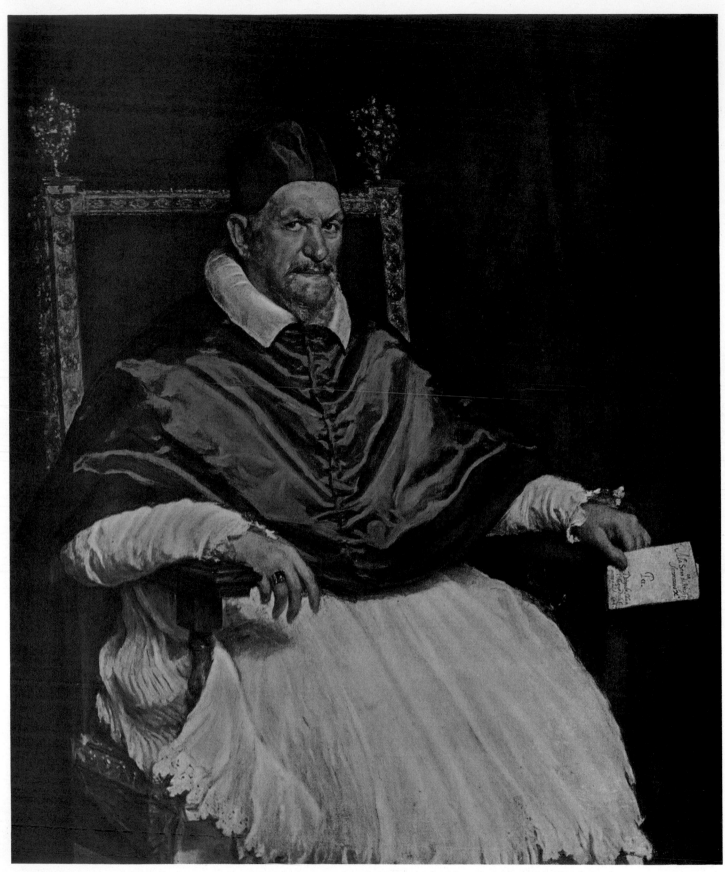

86. *Innocent X* · VELÁSQUEZ · Doria-Pamphili Gallery, Rome. Text, page 166.

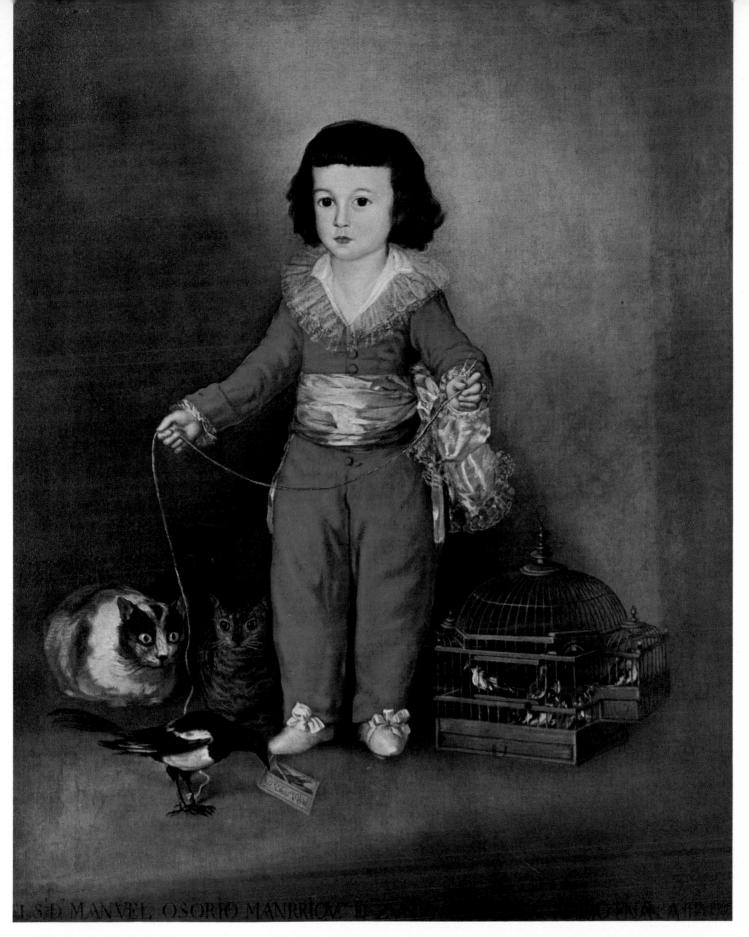

87. *Don Manuel Osorio de Zuñiga* · GOYA · Bache Collection, Metropolitan Museum, New York. Text, page 167.

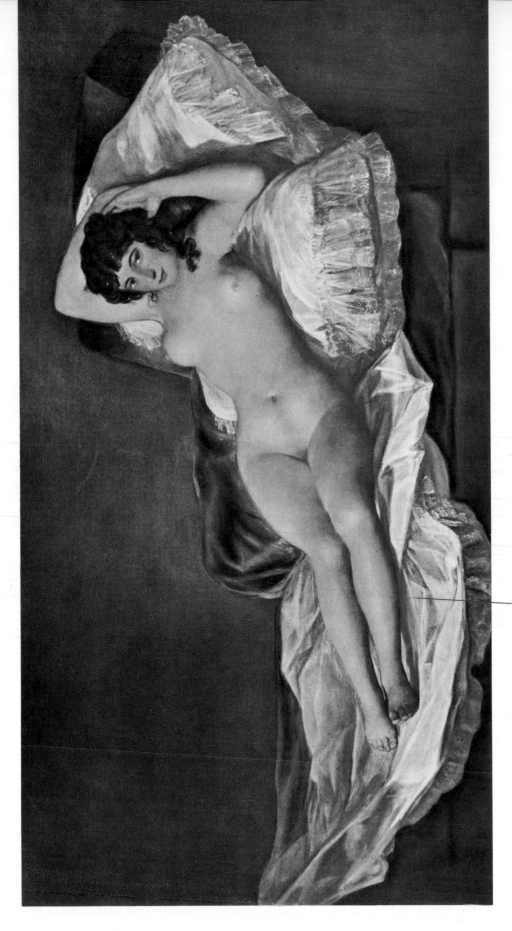

88. *The Nude Maja* · FRANCISCO JOSÉ DE GOYA Y LUCIENTES · Prado, Madrid. Text, page 168.

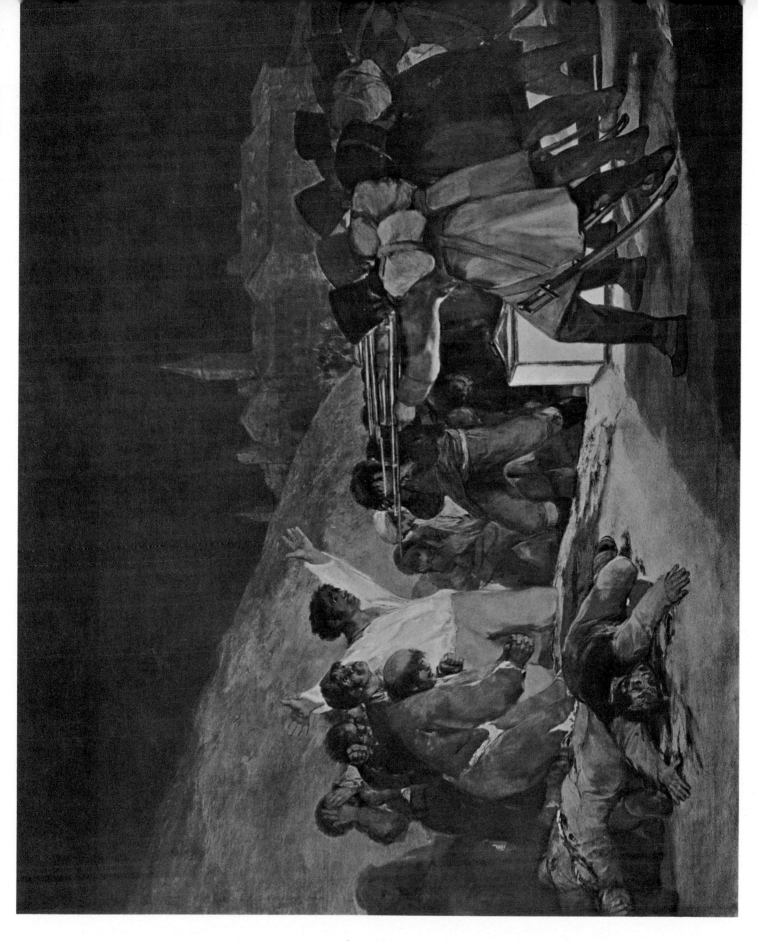

89. *The Execution—May 3, 1808* · FRANCISCO JOSÉ DE GOYA Y LUCIENTES · Prado, Madrid. Text, page 169.

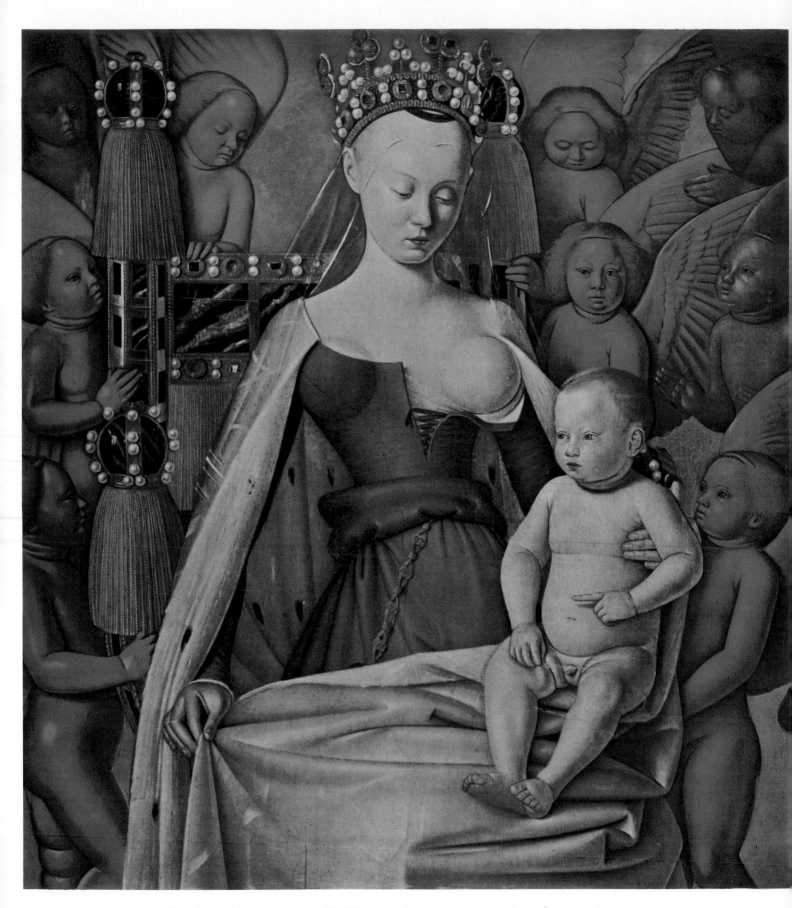

90. *Virgin and Child* · JEAN FOUQUET · Museum of Fine Arts, Antwerp. Text, page 170.

91. *The Funeral of Phocion* · NICOLAS POUSSIN · Louvre, Paris. Text, page 171.

92. *The Ford* · CLAUDE LORRAIN · Metropolitan Museum, New York. Text, page 172.

93. *The Embarkation for Cythera* · ANTOINE WATTEAU · Louvre, Paris. Text, page 173.

94. *Kitchen Still Life* · JEAN BAPTISTE SIMÉON CHARDIN · Museum of Fine Arts, Boston. Text, page 174.

95. *Storming the Citadel* · JEAN HONORÉ FRAGONARD · Frick Collection, New York. Text, page 175.

96. *Mlle Charlotte du Val d'Ognes* · JACQUES LOUIS DAVID · Metropolitan Museum, New York. Text, page 176.

97. *Mme Rivière* · JEAN AUGUSTE DOMINIQUE INGRES · Louvre, Paris. Text, page 177.

98. *Turkish Women at the Bath* · JEAN AUGUSTE DOMINIQUE INGRES · Louvre, Paris. Text, page 178.

99. *La Rochelle* · JEAN BAPTISTE CAMILLE COROT · Stephen C. Clark Collection, New York. Text, page 179.

100. *Liberty Leading the People* · EUGÈNE DELACROIX · Louvre, Paris. Text, page 180.

101. *Oriental Lion Hunt* · EUGÈNE DELACROIX · Art Institute, Chicago. Text, page 181.

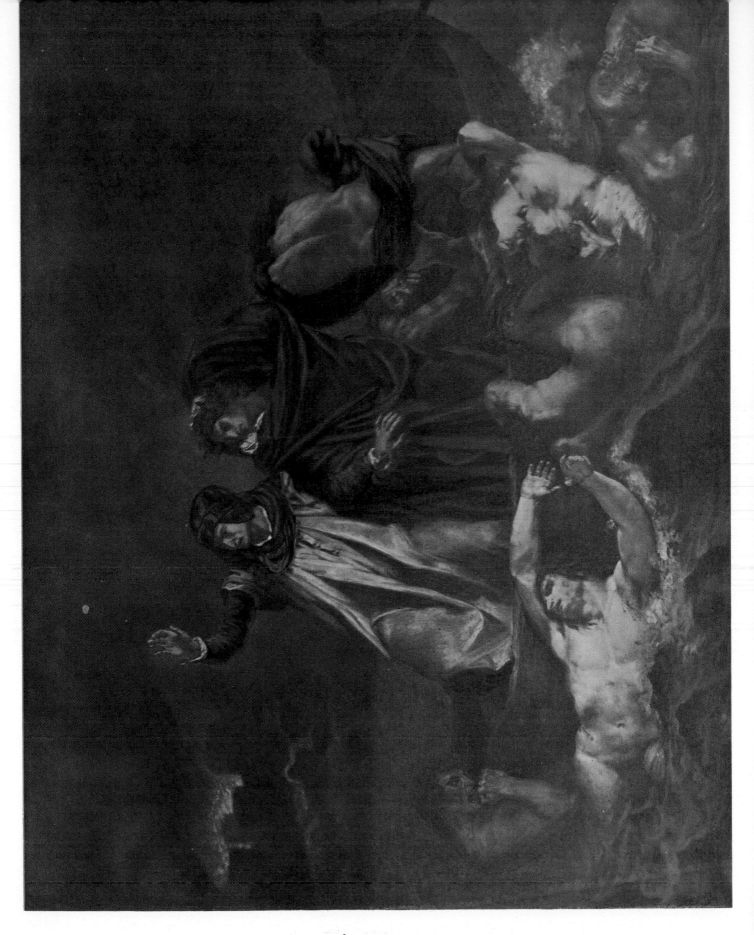

102. *Dante and Virgil in Hell* · EUGÈNE DELACROIX · Louvre, Paris. Text, page 182.

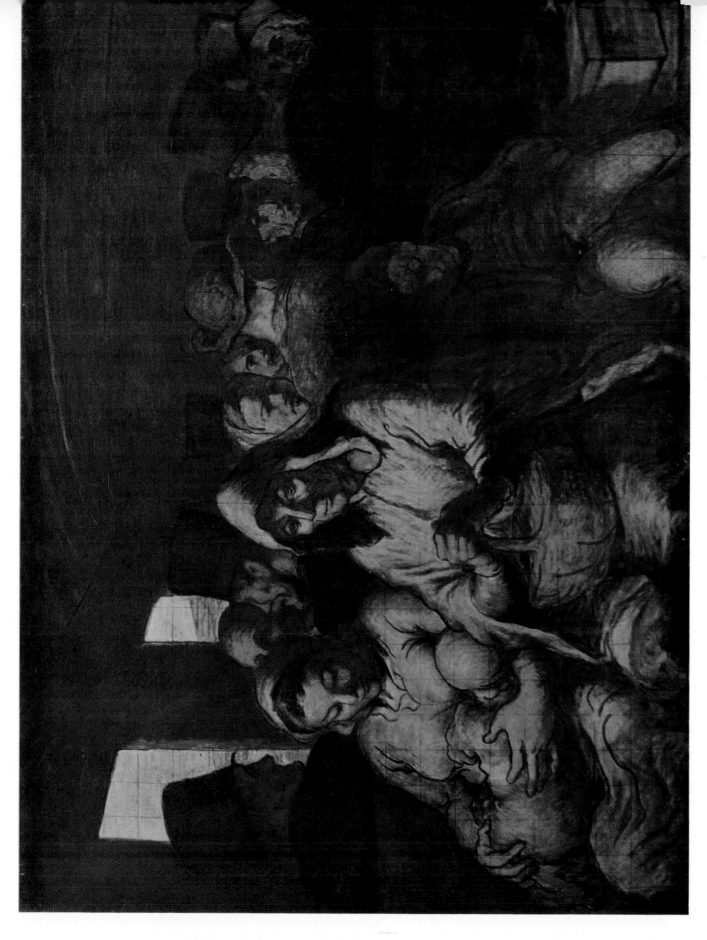

103. *Third-Class Carriage* · HONORÉ DAUMIER · Metropolitan Museum, New York. Text, page 183.

104. *The Washerwoman* · HONORE DAUMIER · Museum of Modern Art, New York. Text, page 184.

# WILLIAM HOGARTH

1697–1764                    ENGLISH SCHOOL

HOGARTH stands first in the list of British painters, above and apart from all others, one of the great men who have carried the name of England into the corners of the world. He is the most various of British artists, truly Shakespearean in his conception of painting as a dramatic art: "My picture is my stage," he said, "my men and women my players." Before him there had been no native painters worth mentioning—only manufacturers of sleazy fashion plates in the style of Van Dyck, or incurable hacks practicing some misunderstood formula picked up on the Continent. The time had come for a return to the more primitive foundations of earth and nature; there was desperate need for a man of high intellectual faculties, combative strength, and masculine artistry; and in William Hogarth, England produced her man.

Hogarth, the son of a poor schoolmaster, said of his early life: "I cut a poor figure at school, but I had a good eye, I was fond of shows, and I was always drawing." From his twentieth to his thirtieth year, he diligently followed the trade of commercial engraver, painting, between jobs, conversation pieces, or little scenes from metropolitan life. He knew his London, and there was no form of life, high or low, that escaped his critical intelligence or offended his artistic sensibilities. From his success in small oils and engravings, he proceeded to cycles of narrative compositions, and thence to portraiture; and against the weight of tradition and the slurs of the bigoted guardians of the grand style, made himself the foremost painter in London.

Hogarth has so much to say that his pictures are full to overflowing; but his groupings are never studio models hashed together arbitrarily—his characters inevitably fall into their natural positions in space. His studies of people are the flower of English portraiture—exquisite in color, superb in draftsmanship, varied and original in design. *The Graham Children* is an example of his humanity and the deceptive artlessness of his designs. These children, in their happy attitudes, convey the spontaneity of a nursery setting; but if the domestic properties were removed, and the background idealized, the picture would readily disclose the formal unity and impressiveness of a classical structure. Hogarth struck an almost perfect balance between his subject matter and the means of presentation.

*Self-portrait with His Dog Trump*, National Gallery, London. Oil, 35½" x 27½", 1745. The solid man who ruined the sham-classicists. On his palette is the famous double curve, or "line of beauty."

Detail from *The Graham Children*. In all painting there is no cat more convincing, technically or as a feline.

[LEFT] *The Graham Children*, National Gallery, London. Oil, 63¼" x 61¼", 1742. Color plate, page 242.

# WILLIAM HOGARTH

### CONTINUED

*The Shrimp Girl*, National Gallery, London. Oil, sketch from last period, 20¾" x 25". Color plate, page 241.

THE whole of England sweeps through Hogarth's imagination: the grim, the sweet, the coarse, the cruel, the lusty, and the tender. He loved English women and the beefy men whom he painted in the bulk forms of sculpture; he frequented fairs and taverns, fishmarkets, sideshows, dances, and all-night supper parties; observed parading redcoats and election riots, and followed the crowd to a holiday of executions. With his good sense and indigenous appetites, he could no more have prostrated himself before the old masters than his friend, Henry Fielding, could have written novels in Latin hexameters. Not that Hogarth was ignorant of the Italians whom, with irritating disloyalty, he nicknamed the Black Masters because of the curse they had cast on British art; but he had the wit to understand that the technique of painting, to be of service to mankind, must be put to work in new situations and transformed in the crucible of experiences into a living implement.

Accordingly, with the perseverance of a craftsman, he attained a style of his own, a style so appropriate to his ideas and so devoid of sleights and shams that it was promptly sniffed at by the connoisseurs and denounced as colloquial and vulgar. It was colloquial—but in the Shakespearean sense; and Hogarth, smarting under the snub, decided on a more effectual means of reproving his adversaries. "I had," he said, "one material advantage over my competitors: the habitual exercise of retaining, in my mind's eye, without coldly copying it on the spot, whatever I intended to paint." He intended, in this case, to paint an English girl whom he retained in his mind's eye, a sterling type in the first bloom of womanhood, and to portray her in such a way as to shame his accusers. There can be no doubt about the result. *The Shrimp Girl*—the picture might be called the Madonna of the Fishmarket—is a work of unaccountable vivacity, a bravura piece created to disarm the skeptics by its economy of means—it is hardly more than a sketch—its scintillating execution, and its authentic warmth and charm.

For nearly two hundred years, the girl with a dish of shrimps on her head has captivated all beholders, particularly painters who have marveled at its quality and its mastery of technique. Perhaps the highest praise came from Whistler, the little Caesar, who, squinting through his monocle, and unsettled in his conviction that only himself and Velasquez had made so much out of so little, exclaimed, "Hogarth, the only great English painter!"

Detail from *Calais Gate*, London. The starved soldier and fat priest beholding the roast beef of old England.

[RIGHT] *Calais Gate*, National Gallery, London. Oil, 31" x 37¼", 1749. Satire on French poverty and superstition to avenge the painter's arrest while sketching at the gate.

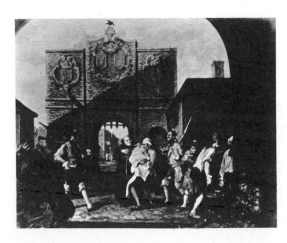

# WILLIAM HOGARTH
## CONTINUED

IMMEDIATELY after his elopement with Jane Thornhill, twenty and very lovely, Hogarth put to practical test his ideas of "composing pictures on canvas similar to representations on the stage"; and in 1731 *A Harlot's Progress* burst upon London. This, the first of his social dramas, was received with instantaneous applause, the only dissenters being the imitators of the Black Masters. The people did not pause to consider the artistic pretensions of the sequence, but they acclaimed vociferously the dramatic representation. Hogarth had revived the oldest and most appealing form of art, that of the connected narrative, which had been lost to painting since the early Italians; and the British, destitute of real art, welcomed his social fables as wholeheartedly as the Italians had welcomed the religious fables of Giotto.

Pleased with himself, but not unmindful of the flaws in the work, Hogarth, in 1735, presented *The Rake's Progress*, a picture drama unfolding in eight scenes the career of a spendthrift. Young Tom Rakewell comes into his inheritance, is surrounded by fashionable parasites, revels, is arrested for debt, marries a hideous old widow for her money, gambles, is thrown into prison, and dies in Bedlam—a morality for any age. In Scene III, an orgy is enacted. A woman caresses the young rake with one hand and steals his possessions with the other; a harpy undresses for a dance; while a drunken confederate in the background sets fire to a map of the world; and across the table an angry wench spits at another who has snatched up a knife.

The scene, without a superfluous stroke or detail, is a masterpiece of painting. The story is present, but with no cheap sentiment of repentance, and no concessions to sobbing parable. In the freshness, the variety, and the organic oneness of this series, Hogarth has not been excelled by any painter. His figures never seem to be striking attitudes; they are all combatants, all necessary to the action, and they transmit the action so perfectly as to create the illusion of living characters involved in realistic difficulties. Because these picture dramas are so plausible and convincing, the artist has been accused of taking his compositions ready-made from real life. No one else ever found such original combinations of attitudes in real life—they are Hogarth's unique possession, and they contain the mind and art of the man who made them.

*Hogarth's Servants*, National Gallery, London. Oil, 29¼" x 24½". The English character has never been portrayed with more kindliness and sympathy. You can hear the accent.

*The Reward of Cruelty*, The Pierpont Morgan Library, New York. Sketch, for engraving, about 1736. The doctors confer as the medical butchers go to work.

[LEFT] *The Rake's Progress—III*, Sir John Soane's Museum, London. Oil, 29½" x 24½", about 1733. Color plate, page 243.

# SIR JOSHUA REYNOLDS

1723–1792                                                ENGLISH SCHOOL

*Dr. Johnson*, Tate Gallery, London. Oil, 24½"
x 29½", 1772. Color plate, page 242.

HOGARTH, in a man's country, had made an art for men; had laid the founda-
tions for a national school of the amplest proportions; but his successors,
unhappily, were carried along by the tide of fashion. England, despite her
wars, was growing rich; and young gentlemen, before settling down to the
more serious business of sedentary living, embarked on the Grand Tour, a
cultural jaunt into Italy where they collected Venetian pictures. In 1768, the
Royal Academy was founded with Reynolds as the first President; the artist
was elevated to an official status in society; a native school was called into
existence—a school of portrait painting which speedily prospered into a na-
tional industry. In fifty years, English portraitists had exceeded three cen-
turies of Continental production. Reynolds painted more than two thousand;
Gainsborough at least one thousand; and Romney boasted of nine thousand
sittings in twenty years! The British painters were clever and gifted men: their
purpose was to heighten gentility, and to portray the Englishman, his wife,
and his children as the most charming people in the world.

Sir Joshua Reynolds, the most famous, was ambitious and scholarly, and,
to his clientele, the master of a new school of art well grounded in the ancient
traditions. He returned from Italy, after three years of study, filled with ven-
eration for classical art, and his *Discourses*—his lectures to his pupils at the
Academy—laid down a set of principles for the formation of a national art
in the grand style, an amalgamation of the loftiest elements of the Italians,
with an admixture of Rembrandt and a curtsey to Van Dyck.

But in practice, Sir Joshua often confused the grand style with the high
station of his subjects, flattering his women ostensibly into goddesses or graces,
but actually into high and mighty creatures surrounded by mythological acces-
sories. Children fascinated him, and he painted them somewhat fancifully but
with the ease and natural readiness he preached to his pupils. In his best por-
traits of men, he forgot his classical paraphernalia and painted British heroes.
His masterpiece is *Dr. Johnson*, a massive characterization and one of the most
distinguished studies of the human head in British art. In the lexicographer,
he found an ideal subject: an autocrat like himself, his closest friend, a man
of size and hidden depths of spirit. Reynolds painted his ponderous bulk with
dignity and assurance, and by accentuating the Doctor's uncouth loftiness,
came within striking distance of the ideal style of his ambitions.

*Miss Bowles*, Wallace Collection, London. Oil,
37¾" x 35½", 1775. Reynolds at his best, and
as one of the first masters to capture the fresh-
ness and roguish charm of childhood.

[RIGHT] *Self-portrait*, National
Gallery, London. Oil, 29¼" x
25", 1749. An early work as a
student of the "grand style"
which is alien to his talents.

# THOMAS GAINSBOROUGH

THE landscape painters of Great Britain were impelled by the same forces that summoned the lyrics of Wordsworth, Coleridge, Shelley, and Keats. Their devotion to nature was intense and unaffected, a communion with things they knew best, the glorious rural world of their birthright; there had been landscape artists before the British, but they had seen nature from afar, like Poussin and Claude, or they had painted indoors after the Dutch fashion. It was the English who took painting into the open air, under God's—and Ruskin's—great blue sky. In peace and freedom, they explored the soul of nature, revealing her secrets and mysteries, her infinite variety and her blessings.

Gainsborough's landscapes are among the most affecting things in British painting. Nature was his first and greatest love, and though his wayward soul was sidetracked into the fashionable art of portraiture, he remained faithful to his first mistress, and continued to sketch from memory the ineffaceable scenes of his early years in Suffolk. As a youth, like the young Shakespeare, he roved the fields and woods, observing for the first time in British painting, not groups of trees and undefined shapes, but individual forms, with all the minutiae of foliage and bladed grass. In after years, with more knowledge and under the spell of Rubens, he painted in more generalized masses, changing nature to olive greens, browns, and silver grays, to enforce a tone of melancholy.

*The Harvest Wagon* was painted in a mood of romantic loneliness. It is one of his masterpieces, but unfortunately the glowing browns and greens, the reflected lights, and the color of the sky have darkened in value. In its theme—the return from toil—it is similar to many of his landscapes; and in a remotely symbolical way, it expresses his yearnings to resume the country life he loved. With him, it was always the pathos of the lonely soul returning home to the consoling tranquillity of the trees and fields at the end of day. Gainsborough's landscapes touch the emotions with the voice of a stringed instrument; the key is low and the volume slender, but the tone is perfect. His world, compared with that of Rubens, his master, is only a corner of nature, but more lyrical and delicate. It is nature reshaped, with the colors modified, the trees and earth conjoined, a mood restrained and gentle, a melody that soothes the spirit.

*Lady Walking in St. James Park,* British Museum, London. Chalk, 19⅛″ x 12¼″, 1780. This sketch for a portrait, probably of Georgiana Spencer, Duchess of Devonshire, shows the lightness and freedom of touch characteristic of all of Gainsborough's work.

*The Artist, His Wife and Elder Daughter Mary,* Sir Philip Sassoon Collection, London. Oil, 27¾″ x 36″, about 1751. A combination Gainsborough, the figures skillfully grouped, and the landscape enchanting.

[LEFT] *The Harvest Wagon,* Art Gallery of Toronto. Oil, 4′ 11″ x 4′, 1784. Color plate, page 246.

# THOMAS GAINSBOROUGH

## CONTINUED

*The Honorable Mrs. Graham*, National Gallery, Edinburgh. Oil, 59½" x 92¼", 1775. Color plate, page 245.

WEARY of his fame and his metropolitan entourage, Gainsborough said, "I'm sick of portraits; I wish very much to take my viol da gamba and walk off to some sweet village, where I can paint landscapes and enjoy the fag end of life in quietness and ease." A self-trained artist, he was lured from the Suffolk lanes into the fashionable circles of Bath and London. He was everything the imperious Reynolds was not: a true Bohemian, fond of music and tramp fiddlers, generous and lighthearted, an enchanting personality—one of those rare souls whom the polite world takes into its bosom. In 1777, he exhibited in London *The Honorable Mrs. Graham*, and Sir Joshua was no longer the kingpin of portrait painters.

The portrait of Lady Graham summarizes Gainsborough's resplendence in a field he did not choose to conquer. It established him as the creator of unadulterated charm, a position unchallenged in British art. The charm of the lady is the real thing, neither strained nor mechanically concocted; and the charm is the pure and spontaneous emanation of Gainsborough's personality. Many valuable qualities an artist may acquire by forethought and labor—but not this quality. In his gay and passionate nature flowed a spring of delicacy which pervades all his portraits, and which shines out with particular luster in his studies of women. He was more than a dazzling executant handling oils with the directness and freedom of crayon; more than a clever face-painter who never missed a likeness—he sensitized his women with the irresistible fascination of his own personality. Against his inclinations he was destined to express to perfection perhaps the most coveted quality in portraiture.

Gainsborough was oblivious of the heroic: to him women were women—they fluttered his heart, and he painted them with loveliness and with sex. He did not flatter them; if they did not touch his sensibilities, he had no luck. In the presence of great ladies, even the formidable personages—he retained his natural deportment and his normal speaking voice. Sir Joshua Reynolds painted Mrs. Siddons, not as a woman but as the Tragic Muse squired by Furies; Gainsborough painted her as a woman of character with a beautiful face, and while busy with the portrait, which gave him trouble (for he was not a finished draftsman), he exclaimed, "Damn your nose, Madam! There's no end to it!"

*Mrs. Siddons*, National Gallery, London. Oil, 39" x 49½", 1784. The face smooth and cold for Gainsborough, the costume exquisitely handled.

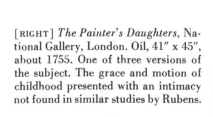

[RIGHT] *The Painter's Daughters*, National Gallery, London. Oil, 41" x 45", about 1755. One of three versions of the subject. The grace and motion of childhood presented with an intimacy not found in similar studies by Rubens.

# SIR HENRY RAEBURN

### 1756–1823         ENGLISH SCHOOL

OCCASIONALLY, in the history of painting, a man appears whose life is distinguished by the absence of temperament and color, whose art is notable for the symmetrical completeness of its development. Raeburn was a man of this stamp, the only Scottish painter of the first rank, and in his shrewdness and practicality as thoroughgoing a Scot as ever lived. In the beginning, he was a jeweler's apprentice and a painter of miniatures; at the age of twenty-two he cannily married a woman of wealth and his financial difficulties were ended. With the exception of a tour in Italy where, on the advice of Reynolds, he studied Michelangelo, and three brief visits in London, he lived in Edinburgh as a Scottish gentleman, and painted with the regularity of a day laborer. A more composed and successful painter never plied his trade—and success did not turn his head; and after the transition from his early square brush-strokes to a more compact modeling, his style was so uniformly vigorous and competent that it is impossible, without external evidence, to ascertain the dates of his canvases. He painted the important families of Edinburgh and all the celebrities, Robert Burns excepted.

From first to last, Raeburn was a self-contained artist: how other painters gained their effects did not interest him, and his improvement was largely a matter of practice and vigilant observation before his sitters. He was essentially a portrait painter, and his one expressed ambition was to paint a man "in his habit as he lived." With this in mind, he was a student of local backgrounds, costumes, animals, and accessories in keeping with the character of his subjects. He painted the Fergusons, the Campbells, the Mackenzies, and the MacNabs—sturdy Gaelic folk whose racial traits and features leave no one in doubt. Raeburn's imagination was excited by no great passions or sorrows, but the charge that he was lacking in warmth and affection is answered by *The Drummond Children*. The painting is without sentimentality and fanciful artifices; but it has the force and attraction of a living representation, and the charm of children rendered with reserved and affectionate penetration— it is an unflinching record of childhood that has not grown old-fashioned with the years.

*The Drummond Children*, Metropolitan Museum, New York. Oil, 60¼″ x 94¼″. Color plate, page 249.

*Mrs. Andrew Hay*, Joslyn Memorial Art Museum, Omaha. Oil, 3′ 3½″ x 4′ ½″, after 1784. As direct and forceful as his portraits of men and emphasizing, as usual, the head at the expense of a summarily brushed costume.

[LEFT] *Boy with Rabbit*, Burlington House, London. The Scotsman in his British manner, and in reproduction, a household favorite in England and America.

# WILLIAM BLAKE

1757–1827         ENGLISH SCHOOL

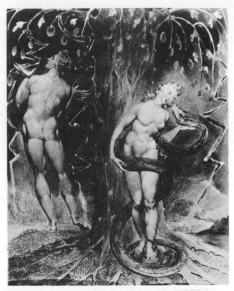

*The Temptation of Eve*, Museum of Fine Arts, Boston. Water color, 15⅛″ x 19⅝″. 1808. One of a series of illustrations for Milton's *Paradise Lost*. The stock figures are transformed into a poetic scene of dramatic power.

BLAKE lived and died in obscurity, and in his last illness expressed his indifference to temporal rewards with characteristic pride: "I should be sorry," he said, "if I had any earthly fame, for whatever natural glory a man has is so much taken from his spiritual glory." The earthly fame, however, has slowly accumulated and today he is accepted as the foremost, if not the only genuine, symbolist produced by the Anglo-Saxons. He was a born visionary. At the age of four, he saw God's face against the window, and when still a child, surprised a flock of angels sitting among the boughs of a tree. His imaginative bent impelled him toward art, and after seven years of apprenticeship in engraving, he made his living as an illustrator, or decorator, of literary texts.

At twenty-five, Blake married an illiterate girl whom he taught to read and write, to use color and to see visions. It was probably the happiest union on record, and they lived together in London—in the same flat for seventeen years—until parted by his death. He was incessantly occupied, not only with bread-and-butter jobs, but also with his paintings and his books of prose and verse, books written, engraved, printed, illuminated, and bound by his own hand—unmarketable while he lived but today more valuable than precious stones. He had, in one compartment of his mind, the power to express himself with crystalline intelligibility; the other half of him was teeming with mystical dreams and psychological fragments.

Blake regarded art as a medium for visionary truth. He used no models for his figures, inventing his own representational devices which he employed over and over again: fiends, angels, singing stars, Biblical symbols—all brought together to personify the ecstasies of the spirit. He had no formula and no science—his sense of harmony was original and instinctive. His best designs are flawless, the figures securely related and supremely appropriate. *The Wise and Foolish Virgins*, executed for Sir Thomas Lawrence in faint washes of color, is typical of the reality of his strange world and the energy of his designs. The wise virgins are grouped processionally to establish a rhythmical sweep of line—a waving frieze balanced by the active supplications of the foolish virgins, and by the flying Angel of the Lord. The water color is a symbol of apprehension and prophecy; and Blake, the author of the *Prophetic Books*, had no hesitancy in proclaiming his faith in the Judgment Day.

*Satan Bringing Destruction on the Sons and Daughters of Job*. Engraving, 1825. Plate 3, of *Blake's Illustrations of the Book of Job*, and a masterpiece of imaginative design.

[RIGHT] *The Wise and Foolish Virgins*, Metropolitan Museum, New York. Water color with pen and ink, 13″ x 14⅛″, 1805. Color plate, page 248.

# JOHN CONSTABLE

1776–1837                              ENGLISH SCHOOL

CONSTABLE's *Haywain* is a picture of historical significance. Painted in 1821, it was exhibited at the Paris Salon of 1824, where it created a sensation among the younger French artists. Struck by its luminosity of tone, Delacroix repainted—in four days, it is said—his *Massacre of Scio*, and hailed Constable as the father of modern landscape. To the romantics of France, the Englishman introduced a method with which to kill the lingering disease of antiquity. He flooded his canvases with natural light and air; he used bright colors—in many of his pictures the original brilliancy has faded—and divided his tones, producing a vivid red or green by separate tones applied with a palette knife, one against another; and he took his easel into the open country. Today, this method is a commonplace: to the men of 1824, it was revolutionary.

In his grasp of the stable repose, the spiritual contentment induced by companionship with nature—in his day a form of pantheism—Constable is the master of the English school. The solid tranquillity is the life of the man. His road to fame was long but his patience was sufficient for the journey; he worked and waited, and eventually enjoyed all that a wise and healthy man required. It was characteristic of him that while the French were praising *The Haywain* to the skies he was painting the countryside at Suffolk.

Constable was the first man of importance to paint in the open air, to restore the color of grass from the brown of an old fiddle to its natural green, the first to paint the wetness of water; he conveys the freshness, the sparkle, the shimmering richness of the outdoor world; his sky is not a background but an enveloping atmosphere of light and color; his clouds move; he carries the spectator away from the painted surface into the presence of nature itself. But Constable did not stop with objective fidelity—the word science was always on his lips. He planned his landscapes systematically, enhancing their vividness and intimacy by a searching scrutiny of natural forms. He added direct observation to landscape painting; and invented a new poetic language which marked the decline of the mechanical exteriors and conventionalized foliage of those who tried so hard to paint in the grand manner.

*The Haywain*, National Gallery, London. Oil, 73″ x 50¾″, 1821. Color plate, page 247.

*Scene in Helmingham Park, Suffolk*, The Art Gallery of Toronto, gift of the Leonard Estate. Oil. Painted before he was thirty, and a rare specimen of Constable before he found himself. A Suffolk scene in the liberal Dutch style.

[LEFT] *Dedham Mill*, Victoria and Albert Museum, London. Oil sketch, 1820. A study of water and foliage observed in an English atmosphere charged with vapor.

# JOSEPH MALLORD WILLIAM TURNER

1775–1851

*Dunstanborough Castle*, Museum of Fine Arts, Boston. Engraving, aquatint and mezzotint, about 1808. One of the less ambitious sketches for *Liber Studiorum*, a pictorial album deliberately composed to surpass Claude Lorrain.

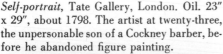

*Self-portrait*, Tate Gallery, London. Oil. 23" x 29", about 1798. The artist at twenty-three, the unpersonable son of a Cockney barber, before he abandoned figure painting.

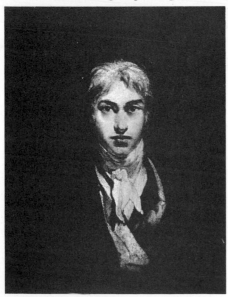

[RIGHT] *The Fighting Téméraire*, National Gallery, London. Oil, 47½" x 35½", 1838-1839. Color plate, page 250.

TURNER was one of the greatest painters who ever addressed their energies to the art of landscape and the sea. During his three-score years of indefatigable activity, he traveled, mostly on foot, twenty-five miles a day rain or shine, over a large part of the British Isles and western Europe, exploring the face of the earth and the heavens above it—the atmosphere, the vegetation, the anatomy of the sea and the architecture of the clouds, storms, sunsets, and ships, splendor and decay—with the eye of a naturalist and the soul of an artist. His first work was dark in tone and realistically observed; in his second phase, after his discovery of the sun, he bound together sea and land, ships and sky, in a fiery atmosphere of gold and scarlet shot with blue. In his last years, his actions betray a mind unhinged by overwork, and a fabulous imagination disintegrated into channels of unclean litter and drunkenness, but leaping out occasionally with flashes of the old majesty. He abandoned his house in London, and it became a monumental ruin; and he died leaving a fortune of £140,000 collected mainly from the sales of his engravings.

After 1835, Turner was an old alchemist buried in paint. His principal concern was with light and color; and on his return from Venice, he launched boldly into what is known as his "period of free expression," producing his final masterpieces, among them *The Fighting Téméraire*. In all these paintings, there is the eternal quiet of death, the sense of desolation expressed by contrasting the glory of nature with the impotent ruin of the works of man. He had seen the old *Téméraire*, the second ship of the line at the battle of Trafalgar, towed to her last berth, the sentence of death upon her—sold to the wreckers; and without relinquishing his grip on design and his knowledge of structure, he transmuted the scene into an emblem of destruction. With characteristic audacity, Turner painted the phenomenon of the sun and moon in joint visibility, and dissolved sea and sky in a blood-red illumination which, he insisted, "suggested violent death." Owing to the deterioration of pigments, the warm colors are now out of key with the blues; but the painting, despite the disturbed balance, is the masterwork of a man whose passion for the sea carried him beyond the bounds of nature. Thackeray, in a burst of eloquence, called it "as grand a painting as ever came from the easel of any artist."

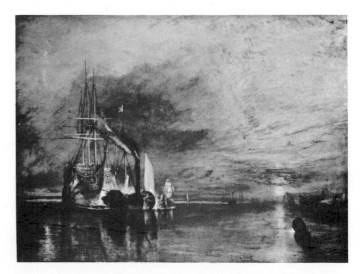

# JOSEPH MALLORD WILLIAM TURNER

CONTINUED

ABOUT 1800, Turner began to live with a girl of sixteen, his housekeeper, and continued to live with her until his death. The first years of the century were the happiest of his life. He purchased two adjoining houses in London, thenceforth his permanent residence, where he maintained, free of charge, a gallery of his own pictures. He was a born tramp, and when the spirit moved him, he deserted his housekeeper, the watchdog of his possessions, and took to the open road. He could eat anything, sleep anywhere, work in all kinds of weather. He wandered over Europe, and when wars closed the Continent to travelers, he sailed up and down the coast in colliers, and made a voyage into the North Sea with a fishing fleet, lashing himself to the mast for hours in a storm so that he might observe the elements in their most turbulent mood. His life during these years, industry aside, was shapeless and erratic, with a steady drift toward solitude and indecent relaxations.

At heart, Turner was half sailor. Three minutes from his father's barbershop ran the great river, and in his boyhood he rode down to the sea in ships, got the hang of them—every rope and spar—made himself a sailor. His early paintings of the sea were influenced by the Dutch, but the Dutch, in his opinion, were limited and passionless. "I know more about the sea," he remarked. "I know what waves do to ships and what storms and ships do to men." In his twenty-eighth year he painted a scene bearing the long title, *Calais Pier: The English Packet Arriving; French Fishermen Preparing for Sea*—a picture which, for technical proficiency, powerful design, and incredible observation, stands as far above the works of other marine painters as his later dramas of light and color stand above those of the impressionists. Here Turner painted the sculptural, plastic sea, waves rolling in as no other painter has created them, piling higher and higher like masonry; he painted the weight and volume of the waves, the heaving of boats, and the huddled groups of fishermen—a drama of black clouds, colors, and varied substances in three united scenes, any one of which would have been a composition in itself.

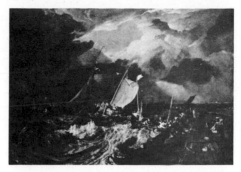

219A. *Calais Pier*, National Gallery, London. Oil, 94½" x 72", 1802-1803. Color plate, page 251.

*Crossing the Stream*, National Gallery, London. Oil, 1815, 65" x 76". Painted under the influence of Claude after years of observation of the radiance of light over trees and hills.

[LEFT] *Grand Canal, Venice*, Metropolitan Museum, New York. Oil, 4' ⅛" x 3', about 1835. The most magnificent Venetian scene in all art, and painted before Turner's absorption in light effects had dissolved ships and architecture.

· 219 ·

*Lady Lilith*, Metropolitan Museum, New York. Water color, 16⅞" x 20", 1867. Color plate, page 252.

*Self-portrait*, National Portrait Gallery, London. Pencil, 7" x 7¾", 1847. The poet-painter and genius of the British Pre-Raphaelites at the age of nineteen.

# DANTE GABRIEL ROSSETTI
1828–1882                                                    ENGLISH SCHOOL

In 1848, seven young novices in art, including Rossetti, Hunt and Millais, in revolt against the stodginess and banality of current British painting, banded together in a working organization known as the Pre-Raphaelite Brotherhood. The dominant personality of the group, and by all odds the finest mind, was Rossetti, then in his nonage; and by his ascendancy the Brotherhood, though officially disbanded at the end of five years, won the critical suffrage of the almighty Ruskin, and the aesthetic allegiance of Morris, Swinburne and Burne-Jones, and exerted a powerful influence on the art and poetry of Great Britain. The aims of the Brotherhood, never too definite, were, in general, to return to nature as the foundation for all technical practice, and to seek the freshness, inspiration, and religious fervor of the early Italians—the masters preceding Raphael and the formalists of the High Renaissance.

Rossetti was extraordinarily precocious in words and pigment. In childhood he composed verses in four languages; he wrote *The Blessed Damozel* at nineteen, and in his early twenties exhibited water colors which, whatever their faults of draftsmanship, were, in design and poetic feeling, among the best things of their kind produced in the nineteenth century. The formal beauty of his poetry is matched, in paint, by the felicity of his designs. He composed his pictures on a linear basis of curves and arches—his *Lady Lilith*, for example, seems to flow into her position in the picture space. But he had no interest in design for its own sake, nor in the detached cultivation of formal relationships. After he had exhausted the medieval inspiration of his first period, he began to regard painting as a purely symbolical or poetic language for the glorification of the body of woman and the spirit of woman, and as time went on the distinction between the two was less insistent.

The physical embodiment of *Lady Lilith* was a certain Fanny Schott, whose "body's beauty," to use Rossetti's expression, was often painted by the artist. The symbolical title, *Lilith*, according to the Hebraic legend woven into one of the sonnets in *The House of Life*, refers to "Adam's first wife . . . the witch he loved before the gift of Eve." Intended as the apotheosis of female loveliness, the picture is described, by F. G. Stephens, one of the Brotherhood, with unrestrained intensity. "The haughty luxuriousness of the beautiful modern witch's face does not belie the fires of voluptuous physique. She has languor without satiety . . . and she is reckless how much or how little of her bosom and shoulders is displayed in a delicious harmony of color with the warm white of her dress, heedless of the grace of her attitude and the superb abundance of her form."

[LEFT] *Dante's Dream*, Walker Art Gallery, Liverpool. 10' 6½' x 7' 1". Oil version of an early water color and the largest and best known of Rossetti's works. Scene from the *Vita Nuova* in which "the gentle Beatrice has been taken out of life."

# JOHN SINGLETON COPLEY

1737–1815                    AMERICAN SCHOOL

*Mrs. Seymour Fort*, Wadsworth Athenaeum, Hartford. Oil, 3′ 4″ x 4′ 2″, 1772-1776. Color plate, page 253.

THE first Colonial master and one of the best painters in American art is John Singleton Copley, born in Boston of Irish extraction. The Puritan climate of New England was not favorable to painting: John Adams wrote that "it was not possible to enlist the Fine Arts on the side of Truth, Virtue or Piety"; and Copley himself complained that "painting would never be known in Boston were it not for preserving the resemblances of particular persons; that people generally regarded it as no more than any other useful trade like that of the carpenter or shoemaker." Artists from Michelangelo forward have distrusted their own times, but Copley, by yielding unreservedly to the pressure of his environment, developed a form of painting which does not suffer by comparison with the work of Hogarth and the leading French portraitists.

According to his son, "He was entirely self-taught, and never saw a decent picture of any kind, save his own, until he went to London in his thirties, a famous portrait painter." The statement is exaggerated—Copley saw engravings after Rubens and the Italians—but it was precisely by pursuing his art as a trade, by demanding as many as twenty-five sittings of six hours each for a single portrait, and by the most persistent study of the features, that Copley acquired his solid mastery of the human head. He is the only dependable artist-historian of the pre-Revolutionary era. He painted not only "resemblances," but a gallery of living Colonials—dignitaries, judges, divines, and merchants, and their strong, self-reliant consorts; he immortalized the Winthrops, Pepperells, Pickmans, and Adamses—tight-lipped colonizers, mercantile aristocrats, and hardheaded patriots who defied the mad King. He knew the character and social background of his sitters, their place in the community, their occupations, their Puritanism, and their pretensions. He painted them in the cold, clear light of New England, austere and not a little pompous in their lace and velvet; and his style matured, step by step, with his growing practice—a severe style, polished and original, the opposite of the sensuous and ingratiating, but compact and devoid of studio makeshifts. *Mrs. Seymour Fort*, painted at the close of his American period—before he went to England and became very British and fluent—is a specimen of his most finished painting. Nothing is known of the identity of the subject: to history she is a Colonial dame painted with dignity and uncompromising directness, living proof of Copley's ability to keep his sitter in character, his firm modeling, and his command over textural accessories.

*Self-portrait*, owned by Mrs. Gardiner Greene Hammond, Santa Barbara, California. Oil, 18½″ in diameter, about 1770. Done in his early British period before his own style had formed.

[LEFT] *Brook Watson and the Shark*, Museum of Fine Arts, Boston. Oil, 90¼″ x 72⅛″, 1778. A bloodcurdling account of the misfortune of Watson, whose leg was bitten off by a shark in Havana Harbor. The picture created a sensation in London, where Watson and his wooden leg were prominent.

# GILBERT STUART

*Mrs. Richard Yates*, Mellon Collection, National Gallery of Art, Washington. Oil, 25" x 30¼", 1793. The portrait of the wife of a New York merchant, and pin-up girl of the 1790's, is devoid of theatrical trappings—a straightforward characterization firmly and fluently managed.

*The Skater*, Mellon Collection, National Gallery of Art, Washington. Oil, 57⅛" x 95½", 1782. The handsome Scotsman on the ice in St. James Park, London, brought Stuart into the limelight after leaving the studio of Benjamin West.

IT WAS the lot of Gilbert Stuart to paint the most famous picture in American art, a portrait which, irrespective of its merits, has been accepted by the American people as inviolable, as the one and only authentic conception of the first President of the United States. Stuart's early life promised no such climax, but when the British had fallen prey to his magnetism and technical parts, he returned home and carried off the greatest portrait prize in modern times.

Stuart was an anomaly to the New England of his day: a temperamental Scot capable of the extremes of lightheartedness and despondency, a man of wit and personality, and an artist in the Continental style. He was born in Rhode Island, the son of an emigrant snuff grinder; and after a willful youth of vagabondage and spurts of painting, he went to England, penniless but confident, and was graciously coached by Benjamin West. He was soon established as one of the leading portraitists of London; his prices were high and he lived in princely style with Bohemian irresponsibility. But he lived beyond his means, and was reduced to beggary, if not to prison fare.

Stuart returned to America in 1794 with the express purpose of painting Washington, instigated alike by hero worship and pecuniary reverses. The artist who had snubbed Dr. Johnson and painted British royalty was bowled over by the "great self-command of the President," he confessed, and his first effort was unsatisfactory. At the second sitting, or the third—the records are not clear—he painted the household portrait—his only extant painting of Washington made from the life—which was sold by his destitute widow to the Boston Athenaeum, whence its name. Stuart painted other pictures of the President, copies and imaginary likenesses, some more rugged, some unquestionably more literal, but none other that has found its way into the hearts of his countrymen. The Athenaeum portrait, here reproduced, was painted thinly with high flesh tints—Stuart had a weakness for certain reds and all but rouged his subjects—and finished only in the head and shoulders. "I copy the work of God," he said, "and leave the clothes to the tailors." It has the technical facility that made him one of the best men of his day; but its popularity is based upon the smooth stateliness and refined paternity consistent with, and perhaps responsible for, the legendary conception of the Father of His Country. As Mark Twain put it: "If Washington should rise from the dead and not resemble the Stuart portrait, he would be denounced as an impostor."

[RIGHT] *George Washington*, Museum of Fine Arts, Boston. Oil, 34½" x 42", 1796. The famous Athenaeum portrait which has become the universal likeness of the first President. Color plate, page 254.

# JOHN JAMES AUDUBON

1785–1851                                    AMERICAN SCHOOL

THE eminence of Audubon in American art and his place in the affections of the American people have never been more secure than at the present time. The man has become a national hero, a legendary figure beloved alike by conservationists of wild life and a troubled generation seeking inspiration in examples of pioneer fortitude. The legend, in part, is Audubon's creation: he had a talent for self-dramatization, carried a dagger into the wilderness, wore long hair, and in the literary circles of Europe posed as an esthetic Leatherstocking with the instincts of a Red Indian and the cultivation of a French aristocrat. Only recently has it come to light that he was not born in New Orleans of high lineage, as he led people to believe, but in Santo Domingo, the illegitimate son of a French naval officer and a nameless Creole mistress.

But his romantic peccadilloes detract nothing from his greatness. As a young man, Audubon voyaged down the Great River, and explored the forests of Ohio, the swamps of Louisiana, and the coasts of Carolina, with the gleaming intensity of conviction of the early French missionaries. The adventures were incidental to his purpose: he was a man with a mission, actuated by a religious zeal to immortalize in graphic form the feathered life of America. From paintings in water color, he published in London, during the years 1827-1838, the original edition of *The Birds of America*, 435 hand-colored impressions from aquatint engravings, the most remarkable work of its kind in existence.

Audubon was an artist and a great one. As a painter of birds, he fixed a standard that has never been seriously contested, his most reverent emulators being no more than taxidermists. It is comforting to know that his pictures are ornithologically accurate, but of more significance that he brought to his birds the imagination of a poet and the hand of an artist trained in the studio of David. He had an eye for dramatic situations, an infallible sense of placement, and an originality of design determined, in each instance, by the individuality and habitat of his subjects. The *Snowy Heron*, one of the noblest specimens of his art, was painted from drawings made in the rice fields of South Carolina, in 1831. The bird is true to its species, but it is a bird with personality, a portrait of a particular heron, imposingly oversize, by the artist's license—a startling creature in a Southern landscape painted throughout with a clarity of detail which was one of Audubon's devices to point out the natural environment of his subjects.

*Chuck-Will's Widow*, New York Historical Society. Original water color painted from nature for Plate 52, of the great folio. A pair of nightjars, or Spanish whipporwills battling a snake in a dramatic rage.

*Snowy Owls*, New York Historical Society. Original water color of a couple of birds that are ornithologically sound and strikingly decorative.

[LEFT] *Snowy Heron or White Egret.* Plate engraved by Havell, 1835, for Audubon's *Birds of America.* Color plate, page 255.

# GEORGE CALEB BINGHAM

1811–1879                                                    AMERICAN SCHOOL

*Stump Speaking*, St. Louis Mercantile Library. Oil, 58″ x 42½″, 1854. Color plate, page 256.

*Fur Traders Descending the Missouri*, Metropolitan Museum, New York. Oil, 29″ x 36″, about 1845. Executed with a tonal mastery that Whistler might have envied.

THE history of American art, from its distant gropings to the present moment, is largely the biographical record of a few valiant souls who dared resist the overwhelming pressure of European authority in order to gain the one element indispensable to the growth of original genius—complete independence of spirit. In the Colonial period, painting was exclusively a matter of portraiture, and such distinguished practitioners as Copley and Stuart, despite their success at home, yielded to the temptations of European prestige and went to London to paint like Englishmen. Before 1850, the men of the Hudson River School dedicated their talents to native landscape, but handicapped by the heavy burden of foreign styles and technical precedents, achieved little that could be called American in its own right.

The first artist of stature on this side of the Atlantic to be delivered from the tyranny of continental tradition was George Caleb Bingham, of Missouri. In life and art alike, he was a true pioneer—hardy, self-reliant, respectful of the past but not subservient to it, venturesome and quite capable of setting out on his own hook, undeterred by the fear that he might not be proceeding properly. Born in Virginia, he migrated with his parents, in 1819, to Missouri, in which state, save for occasional wanderings in the pioneer fashion, he lived for the rest of his days. In his extreme youth, he preached the gospel and read law, and at nineteen, entirely self-instructed, earned his bread as an itinerant portrait painter. He studied painting in Philadelphia, New York, and Düsseldorf; exhibited, for the first time and with popular approbation, authentic American genre, and spent his last years at Columbia, Missouri, where he was attached to the State University as professor of painting.

Bingham was an eminently successful man not only in his professional attainments but in the material rewards and public appreciation which an artist has the right to expect. That he was a great artist is an open question; that he was a real and valuable one is beyond debate. He made his pictures out of his own observations and experiences—the only way in which any real art is made, big or little: out of the raftsmen he had seen on the Mississippi; out of the pioneers crossing the Cumberland Mountains into the wilderness; out of familiar political scenes and local customs. A member of the State Legislature and a candidate for Congress, he knew what he was about when he painted *Stump Speaking*, one of several election scenes. As an historical occurrence, the scene, with its honest characterizations and appropriate background, is most agreeably presented; as a painting, it shows how a method of drawing which had its roots in the late Renaissance, when put to work by an artist in new conditions, was modified to produce a work of art that is unmistakably American.

[LEFT] *The Jolly Flatboatmen, No. 2*, City Art Museum of St. Louis. Oil, 1857. Frontier relaxation on the Father of Waters.

# JAMES ABBOTT McNEILL WHISTLER

1834–1903

AMERICAN SCHOOL

THE most persuasive champion of "art for art's sake" in the nineteenth century was Whistler, an expatriate American who thrived in the cosmopolitan atmosphere of Europe. Like a born Frenchman, he affiliated himself with the superior painters of Paris, and was constantly before the public as exhibitor, irritant of the old guard, and spokesman for a new school of artists busily making history. With an incorrigible lust for battle, he opened a studio in London where he won exorbitant publicity by his eccentricities and his controversial brilliancy.

Armed with a piercing intelligence and a dialectical weapon that was specious and deadly, Whistler erected a captivating philosophy of art, and confirmed his ideas by the most scrupulous application to his craft. He became the rightful leader of an esthetic coterie numbering, among its apostles, Swinburne, Beardsley, and Oscar Wilde—with a fellowship for Walter Pater; and he antagonized the patriots by announcing that the true artist was above the insularity of nationalism, and exempt from the social codes governing ordinary mortals. It was a vainglorious world that he dominated—a world of conceits and studied attitudes—but Whistler was no charlatan. He had the courage of his convictions, and no painter labored more steadfastly to acquire the technical perfection which, to him, was the end of art.

Whistler's life and art were consciously ordered to conform to his fastidious tastes. He tells no story in his pictures and points no moral—he stakes everything on his taste, his supersensitivity, and his tact—on the faultless balance between his subject and the niceties of tone. Influenced by Velasquez and the Japanese, he commanded, with exquisite perception, an art which, in his own words, "was the result of harmonies obtained by employing the infinite tones and varieties of a limited number of colors." It is a fragile art, but in its own sphere indefectible. He added musical titles to his pictures, and growing more and more exacting, painted "nocturnes" in which, to all but the most vigilant observers, the attenuated delicacies of tone are invisible. His masterpiece is *The Little White Girl*, painted in the early sixties and bearing the secondary label *Symphony in White*. In its pattern of light tones, the azalea blooms, and the fan, it attests the Japanese print; but the arrangement is Whistler's own, and the wistful humanity—which he disclaimed—justifies the purely abstract, or symphonic perfection, he advised the public to find in it.

*The Little White Girl*, National Gallery, London. Oil, 19½" x 29½", 1864. Color plate, page 257.

[RIGHT] *Portrait of Whistler* by Ernest Haskell, The Cleveland Museum of Art, gift of Mr. and Mrs. Ralph King. Charcoal drawing, 11" x 7", 1898. The foppish master as he loved to exhibit himself.

[LEFT] *Thomas Carlyle*, Corporation Art Gallery, Glasgow. Oil, 56" x 67", 1872. A marvelous silhouette of the Scotsman constructed with singular respect.

# THOMAS EAKINS

WHILE Whistler and his French confreres, in Paris, were assailing the tyranny of the Salon, another American, a reticent young man from Philadelphia, was industriously working as a pupil of the academician par excellence, Gérôme, the purveyor of moldering allegories. Eakins had no use for his master's pseudoclassical merchandise, but he took such formal discipline as was offered, returned to Philadelphia, and in his long career as practitioner and teacher never wavered from his first concept of art. He believed, with Courbet, that a man should confine himself to contemporary subjects, and that he should paint them with technical excellence and convincing solidity.

With scientific poise and thoroughness, Eakins scrutinized the world about him, and accumulated precise knowledge of many subjects admirably adapted to painting. He studied and painted many branches of sports, but enjoyed none; attended concerts to watch the performers, visited clinics, and dissected corpses—and the sight of flowing blood left him unperturbed. In brief, he viewed the world as an educated observer looking for material data. Painstakingly he acquired a technique commensurate with his habits of severe calculation, and succeeded in painting, if not with passion and energy, then with extraordinary solidity and objective truth.

As a colorist, Eakins has small claims to distinction; and his most ambitious undertakings such as his prize fights and clinics are ineptly put together. His fame rests upon his portraits which, though painted with benign detachment, have the substance of flesh and blood molded into inflexible characterizations. His heads, he said, were painted "the way they looked," and no one acquainted with those heads would contradict him. They are not greatly animated, nor have they the magic touch of personality; but they live with a stern vitality that seems to increase with time. *The Concert Singer*, a work of statuesque dignity, is devoid of flattery and the glittering, structural looseness of most portraits of the kind. When Eakins concentrated on a subject, as he did on his *Singer*, bringing into play his searching vision and his skill in modeling, he painted portraits which hold their own with the best in American art.

*The Concert Singer*, Philadelphia Museum of Art. Oil, 54″ x 75″, 1892. Color plate, page 259.

*Walt Whitman*, The Pennsylvania Academy of Fine Arts, Philadelphia. Oil, 24″ x 30″, 1887. The good gray poet in old age—faithfully portrayed but with more humanity than Eakins usually displayed.

[RIGHT] *The Agnew Clinic*, University of Pennsylvania, Philadelphia. Oil, 130½″ x 74½″, 1889. Harking back to the old Dutchmen, Eakins composes an anatomy lesson to set against the shoddy romanticism of his day.

# THOMAS EAKINS
## CONTINUED

AFTER his graduation from the public schools of Philadelphia, Thomas Eakins studied art at the Pennsylvania Academy of Fine Arts, copying the dusty busts of antiquity in the usual dusty manner—and much against his will. To recover from this venture in dry-rot, he took a course in anatomy at a medical college, and at the age of twenty-two, departed for Europe, after the custom of his time, to educate himself in the profundities of his calling. He labored sweatfully under the academicians, studied independently the realistic Spaniards, and returned to America to set up shop as a professional portrait painter. Some six years later he was attached to the Pennsylvania Academy as instructor in the life and anatomy classes, but eventually was forced to resign his post because of his sharp criticisms and his practice of working from nude models. In those days such models as were available for the altogether hid their faces in bandanas like western criminals. Unable to sell his portraits, or the bulk of them—the most objectively convincing portraits since Copley—because of the newfangled camera likenesses, he turned his talents in other directions, and gradually rose to a position in American art that grows bigger with the years. Without glamour or the blandishments of the virtuoso, he was never exactly a popular painter, but for thorough-going solidity and the rendering of the material world in completely embodied forms, he is one of our masters.

After his return from Paris, sick of academic statutes and official flummery, Eakins, without any fuss or promotion, began to paint scenes and subjects which, at the time, were of a radical nature, but with him no more than the natural expressions of his temperament. He cultivated sports and attended anatomy lessons, and without pedantic literalness, depicted surgical operations—to the horror of the purists—and the healthy outdoor life destined to be one of the national American traits. He also painted competitive sports—boxing and rowing, and hunters after their quarry; and he was the first American of any distinction to portray the Negro without condescension. His picture of Will Shuster on a hunting expedition with his colored companion, in a gallery of classic Renaissance paintings, would probably impress a European as something outside the realm of art; but with those who love unaffected realism and American genre, the picture has always been popular.

*Will Shuster and Black Man Going Shooting*, Stephen C. Clark Collection, New York. Oil, 30" x 22", 1876. Color plate, page 260.

*Mrs. Frishmuth*, Philadelphia Museum of Art. Oil, 72" x 96", 1900. With stability, dignity and not a trace of flattery, Eakins presents a connoisseur of musical instruments.

[LEFT] *Sailing*, Philadelphia Museum of Art. Oil, 45¾" x 31½", about 1874. An early work, painted at a time when the artist was busy with genre and outdoor subjects.

# WINSLOW HOMER

1836–1910                    AMERICAN SCHOOL

[ABOVE] *The Lookout—"All's Well,"* Museum of Fine Arts, Boston. Oil, 30" x 40", 1896. One of Homer's best-known paintings. The man on watch sings out the ancient call.

WINSLOW HOMER was a plain American, a cantankerous Yankee opposed to cosmopolitan refinements, a native artist entitled to a seat among the master painters of the sea. There is nothing sensational in his pictures—he never strayed from the line of direct experience into the realm of cryptic suggestion—and there is nothing sensational in his life. Born in Boston, self-instructed in the rudiments of drawing, he took the hard road to fame, serving a long apprenticeship in lithography, and working, during the Civil War, as a magazine illustrator assigned to distract the public by sketches of intimate scenes from the extramilitary life of soldiers. Against his puritanic conscience, he subjected himself to a year in Paris where he was more alien than a New England lobsterman. He attended no schools, painted little, refused to talk about art, and dreamed of the waves hammering against the Atlantic coast line. On his return to America, he gained considerable notice as a delineator of healthy, bucolic life, idealizing his women into strapping, sweet-faced heroines. But all that is memorable in his work was painted after his forty-fifth year.

On a holiday among the fishermen of the British seacoast, Homer saw the light, and thereafter was exclusively a painter of marines. In 1884, he retired to Maine, built himself a cottage on a wild headland, and save for an occasional visit to the islands in the Gulf Stream, lived alone in his rockbound studio. Awards came in abundance; the French, in 1900, praised him as the only generic American; and he sold everything he painted—but he was indifferent to material honors, and acquired a local reputation as a formidable eccentric.

No more than Turner was the Yankee solitary an eccentric: he loved the sea—not the fabulous sea of the old Turner—but the terrifying agent of destruction, the friend and enemy of man, the realistic multiform sea, inconstant and seductive. In the winter of 1899, Homer sailed to the Bahamas, a voyage which netted him his most famous painting, *The Gulf Stream*. Here we have the sea at its deadliest, warm and blue in the tropical sunlight, in contrast to the dark, slate tones of the northern waters, yet still agitated with a distant water spout after a hurricane has driven the Negro to his doom. Less heroic perhaps than his pictures of the Maine coast line, it is, with the outstretched Negro calmly resigned to his fate of sunburn and starvation—and the milling sharks with a trail of blood—his most effective exposition of the sea as an element of destruction.

[BELOW, RIGHT] *Gulf Stream*, Metropolitan Museum of Art, New York. Oil, 49⅛" x 27⅞", 1899. Color plate, page 261.

[BELOW, LEFT] *The Bass*, The Knoedler Galleries, New York. Water color, 20½" x 13½". A New England fisherman as well as a great water-colorist. Homer depicts a food fish.

# ALBERT PINKHAM RYDER

1847–1917                                    AMERICAN SCHOOL

THE most poetic, and in the restricted sense, the most original of American painters is Albert Ryder, born in New Bedford, Massachusetts. He was born a Puritan and a Puritan he remained; but his pietistic inheritance was leavened by gentleness and good will. There was a pronounced strain of New England transcendentalism in Ryder, but his spiritual quandaries were humanized by healthy contacts with sturdy mechanics and seafaring men. As independent in his own way as Thoreau, he believed that he had a great work to perform; and at an age when most boys were savages, he was painting from nature and experimenting with color. When his family moved to New York as a final stand against poverty, he came with them, in his early twenties, and for ten years was supported by his brother.

New York afforded Ryder all that his soul desired. "A rain-tight roof, frugal living, a box of colors, and God's sunlight keep the soul attuned and the body vigorous for one's daily work," he said. He lived alone in an attic room in Fifteenth Street from which, at rare intervals—mainly because it took him so long to finish anything—he sold a canvas; and his income, once he had found himself, was sufficient for his slender wants. He was a contented painter, if ever one lived—admittedly a dreamer refining and reworking his conceptions with the patience of a cabinetmaker. Again and again he painted the sea, but always to emphasize the pitiable insignificance of man; and in his most dramatic pieces—those of sinister waves, opaque as slate and crossed with wan lights—he introduced small figures to sound the inescapable cry of human anguish.

If Ryder was a dreamer, he was also a great designer who built his dreams upon an objective foundation, investing New England landscapes and the sea, which he had observed from infancy, with magical or supernatural qualities. He was never abnormal or exotic, never stooped to nightmares or absurdities: the path of his emotional journey lay along the horizon of the world in which the reckless human comedy is played. The more elusive states of the soul—strange fears and dangers, premonitions of death, the mysterious power of the sea, the intoxication of moonlight—absorbed his whole life. *The Forest of Arden*, a subject twice painted, is his vision of the world beyond the world—his invitation, expressed in marvelously composed irregularities of earth, trees, and sky, to enter the enchanted land of the spirit.

[ABOVE] *The Forest of Arden*, Stephen C. Clark Collection, New York. Oil, 15″ x 19″, 1888-1900. Color plate, page 258.

[BELOW, LEFT] *Moonlight Marine*, Metropolitan Museum, New York. Oil, 15″ x 19″. With absolute simplicity and in the smallest compass, Ryder produces the illusion of great magnitude.

[BELOW, RIGHT] *Death on a Pale Horse*, The Cleveland Museum of Art, The J. H. Wade Collection. Oil, 35⅛″ x 27¾″, about 1910. A moral design inspired by the story of a waiter who killed himself after losing his savings on a pale horse.

# JOHN SINGER SARGENT

1856–1925                                    AMERICAN SCHOOL

*Asher Wertheimer*, Tate Gallery, London. Oil, 38″ x 58″, 1898. Color plate, page 262.

*Madame X*, Metropolitan Museum, New York. Oil, 43¼″ x 82⅛″, 1884. When first exhibited in Paris, this portrait of Madame Gautreau created a riot. The Mme was a friend of Gambetta, and Sargent, at his realistic best, was accused of deliberate caricature.

AT the galleries of the Royal Academy in London, in the year 1926, a memorial exhibition of Sargent's paintings was placed before the public. It was an enormous exhibition; for Sargent, besides his work in murals, water color, and landscape, painted more than five hundred portraits—and the ensuing laudations were resounding and extravagant. The least critical enthusiasm, naturally enough, came from the subjects themselves, all of whom, if not distinguished, were socially prominent; but to the public as well, Sargent was the sovereign portrait artist of modern times. Furthermore, despite his American parentage and French training, he was a British institution, a cultured gentleman, and for forty years the historian of high life in Great Britain.

Sargent bore his honors modestly and in his last years with a distressing consciousness of his limitations which prompted him to abandon portraiture for landscape. He worked hard and with a uniformity of excellence astonishing even in a man so generously gifted as an executant. His rightness in proportions was microscopically unerring—he never missed a dimension, or varied a hairsbreadth from the exact size and just relationships of features; he was a dead shot at likenesses; his eye was never confused and his hand the obedient and skillful servant of his eye. He was not a probing psychologist and he was not greatly interested in character; but as a portrayer of men and women wearing, not too shrinkingly, the attributes of social position, he was without a peer.

Sargent's best work is his series of portraits of the Wertheimer family, painted between the years 1898 and 1902, and inducing in him, he said, "a state of chronic Wertheimerism." He painted the father, a great art dealer with a sublime admiration for Sargent, the mother, the numerous children—young and old, single and wedded, en masse and separately—ten pictures in all. The artist neither flattered nor maligned them: he turned his cold observant eye on them—as he did on all his sitters—and transferred to canvas as much as he could grasp at a single impression—and no more—of a family moving with ducal importance in high society. His *Asher Wertheimer*, the art dealer, is a peering masterpiece—the portrait of a plutocrat who, by virtue of an artist's great prestige, planted himself and his family in one of the great national galleries. For this service, Sargent, according to Roger Fry, became "the brilliant ambassador between Asher Wertheimer and posterity."

[RIGHT] *Repose*, National Gallery of Art, Washington, gift of Curt H. Reisinger. Oil, 25½″ x 30″, 1911. The dexterity, suavity—and open spaces — of the modern virtuoso.

# GEORGE BELLOWS

1882–1925                        AMERICAN SCHOOL

GEORGE BELLOWS was the most popular painter of his time, and the best of his work has survived the embarrassing adulation bestowed upon his purely spectacular performances. In his college days in Ohio, he was a baseball player and a professional cartoonist; in New York, before he was thirty, he had won all the honors—and a national reputation as an artist. His popularity was not an accident: in spirit he was essentially American, boisterous and sentimental, exhilarated by the riotous and gaudy, the physically obvious and richly colored aspects of his background. He was almost excessively talented; he worked strenuously and with athletic enjoyment; life to him was a pageant with the abounding vitality of a circus poster.

Bellows, by intuition, understood the importance of subject matter. He had a genius for the right thing, and he discovered glamorous material for his brush in a hundred different quarters. He painted social studies, prize fights, political sessions, river fronts, revival meetings, landscapes, nudes, and innumerable portraits. He was not afraid of criticism or of making a mistake; he offered his work for what it contained and with a full measure of honesty— he meant what he said. Unfortunately, he was susceptible to influences which inveigled him into painting by rule and formula, to the detriment of his naturally vigorous expression. He was also the victim of his early training: he was taught to believe that an artist who reflected on his work was mechanical or old-fashioned; that one should paint in the first heat of emotion, boldly and without thinking. And no man ever painted more boldly, or at times, with greater damage to his true capacities. His prize fights and nudes, for example, are crudely put together, and saved from nullity by his unbridled confidence and his huge, undisciplined, muscular enthusiasm.

The pictures of his last years, with a few exceptions, are brilliant commentaries on American life. In this 1924 portrait of his daughter whom he painted many times, he surpassed himself. In *Lady Jean* Bellows forgot the grand manner and prestidigitation, and confined his energies to the demands of the subject. Here, painted simply in a decorative setting, is a portrait of a child, and here also is the wondering make-believe, the spirit of fantasy, common to all children.

[ABOVE] *Lady Jean*, Stephen C. Clark Collection, New York. Oil, 36″ x 72″, 1924. Color plate, page 263.

[BELOW, LEFT] *Cliff Dwellers*, Los Angeles County Museum. Oil, 40″ x 42″, 1913. Bellows had a profound sympathy for the underprivileged, as this slum picture attests.

[BELOW, RIGHT] *Stag at Sharkey's*, The Cleveland Museum of Art, The Hinman B. Hierlbut Collection. Oil, 48″ x 36″, 1909.

# DIEGO RIVERA

1886–1957    MODERN MEXICAN SCHOOL

*Man and Machinery*, Detroit Institute of Art. Mural, about 1933. Color plate, page 264.

WALL painting on a grand scale received its first modern impetus in the murals of two powerful and energetic Mexicans, Rivera and Orozco. From the turmoil of their own people, from living subject matter, the two Mexicans produced a living art of the wall. This primary impetus, destined to play havoc with the citadels of American culture, not only placed in bold relief the possibilities of a mural revival, but opened again the question of the relation of art to society and to the promulgation of ideas. The achievements of the Mexicans, in terms of meaning and function, in organizing ability and draftsmanship, in human significance and social criticism, mark the beginning of an art movement that has spread throughout the Western Hemisphere.

Rivera was an odd compound of esthete and radical: he was the tribal deity of the proletariat, and yet he had frequently been employed by capitalists. In his youth, he left his homeland and went to Paris where he was, for years, a clever eclectic, a combiner of styles. Well trained in the old and modernist schools; a jovial soul at ease in the art talk of the boulevards; ingenious, able, and filled with European experiences, he returned to Mexico with a technical and intellectual equipment that lifted him head and shoulders above his confreres. He developed rapidly in the medium of fresco; and tremendous murals literally rolled off his brushes. Facile and brilliant, he won and held public attention. He was an artist, a most distinguished artist; and his countrymen praised him to the skies, or condemned him for his revolutionary ideas. But they did not ignore him.

Rivera visited the United States in 1932, incurred the hostility of the San Francisco artists, and in Detroit created a national disturbance. Commissioned to decorate the walls of the Institute of Arts, the Mexican painted a panorama of frescoes which are certainly not flattering to the capitalist regime or to preconceived notions of beauty. But as certainly they are not communist propaganda, as his enemies vociferously claimed. What offended people was not the rather cryptic social message, but the absence of prettiness and graceful allusions to the gods and heroes of conventional painting. The Detroit frescoes are not remarkable for their portrayal of American workmen— American faces baffle the Mexican—but for their phenomenal competence in the management of large and difficult spaces, and for the ease with which the artist assembled and depicted the complicated machinery of an industrial age.

*Mother Mexico*, Art Institute of Chicago. Oil, 27¾″ x 28¾″, 1935. The Indian mother of the Mexicans in Rivera's massive style.

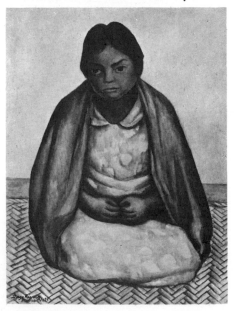

[RIGHT] Detail from *Betrayal of Cuernavaca*, Palacio de Cortés, Mexico. Mural, 1929-1930. An Indian guide, dressed as a wolf, leads the Spaniards to a surprise attack.

# JOSÉ CLEMENTE OROZCO

1883–1949          MODERN MEXICAN SCHOOL

RIVERA's most notable competitor in the Mexican renascence was José Clemente Orozco, an artist who was content to remain in the oppressed land of his birth. Orozco was not endowed with dexterity or brilliance, and he was ignorant of the popular advantages of eclecticism; but his art was fortified by two unimpeachable assets—he was a trained architect before he risked the hazards of wall decoration, and he was born with a passionate belief in the regeneration of his countrymen. As time went on, he increased in stature, and his frescoes, informed by a fierce integrity of spirit, grew steadily in importance. He brought into modern painting the austere conviction, the deep-plumbing search into religious feelings, and the tragic cry of suffering humanity lost to mural decoration since the early Italians. He has written on the walls of Mexican buildings, not merely the external clashes of the revolution, but the spiritual clashes of a race he loved and understood. Considering the antiquity of painting, one might think that every compositional scheme had been discovered and exhausted; yet this man, untrammeled by precedent, created new attitudes and astonishing relationships which could only have been inspired by his insight into the actualities of Mexican troubles.

A resident of the United States for many years, Orozco lived imaginatively in the sun and shadow of his native land; and the types and symbols of his work in this country—the tribal gods, the cactus, the Indian pyramids, the sudden contrasts of light and dark, and the physiognomies of his people—remain, as in his Mexican murals, unchanged and unchangeable. For his decorations at Dartmouth College, he chose themes from the cultural background of old Mexico—a wise decision on his part but one which has converted a library into a personal museum. These frescoes are divided into two parts, the first a sequence of ancient cultural superstitions, the second symbolizing the elements imported by the white men. *Hispano-America,* following a panel showing the reasonableness and discipline of the English settlers of northern Mexico, represents the Latin-American peasant of the South, self-sufficient and rebellious, the leader of the people and the foe of imperialist oppression.

[ABOVE] *Hispano-America,* Baker Memorial Library, Dartmouth College. Mural, 1932-1934. Color plate, page 265.

[BELOW, LEFT] *Zapatistas,* Museum of Modern Art, New York. Oil, 55″ x 45″, 1931. The followers of the insurrectionist in one of the most original compositions in modern art.

[BELOW, RIGHT] *Rich and Poor.* Pen drawing, 1944. Caricature of the wealthy by a born insurrectionist.

# GEORGE GROSZ

1893–  MODERN GERMAN SCHOOL

ONE of the most eminent artists of modern Germany was condemned, in his early years, to a life of squalor and sullen poverty. The cruel suffering of those dark days infected his spirit, leaving a wound which, in the hideous upheavals of postwar Germany, broke out afresh with unmitigated virulence. In the most adverse circumstances, he studied art in Dresden and Berlin, and at the beginning of the war he was a caricaturist of national reputation. Grosz, the scourge of the Junkers, opposed the war with a weapon as deadly as the machine gun, but he did not escape it; and at the conclusion of the shambles, returned to Berlin where, at twenty-three, he was acknowledged to be the most powerful artist in the country—and the most hated of men. He had no faith in the royalists and none in the Fascists, and he attacked both with all his strength—with an old skepticism sharpened in the trenches.

In this frame of mind, he produced *Ecce Homo*, the anatomy of German degradation succeeding the war, the most surgically explicit satire on the social habits of man since Swift. This dreadful history of fleshly corruption was composed in line and water color, a medium in which Grosz has attained a technical mastery beyond that of any other living painter. Having delivered himself of the monstrous epic, he settled down to less violent subjects—to still life, street scenes, and nude studies of meaty German girls. His water colors have their own peculiar furniture—odds and ends construed as decorative properties—and his most pitiless expositions of carnal vanity are relieved by passages of great delicacy and gentleness of feeling. His famous style has been imitated by artists of all countries, not excluding the Japanese. *A Man of Opinion*, painted in water color in 1928, was a premonitory warning of the Nazi terror, when apparently harmless propagandists were delegated to perform their deadly work among unsuspecting people.

Grosz's satirical days are over—his career as a German artist is ended. Exiled by Hitler, he came to America in 1932, at the invitation of the Art Students' League of New York. He is now an American citizen, but he has no desire to conquer America on the strength of his European reputation. All he requires, he says, "is a little place in the social scheme to do his work." At present his work is mainly in oils, a medium that he uses with marvelous and newly discovered skill in textural effects and in all sorts of studies painted in anticipation of his developing point of view on his adopted country.

[ABOVE] *A Man of Opinion*, Walker Galleries, New York. Water color, 1928. Color plate, page 266.

[BELOW, RIGHT] *After the Questioning.* Water-color drawing made in America, in 1935, after Grosz had left the obliterating backwash of the Fatherland.

[BELOW, LEFT] *Dr. Max Herrmann-Neisse*, Eric Cohn Collection, New York. Oil, 24¾" x 19½", about 1927. An oil statement of the German author in the pitiless style of George Grosz.

# JOHN SLOAN

## 1871–1951     AMERICAN SCHOOL

FOR thirty-five years, John Sloan has been an active force in American art, an interpreter of life in the great cities, celebrated at home and abroad as painter, draftsman, and the foremost etcher of modern times. Never a lily painter afraid to soil his hands in the grime of reality, he served a long apprenticeship as illustrator to newspapers in Philadelphia; and in 1905, moved to New York to join a group of congenial spirits including Bellows, Henri, Robinson, Luks, and Glackens. Belligerent and observant, he soon became a leader and an influence, a man invariably on the side of social decency, an artist who discerned and loved the humanity of the masses. When most American painters were overborne by the dazzling surfaces of Manet and Sargent, Sloan, a deadly realist, followed some deep-seated impulse which shunted him out of the studio into the behavior of people in lower New York.

In the role of social historian, he has portrayed in thousands of etchings, drawings, lithographs, and oils the life of his favorite locality—Washington Square in every circumstance of color and movement: shopgirls returning from toil, the old saloons, the Bohemian haunts of local geniuses, the indigence and gaiety of Greenwich Village in the days of its pristine glory, the street, theaters, backyards, and public playgrounds. Modernistic art in America has begotten nothing to compare with the vitality and scope of his earlier work which, by right of intelligence and execution, ranks with the studies of Hogarth. Spurning the time-eaten subject matter of fashionable romanticists, etching with fearless precision, painting in a straightforward style, Sloan was long denied a lucrative market, and was forced into teaching and book illustration. With his usual good sense, he understood that all enduring art partakes of illustration, and for his work in this field he has been honored by European connoisseurs.

*McSorley's Bar* is a landmark in the story of American art. Painted in 1912, when the old bar in lower New York was the rendezvous of the lowly, it is not only an example of Sloan's honest realism but also a portent of the realistic tendency which, after the modernist influences had run their course, was to guide American artists in the exploitation of regional subject matter.

[ABOVE] *Fifth Avenue, 1909*, Metropolitan Museum, New York. Etching, 1909. A view of mid-town New York when the Flatiron Building was the cultural center.

[BELOW, LEFT] *McSorley's Bar*, Detroit Institute of Arts. Oil, 32″ x 26″, 1912. Color plate, page 267.

[BELOW, RIGHT] *Backyards, Greenwich Village*, Whitney Museum of American Art, New York. Oil, 32″ x 26″, 1914. In the words of the artist, "The winter atmosphere well rendered, the cats unforgettable."

# CHARLES BURCHFIELD

1893–

CHARLES BURCHFIELD is one of those grim, gifted, independent Americans who take nothing for granted, essentially a Middle Westerner with a melancholy, sharp-seeing interest in hard facts. He was reared in drab towns and monotonous farm lands that no one loved. But the life of the midlands made a profound impression upon him: the wretched architecture, the fields, and the forlorn vistas of unoccupied earth; the stern farmers and their sad, patient wives; and the social gatherings of ragged villages. In his late twenties, after some schooling in art at Cleveland, Burchfield, a tailor's son born in Ohio, exhibited in New York a collection of water colors of astonishing originality. His first works—brilliant descriptive sketches with no traces of Continental influences—brought painting down to earth, proclaimed the arrival of an authentic American artist, and changed the direction of native painting.

Burchfield has faced life and extracted from it an art that may be justly termed his own. He has chosen subjects hitherto proscribed because they were supposed to be provincial or intrinsically ugly—and he has not presented them in rosy colors. He has painted villages in winter, the coming of spring, the season of harvests, and fall plowing; he has painted the countryside with a row of false-front stores straggling on one side of the highway; farmers in T-model Fords; little towns on a Saturday afternoon—the epitome of cheap tastes and starved ideals.

*November Evening*, an oil painting of the year 1932, is a powerful illustration of his most representative mood, a mood engendered by experiences which have taught him that life is neither classical nor charming; but, on the other hand, neither despicable nor spiritually repellent. Those commonplace scenes which Sinclair Lewis has publicized with ostentatious disapproval, and with a satirical particularization which has convinced Europeans of the prevailing vulgarity of small-town life in America, Burchfield has approached in another vein. He has made his backgrounds descriptively true, but he has also revealed them in a bleakness that is rich and strange; and beneath the loneliness and shabby monotony, he has created a mood of naked, haunting grandeur. He has surrounded his subjects with a tragic atmosphere—the tragedy of barren living; in him the vast unloveliness of rural America strikes home and becomes material for the expression of his poetic view of common things.

[ABOVE] *Church Bells, Rainy Night,* The Cleveland Museum of Art, gift of Mrs. Louise M. Dunn. Water color, 19″ x 30″, 1917. In the bold early style when symbolism was rampant.

[BELOW, RIGHT] *November Evening,* Metropolitan Museum, New York. Oil, 52″ x 32″, 1934. Color plate, page 268.

[BELOW, LEFT] *March Wind,* The Cleveland Museum of Art, The J. H. Wade Collection. Water color, 39¾″ x 26½″, 1926. Intimations of the sharp realistic style.

# THOMAS HART BENTON

1889–                                    AMERICAN SCHOOL

IN THE variety and range of his attack; in his ability to seize upon and communicate the healthy strength, the telling details, and the large characteristic modes of action, Benton stands today as the foremost exponent of the multifarious operations of American life. Born in the Ozarks of Missouri, he passed his boyhood in an environment not unlike that of Huckleberry Finn, and at the age of nineteen went to Paris to make an artist of himself. Four years later, having absorbed and rejected the doctrines of the modern school of Paris, he returned to his own country to undergo a long period of readjustment. In 1918, his repatriation completed, he resolved to devote his life to a pictorial history of the United States.

Since that momentous decision, Benton has been an inveterate explorer of the interior of America, and has accumulated a veritable mountain of notes and sketches which, with audacious energy, he has utilized in an art ranging from lithographs to the most forceful and complicated wall decorations in the land. His murals are alive with living characters reflecting the broad humor, the occupational differences, and the inextinguishable gusto of his people. His painting is a complex instrument; in popular appeal, a folk art, but fundamentally an intellectual performance—a folk art elaborated from a structural mechanism derived from the Renaissance. He is a master designer, an artist who can resolve and harmonize seemingly impossible contradictions of subject matter.

A resident of Missouri for many years, Benton has taken, one might say, as his own particular material, the picturesque behavior and individuality of the backwoodsmen of his native State, and the sad struggle for existence of the poor whites and blacks living in the Mississippi Delta. Deeply sensitive to the plight of the lowly and unfortunate, he portrays them truthfully—not with propaganda or sentimentality but with sympathy, insight, and humor. His picture of the sharecropper's son inspecting a little patch of sweet corn was painted in 1939, when he introduced, for the first time in his work, textured details and variations to relieve the starkness of his style without impairing its essential structure. The picture, in which the components—the stalks of corn, the trees, the boy and the roll of the land—are worked out with minute care and in bold relief to form a beautiful design, is as authentic and American as its subject, *Roasting Ears*.

[ABOVE] *Aaron*, The Pennsylvania Academy of Fine Arts, Philadelphia. Oil-tempera, 1943. A powerful and sympathetic study of an aged Negro preacher.

[BELOW, LEFT] *Roasting Ears*, Metropolitan Museum, New York. Oil-tempera, 39¼″ x 32″, 1938-1939. Color plate, page 269.

[BELOW, RIGHT] *Arts of the West*, Whitney Museum of American Art, New York. Mural, 1932. A living challenge to the cheesecloth, pseudo-classical murals in America.

# JOHN STEUART CURRY

[ABOVE] *John Brown*, Mrs. John Steuart Curry Collection, Newburyport, Massachusetts. Red chalk, 11″ x 15″, 1940. Study for the preponderant figure in the mural decorations at the Kansas State House, Topeka.

[BELOW, RIGHT] *The Line Storm*, Mr. and Mrs. Sidney Howard Collection, New York. Oil, 4′ x 2′ 6″, 1934. Color plate, page 270.

[BELOW, LEFT] *Hogs Killing a Rattlesnake*, Mrs. John Steuart Curry Collection. Watercolor sketch for one of Curry's best paintings now in the Art Institute of Chicago.

JOHN STEUART CURRY was born on a Kansas farm, the descendant of many generations of farmers. He lived in a country of sudden and fearful changes of weather. He saw the cornfields and the early vegetation of the far-off slopes shriveled to the ground by the southwest wind; he saw tornadoes come crashing down the broad valley with families scurrying into cellars, and white-eyed horses running madly before the storm. Every day of his life he heard the weather discussed, and read in the eyes of men and women the apprehensions born of the constant threats of the destructive forces of nature. As a boy on the farm he made sketches of storms and animals; and in after years, painting the same subjects, he won great renown. The subjects were important to him, as his interpretation of them is important to the understanding of American life.

Curry enrolled in the Art Institute of Chicago in 1917, and at the end of two years succumbed to the lure of magazine illustration in New York. His success in this department was less than moderate, and discouraged by his lack of cleverness, he went abroad to improve his draftsmanship. He passed a cheerless winter in Paris, returned to America with no prospects, revisited Kansas, and with iron determination set out to prove his capacities as a painter of the wheat lands. On his first trial he produced the celebrated *Baptism in Kansas* and, during the next four years, a succession of Western dramas which placed him in the front rank of American artists.

It would be hard to name a less derivative painter than Curry: he seemed to know by instinct the field he was to make peculiarly his own. His materials were common property, yet no one else was disposed to adapt them to painting. He is the most poetic American artist since Albert Ryder, but he is no fantasy builder: he works directly from realities and natural phenomena; and in the act of putting his materials together, he instills into them his love for the homeland with the intimacies and memories he has preserved in all their freshness. Curry's genius is no antique presence wheedled out of the old masters; nor is it a synthetic agent evolved from modernism. It is a living spirit springing out of the ground like the growing wheat, or out of the threatening elements like a storm cloud. In his delineations of elemental disturbances he is in a class by himself, his *Line Storm*, for example, being a masterpiece in which earth and sky and the whole landscape together with the frightened animals are transformed into an enormous personality alive with dramatic terrors.

# REGINALD MARSH

1898–1954          AMERICAN SCHOOL

IN THE younger generation of American artists, those who came forward since the First World War, Reginald Marsh stood apart as the offspring of the city, a painter concerned exclusively with the urban scene. After his schooling at Lawrenceville and Yale, he settled in New York, and in a short time became conspicuous for his studies of the humbler aspects of metropolitan life. Influenced by the robust Americanism of John Sloan, and with the same eye for significant detail, Marsh turned his back on the esthetic whims and theories of the day, and established headquarters in lower Manhattan. A man of even temperament, with no disposition to take sides in economic or social issues, or to whip himself into a fighting rage, he was an observer of life, or that very real slice of it extending from the shop and subway to the dance hall and Coney Island. Other artists have painted the city, but with a grinning cynicism, or a political bias that destroys reality: Marsh, in contrast, really loved New York and all its grand vulgarity.

The smart circles of society left him cold; well-bred people bored him, and he could not paint them with any degree of success. He was interested in the submerged orders—in their vigorous sensuality which he accepted as frankly and affectionately as Renoir accepted it. He painted Harlem and the Bowery, the parks and the bread lines; and he painted the shopgirls of Fourteenth Street and the girls of the public beaches and burlesque shows with sensual tenderness and deep appreciation of the enticements of exposed flesh. He was an artist of power, one of the best of modern draftsmen, with a steady flow of productive energy directed into etchings of the highest quality, tempera paintings, and murals. His decorations, in fresco, in the Customs House of New York, a Federal commission for which he received the wages of a day laborer, are monumental representations of great ocean liners and the congested excitements of landings and departures.

Marsh developed an original method of painting in transparent glazes which lend a curiously vibrating quality to his surfaces but which are difficult to reproduce. *Wooden Horses* is an illustration of this personal method: a section from the playgrounds of New York, with the surge of light and color, and the irresponsible animation of his favorite actors in the metropolitan carnival.

[ABOVE] *High Yaller*, courtesy of Mrs. John S. Sheppard, New York. Egg tempera, 24″ x 18″, 1934. A Harlem belle who has become a metropolitan contribution to our Americana.

[BELOW, LEFT] *Wooden Horses*, Mr. and Mrs. Carl W. Kelly Collection, Winnetka, Illinois. Egg tempera, 24″ x 36″, 1936. Color plate, page 271.

[BELOW, RIGHT] *"Why Not Use the El?"*, Whitney Museum of American Art, New York. Oil-tempera, 48″ x 36″, 1930. The humdrum side of New York life translated into sober, solid forms.

# GRANT WOOD

1892–1942     AMERICAN SCHOOL

*Woman with Plants*, Cedar Rapids Art Association. Oil, 17½″ x 20½″, 1929. Color plate, page 272.

BY BIRTH and training, Grant Wood is a workman, a craftsman who has applied his inimitable talents to almost every branch of the manual arts from carpentry to the making of jewelry. Self-supporting in an Iowa town from the age of ten, he was overworked in his youth, but he contrived somehow to teach himself to draw and to paint with professional ease. When he resigned himself to the lot of the artist, he suffered prolonged agonies of cultural inferiority; and when he went out into the world, a great fear came upon him—the fear that he was not proceeding properly, that he had been eternally contaminated by a raw environment. Four times he went to Europe in search of something soft and mellow to paint—he had not yet discovered, he says, "the decorative quality of American newness."

As late as 1930, save for a few delicately executed portraits, Wood was bound to the conventions of impressionism; but suddenly, as if by a flash of revelation, he developed into the designer of original pictures which have no parallel in modern art. He painted *American Gothic*, one of the most deservedly popular pictures of the last generation, and found himself famous. He had not, of course, become a creative painter overnight: he had returned to the crafts as the technical basis of his art and had yielded, without esthetic fears, to the early influences that had made him a part of his environment.

Since *American Gothic*, Wood, a painfully slow and finical workman, has produced a substantial body of work in landscape and mural decoration, but his highest attainments are in portraiture and figure painting. Not since Copley has America seen his equal in the delineation of people, and in subtle analysis of character and inventive design, he surpasses the Colonial master. By dealing unreservedly with local psychologies, he has created men and women who, though rooted in the Iowa soil, belong in the gallery of American types. *Woman with Plants*, slightly darkened by imperfect preservation, is a portrait of his mother, who was a pioneer woman of infinite forbearance. As concerns the artist, the work is a devotional picture of the purest type; for the world at large it is a woman with plants—portrayed with the integrity, methodical planning, impeccable craftsmanship, and love of detail which Wood, in his European travels, had admired in the Flemish and German primitives, and which, on his return to his old working habits, he discovered were the distinguishing qualities of his own American art.

*American Gothic*, The Art Institute of Chicago. Oil, 25″ x 29⅞″, 1930. After Stuart's *Washington* and Whistler's *Mother*, the most popular picture produced by an American artist.

[RIGHT] *Midnight Ride of Paul Revere*, Metropolitan Museum, New York. Oil, 40″ x 30″, 1931. An historical episode interpreted with a rare and exhilarating sense of design—and a sense of humor.

105. *The Shrimp Girl* · WILLIAM HOGARTH · National Gallery, London. Text, page 210.

106. *The Graham Children* · WILLIAM HOGARTH · National Gallery, London. Text, page 209.

107. *The Rake's Progress—III* · WILLIAM HOGARTH · Sir John Soane's Museum, London. Text, page 211.

108. *Dr. Johnson* · SIR JOSHUA REYNOLDS · Tate Gallery, London. Text, page 212.

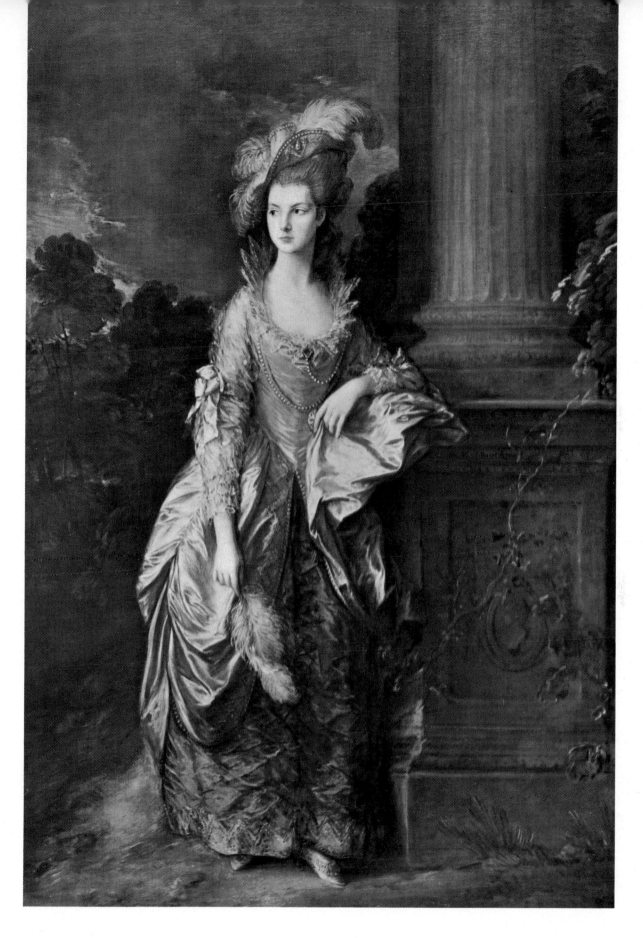

109. *The Honorable Mrs. Graham* · THOMAS GAINSBOROUGH · National Gallery, Edinburgh. Text, page 214.

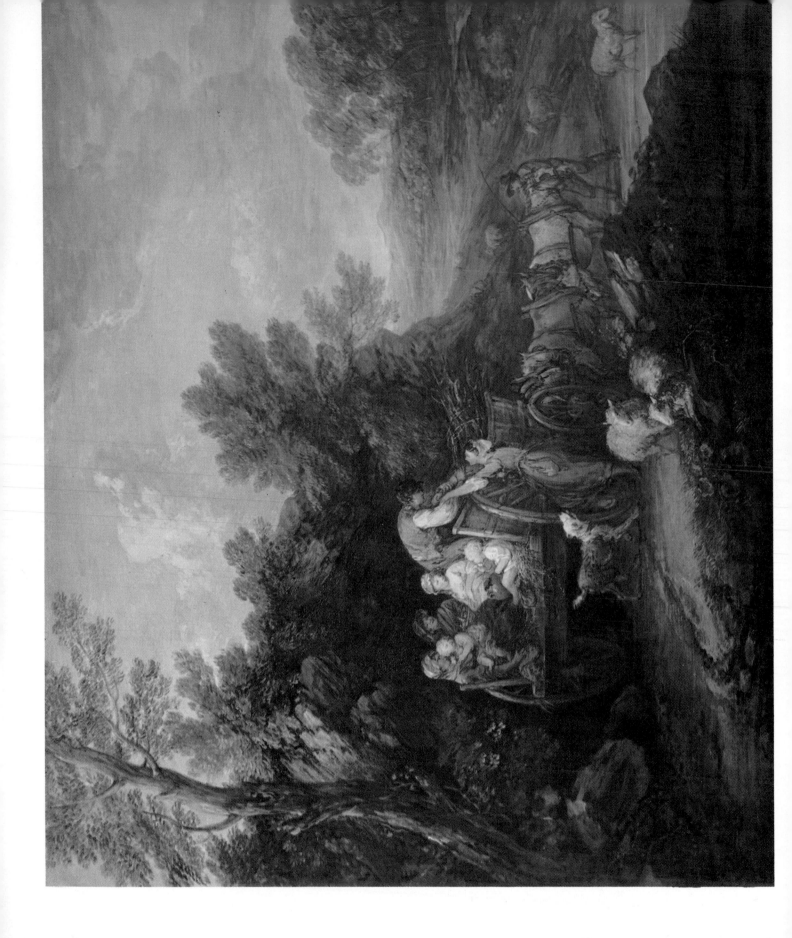

110. *The Harvest Wagon* · THOMAS GAINSBOROUGH · Frank P. Wood Collection, Toronto, Canada. Text, page 213

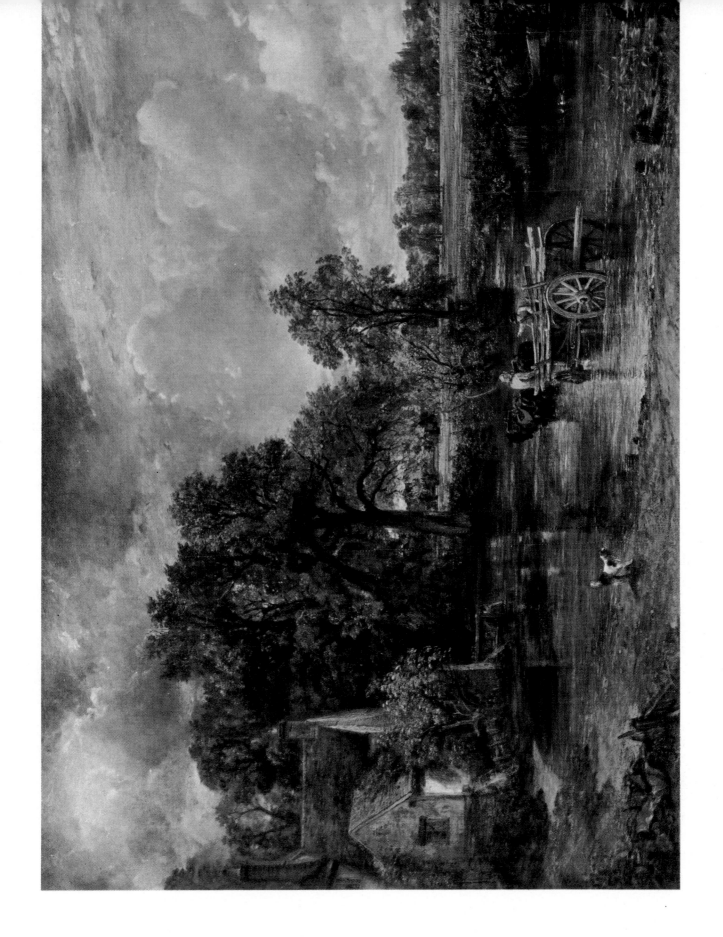

111. *The Haywain* · JOHN CONSTABLE · National Gallery, London. Text, page 217.

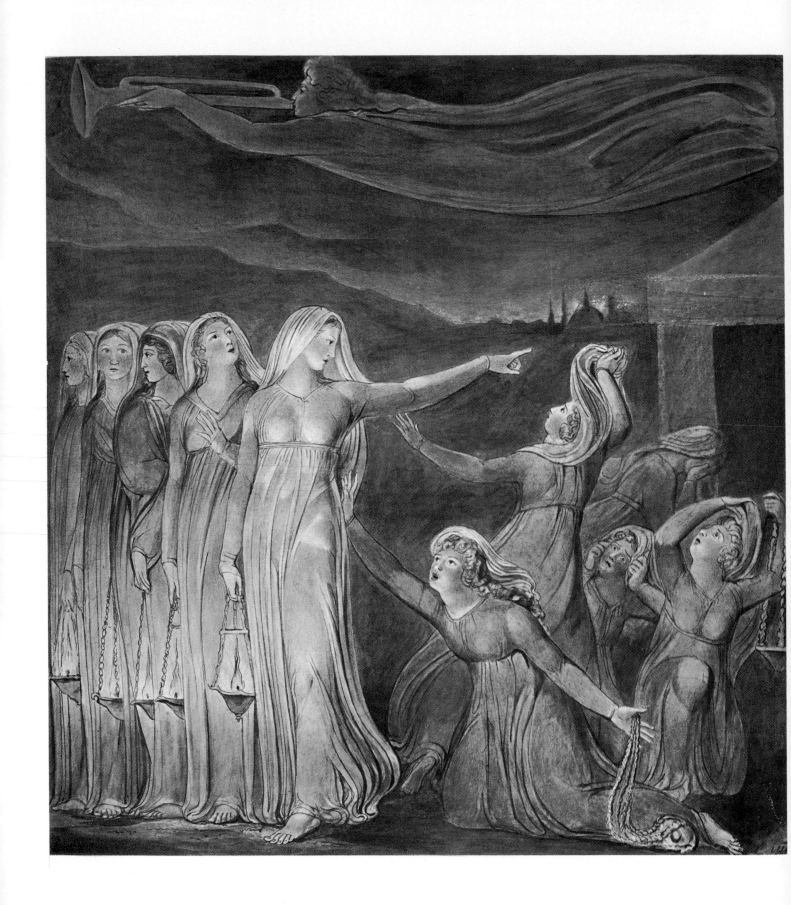

112. *The Wise and Foolish Virgins* · WILLIAM BLAKE · Metropolitan Museum, New York. Text, page 216.

113. *The Drummond Children* · SIR HENRY RAEBURN · Edward S. Harkness Collection, New York. Text, page 215.

114. *The Fighting Téméraire* · JOSEPH MALLORD WILLIAM TURNER · National Gallery, London. Text, page 218.

115. *Calais Pier* · JOSEPH MALLORD WILLIAM TURNER · National Gallery, London. Text, page 219.

116. *Lady Lilith* · DANTE GABRIEL ROSETTI · Metropolitan Museum, New York. Text, page 220.

117. *Mrs. Seymour Fort* · JOHN SINGLETON COPLEY · Wadsworth Athenaeum, Hartford. Text, page 221.

118. *George Washington* · GILBERT STUART · Museum of Fine Arts, Boston. Text, page 222.

119. *Snowy Heron or White Egret* · JOHN JAMES AUDUBON · Text, page 223.

120. *Stump Speaking* · GEORGE CALEB BINGHAM · St. Louis Mercantile Library. Text, page 224.

121. *The Little White Girl* · JAMES ABBOTT MCNEILL WHISTLER · National Gallery, London. Text, page 225.

122. *The Forest of Arden* · ALBERT PINKHAM RYDER · Stephen C. Clark Collection, New York. Text, page 229.

123. *The Concert Singer* · THOMAS EAKINS · Philadelphia Museum of Art. Text, page 226.

124. *Will Shuster and Black Man Going Shooting* · EAKINS · Stephen C. Clark Collection, New York. Text, page 227.

125. *Gulf Stream* · WINSLOW HOMER · Metropolitan Museum, New York. Text, page 228.

126. *Asher Wertheimer* · JOHN SINGER SARGENT · Tate Gallery, London. Text, page 230.

127. *Lady Jean* · GEORGE BELLOWS · Stephen C. Clark Collection, New York. Text, page 231.

128. *Man and Machinery* · DIEGO RIVERA · Detroit Institute of Arts. Text, page 232.

129. *Hispano-America* · OROZCO · Baker Memorial Library, Hanover, New Hampshire. Text, page 233.

130. *A Man of Opinion* · GEORGE GROSZ · Walker Galleries, New York. Text, page 234.

131. *McSorley's Bar* · JOHN SLOAN · Detroit Institute of Arts. Text, page 235.

132. *November Evening* · CHARLES BURCHFIELD · Metropolitan Museum, New York. Text, page 236.

133. *Roasting Ears* · THOMAS HART BENTON · Metropolitan Museum, New York. Text, page 237.

134. *The Line Storm* · JOHN STEUART CURRY · Mr. and Mrs. Sidney Howard Collection, New York. Text, page 238.

135. *Wooden Horses* · REGINALD MARSH · Rehn Gallery, New York. Text, page 239.

136. *Woman with Plants* · GRANT WOOD · Cedar Rapids Art Association, Cedar Rapids, Iowa. Text, page 240.

# GUSTAVE COURBET

1819–1877                    FRENCH SCHOOL

ABOUT 1850, when the fight between the classics and romantics was still waging in France, and to express an opinion on painting was to take sides with Ingres against Delacroix, or the other way round, two men appeared who gave the immediate impulse to the technical revolt known as impressionism. These two, Courbet and Manet, in their point of view, differed little from Velasquez and Hals: both were accomplished workmen; both realists, both indisposed to consider the psychological issues that disturbed men's souls.

Courbet, the older, was a peasant of independent means, a defiant showman from Ornans, and to the aristocratic Delacroix, who admired his painting but deplored his manners, an overconfident vulgarian. He was immensely talented, but his lusty scenes from plebeian life were officially excoriated as the work of a socialist, and he was ostracized by the Salon. He retaliated with blatant hostility; recruited his young disciples who called him Master, and became a deputy in the Commune, with foolish dreams of making himself the dictator of art after the example of David. This was more than France could tolerate in an artist, and when the Communards were overthrown, Courbet was chased out of the country into Switzerland, where he died in disgrace.

Courbet used, or allowed to be used in his behalf, for the first time in painting, the word *realism*. When asked to paint a religious picture, he roared with laughter. "Show me an angel," he exclaimed, in a remark now famous, "and I will paint one! Painting is an art of sight!" He intended to say that, to a modern Frenchman, religious imagery was dead, an allegory, a farce; and his doctrine, as expounded quietly by Daumier, was the best of good sense. Courbet was ambitious to restore to painting the vitality of the old art which, he swore, had been lost because artists had been slaves to precedent. He had animal spirits and a sensual relish for work and for battle: the man was alive, and if he was not moved by the loftier problems of the spirit, at least he could see clearly. His smaller nudes, portraits, and landscapes are extraordinarily masculine, most of them sane and delectably painted, the best of them powerful. *The Amazon*, of 1856, a portrait of Louise Colet, remembered for her literary feuds and friendships rather than her writings, is a sober study, painted with directness and integrity, not too literal in its insistence on realism, yet of striking verisimilitude in contrast to the portraits of his classical opponents.

*The Amazon*, Metropolitan Museum, New York. Oil, 34⅛″ x 45½″, about 1856. Color plate, page 297.

Detail, left center, of *L'Atelier du Peintre*, an enormous canvas, 18′ x 12′, with the subtitle, *"A True Allegory of Seven Years in My Life as an Artist."* Courbet and his favorite model —as handsome a pictorial job as any man has done since the Renaissance.

[LEFT] *The Meeting*, Musée Fabre, Montpellier. Oil, 6′ x 5′, 1854. Often called *Bonjour, M. Courbet!* The artist himself, vainglorious as usual, greets his patron, Alfred Bruyas, and the obsequious valet.

# GUSTAVE COURBET

*Roe-Deer in a Forest*, Louvre, Paris. Oil, 81½″ x 68⅞″, 1866. Color plate, page 298.

IT WAS Courbet, the swaggering, prodigiously gifted egoist from the province of Franche-Comté, who, singlehanded, slaughtered the sham classicism of the camp-followers of Ingres on the one hand and the effete romanticism of the idolaters of Delacroix on the other. As an artist he was magnificent, and as the exponent of visual realism he became the founder of modern painting, turning out masterpieces with appalling rapidity. He shouted his pragmatic philosophy from the treetops and housetops, and the people of France listened and acclaimed. He swore that he painted what he saw, and no doubt he did, but out of his direct observations and healthy experiences he created plastic structures of monumental vitality—and for technical guidance returned to the old masters—to Caravaggio and the late Italians, Ribera and the Spaniards, and Franz Hals, the old toper of Haarlem. With his courage, energy and over-weening self-confidence, he smote the bigots of officialdom, and of all the brave men who kept art alive and exciting in the nineteenth century, he was the least dependent on conventions, traditions or precedent.

Courbet was a painter pure and simple, hating books and everything connected with polite learning or formal education. His primary and profound source of inspiration was France herself and the sturdy glories of the provinces. He was rooted to the soil and to the end of his days his finest canvases were those depicting the men and women—old women and young meaty nudes—and the landscape, the flowers, animals, and customs of his native heath. Throughout his entire career, he maintained a studio in Paris, incredibly industrious, and always battling the bureaucrats but during his forensic tilts returning annually for a rustic interlude at Ornans, his birthplace and the country he loved.

Courbet was not the first to paint animals, but his studies of animals and landscape together are in a class by themselves. He was a mighty hunter and pedestrian and knew his native terrain like a book or the face of a favorite model. No other painter, except Constable, can match him in conveying the freshness of nature, the wetness of water, the sylvan atmosphere and the poetic density of the forest. The covert of the roe-deer is the most beautiful of his landscape-animal pictures—an antlered buck to the left, a doe near by, and another buck standing in the shallow water. The landscape was painted on the spot in a few hours, and the animals added, from studies, in his workshop in Paris—and the canvas, when exhibited at the Salon of 1856, was a great success—applauded even by his enemies.

*The Man with the Pipe*, Musée Fabre, Montpellier. Oil, 14½″ x 17¾″, about 1846. Self-portrait of the painter at twenty-seven, a shaggy Bohemian but tough and sensitive.

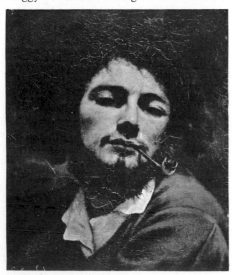

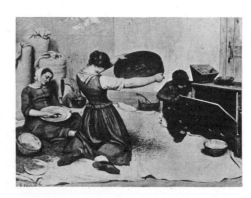

[RIGHT] *The Winnowers*, Musée des Beaux-Arts, Nantes. Oil, 6½′ x 5′, 1854. Socially conscious, the artist paints his sister, the kneeling figure, and a sleepy companion in a grass-roots, occupational scene.

# ÉDOUARD MANET

### 1832–1883           FRENCH SCHOOL

MANET was a Parisian of the old school, well bred, well dressed, loyal to his friends and to his brush, a man of the world and a man of principle. His parents were comfortably situated, and he was spared the necessity of painting for money; but the subjects of his pictures provoked the execration of the juries and the multitude, and he died a nervous wreck—by popular verdict the most notorious painter in Paris.

Manet looked upon painting as a routine job, in essentials the same as any other occupation. He took his job very seriously, but he had little interest in what people thought or in what they did; one thing was as good as another, and from the conglomeration of diversities composing the world, he fastened upon a single item—a dwarfish nude or a barmaid—posed it in his studio, and made a cunning pattern out of its surfaces. He was preoccupied with tones and values, not with any light that tones and values might shed on the riddle of living. When he had ceased to bother about what he should paint, he schemed out a formula for the rendering of the visible world; working in flat tones because, he argued, visual impressions were flat; lighting his models from the front in order to give a more direct approach to nature; and using shadows meagerly—they complicated the problem.

The purpose of his system was to present sharp impressions of nature; to reveal the face of things as they flashed suddenly into the field of vision. Manet's canvases have the quality of unexpectedness—the arousing freshness and strangeness of things seen for the first time. *The Bar of the Folies-Bergères*, painted in 1881 when his technical proficiency was only this side of miraculous, gives the instantaneous effect of a snapshot, and was, in fact, painted in his studio with the help of photographs. But the camera does not find in life such a dazzling interplay of lights and textures—that was Manet's special contribution. He made no exalted claims for his art; but simply asked to be allowed to paint what was registered by his unerring eye, and within the terms of his own definition no man ever painted better. The everyday world was material for his brush, and when he had finished with it, he had fashioned glowing patterns, brilliant silhouettes, and vividly apprehended surfaces in which the beholder is not ensnared by the artist's personality, but delighted by new aspects of nature.

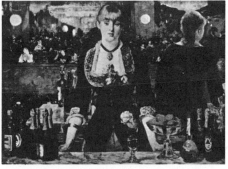

*The Bar of the Folies-Bergères*, Samuel Court-auld Collection, London. Oil, 4′ 2″ x 3′ 2″, 1881. Color plate, page 299.

*The Ragpicker (Le Chiffonier)*, Wildenstein and Co., New York. Oil, 51¼″ x 76¾″. The modern aesthete paints a human subject with the same consideration he bestowed on a plate of oysters.

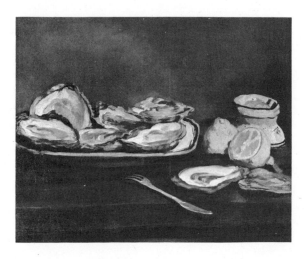

[LEFT] *Oysters*, Dr. and Mrs. David Levy, New York. Oil, 17¼″ x 15″, 1862. The "painter's painter" gives the profession a lesson in the manipulation of oil pigments.

# ÉDOUARD MANET
## CONTINUED

*Boating at Argenteuil*, Tournai Museum, Belgium. Oil, 3' 6⅛" x 5' 10⅝", 1874. Another brother-in-law, Rudolph, and companion, recorded on a boating party.

MANET was one of the leaders in the revolt of the modern French artists against the stupidities of officialdom and the entrenched arrogance of the Salon painters. He was not by nature pugnacious, nor was he disposed to advance himself by the tactics of the scandalmonger—but his convictions were as honest and intelligent as they were offensive to the academic juries, and for many years, almost singlehanded, he carried the battle into the camp of the enemy. He began by infuriating his teacher, an imitation classicist, with a picture of an absinthe drinker; they parted company, and thenceforth he went his way alone, certain of what he wanted to do and with a levelheaded notion of his capacities. He matured early, painting with a clear caressing elegance that left its mark on Whistler and a host of subsequent artists; painting exciting arrangements of tone which today are contemplated with delight and with no sense of embarrassment or affronted decency.

But the bigwigs of the Salon were not delighted. Buried in historical or mythological lore, they fancied themselves idealists, whereas they were hardly alive. They regarded Manet's realism as abominable, and his unexpected aspects of nature created a tumult of protest. Two pictures painted in his early thirties ruined him for life; one a representation of two nude grisettes lunching in the woods with a couple of dressed gentlemen; the other, the infamous *Olympia*, a reclining nude. Both pictures are modernizations of paintings by Giorgione; both are challenges to the classical conception of nudity. The Salon retainers, abetted by Napoleon III and the Empress who supervised the wholesale condemnation, approved of nudes, but for the sake of their official trade clamored for something less ingenuous—an artificially idealized goddess or a discreetly seductive nymph, not an undisguised Parisian model. For his honesty, Manet paid the penalty of persecution.

The original ancestor of *Le Déjeuner sur l'herbe* is Giorgione's *Concert champêtre* (Plate 36), but the more direct parent is an engraving after Raphael, whose grouping of the figures in the foreground is closely followed. The painting, now in the Louvre, is no longer an object of moral indignation. It was never intended for an actuality: it was painted by Manet in an arranged lighting as an exhibition picture, and that is precisely what it is—an exhibition of his great skill, and of his valiancy in demanding for the modern artist the same freedom of expression conceded by the official juries to the old masters.

*Boy Blowing Soap Bubbles*, National Gallery of Art, Washington (lent by C. S. Gulbenkian, Esq.). Oil, 31½" x 39", 1867-1869. Portrait of the artist's brother-in-law, Léon Leenhoff, who served as a piece of still life.

[RIGHT] *Le Déjeuner sur l'herbe*, Louvre, Paris. Oil, 8' 10⅜" x 7' ¼", 1863. Color plate, page 300.

# CLAUDE MONET

1840–1926            FRENCH SCHOOL

IN 1874, nine years after the scandal precipitated by Manet's *Le Déjeuner sur l'herbe*, a group of French painters rejected by the Salon organized a joint-stock company and exhibited their works independently in Paris. The group included the familiar names of Monet, Sisley, Pissarro, Renoir, Cézanne, and Degas; and its first showing was received by the public with jeers and laughter, and by the critics with exceptional insolence. Taking his cue from one of Monet's pictures called *Sunrise, an Impression,* a facetious writer lumped all the exhibitors together under the name *impressionists.*

Despite its ignominious beginnings, impressionism gained momentum, won the sympathies of men of talent, and flourished for more than forty years. The movement was the logical culmination of the historical tendency of painters to investigate the phenomena of light and atmosphere. The impressionists laid great stress on the "innocent eye," the eye that registers nature impartially like the lens of the camera; and aided by scientific experiments, evolved a chromatic equation for the transcription of nature. In the final stages, they indicated shadows and local colors by facets—by dots and dashes—of pure pigments which, when recomposed by the eye at a distance, produced the vibrant liveliness of nature itself. Thus, in painting grass, they used, not a prepared green, but innumerable touches of blue and yellow, leaving the blending process to the spectator. The movement, besides exploring the relation of light-values to color, carried on the healthy realism of Courbet, repudiated academic subject matter, forced attention on the artistic material in the everyday world, removed quantities of ugly mud from the palette, and taught painters not to fear gay and brilliant tones.

Claude Monet was associated with impressionism through all its ramifications, and had the satisfaction of seeing his canvases rise in price from ten to one hundred thousand francs. While in London in 1870 to evade conscription, he discovered Turner and the Englishman's luminous studies in broken color of the Thames and the railway trains. Returning to France, he painted the Seine, and in 1877, the St. Lazare railway station. This picture, a swift impression painted before he had developed his pure-color technique, is an excellent example of his art of glorifying a mundane subject by enveloping it in veils of atmospheric tones.

*Portrait of Mme Monet and Bazille,* Molyneux Collection, National Gallery of Art, Washington. Oil, 36⅝″ x 27¼″, 1868. The artist's wife and one of the founders of Impressionism in a background of vibrant color.

*Rouen Cathedral,* National Gallery of Art, Washington (Chester Dale Collection). Oil, 25½″ x 40″, 1894. One of a series of cathedral studies in which the architectural framework is almost obliterated by spectrum colors.

[LEFT] *Gare St. Lazare,* Art Institute, Chicago. Oil, 31½″ x 23½″, 1877. Color plate, page 301.

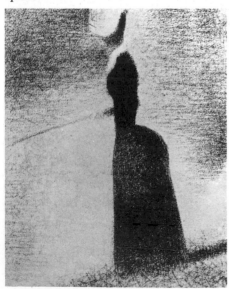

*The Model*, Louvre, Paris. Oil, 6¼″ x 9¼″, 1887. A figure of classic stability compounded of an infinite number of juxtaposed dots.

# GEORGES SEURAT

1859–1891                                        FRENCH SCHOOL

THE elaborate technique of the impressionists was reduced to an exact science by a small school of painters generally known as neoimpressionists, or divisionists and pointillists, from their method of dividing tones into circular dots. The glory of the school is reserved for one man, Georges Seurat who, in the present century, has risen to a high position among modern artists. Seurat died at the age of thirty-two from an attack of pneumonia; in his last years working feverishly day and night in a poorly lighted studio, an emaciated figure with an irking presentiment of his end.

Endowed with intellect and imagination; recognizing the limitations of the impressionists, but commending their science, Seurat engaged to restore classic dignity and architectural order to painting—and in large degree his purpose was rewarded. He chose his subjects from the world he knew and understood—landscapes he had loved and pondered, circuses, parks, dancers, and groups of bathers by the riverside—idealizing his forms, stripping off useless details, emphasizing geometrical structure, but preserving specifically French characteristics of figure and costume. But he shortened his life by a technique of fatal intricacy.

Seurat painted by rule: he had laws for the emotional properties of straight and curved lines; laws for the manufacture of gay, sad, and calm harmonies; and laws, taken from Helmholtz, for the translation of color into light. He applied his pigments in minute points, detached granules of color or tone, which, like the juxtaposed touches of the impressionists, were fused by the eye into optical mixtures. With the patience of genius, he covered large canvases with thousands of circular specks, each premeditated and placed with exact knowledge of its action on contiguous specks.

The summation of his calculated efforts is fully displayed in *La Grande Jatte*, a large picture compounded from studies made on the island of La Grande Jatte in the Seine near Paris, an island he frequented of Sunday mornings to observe the parade of visitors and to relax his febrile energies. The indisputably French elements of the scene—the types and local flavor—are retained intact; but they are ennobled by Seurat's sense of the grand style, his classic gravity, and his motionless perfection. As a specimen of flawlessly articulated design, *La Grande Jatte* has elicited the wonder and the admiration of all modern painters.

*Lady Fishing*, Museum of Modern Art, New York. Crayon, 9″ x 12″, about 1885. Sketch for an oil painting done to show the exact size, position and intensity of a figure in space.

[RIGHT] *La Grande Jatte*, Art Institute, Chicago. Oil, 10′ ⅜″ x 6′ 9″, 1884-1886. Color plate, page 302.

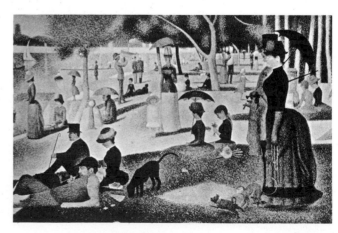

# EDGAR DEGAS

1834–1917         FRENCH SCHOOL

DEGAS was a Parisian with an income, the son of a banker and a Creole mother born in New Orleans. He prepared in desultory fashion for the law, but at the age of twenty-one found his vocation in painting, which he practiced incessantly to the end of his long life. Hot-tempered and vituperative, he ceased to exhibit in 1886, and became a recluse in his Montmartre studio, a disagreeable old bachelor with an untidy beard, railing at everything new, alienating all his friends by his sarcasms, and venturing out occasionally, deaf and half blind, to the greenroom of the opera to study the ballet dancers and to insult the ancient roués who tottered in to claim their girls.

Degas was tough-minded and disillusioned: in his trenchant detachment, his honesty, and the perfection of his craft much like another great artist of the day—Guy de Maupassant. He spurned the dot-and-dash evasions of the painters of sunlight, but he was, by broadest definition, a true impressionist whose ambition, in his own words, was "to observe his models through the keyhole," to gather an eyeful of nature, a vivid segment of life. A close student of photography, he caught his models in eccentric poses, stressing camera effects such as the overexposure of anatomical prominences, dislocated lines, and foreshortenings made from odd angles of vision. He did this to render the intimacy of life as disclosed by people in their natural habits.

He was a man without sentiment, loving nothing but fascinated by the curious aspects of familiar scenes in which, with his detective's eye, he saw the hidden sources of unfamiliar beauty. For the convenience of his models and for his own esthetic requirements, he had, in his studio, what was then unknown in Paris—a bathroom. He compelled the girls to undress, bathe, and make their toilets while he sketched them at close range. The results of this unusual procedure may be seen in *After the Bath*, done in pastel, a medium that Degas used with consummate mastery. Here a private ablution depicted with unsparing realism—with none of the enticements of the French nymph manufacturers—is raised to a high order of decorative art. The miracle was performed by guiding the firm outlines of the bather, the curve of the tub, the footcloth, and the figure of the maid into an arabesque; by the ingenious distribution of lights and colors, and by posing modeled flesh against a flat background; but over and beyond formal triumphs, it was performed by the mysterious workings of the artist's personality.

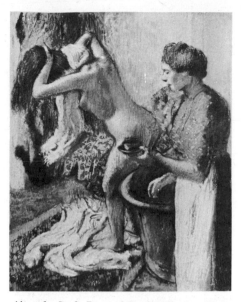

*After the Bath*, Durand-Ruel Galleries, Paris. Pastel, 3′ x 4′, 1883-1890. Color plate, page 303.

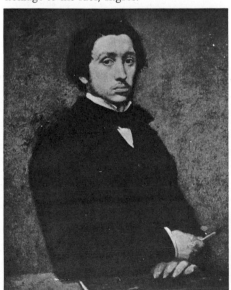

*Self-portrait*, Louvre, Paris. Oil, 25¼″ x 31½″, about 1854-1855. The caustic, disillusioned painter in an early study done with homage to his idol, Ingres.

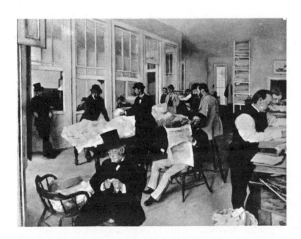

[LEFT] *The Cotton Market in New Orleans*, Musée de Pau, France. Oil, 36⅛″ x 29⅛″, 1873. An impression of his father's American brokerage offices painted after a holiday in New Orleans in 1870.

# HENRI DE TOULOUSE-LAUTREC

1864–1901

FRENCH SCHOOL

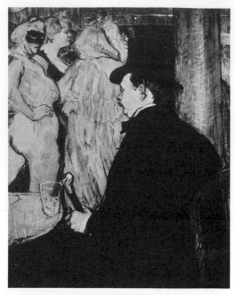

*Portrait of Maxime Dethomas*, Chester Dale Collection, New York. Pastel, 20¾″ x 26½″, 1896. Color plate, page 305.

*Le Jockey*, The Art Institute of Chicago. Lithograph with water color, 14″ x 20″, 1899. A late study of the track. Lautrec inherited a love of sports and depicted them throughout his short life.

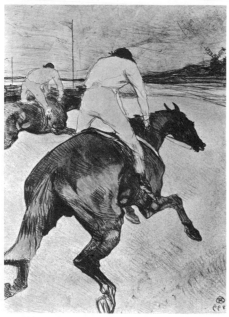

NEXT door to Degas's studio in Montmartre lived a young aristocrat named Toulouse-Lautrec, one of the most singular figures in modern art, a man whom the misfortune of physical deformity converted to the philosophy of sadism. He too was an impressionist snatching at fugitive poses and positive colors—the grotesque beckonings of the obscene, the rhythms of dancers hardened in impudicity; he too painted the racecourse and the brothels, but not in the spirit of curiosity. This sinister gentleman, one of the best artists of the century, was moved by deep, though satanic convictions, imaginatively aroused by degenerate things, a confirmed believer in the innate depravity of the human race—a bitter faith, and only possible perhaps to an artist whose mature life and art were spent in the dens and cabarets of Montmartre.

In his thirteenth year, Lautrec, a descendant of one of the oldest of French families, was the victim of two accidents which broke his legs and left him incurably disabled. His torso developed but not his extremities, and he became a hideous midget unable to walk without the aid of a diminutive cane. He derived some consolation from painting, and more from sensual excesses in the underworld he preferred to the society of his blue-blooded admirers. But he was doomed. His excesses led to dipsomania and he was committed to an asylum; on his release he died from a stroke of paralysis.

Lautrec's dissipations seemed to sharpen rather than injure his artistic faculties. He invented the poster as we know it today, and made it synonymous with his fame; his portraits are among the most distinguished of a prolific era; as a draftsman, Daumier alone, of the latter-day Frenchmen, ranks above him. There is no compassion in his work, no romantic posing, no ingratiating sop. It excludes the noble in man, and it excludes the tragic—it deals with the morally relaxed or the vicious. Maxime Dethomas was his closest friend and his companion in satanic recreations, and his conception of him, drawn in pastel in 1896, is not only a portrait but an immortal record of a type—the connoisseur of Bohemian life. The picture, in its juxtapositions of lights and darks, has some of the qualities of the artist's posters, but its appeal is not limited to the arresting design. It tells us more incisively than could be told in a psychological novel the relation of Lautrec to his environment, the situation of the man in a strange world that Paris mercifully provides for the satisfaction of irregular souls.

[RIGHT] *Au Salon: La Rue des Moulins*, Albi Museum, France. Pastel, 43³⁄₁₆″ x 51⅛″, 1894. Crayon study for the famous oil painting of a brothel. The reception room with the merchandise on exhibition.

# HENRI DE TOULOUSE-LAUTREC

LIFE, to Toulouse-Lautrec, was anything but lethargy, compromise, or even physical comfort. He was predominantly an artist and by everlasting application to his craft, and great talent, of course, made himself one of the most distinguished painters of the nineteenth century. But his organic deformities and his compensating febrile activities—his drinking, debauchery and orgies of toil—would have laid low a whole man much less a dwarf, and in 1899, he was clapped into an asylum, or mental home, for dipsomania. His bearded father, the blue-blooded count of interminable lineage, was disgusted, but the artist did not seem to mind. During his therapeutic incarceration, he executed about fifty drawings and the day of his release, restored and bursting with ideas, he crossed the channel to attend the trial of the fallen idol, Oscar Wilde. Returning to France, he lined his portfolio with sketches called *Elles,* or procurable young girls at their toilets, and made a good living by his posters—though he had no need to work for a living. In 1899 and 1900, he developed a new style of painting, partly, it is said, from the energizing sting of his unrequited addresses to a lovely English barmaid at Havre. The girl was a beauty but she fled with a tout, and the artist, conscious of his dwindling powers, hurried back to his mother, always his closest counselor, at Bordeaux. He died there, at the age of thirty-seven, and the splendor of the noblemen of Toulouse was interred with him.

Lautrec was one of the few French draftsmen of Impressionist derivations, and if literary comparisons are valid, resembled De Maupassant who, in the medium of words, was equally harsh and incorruptible as an interpreter of French manners—and without a trace of sentimentality. He did not delineate his models as isolated performers in a studio, but as participants in the scheme of life, as characters springing from and affected by their own peculiar environment. His models, save for a few illustrious portrait sitters, were the merchandise of a degraded world, mostly dancers or prostitutes, but sometimes grisettes who worked in the shops and were kind to artists. His *Modiste,* or milliner, painted a year before his death, was the comely Mlle. Margouin, whom he admired and employed as a model, in a style cut down at his death—a style in which his sharp outlines and flat poster areas were supplanted by strong, simple masses and unbroken tones.

*La Modiste,* Albi Museum, France. Oil, 19″ x 24″, 1900. Color plate, page 304.

*Self-portrait,* Albi Museum, France. Oil, 1880. Lautrec painted with astonishing proficiency at sixteen, as this impression attests.

[LEFT] *The Troupe of Mlle Eglantine,* The Art Institute of Chicago. Lithograph printed in color, 31″ x 24″, 1896. Characteristic design by the man who originated the modern poster.

# PIERRE-AUGUSTE RENOIR

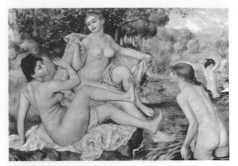

*Bathers,* Carroll Tyson Collection, Philadelphia. Oil, 5' 6¾" x 3' 9", 1885-1887. Color plate, page 306.

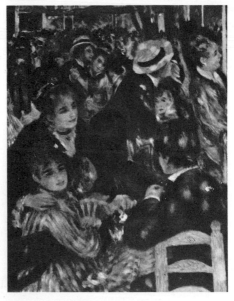

Detail from *Le Moulin de la Galette,* Louvre, Paris.

To Renoir the nude was as natural as a bowl of fruit was to Cézanne. His nudes are among the few in modern art that have any meaning: they are not studio exhibitionists; nor are they distorted scarecrows or harlots. Out of the naked woman he created a type—a symbol, if you will—adding to the natural fact his own voluptuous appreciation. There is no false emphasis on biological accessories; his nudes stand out as symbols of his delight in living, his satisfaction with God's handiwork. It is hard to paint nakedness in that way—as an expression of honest joy and unashamed exhilaration.

Renoir faced the obstacles in the path of the artist with unlimited forbearance, never whined, never expected too much of the world, and was uniformly happy and productive to the end. His harmless exterior was balanced by the shrewdness and spice of the practical son of a French tailor. In his first period, he earned his bread and wine by commercial work, mainly china painting; in his second, as a rejected impressionist, he received a small income from portraiture; in his final period, an arrangement with his dealer liberated him from financial worries. He was a rheumatic cripple in his last years, but continued to paint every day, his brush strapped to his paralyzed hand.

At every stage of his development Renoir painted nudes, always with affection and with a craftsmanship that is the despair of his successors. Those of his early impressionist years are notable for the deftness of the brushing and the sensuous play of interwoven lights and colors; those of the final period need not detain us—in his old age, painting with arthritic hands, he effaced the physical charms of his women and expanded them into overblown creatures of unsightly bulk and floridity. But in his middle period he struck a happy medium in his accomplishments.

On his return from Italy in the eighties, dissatisfied with the looseness of structure and the oversweetened colors of his early work, Renoir tightened the lines and contours of his women, subdued his palette, and startled his supporters with a number of masterpieces. *Bathers,* from the Tyson collection, is perhaps the greatest of the lot. The picture is arbitrarily posed and is not intended as a realistic bathing scene—it is a tribute to young nakedness, painted with discretion and dedicated to animal loveliness. The Venetians set the standard for this kind of painting; Rubens excelled in it; and in the modern world, Renoir alone painted to the tune of physical rejoicing.

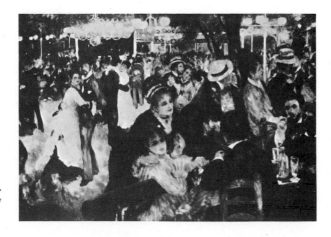

[RIGHT] *Le Moulin de la Galette,* Louvre, Paris. Oil, 5' 8⅞" x 4' 3½", 1876. Impressionist view of the café at the old mill of Montmartre—a brilliantly animated scene in broken colors.

# PIERRE-AUGUSTE RENOIR
## CONTINUED

*Luncheon of the Boating Party (Le Déjeuner des canotiers)* was painted at the beginning of Renoir's maturity, before his preoccupation with billowy nudes had robbed him of his interest in portraiture and scenes of public gaiety. No other painter, not even the most domestic of the Dutchmen, ever brought together within the compass of a single canvas a purer reflection of his environment and his people. Unmistakably a Renoir, it is also wonderfully representative of French life—not the whole of French life, to be sure, but that part for which Renoir stands as the supreme exemplar.

For he was an artist on good terms with French life, and his delight in living was suffused in his pictures. He was rooted to the things which make the journey more pleasurable in every age and at any time—social pastimes and pagan joys that never degenerated into Bohemian lecheries. If he was unmoved by the tragedy of man; if he pretended to no abstruse philosophies, and refused to busy himself with tall thoughts of God and destiny; he never stooped to the base, the empty, or the absurd. He painted trees and sunlight, fruits and flowers, bourgeois recreations, children and the mothers of children.

Renoir directed his talents and his marvelous craftsmanship to but one end: the acceptance of nature and the rendering of the sensuous aspects of the physical world. His *Luncheon of the Boating Party* realizes his ideal in his most sumptuous style. The technique is complicated but the meaning is direct and clear. The technique is a modified form of impressionism: he depended on the flow of natural light but manipulated it to his own needs; that is, he focused the strongest lights on the crests of his forms to accentuate fullness and mass. This picture, with its saturated tones and its naturalistic lighting, is related to the simple patterns of Watteau and Fragonard—obviously more sculptural but modeled in relief, not in the round. In truth, Renoir, by temperament, is a modern Fragonard, but more robust and enchanting. He erects no barriers, technical or sensational, to confound the spectator; he is so perspicuous and enjoyable that the French esteem him as another great exponent of their measured delight in the visible world.

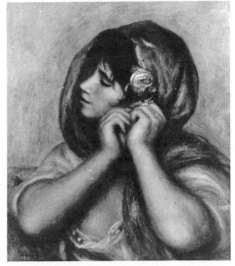

*Young Woman Arranging Her Earring*, The Cleveland Museum of Art, bequest of William G. Mather. Oil, 18¼" x 21¾", 1905. The artist's servant and model, whom he endowed with the warmth, the color and the charm of old France.

*Self-portrait*, Durand-Ruel, Paris. Oil, 13" x 16½", 1910. The French master in his seventieth year, when he was largely devoted to women, children and flowers.

[LEFT] *Luncheon of the Boating Party*, Duncan Phillips Gallery, Washington, D. C. Oil, 69" x 51", 1882-1883. Color plate, page 307.

# PAUL CÉZANNE

1839–1906 FRENCH SCHOOL

*L'Estaque*, Metropolitan Museum, New York. Oil, 39⅜″ x 28¾″, 1883-1885. Color plate, page 308.

In 1861, a young man of twenty-two named Cézanne came up to Paris from a southern province with ambitions to be a painter. He was boorish and inhibited, with an unpleasant dialect and a sour countenance; but he had the qualities of courage and patience, and great humility in the presence of great art. A colorist by the grace of God, he twice exhibited with the impressionists, and twice was singled out for an unconscionable drubbing. Morbidly thin-skinned, after ten years he went back to the farm—to a large estate inherited from his father—and thereafter was seldom mentioned in Paris. In his last years he was the loneliest of painters, an exacerbated old man, bald and as homely as a bust of Socrates, painting his life away, destroying his canvases, abandoning them in the fields, or giving them away to the peasants who smiled behind his back and called him a crackpot, or artist.

Cézanne, after his death, was unexpectedly canonized, reigning in the world of art with the authority of an old master. His art was instrumentally fertile, wide open to technical developments; and his influence on his successors could hardly be overestimated. His aims were identical with those of the masters: to create a rich, full, amply dimensioned world in the mass and depth of which one might undergo experiences comparable in force with those of practical life. For this he slowly evolved a technique of agonizing complexity. While adopting the discoveries of the impressionists—the men who painted the face of nature in vibrating colors and tones—he was not blind to the shallowness of their efforts. He would use the modern language of glowing tones to reveal the mass and character of objects.

In the middle eighties, Cézanne lived at L'Estaque, a little village near Marseilles, a place after his own heart, with roofs of red tile, green trees, an expanse of blue gulf, and in the distance a line of hills washed with violet. It was quiet there; and unmolested, he studied the anatomy of the landscape as concentratedly as Michelangelo studied the human figure. In painting the scene, without impairing its individuality and local coloring, he emphasized, not the surfaces, but the organic structure—the rigid land set against the density of the sea, and the whole as simply stated as a primitive painting. It is not a pretty snapshot, and the color balance of the upper areas of sea and sky was not finally realized—but it does represent nature on a vast scale, serene and unencumbered, and with much of the monumental about it.

*Boy in Red Waistcoat*, E. Bührle Collection, Zurich. Oil, 25¼″ x 31⅛″, 1890-1895. The human figure treated as composition in planes to achieve solidity.

[RIGHT] *The Cardplayers*, Stephen C. Clark Collection, New York. Oil, 31⅞″ x 25⅝″, 1890-1892. A favorite motif of Cézanne's—a synthesis of figures in three dimensions—a struggle to present the maximum of volume with the most intense colors.

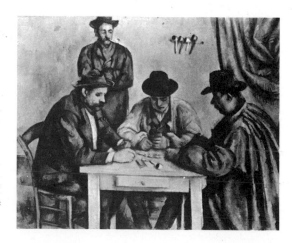

# PAUL CÉZANNE
## CONTINUED

CÉZANNE was inordinately timorous, pathetically bound to a narrow routine, out of joint with the world. He nursed a secret passion for the nude, and his lifelong desire was to pose a nude woman in the open air. He never did; nor did he paint more than two or three in his studio—he was afraid. He regarded all women as designing creatures; they frightened him out of his wits; and in consequence, he suffered from a repressed eroticism that increased his irritability. That he should have consented to the ordeal of matrimony is surprising; and he could arrive at no decision in the matter until the woman, after a liaison of long standing, had finally borne him a son.

Nature had not been generous with Madame Cézanne. She was a peasant, far from personable, and as obtuse in the ways of art as the painter was in affairs calling for the exercise of only ordinary judgment. Notwithstanding, she made him a good wife. She was obedient and unquestioning, content to let him paint, to remain at home while he was away in Paris, and willing to sit like a graven image when he needed a model. She was a brave woman to endure not the one but the hundred sittings he required; and to put up with those misshapen masks he slowly fashioned from her unlovely face.

Cézanne painted his wife many times, and most of the portraits, by a strictly physical criterion, are the opposite of the beautiful. Some are frankly repulsive; and not one is finished, for the man's capacities always fell short of his far-reaching intentions. To him, as a painter, his wife was a piece of still life; and with mortifying exactitude, applying his pigments in small touches. each predetermined in space, he labored to make of her a harmonious union of form and color, with corporeal weight and volume. Not that he consciously obliterated her identity; but his technical method was painfully in evidence, fascinating in itself, but compressing the woman into an immobile effigy. In *Madame Cézanne in the Conservatory*, painted in 1891, he approximated a complete realization of his aims in portraiture. The likeness is conveyed without noticeable distortions; the figure superbly embodied; the background rich in pictorial effects attained by a knowledge of color that cannot be too extravagantly praised. In modern French painting the work takes its place as a portrait of memorable originality; in substance and material impressiveness, it connects the best of Cézanne with the grandeur of the classical style.

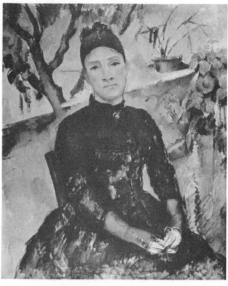

*Madame Cézanne in the Conservatory*, Stephen C. Clark Collection, New York. Oil, 29½″ x 36¼″, 1891. Color plate, page 310.

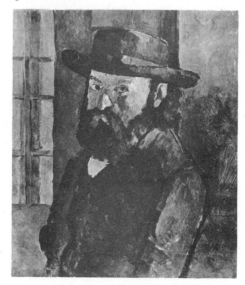

*Self-portrait*, Berner Kunstmuseum, Berne, Switzerland. Oil, 20⅛″ x 25⅝″, 1879-1882. The grotesque founder of modernist art as a member of the newly formed group of Impressionists.

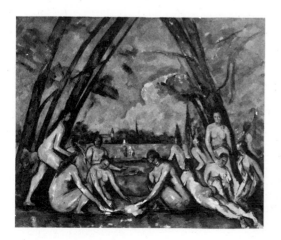

[LEFT] *Les Grandes Baigneuses*, Wilstacht Collection, Philadelphia Museum of Art. Oil, 98″ x 82″, 1898-1905. Cézanne's attempt to achieve the architectural order of the old masters by the use of nude volumes in deep space.

# PAUL CÉZANNE

## CONTINUED

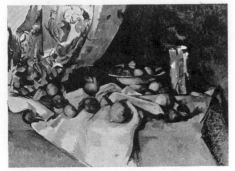

*Still Life wih Apples*, Museum of Modern Art, New York. Oil, 35¾″ x 26¼″, about 1895. Color plate, page 309.

*La Plante*, Mr. and Mrs. Paul M. Hirschland Collection, New York. Water color, 13″ x 20″, after 1890. With infinite patience, the artist set tone against tone in the interest of design in depth.

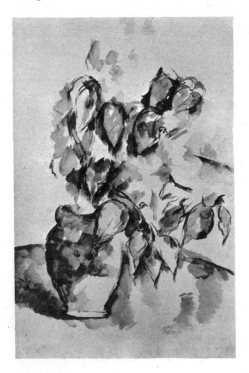

WITHDRAWING from the harsh, competitive struggles of mankind into the vegetable kingdom, Cézanne transferred his secret passions to inanimate objects—to fruit, stuffs, and crockery. In still life, he was not hindered by his slowness and diffidence—there was no human element to distract him; and he became, in time, the lonely monarch of the realm of fruit. It would seem to be an elementary job to paint an apple, but with Cézanne it was a desperate undertaking that he attacked in this fashion.

Before him on a table lay an apple, a red sphere to the casual observer, but to his trained eye, a sphere broken into surface divisions absorbing or reflecting light from different sources. His purpose was to retain the dominant color and character of the fruit, but to heighten its appeal by a scheme of resplendent tones. He began by painting the first plane, the one nearest the eye, in the brightest tone—red with a strong injection of yellow; and then, with infinite caution, he proceeded from one division to another, arriving at the last planes—in shadow and therefore the darkest—for which he used deep blues and rich violets.

This tortuous business of creating a new and more exciting apple all but killed the man. No wonder he threw his canvases out of the window and moaned that he was only a primitive blundering on an untraveled road! For he discovered that despite his pains he had violated the natural appearance of the apple, and to counteract the unshapeliness, he resorted to hard, binding outlines. In composing a number of objects, the distortion of one compelled him to change the position in space of all the others, to knock tables out of plumb, and to hold objects stationary where, by the laws of motion, they should roll out of the picture. He distorted things because he could not help it—deliberately, but with anguish in his heart.

*Still Life with Apples* is as astonishing as it is powerful and the means employed are not concealed. The draperies and objects are set at angles to trap the eye and lead it back into deep space; and the fruit is modeled in full relief in order to make it as concrete as the mind knows it to be in its natural state. No other painter ever brought to vegetable compositions a conviction so heated, a sympathy so genuine, an observation so protracted. No other painter of equal ability reserved for still life his strongest capacities, and converted the small facts of nature into designs of such massiveness and color.

[RIGHT] *Mont Sainte-Victoire*, Philadelphia Museum of Art, Elkins Collection. Oil, 36¼″ x 27⅞″, 1904. The mountain translated into component planes, and the structural basis of the cubist method.

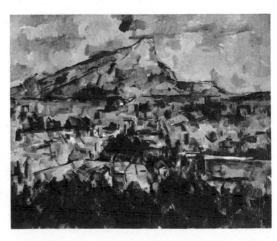

# VINCENT VAN GOGH

1853–1890                FRENCH SCHOOL

THE life of Vincent van Gogh was a succession of emotional debauches and a preparation for suicide. It was a tragic experiment from the beginning. In the first place, his appearance was against him: his face was a thing to turn one's soul, the composite of peasant, convict, and Christian martyr. Second, nervous derangements annulled those human companionships that he needed, above all men, as an outlet for his unselfishness and his immoderate affections. Four times he tried to save himself by frustrated love affairs with women who could not suffer his addresses; he sought regeneration by preaching the Gospel, and later by the pursuit of art, in the final years painting with fanatical rapidity. An inmate of a lunatic asylum in the South, he was removed to the care of a specialist near Paris; and one afternoon, visualizing clearly the end of the road—permanent madness, he shot himself.

At Arles, in Provence, Van Gogh, a wandering Dutchman trained in Paris, had glimpses of the promised land. "Behold the kingdom of Light!" he wrote to his brother, his good angel. "How wonderful the golden sun!" In a year's time he produced scores and scores of pictures—canvases painted in fury and signed with fire. The most familiar things in life—the sun, a child, a tree, or an old woman—transported him into a state of spiritual intoxication. The subjects served as a scaffolding upon which he loaded his great love for humanity, a ferocious, all-absorbing passion which, released by art, gushed forth in a torrent of energy. Working at white heat, lashing the canvas with streaks of heavy pigment, with colors of undiluted intensity and strained silhouettes, he painted with primitive directness and the simplicity of a child.

It was Van Gogh's habit to finish a picture at one sitting, even if it cost him his reason, and he was unable to improve upon the initial effort. That is the strength and the weakness of his art—his most frenzied works being plainly the outpourings of a disordered mind. *L'Arlésienne*, one of several versions of the wife of an innkeeper, represents him in a comparatively sober mood, his abnormal propensities restrained by the austerity of the French provincial. Technically, he achieved a unity of surface by means of linear balance and areas of harmonized color after the manner of the Japanese prints. But the picture is more than an extraordinary pattern. It expresses with the utmost force his state of mind in a land of light and color; and as a passionate, instantaneous characterization, it is a portrait masterpiece.

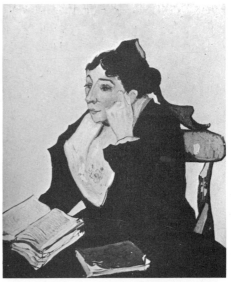

*L'Arlésienne*, Lewisohn Collection, Metropolitan Museum, New York. Oil, 28¼″ x 36″, 1888. Color plate, page 311.

*White Roses*, Mrs. Albert Lasker, New York. Oil, 28⅜″ x 36⅝″, 1890. Painted in streaks of pure pigment, when the agony of living was nearly over.

[LEFT] *Van Gogh's House at Arles*, Municipal Museum, Amsterdam. Oil, 30″ x 36″, 1888. The house of light, which the artist shared, in turmoil and suffering, with Gauguin.

# VINCENT VAN GOGH

*Starry Night,* Museum of Modern Art, New York. Oil, 34¼″ x 29″, 1889. Color plate, page 312.

AT ARLES, to escape public curiosity, Van Gogh rented a little house of his own, which he proceeded at once to furnish, fussing like a woman over beds and curtains. He felt snug again and his courage rose. "I have had the little house painted yellow," he said, "because I want it to be for everyone the House of Light." The cost, however, was more than he had counted on, and to divide expenses, as well as to solicit companionship, he invited Gauguin to live with him. After long negotiations, Gauguin, arrogant and disobliging, arrived on the scene, took possession of the place immediately, and the glory of the House of Light faded into gloom.

There were quarrels and truces: Van Gogh was not the easiest person to have at one's elbow, and Gauguin must be top dog in everything. They lived in increasing discord for two months with the Dutchman's mind perilously close to a breakdown. One day they came to blows, and Van Gogh, his faculties unhinged by the fracas, cut off his ear with a razor and presented it as a Christmas present to one of the girls of the town brothel. The stricken painter was removed to a hospital, and two months later, at his brother's request, sent to an asylum at Saint-Rémy, near Arles.

He remained at Saint-Rémy for a year, first in solitary confinement and then with liberty to paint; and a visitor to the asylum has told the story of the red-headed inmate who labored all day long covering canvases with thick streaks of color, while close by sat another lunatic patiently scraping the paint off the finished pictures. During this period he enjoyed intervals of profound self-mastery and penetration—the unnatural poise, the terrible lucidity that precedes death—and he produced several of his greatest pictures. He painted at one sitting, in June 1889, *Starry Night,* which he describes in one of his letters: ". . . a night sky with a crescent moon emerging from the shadows; stars of exaggerated brilliance in an ultramarine sky across which are hurrying and swirling almost invisible clouds. Below is the village with the blue Alps in the background, an old inn with yellow, lighted windows, and a very tall cypress, very upright, very somber." This picture, with others of the same desperate interlude, cannot be called the disordered litter of a madman's imagination. It must be accepted as the compacted symbol of the life of a painter who was also a poet, the symbol of his dreams, his trepidations and his sufferings—of the terror and tragedy of his superhuman effort and sensibility.

*Self-portrait, Arles,* Mr. and Mrs. Leigh B. Block, Chicago. Oil, 17¾″ x 19¾″, 1889. One of the final self-portraits—the Dutch genius as his mind grew more unstable.

[RIGHT] *The Public Gardens, Arles,* The Phillips Collection, Washington, D.C. Oil, 36″ x 28⅜″, 1888. The paint applied with dazzling speed in order to convey the immediate impact of the scene on the senses.

# PAUL GAUGUIN

1848–1903          FRENCH SCHOOL

GAUGUIN was born with a grievance against the world. There was bad blood in his veins, and in his soul a splenetic grudge which ripened into an active contempt for modern civilization. In his erratic youth he was a sailor; for eleven years he was a brilliantly successful stock broker who turned to art occasionally as an escape from life; and when his hatred for humanity had rendered his own countrymen intolerable, he abdicated to the primitive sensualities of the South Seas, carrying the exotic element of French painting to the unexplored lore of the tropics. Better equipped than most artists for a reversion to tribal life, he discovered that he could not shuffle off his inheritance by an act of will, and he remained half savage and half the sophisticated Parisian with the civilized habit of painting for exhibitions.

*The Spirit of the Dead Watching* was first exhibited in Paris, in 1893, in a group of Tahitian pictures, all bearing strange Maori titles and all steeped in an unintelligible mythology. Gauguin, notoriously untrustworthy, explained the genesis of the painting in bantering, ambiguous terms.

"The undulating horizontal lines, the harmonies of color, the phosphorescent flowers in the background," he wrote, "are used symbolically as musical notes to create an awesome ghostly atmosphere. The Spirit, personified as an old woman, is thinking of the girl—or the girl is thinking of the Spirit; the living united to the dead; night and day. But after all," he concluded, "it is only a study of a nude in Oceania."

His last remark may be accepted as the most satisfactory explanation—there are no deep spiritual meanings in the painting. Gauguin harbored a justifiable grievance against the indecent flummery of the Paris salons; and with his shrewdness, his magnificent color sense, his genuine passion for the dark women of the tropical islands, his familiarity with mysterious properties, and his skill in design—in dividing a flat surface into partitions of balanced colors and tones—he sought to bring to art a new type of undraped woman. How he succeeded in one of the most difficult departments of painting is a matter of history. His *Manao Tupapaou*, as he called it in Maori, is among his most famous works, but unfortunately he did not live to see the influence of his nude on a whole generation of modern painters.

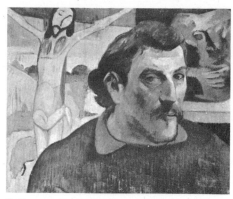

*Self-portrait*, Collection of Maurice Denis, Paris. Oil, 17¾" x 14½", 1890. The hard and gifted artist with a sketch of *Le Christ Jaune* in the background. Influenced, he said, by the imaginative appeal of stained-glass windows.

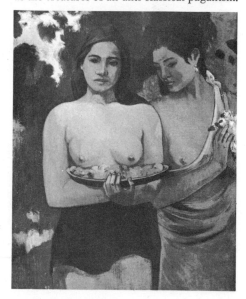

*Les Tahitiennes*, Metropolitan Museum, New York. Oil, 28¾" x 37", 1889. Polynesian women whom Gauguin portrayed decoratively as the creatures of an anti-classical paganism.

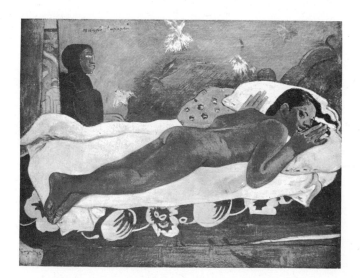

[LEFT] *The Spirit of the Dead Watching*, A. Conger Goodyear Collection, New York. Oil, 36¼" x 28¾", 1892. Color plate, page 313.

# HENRI ROUSSEAU

1844–1910            FRENCH SCHOOL

*La Bohémienne Endormie*, or *Sleeping Gypsy*, Museum of Modern Art, New York. Oil, 70″ x 51″, 1897. Color plate, page 314.

*Myself, Portrait-Landscape, Prague*, Museum of Modern Art, New York. Oil, 44¾″ x 57½″, 1890. Le Douanier, as no sophisticated painter could have seen him, in a nicely patterned background.

IN 1862, a young French conscript, performing his military service as flutist in the regimental band, was sent to Mexico where he passed four bewildering years. Discharged from the army on his return to the homeland, he went to work as a petty customs house official, or *douanier*, in the outskirts of Paris. In his early forties, without warning or preliminary training, he took to painting and throughout his life continued to make pictures which have captivated all sorts of people, from children and misfit artists to collectors and painters of high renown. Retiring from the customs house on a microscopic pension, he supported his family by painting portraits for a few francs a head and by giving music and drawing lessons to youngsters at pathetically low rates.

The dupe of swindlers, the Douanier, as he was called, was once haled into court on a charge of forgery, but was promptly acquitted when his lawyer explained that the defendant was a simple-minded artist and adduced some strange paintings which the court decided were the transgressions of a person likely to be hoodwinked. The term "simple-minded" is perhaps the most appropriate description of an artist usually referred to as "the modern primitive." The Douanier had the habit not only of seeing ghosts but of communicating with them at the slightest provocation; he was a born visionary and his dreamworld was more real to him than the workaday routine of teaching. Thus, his exotic recollections of Mexico were transformed into jungle paintings—enormous trees and flowers and in the undergrowth nude princesses about to be attacked by savage beasts.

The Douanier painted portraits, still life, landscape and festive events, all characterized by the undisciplined exuberance and nice sense of decoration common to children, and all innocent of draftsmanship. He is one of those remarkable exceptions in art, a truly naïve improvisator, and the despair of sophisticated painters hoping to become primitives by the exercise of determination. Rousseau was best in his dream pictures which have vividness and supernatural clarity of things seen in a trance. *The Sleeping Gypsy* is his visionary masterpiece, an entirely "made-up" painting, with paper-thin forms and unprofessional drawing, an extraordinarily effective piece of surrealism conjured up in 1897, long before the surrealists were in operation.

[RIGHT] *Storm in the Jungle*, Collection of Mr. and Mrs. Henry Clifford, Radnor, Pa. Oil, 50½″ x 63½″, 1891. The most graphic of many tropical scenes inspired by the painter's travels in Mexico as a young man.

# AMEDEO MODIGLIANI

AMEDEO MODIGLIANI was a wayward Italian who threw himself into the Bohemianism of Paris, produced a fragile, but unmistakably original form of art, and died of tuberculosis, at the age of thirty-six, in the charity ward of a hospital. Born in Tuscany, he began to draw when very young, and in his twenty-second year went to France filled with vague notions of a new art as simple and clean and moving as the religious pieces of the early Italian masters. In Montmartre, his personal charm endeared him to all who met him, but he was utterly without will power, incapable of sustained effort, and of incorrigible habits. He hurried from bar to bar, from girl to girl, and at intervals, excited by some young creature whom he esteemed as a fallen angel, painted excessively. He burned, occasionally with the fire of genius, and his humanity lifted his delicate art above craftsmanship or formula; but as his illness increased, he resorted to drink and to drugs and plunged headlong into swift disintegration.

Modigliani's introduction to his own originality came through the Negro carvings which the radical artists of the day were beginning to imitate. He seemed naturally to turn to primitive forms and to find in them some sort of spiritual kinship, and compatibility. His painting falls into two divisions, portraits and nudes, which, structurally, follow the Negro fetish with accentuated planes borrowed from the Cubists, and with color schemes reminiscent of the clear-toned Italian frescoes. He limited his designs to a single figure: an ovoid head set, as a rule, at an angle on a cylindrical neck, and an elongated torso with the arms and legs only roughly indicated. Though he adhered to the rigid pattern of the sculptural grotesque, casting his faces in the same mold, he managed to express the character of the sitter and to retain the essential features of the different subjects.

The *Gypsy Woman*, like all his models, was bound to him by feelings of affection. She was painted the year before he died, one of the last of the pictorial family he created: a sad family, some of the members a little monotonous, some sickly with a morbid sweetness, some overborne by futile pathos, all of them the same color and stature, orange and green and white. Somehow, despite his limiting pattern, he instilled into them his own tenderness and delicacy of feeling. And most of his pictures, portraits and nudes alike, though not too strong in vitality, contain the neurotic charm of one of the most hapless souls in modern art.

*Gypsy Woman and Baby*, Chester Dale Collection, Chicago. Oil, 29″ x 46″, 1916. Color plate, page 315.

*Self-Portrait*, Matarazzo Sobrinho Collection, São Paulo, Brazil. Oil, 23½″ x 33½″, 1919. The artist's personality as revealed in a style formed, in part, on African sculpture.

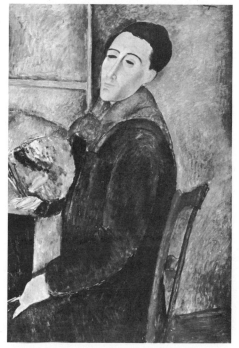

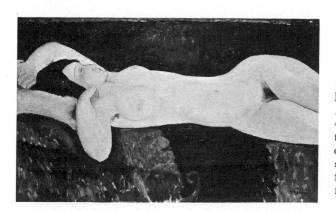

[LEFT] *Reclining Nude*, Museum of Modern Art, New York. Oil, 45¾″ x 28¾″, 1920. In this and many similar canvases, Modigliani stylized the nude in a form suggesting a bas-relief.

# PIERRE BONNARD

1867–1947        FRENCH SCHOOL

*Luncheon*, Museum of Modern Art, New York. Oil, 24½″ x 16¼″, about 1927. Color plate, page 316.

IN THE month of January, 1947, in Paris, the hundred and one subdivisions of modern art, each continually denouncing the others and all unusually hostile after the bitter years of the second World War, buried their individual grievances and joined forces to mourn the death of the most beloved Frenchman of the last fifty years. His name was Pierre Bonnard, a shy, bespectacled, gentle painter whose life and work epitomized all that is cleanest, most joyous and lasting in the long chronicle of French achievements. He was born at Fountenay-aux-Roses, not far from Paris, and had interpreted in a multiplying variety of pictures, the simple, eternal fruitfulness of the lovely French countryside, on the one hand, and on the other, the shrewdly observed glimpses of city-dwellers caught off their guard in instants of startling revelation.

Bonnard studied at the Académie Julien with, of all masters, the one and only Bouguereau; endured a wasted year at the Beaux-Arts, and then went over to the Independents. Henceforth, with unostentatious resolution, he built his career, very early a finished professional in all departments of art from book illustration, posters and stage settings to what is known as pure painting. Influenced, at first, by Gauguin, Degas and the Japanese print-makers, he passed through a period of high colors to a gray palette; and later in life, after the example of Renoir, his friend, developed his final style—brilliant, resonant color to emphasize his love for the warmest aspects of French civilization.

Out of Impressionism, a glorious method of enjoying nature, or of turning the world into a congeries of vibrant tones, Bonnard evolved a personal style that has been pillaged for years, but to little avail. The *Luncheon* is a fine example of this style—an informal scene in which the design seems haphazard and the drawing unkempt, but which is actually the fruit of fifty years of training and exact planning. He sought and achieved luminous harmonies enclosed in a simple, unobtrusive framework, deliberately violating the conventions of perspective and anatomical draftsmanship, and reducing the picture to a simple, sensuous statement of his feelings and responses. At first glance, his style looks elementary in the extreme, and it has misled thousands of eager amateurs into the fallacy that painting is a matter of spontaneous generation. But Bonnard remains alone and apart from the turbid current of modernism, a painstaking, inspired artist whose little masterpieces may conceivably outlast the more publicized efforts of his fame-stricken contemporaries.

*The Breakfast Room*, Museum of Modern Art, New York. Oil, 44⅛″ x 63¼″, 1930-1931. Bonnard's exquisite table compositions may prove to be the most enduring paintings of his generation.

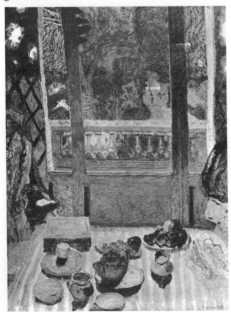

[RIGHT] *Self-portrait*, Collection of Georges Wildenstein, New York. Oil, 26⅜″ x 23″, 1938. The artist at seventy-one, a modest, reflective man who preserved his equanimity in an age of upheavals.

# HENRI MATISSE

1869–1954          FRENCH SCHOOL

HENRI-MATISSE came to Paris from a northern province in his early twenties to study pharmacy, but soon veered into painting, and for ten years was an official copyist in the Louvre. Slowly, and with scholarly caution, he moved toward the storm centers of radicalism; and in 1905, suddenly emerged as the chief of the Fauves, as they were popularly labeled—the wild animals or hoodlum artists. He won his position at the price of severe poverty and vilification, but eventually came into a handsome living. During the opening years of the century, his name was not mentioned in polite society. At the present time, public opinion has swung round to an attitude of generous acceptance, and Matisse is now esteemed as a traditionalist who, by transferring the ingredients of genre painting to the field of decoration, has revived a form of art of which the French are past masters.

"Expression to me," Matisse wrote, "is the art of arranging in a decorative manner the various elements used by the painter—the place occupied by the figures, the empty space around them, the proportions. Everything that has no utility is harmful for the reason that every superfluous detail will occupy, in the mind of the spectator, the place of some other detail which is essential."

This, plainly, is an art in which the size, proportions, and colors of objects are not authorized by visual accuracy but largely by the painter's skill in improvising new arrangements. It is an art of surfaces enriched by sound technical training, a color sense of unexampled originality, exotic borrowings from the Orientals, and a pleasing savor of the sensuous aspect of things—in a word, a sensuous vision enclosed within the boundaries of pure design. Almost everything that Matisse touches bears the stamp of ease and joy, the gaiety and color of life, and an enthusiasm springing from healthy conviction and extraordinary fluency of execution. To a sophisticated curiosity he has added his great talent for unexpected color combinations and a perception of linear rhythms which is perhaps his outstanding charm.

His *Odalisque*, one of several versions of the subject, was painted at Nice where he has lived since 1917. It is an achievement in design, the scene spaced and reproportioned so as to fulfill his dream, as he says, of "balance, purity, and tranquillity." Such designs, opposed to the old stenciled patterns of unalterable symmetry, have gone round the world and revolutionized all branches of decoration involving taste, color, and technical dexterity.

*Odalisque*, "The Hindu Pose," now in collection of Mr. and Mrs. Donald S. Stralem, New York. Oil, 28½" x 33⅜", 1923. Color plate, page 317.

*The Young Sailor, II*, Hans Seligmann Collection, Basel. Oil, 31⅞" x 39⅜", 1906. From the early *Fauve* period in which contours were freely proportioned for the sake of a balanced design.

[LEFT] *Self-portrait*, The Baltimore Museum of Art, Cone Collection. Charcoal drawing, 1937. "A portrait," Matisse said, "is the interpretation of the human sensibility of the person represented."

# PABLO PICASSO

[ABOVE] *Gourmet*, Chester Dale Collection, Art Institute, Chicago. Oil, 26⅝" x 36", 1901. Color plate, page 318.

[ABOVE] *Gertrude Stein*, Museum of Modern Art, New York. Oil, 1906. Picasso's patron, after eighty sittings, has the face of a sculptured mask.

PICASSO was born in Málaga, in 1881, and as far back as he can remember, had no other ambition than to be an artist. When he was a small boy, he displayed prodigious skill as a copyist, and, in 1900, was sent to Paris by his father, an art teacher in the academy of Barcelona. He saw at once that Paris was the place for him and, after a second visit in 1901, settled there permanently. A Bohemian by nature, and with a sharp eye to the main chance, he accommodated himself easily to the gregarious habits of the international confraternity of artists and rose swiftly to prominence. Perceiving as a youth the trend of modern painting toward an abstract basis, he took, after a few experimental years, the bold but quite obvious step of denuding art of its representational vestments. The effects of his operations are known to everyone. Rich and respected, he received the homage of the aesthetes of both hemispheres; during World War II he managed to remain unmolested in Paris and even to coerce the Nazis into competing for his pictures; and today he has been re-enthroned as the aging sovereign of non-objective painting.

Throughout his long career, Picasso has adhered pretty faithfully to the principles of abstract composition. He has never been much interested in nature, nor in the emotional life of men and women, nor in the world of affairs. His primary concern—one might call it an obsession—is with the composition of pictures; not with the subject, or what is put together, but in how it is put together. From a student of styles, he has developed into a master of ways and means, or methods—one of the greatest the world has seen.

Early in the century, Picasso probed into many styles and methods, but his favorite source of inspiration was Toulouse-Lautrec. Under the influence of the deformed and brilliant Count, he painted morphomaniacs, emaciated mendicants and forlorn women, but he depicted them, not at firsthand as the Count did, but from attitudes and types borrowed from Lautrec's original studies. Thus it happened that his conceptions were isolated figures related to no discernible background; and even when bearing such titles as *Life* and *Maternity*, his strange creatures hardly seemed to have more than a vague physical existence. Twice, however, in his first stage—the Blue Period extending from 1901 to 1904, and so named from the dominant blue-green tone of his canvases—he painted pictures of undeniable warmth and charm. Both were done in 1901 and both deal with childhood. It is not hard to find evidence of Toulouse-Lautrec in *The Gourmet*, or of Cézanne, for that matter, but the picture is a Picasso in any collection. At the age of twenty, the amazing Spaniard painted perhaps the most appealing work of his long career.

[LEFT] *Sleeping Peasants*, Museum of Modern Art, New York. Gouache, 19¾" x 12¼", 1919. An example of the artist's neo-classic style in which he composed figures of extreme bulk with a linear quality derived from Ingres.

# PABLO PICASSO

### CONTINUED

By universal consent, Picasso is the master of the modern school of Paris, the leader of a group of international artists whose pictures transcend the confines of time and place, and in many instances, ignore the outward behavior of man. He has consistently refused to traffic in the accepted emotional struggles of men and women—his major interest is in the formation of pictures. Like the old scholastic philosophers, he has exercised his nimble intelligence on the subtleties of methods and procedures, and thus has rightly become the ruler of those who believe that painting, in its purest manifestations, is a language of abstractions.

During his first years in Paris, Picasso was dominated by Toulouse-Lautrec, but the abstract ideal was already upon him; and though he painted recognizable harlequins and beggars, his subjects were deliberately withdrawn from their environment. From the outset, he has adhered to the inflexible tenet that art is essentially a composition, a material unit; that its value is gauged by the skill, the orderliness, and the originality of the structural framework. This principle affords complete freedom for his unique gifts, and absolves him from all commerce with the world of affairs.

It was cubism that made Picasso famous. Absorbed, not in what is put together, but in how things are related, he divested objects of their representational features, and reduced them to abstractions—to assemblages of geometrical planes and angles. Some years ago he lent his prestige to the surrealists, a school of artists who distorted nature to symbolize the workings of the subconscious mind, but he never subscribed wholeheartedly to their creed. He merely introduced silhouetted faces and hints of torsos into his patterns. His *Young Girl at the Mirror* is of this period. It is a fantastic pattern of abnormally high visibility. It is not too much to say that no other artist has so strikingly impressed on areas of color and particles of matter the individuality of genius. Picasso has experimented with all the historical ways of handling space; he is a master of every technical instrument known to painting. His great technical powers, his unrivaled inventiveness, and his exhaustive researches leading to the most puzzling combinations in painting have stimulated artists in all parts of the world to the study of form and structure. He has been named the liberator, the man who delivered art from the bondage of academic practice and restored the principles of design.

[ABOVE] *Young Girl at the Mirror*, Museum of Modern Art, New York. Oil, 51¼″ x 63¾″, 1932. Color plate, page 319.

[ABOVE] *The Three Musicians*, Philadelphia Museum of Art, A. E. Gallatin Collection. Oil, 74″ x 80″, 1921. One of two versions of a subject in which human figures are reduced to the integers of a flat pattern .

[RIGHT] *Guernica*, Museum of Modern Art, New York, lent by the artist. Oil, 25′ 8″ x 11′ 6″, 1937. Inspired by the bombing of a Basque town. The horrors of war symbolically presented by mutilated forms in the style of Malayan batiks.

# GEORGES BRAQUE

1881——                                          FRENCH SCHOOL

THE MOST gifted and ingratiating of all the practitioners of non-representational art is Georges Braque, born in Argenteuil and trained, in his youth, as a commercial, or house painter, in Le Havre. In his breadwinning trade, he demonstrated very early his astonishing ability to imitate surfaces—the graining of woods, the veining of marble, and all sorts of textural effects—and in his twentieth year went up to Paris to enter the more creative branches of painting. At first, he ran with the pack of Wild Animals yapping after Matisse, but the capricious splashes of the *Fauves* were not congenial to his analytical mind, and he began, with Picasso, to experiment in the geometrical formation of objects. These experiments, pursued independently, culminated in a species of painting described as "entirely constructed of little cubes" by Matisse, who, as one of the jurors in the *Salon d'Automne*, rejected Braque's paintings, the first works of their kind offered for public exhibition. Since that fateful day, untold multitudes of painters throughout the world have joined the cubist ranks, and the number multiplies annually; but in this department, Braque remains unique in his ability to endow abstract objects with poetic style and personal charm.

The cubist method, or formula, as originally compounded by Braque, was the abstraction of natural objects into their nearest geometrical equivalents, a process, when carried to its logical conclusion, ending in a contradiction in terms. Cubism, a solid art as its name connotes, paradoxically went flat as the three visible planes of the cube, by extension beyond the field of vision, or to the frame of the canvas, ceased to function as indications of volume and became three flat tones. As the method caught on, the problem of each practitioner was to vary the pattern and to invent arresting combinations of geometrical integers.

Braque, after twenty years of ceaseless structural experimentation in which the visual aspects of objects were dissolved beyond recognition in flat patterns, returned to nature and evolved his current style—a retention of a sufficiency of nature to give stability to his designs without sacrificing the formal planes he loved so well. In his own words, he utilized "the discipline of abstract composition, not to reconstruct an anecdote but to create a living pictorial fact with its poetic, or lyrical, beauty." His *Guitar, Fruit and Pitcher*, a rendering of favorite properties, is one of his most finished canvases, not only as an illustration of his individual style—the transformation of objects into small related units held together by basic compositional lines—but also as proof of the fact that he stands above all other modernists, not excepting Picasso, in the appealing charm of his handsome decorations.

[TOP] *Woman with a Mandolin*, Museum of Modern Art, New York. Oil, 38¼" x 51¼", 1937. A design showing how Cubism, by extension, resulted in flat posters.

[CENTER] *Man with a Guitar*, Museum of Modern Art, New York. Oil, 31⅞" x 45¾", 1911. Painted when Braque and Picasso were experimenting with geometrical equivalents.

[BOTTOM] *Guitar, Fruit, and Pitcher*, Mr. and Mrs. M. Lincoln Schuster, New York. Oil and sand on canvas, 29" x 36", 1927. Color plate, page 320.

137. *The Amazon* · GUSTAVE COURBET · Metropolitan Museum, New York. Text, page 273.

138. *Roe-Deer in a Forest* · GUSTAVE COURBET · Louvre, Paris. Text, page 274.

**139.** *The Bar of the Folies-Bergères* · ÉDOUARD MANET · Samuel Courtauld Collection, London. Text, page 275.

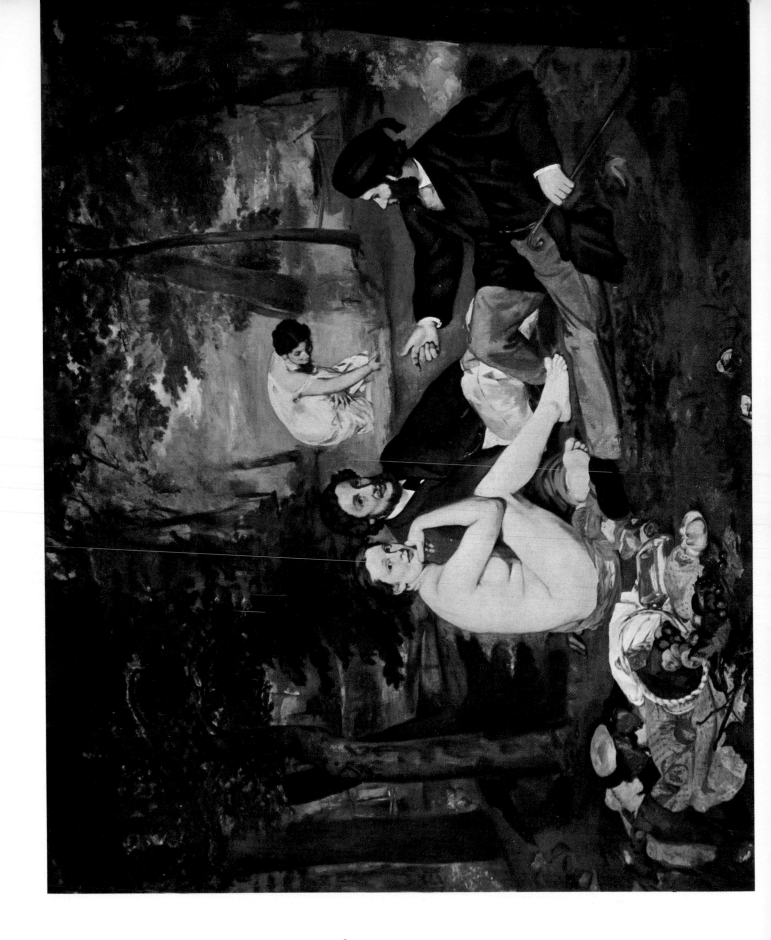

140. *Le Déjeuner sur l'herbe* · ÉDOUARD MANET · Louvre, Paris. Text, page 276.

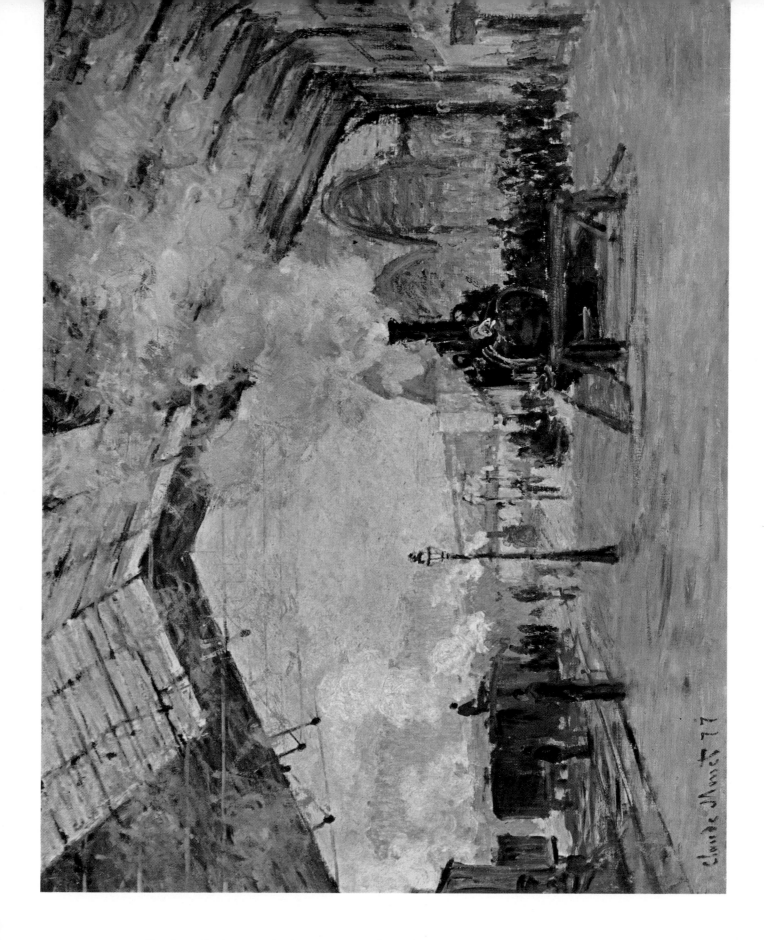

141. *Gare St. Lazare* · CLAUDE MONET · Art Institute, Chicago. Text, page 277.

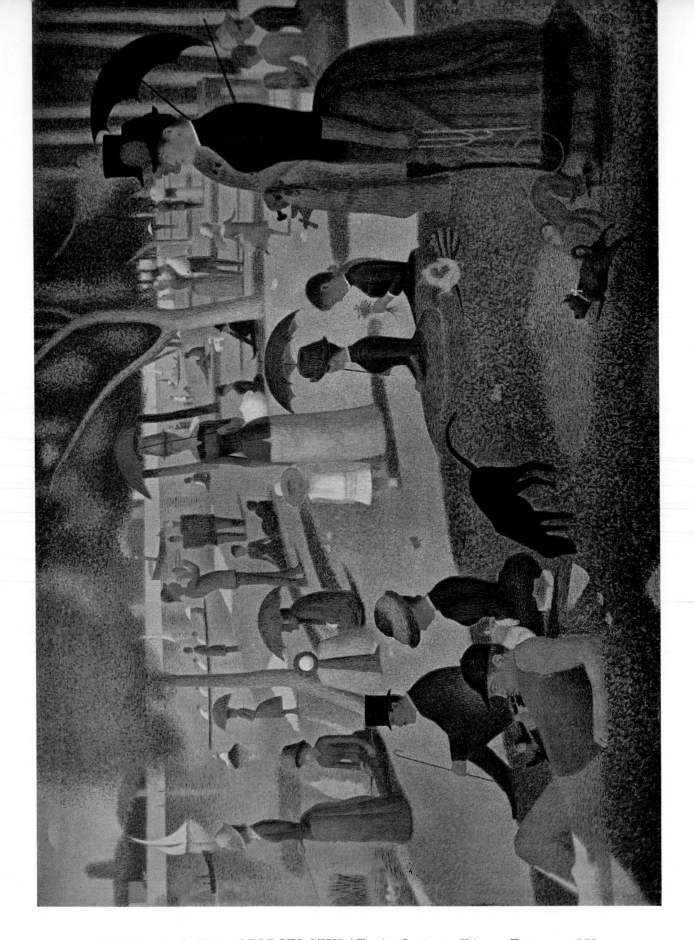

142. *La Grande Jatte* · GEORGES SEURAT · Art Institute, Chicago. Text, page 278.

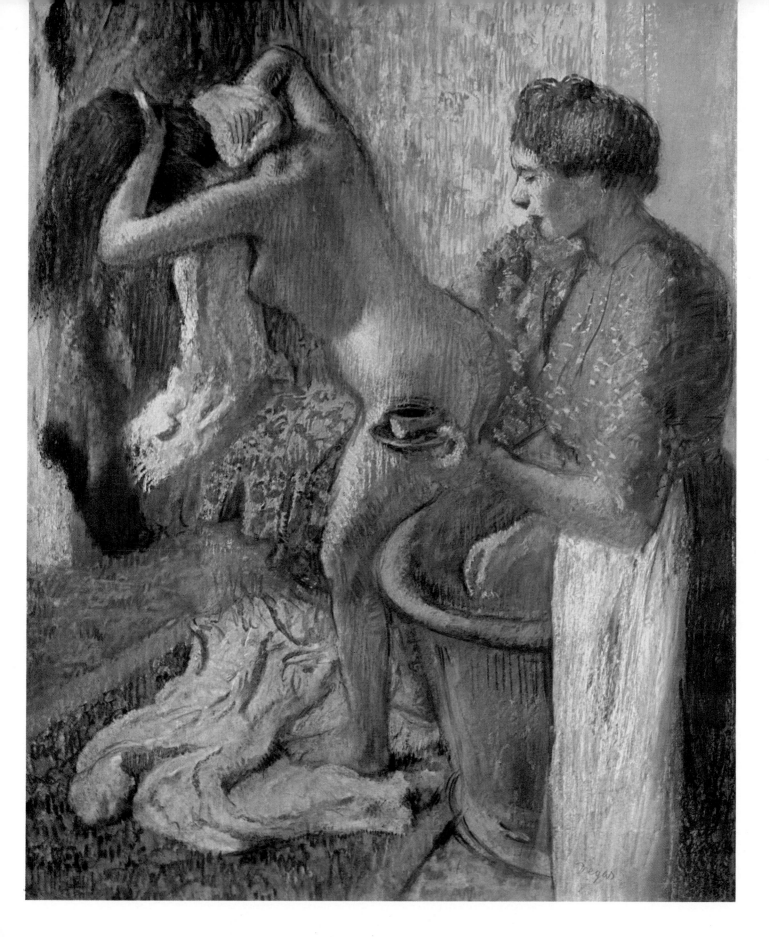

143. *After the Bath* · EDGAR DEGAS · Durand-Ruel Galleries, New York. Text, page 279.

144. *La Modiste* · HENRI DE TOULOUSE-LAUTREC · Museum of Albi, France. Text, page 281.

145. *Portrait of Maxime Dethomas* · TOULOUSE-LAUTREC · Chester Dale Collection, New York. Text, page 280.

146. *Bathers* · PIERRE-AUGUSTE RENOIR · Carroll Tyson Collection, Philadelphia. Text, page 282.

147. *Luncheon of the Boating Party* · RENOIR · Duncan Phillips Gallery, Washington, D. C. Text, page 283.

148. *L'Estaque* · PAUL CÉZANNE · Metropolitan Museum, New York. Text, page 284.

149. *Still Life with Apples* · PAUL CÉZANNE · Museum of Modern Art, New York. Text, page 286.

150. *Madame Cézanne in the Conservatory* · CÉZANNE · Stephen C. Clark Collection, New York. Text, page 285.

151. *L'Arlésienne* · VINCENT VAN GOGH · Lewisohn Collection, New York. Text, page 287.

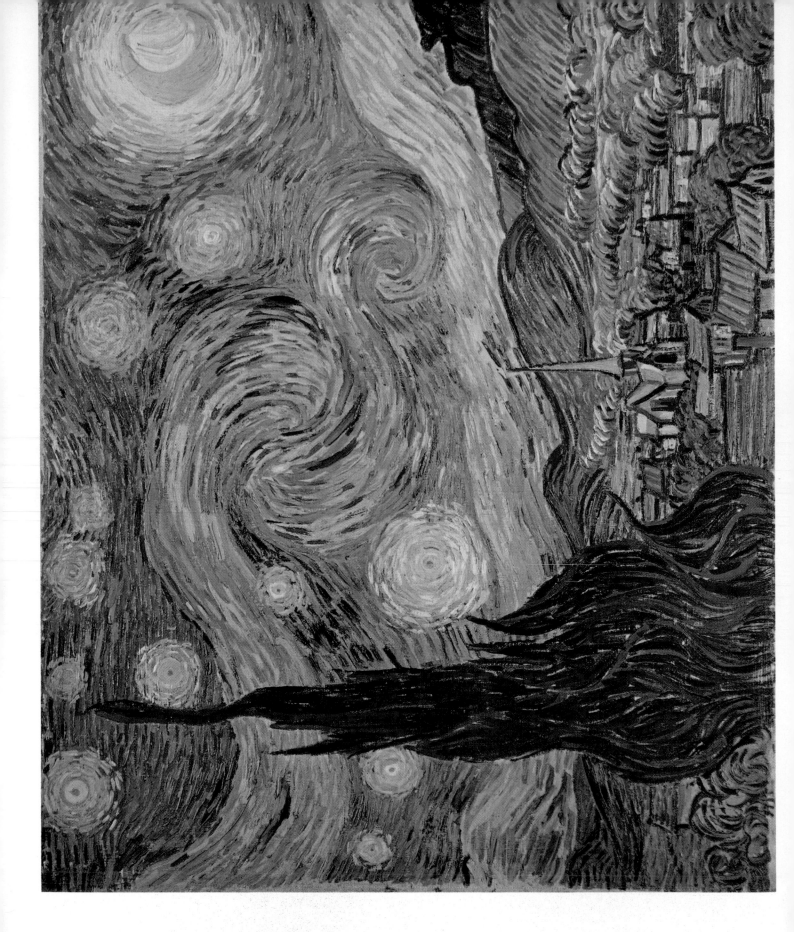

152. *Starry Night* · VINCENT VAN GOGH · Museum of Modern Art, New York. Text, page 288.

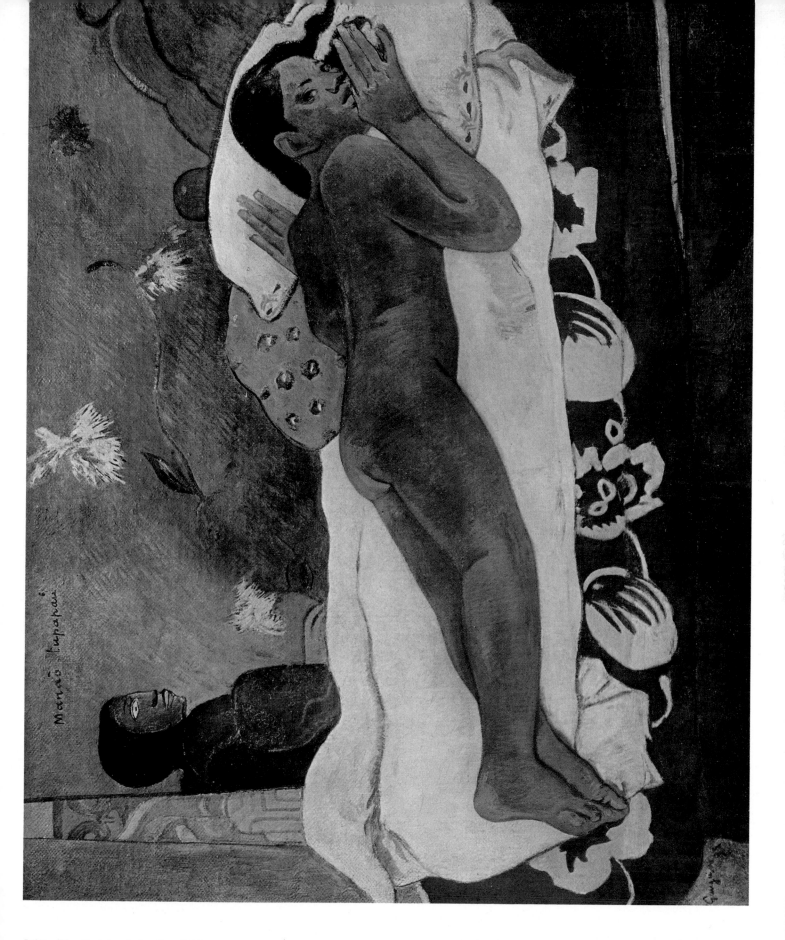

153. *The Spirit of the Dead Watching* · PAUL GAUGUIN · A. Conger Goodyear Collection, New York. Text, page 289.

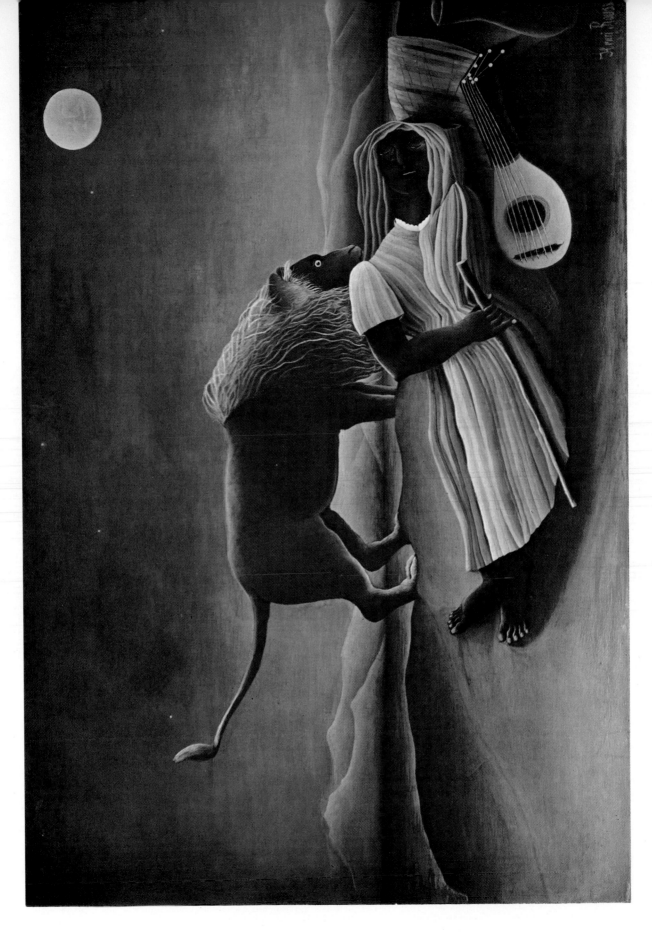

154. *Sleeping Gypsy* · HENRI ROUSSEAU · Museum of Modern Art, New York. Text, page 290.

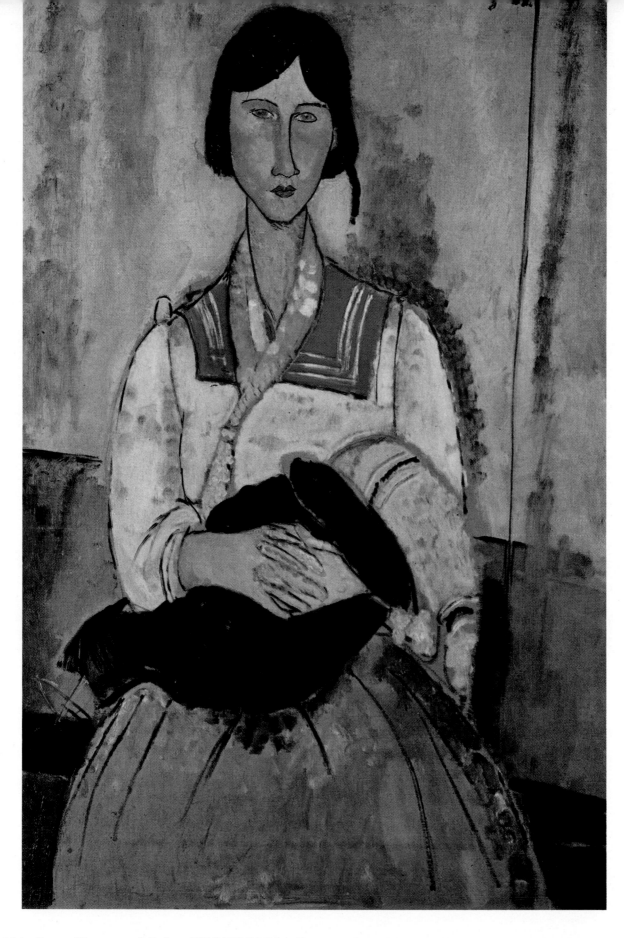

155. *Gypsy Woman and Baby* · MODIGLIANI · Chester Dale Collection, Chicago. Text, page 291.

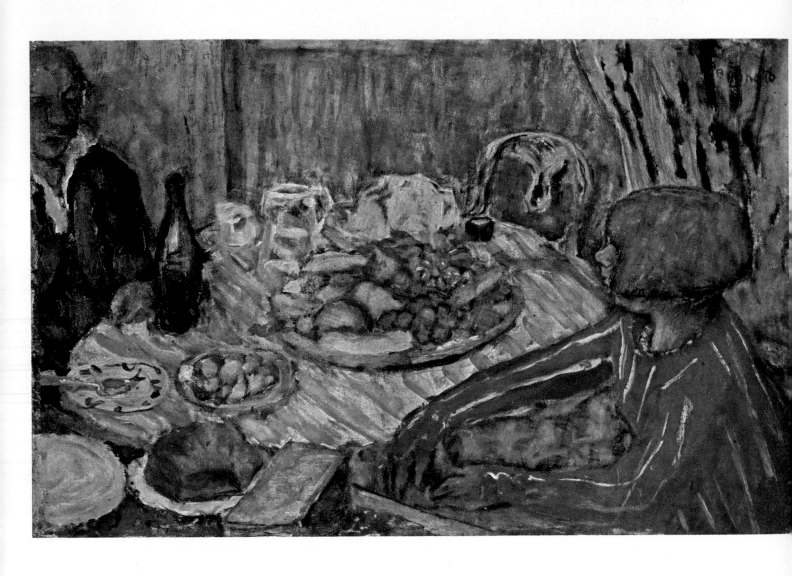

156. *Luncheon* · PIERRE BONNARD · Museum of Modern Art, New York. Text, page 292.

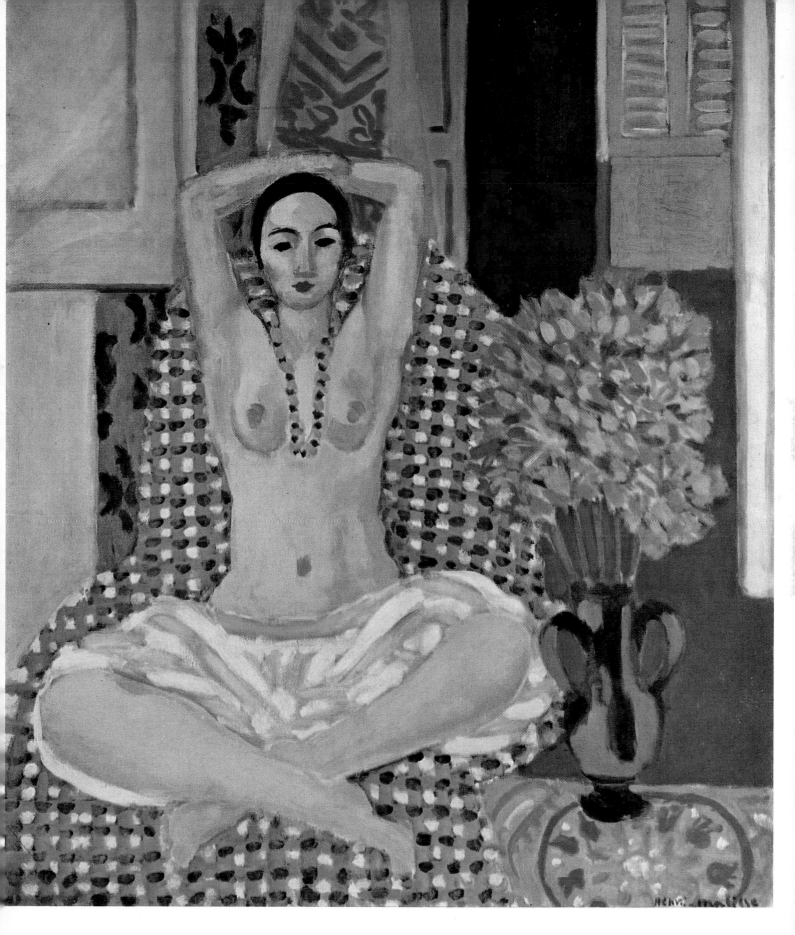

157. *Odalisque* · HENRI-MATISSE · Stephen C. Clark Collection, New York. Text, page 293.

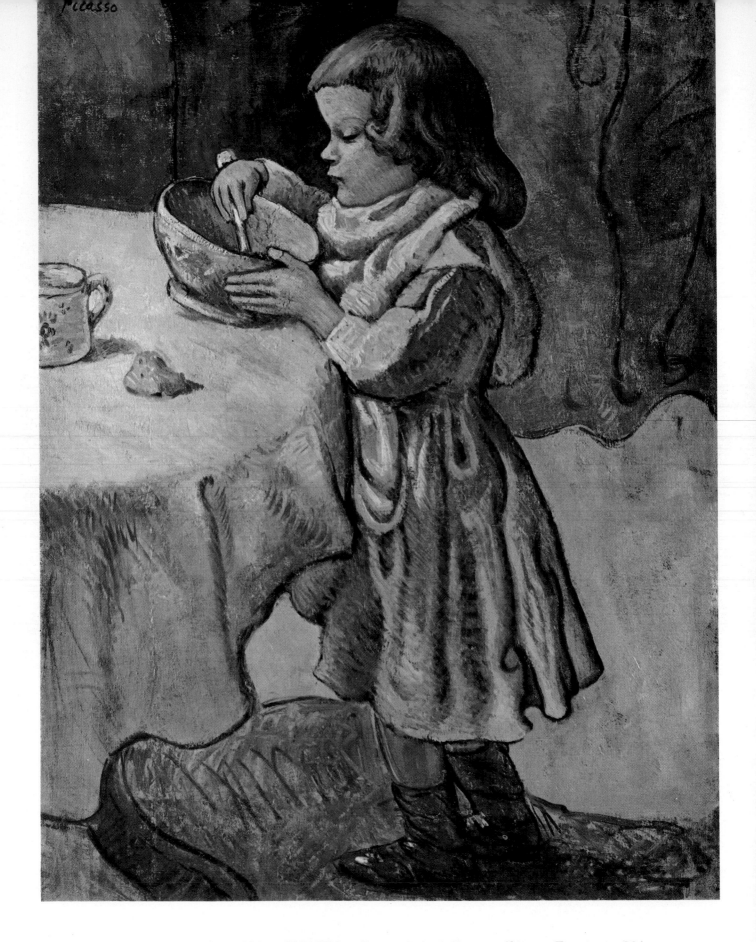

158. *Gourmet* · PABLO PICASSO · Chester Dale Collection, Chicago. Text, page 294.

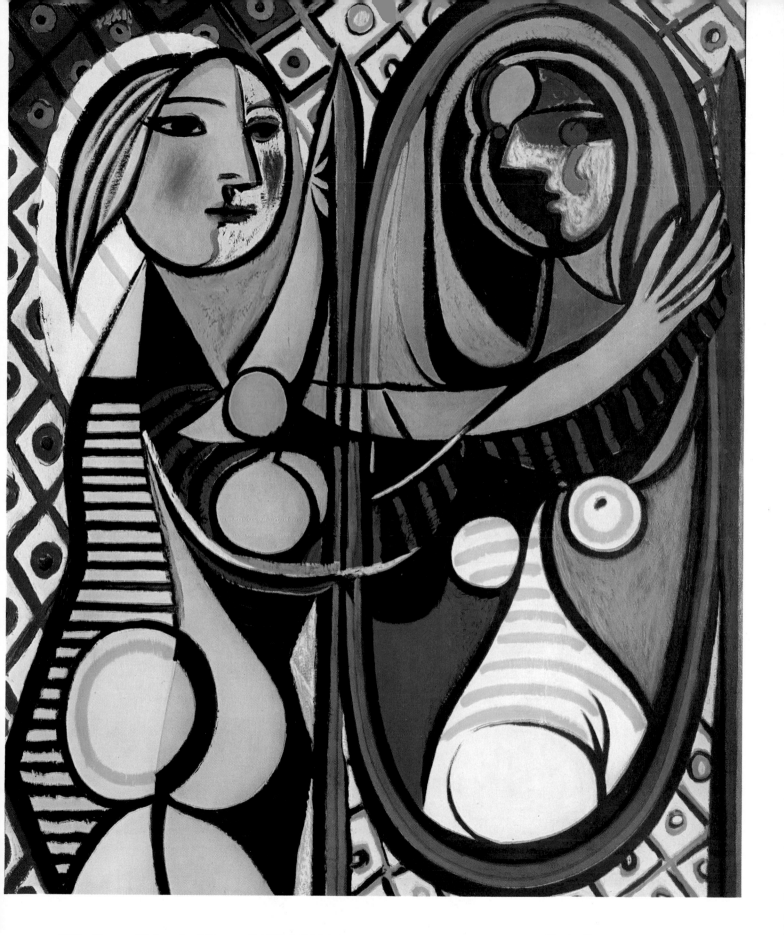

159. *Young Girl at the Mirror* · PABLO PICASSO · Museum of Modern Art, New York. Text, page 295.

160. *Guitar, Fruit and Pitcher* · BRAQUE · Home of Mr. and Mrs. M. Lincoln Schuster, New York. Text, page 296.

# EDITOR'S ACKNOWLEDGMENTS

A PUBLISHING PROJECT of the magnitude of *A Treasury of Art Masterpieces* could only have been made possible with the aid and wholehearted co-operation of individual collectors, museums, and galleries in all parts of the world. In dedicating this volume to these lovers of great paintings, and to the technicians and workmen who carried the project through to its fruition, I find it difficult to express adequately the full measure of my gratitude.

In preparing the original edition of the book, I have been deeply indebted to Mr. Otto Vonderhorst who, in the face of political disturbances and changing museum conditions in Europe, succeeded so brilliantly as supervisor of color photography; to Mr. Philip H. Ahrenhold whose skill and extraordinary patience are responsible for the quality of the engravings; to Dr. William R. Valentiner, director of the Detroit Institute of Arts; to Mr. Perry T. Rathbone, curator of paintings of the Detroit Institute of Arts, and to Mr. Frank Crowninshield for their generous assistance and continuing interest in the publication of this book; to Mr. Wallace Brockway, to Mr. Albert Rice Leventhal, and to Miss Nina Bourne for their co-operation and tireless industry in all departments of the project from research to manufacturing; to Mr. Charles T. Merritt, to Mr. Martin Hurley, and to Mr. Joseph Chanko for their day-to-day assistance and enthusiastic support.

For their graciousness in extending permission to photograph and reproduce the great paintings in their collections, thanks are due to the Comtesse de la Béraudière, Mrs. Ralph Harmon Booth, Mr. Stephen C. Clark, Mr. and Mrs. Chester Dale, Mr. A. Conger Goodyear, Mr. Maitland F. Griggs, Mr. Edward S. Harkness, Mr. and Mrs. Sidney Howard, Mr. Sam A. Lewisohn, Mr. Clarence Y. Palitz, Mr. Duncan Phillips, Mr. Henry Reichhold, Mr. Carroll Tyson, Mr. Joseph Widener, Mr. Frank P. Wood, and Mr. and Mrs. M. Lincoln Schuster.

I am profoundly grateful to the directors and officials of the great European museums and galleries for their co-operation and for the many courtesies shown our technicians and photographers abroad. Thanks are extended to Sir Kenneth Clark, director of the National Gallery, London; to M. Henri Verne, director general of the Louvre, Paris; to Mr. Frederik Schmidt-Degener, director of the Rijks Museum, Amsterdam; to Dr. Paul Ganz, director of the Swiss Archives for the History of Art, Basel; to M. Arthur Cornette, director of the Museum of Fine Arts, Antwerp; to M. Leo van Puyvelde, director of the Museum of Fine Arts, Brussels; to Commandatore Bartolomeo Nogara of the Vatican Museum, Rome; to Dr. Friedrich Kriegbaum of the Kunsthistorisches Institut, Florence; and to Mr. Chester Aldrich, director of the American Academy in Rome.

My thanks go as well to the directors, curators, or custodians of the church of San Francesco, Arezzo; the Kaiser Friedrich Museum, Berlin; the Hospital of St. John, Bruges; the Museum of Colmar, Alsace; the Art Gallery, Dresden; the Uffizi, Florence; the San Marco Museum, Florence; the Pitti Palace, Florence; the church of the Carmine, Florence; Sir John Soane's Museum, London; the Samuel Courtauld Collection, London; the Alte Pinakothek, Munich; the Chapel of San Brizio in the cathedral of Orvieto; the Arena Chapel, Padua; the Opera del Duomo, Siena; the Academy, Venice; the Doges' Palace, Venice; the Church of Santa Maria dell' Orto, Venice; the Kunsthistorisches Museum, Vienna. I am also grateful to Mr. James Stuart MacDonald, director of the National Art Gallery of Victoria, Melbourne, Australia.

Our efforts to photograph the great art masterpieces directly from the originals in the United States were met with the same gracious spirit of co-operation. I am deeply indebted to Mr. A. Everett Austin, Jr., director of the Wadsworth Atheneum, Hartford; to Mr. Alfred H. Barr, Jr., director of the Museum of Modern Art, New York; to Mrs. Mary Duggett Benson, custodian of the Bache Collection, New York; to Mr. F. Mortimer Clapp, director of The Frick Collection, New York; to Mr. George Harold Edgell, director of the Museum of Fine Arts, Boston; to Mr. David E. Finley, director of the United States National Gallery of Art, Washington, D. C.; to Dr. Walter Heil, director of the M. H. de Young Memorial Museum, San Francisco; to Mr. Fiske Kimball, director of the Philadelphia Museum of Art; to Mr. Reeves Lewenthal, president of Associated American Artists; to Dean Lloyd Kellogg Neidlinger of Dartmouth College, Hanover; to Mr. Daniel Catton Rich, director of the Art Institute of Chicago; to Mr. Theodore Sizer, associate director of the Gallery of Fine Arts, Yale University, New Haven; to Mr. Harry B. Wehle, research curator, department of paintings, Metropolitan Museum of Art, New York; to Dr. Alfred Frankfurter, of *Art News*; and to Mr. Harry Abrams.

I acknowledge with thanks the co-operation of the directors and curators of the Durant-Ruel Galleries, New York; the Rehn Galleries, New York; the Walker Galleries, New York; the Detroit Institute of Arts; and the Boston Atheneum for permission to reproduce the Gilbert Stuart portrait of George Washington. I am

grateful also to Mr. Thomas Hart Benton and to the late Mr. Grant Wood for their courtesy in making available their paintings, and to the photographers, engravers, and printers whose proficiency and devotion to their work have been a constant inspiration.

The editing of the new and revised edition of *A Treasury of Art Masterpieces* has exceeded, in some respects, the magnitude of the original labors. It has meant, in addition to the new plates in color, the incorporation of 489 reproductions in black-and-white, with the attendant problems of selection, research, integration and layout. In this, I have had at my command the skill, direction and patience of Helen Barrow and Doris Dixon of the Simon and Schuster staff. My thanks go out, as well, to Marilyn Silverstone for her research assistance, to Eve Metz, and to the many museums, galleries, and individuals who so generously contributed permission for the black-and-white reproductions.

THOMAS CRAVEN

# INDEX

ALPHABETICAL LISTING OF ALL THE ARTISTS AND THEIR PAINTINGS. THE PAINTINGS
REPRODUCED IN FULL COLOR ARE INDICATED WITH BOLD FACE PAGE NUMBERS.